Surpassing Modernity

Against Transmission, Timothy Barker
Enduring Time, Lisa Baraitser
Reparative Aesthetics, Susan Best
Misanthropy, Andrew Gibson
A History of Light, Junko Theresa Mikuriya
Civic Aesthetics, Noa Roei
Retroactivity and Contemporary Art, Craig Staff
Slow Philosophy, Michelle Boulous Walker

Surpassing Modernity

Ambivalence in art, politics and society

ANDREW MCNAMARA

BLOOMSBURY ACADEMIC
LONDON • NEW YORK • OXFORD • NEW DELHI • SYDNEY

BLOOMSBURY ACADEMIC
Bloomsbury Publishing Plc
50 Bedford Square, London, WC1B 3DP, UK
1385 Broadway, New York, NY 10018, USA

BLOOMSBURY, BLOOMSBURY ACADEMIC and the Diana logo
are trademarks of Bloomsbury Publishing Plc

First published in Great Britain 2019
Reprinted 2019

Cover design: Irene Martinez-Costa
Cover image © Anita Berber and Sebastian Droste in their dance martyr. 1922.
Photograph by Madame D'Ora © Imagno / Getty Images

A catalogue record for this book is available from the British Library.

A catalog record for this book is available from the Library of Congress.

ISBN: HB: 978-1-3500-0833-5
PB: 978-1-3500-0834-2
ePDF: 978-1-3500-0832-8
eBook: 978-1-3500-0835-9

Typeset by Deanta Global Publishing Services, Chennai, India
Printed and bound in Great Britain

To find out more about our authors and books visit www.bloomsbury.com
and sign up for our newsletters.

CONTENTS

IMAGE CREDITS

ACKNOWLEDGEMENTS

With any concentrated undertaking, various debts accumulate. First of all, my gratitude to Lydia not only for putting up with me during the long gestation of this publication, but also for her encouragement; thanks to Felix and Astrid too. Many thanks to Liza Thompson for originally commissioning this book way back in the mists of time and for believing it might be a good idea. My debt to the strained patience of Frankie Mace at Bloomsbury for dealing with the fluctuating deadlines and for shepherding this book through to publication.

My deep appreciation to many friends and colleagues, who gave feedback on versions of the content at various stages of its development – Susan Best, Ann Stephen, Toni Ross, Manfred Milz, Justin O'Connor, Paul Wood, Catherine Liu, Robert Leonard – and also for the support of my colleagues in Visual Arts at QUT, while I bunkered down to complete the project. I would like to thank Josh Milani, director of Milani Gallery, for rights to reproduce the works by Ian Burn and Robert Hunter in Chapter 4; Mustapha Benfodil for permission to reproduce his work in Chapter 3; as well as the Polke Estate for the rights to reproduce the Polke works in Chapter 2. My gratitude to Michelle James for editing some earlier versions, and in particular to Claire Armstrong for seeing the editing job through to completion so efficiently and smoothly. Finally, a note of thanks to my faculty, Creative Industries at QUT, for granting me study leave to complete this project and to my former students in a now-defunct research seminar (Contemporary Aesthetic Debates) who, over a number of years, accompanied me on the journey to develop this material. They were willing to take the leap, which made it all the more rewarding for me and, hopefully, for them.

While studying at the Power Institute, University of Sydney, many years ago, I was fortunate to attend the seminars of György Márkus in the philosophy department, which opened my eyes to the complexity of a culture of modernity. May the examination continue!

Introduction:

The surpassing urge

Over the course of the past four to five decades, analyses of art, culture, and social inquiry have been gripped by an urge to devise new terms. Almost imperceptibly the height of critical achievement became associated with the ability to conjure terms heralding the contemporary situation as a new epoch. Suddenly, an entire career could be ignited on the basis of terminological invention – whether as an artist, curator, art writer, sociologist, generic theorist, a seer, art historian, or art critic. It did not even seem to matter how fleetingly successful the term was. From the 1960s until the first decades of the twenty-first century, the process gathered such momentum that terminology invention became equated with the highest level of critical insight, triggering a kind of critical gold rush for novel critical labels.

The significance placed on the status of contemporary art in this zeitgeist frenzy is curious. A likely explanation for its prominent role is that theories of art have long been preoccupied with such a surpassing quest. Invariably, the target to be surpassed was modernism. Yet, any cursory analysis of routine discussions of the term 'modernism' would leave an uninitiated reader thinking that most studies and most fields of research are talking about completely different things. Yet, there is one thing that the various discussions

tend to agree on: somewhere around the 1960s, art changed to such a degree that it needed a new description or label.

This conclusion prompted a terminology inflation that has never ended. It has yielded a dizzying array of labels. Not only do we have to contend with the meaning of the redundant terms – such as the modern, modernity, and modernism (as well as the elusive, though usually derogatory label 'high modernism') – but we also have to grasp all the new terms in their aftermath: postmodern, the anti-aesthetic, post-postmodern, contemporary, contemporaneity, hypermodern, non-modern, digi-modernism, auto-modernism, relational aesthetics, altermodern, metamodernism, remodernism, militant modernism, liquid modernity, multiple modernities, *nachmoderne*, the off-modern, polymodern. Not all of the terms in this long list constitute terms of surpassing: many seek to complicate an earlier account of modernity or otherwise seek to provide a qualified explanation of its subsequent development. The list is not even exhaustive, yet the proliferation is reminiscent of the lyrics in the old John Lennon song, *Give Peace a Chance*, with its litany of nonsense 'isms': 'Bagism, Shagism, Dragism, Madism, Ragism, Tagism/This-ism, that-ism, ism ism ism.' For all the energy devoted to the task of surpassing, it appears that all we have done is trade the passage of self-differentiating 'isms' for a never-ending list of surpassing terms. Even Lennon's song confirms to the logic of the surpassing paradigm – its motto is to disregard all the phoney 'isms' and rally instead to the cause of one supreme banner term, peace. This is not surprising because the song dates back to the 1960s, the period when the surpassing quest was in its initial stages, if not its heyday, when the blossoming of modernist 'isms' was perceived to have ground to a halt.

Surpassing terms are attractive because the ability to conjure a magical, new term implies having one's finger on the pulse of the times. It means being able to differentiate the current moment as *unique* and entirely distinct from anything previously associated with the past, particularly modernity. Every generation desires to believe that their time is truly unique, that it presents never-before-seen opportunities and throws up challenges never previously confronted. It supposes a razor-sharp insight that can cut through the myriad, chaotic, and disparate aspects of contemporary existence and to condense it all into an insight of pristine clarity. While others flounder in confusion or nebulous circumspection, the

authors of surpassing terms discern the distinct mood and shape of the new with exemplary precision.[1] They are the metaphysical diamond cutters of our age.

While it is a very enticing prospect, which perhaps explains why there are so many of them, it is also daunting. Each new term must be measured by its capacity to capture the mood of the zeitgeist, while simultaneously explaining how present circumstances are utterly different than anything ever before experienced, thus confirming the need for a unique label. This is a tall order, rarely achieved. In order to proclaim a fresh age, any new term of surpassing only makes sense by showing how the superseded has become redundant – whether technologically, culturally, or socially – and is eclipsed by the fresh formulation. This is the only way to substantiate the case for a genuine cultural or social paradigm break. Any new case for surpassing must therefore outline the circumstances that make the new situation so different from anything we have known before, which means that – with each new term – the expectations escalate for terms of surpassing.[2]

Such a daunting level of requirement seems to have now inhibited the surpassing momentum. Now terms rarely attract as much attention or enthusiasm. We may be witnessing a critical malaise. New terms no longer seem to possess a strong sense of change or inevitable momentum. Each new term proposed seems less capable of attracting and sustaining significant adherents to the cause of its argument. Instead, we seem to be groaning under the accumulated weight of so many divergent claims. The surpassing quest is enticing, but prone to hyperbole, especially when terminology invention becomes tied to epochal change. How many distinct cultural paradigm breaks can occur in one lifetime? Once it became commonplace to formulate a new critical initiative in terms of terminology invention, then the process became less convincing and more strained as it accelerated. We have reached a point where new terms and concepts are fashioned more quickly. Today, writers seem compelled to offer a new term with each new publication. While the pursuit may have sped up, expectations surrounding terminology invention have simultaneously escalated and waned. The quest far outstripped the original ambition of clarifying what happened to art in the aftermath of modernism. Even that topic remains a vexed issue as there is renewed research interest in the topic of modernism evidenced by proliferating research bodies

exploring forgotten corners of the modernist endeavour, including research devoted to investigating new material, or works and ideas too quickly bypassed.

At the same time, it is difficult to avoid the suspicion that the surpassing quest's critical enterprise has reached a point of redundancy. Very few of these alternative terms have endured in any convincing fashion – not even postmodernism persists with any great conviction.[3] This is despite the fact that many of these terms attracted a great deal of critical investment at their inception. While there is still a strong commitment to some of them, other terms have disappeared without a trace, neither mourned nor remembered for long. While the critical enterprise may look like it is waning, it would be premature to forecast the passing of the surpassing quest any time soon. There is, after all, a market for a constant parade of new proposals, fresh ideas, and formulations (even if it means repackaging old ones). Too much is invested (and too much rewarded) for this effort of surpassing to abruptly decline. Even though the quest looks increasingly frantic and forlorn, it persists.

The mercurial task of the surpassing endeavour is evoked in the strange dynamic explored in the performance work *Waltz* (2001) by the Russian artist Elena Kovylina. Her performance began straightforwardly enough with Kovylina inviting (invariably male) members of the audience to dance with her, one at a time. After completing each waltz with her temporary dance partner, she celebrated with a generous shot of vodka, sometimes nonchalantly discarding the glass over her shoulder, pinning another Soviet-era military medal to her army jacket, and then choosing a new partner. In this way, the dance cycle would begin all over again with minor variations. Those who were witnessing this ritual for the first time had no idea where it was heading. By inviting spectators to become participants in this voyeuristic spectacle, each dance offered the hint of the unexpected within a curiously repetitive ritual. Against a scratchy soundtrack of an old Marlene Dietrich recording, this circuit of waltz and subsequent celebration continued, undertaken as many as thirteen times – and thereby entailing the consumption of a lot of vodka within a short period of time.

At first, *Waltz* suggests a convivial event, though one tinged with an uneasy mixture of enticement, whimsical delight, and trepidation. Kovylina directs the performance to the extent that she determines its key parameters, such as who shall dance next

and when. From this position of control, Kovylina ultimately leaves her audience with a wreck. Because each additional waltz is greeted with yet another medal and another toast of vodka, the performance progressively descends into a more macabre spectacle as Kovylina borders on passing out in her own performance. The performer first glides across the improvised dance floor, then stumbles, and – as an ever-greater level of intoxication is reached – eventually staggers across the makeshift dance floor now strewn with the accumulated debris of broken glass until the artist virtually slumps inert against her final dance partners. By alluding to a fleeting act of rudimentary civility – a dance with an unknown stranger – *Waltz* first appears to celebrate fleeting moments of spontaneous interpersonal connection, but then shifts register to present a more brooding spectacle. At which point it becomes increasingly difficult to stand aloof as the audience grows ill at ease at the prospect unfolding. All faint traces of potential seduction, renewal, or civility recede into this frightening spectacle of a discombobulating performance in which an audience is left to fear for the well-being of an artist who exposes herself to such an extreme state of vulnerability.

The military resonance hints at perverse initiation rituals: the brutal rites of passage that admit one to a group only by demeaning the initiate. Kovylina herself suggests a range of specific inspirations for this gruelling performance. Among them, she recalls witnessing as a child the ritual gatherings of female veterans in Russia commemorating the Great Patriotic War – and, thus, the catastrophic civilian and military losses of the Second World War. These celebrations permeated the collective experience of subsequent generations as much as they did for those who survived its horrors.[4] Moving forward in time, Kovylina also reflected on more contemporary experiences of travelling across borders as a Russian woman in the years following the fall of the Berlin Wall. This was meant to be a moment that delivered a cosmopolitan and liberal utopia of unimpeded freedom from restriction. Kovylina, however, recalls the tawdry inverse state of the 'post-Soviet feminine condition', as she refers to it, in which the 'specter of communism' transmuted into 'a specter of prostitution'. Travelling across borders meant being subjected to perennial indignities: 'It starts when you ask for a visa. Being a young, single, traveling woman, don't even try to imagine a welcoming treatment at the consulate. When you

cross the border, guards order all young women off the bus and ask lots of unfriendly questions.'[5]

The fall of the Berlin Wall heralded not only the end of the Soviet bloc in Europe and the end of the Cold War, but also, conversely, many premature announcements of the ultimate surpassing: the end of ideology and even of history, no more struggles, simply the victory of liberalism and the capitalist free market, thereafter supposedly unimpeded to establish its prosperity and hegemony throughout the world.[6] For some observers, 1989 also marked the advent of a new era of art called the 'global contemporary'.[7] In its more euphoric conceptions, it marked a more diversified, postcolonial, and transcultural contemporary art, one that was able to free itself of all the Eurocentric biases of modernity, embracing a uniquely planetary experience, albeit with far more intense levels of technological disruption, economic–technological transformations, driven by speed and connectivity on a scale never seen before.[8]

The year 1989 was also the pivot point for Kovylina's *Waltz*, except that she represents it as a stark world in which the ideals and the reality remain greatly separated. Kovylina's *Waltz* seeks, by contrast, to manifest the experience of new, less visible borders of post-Glasnost capitalism pervaded by people-smuggling, drugs, the sex trade, mail-order brides, oligarchs, as well as chronic social and economic inequity. Seen in this light, *Waltz's* more ominous qualities acquire sharper focus. *Waltz* is no doubt Kovylina's 'signature' work, as she herself admits. While the basic parameters of the performance are quite straightforward, the work is highly evocative. At once, it borders on a celebration, a dance, a protest, and a commemoration. *Waltz* exists in the netherworld of the gap between the celebrated post-1989 era and the sordid realities of its shortfall, between the promise of the ultimate realization of the surpassing mode – the moment of delivery beyond former ideological divisions in a new unified and single liberal-American world order – and everything that compromised and defied this promise, to name a very few: the attacks of 11 September 2001; the Bali bombings of 2002; two wars in Iraq; the Arab uprisings of 2010–11 and the fierce repression in their aftermath; the global financial crisis of 2007–08; with its attendant consequences of growing wealth disparities, declining infrastructure as well as stagnant working-class and middle-class incomes; the rapid economic rise of China and Asia; and weariness and trepidation about representative democracy. *Waltz* is both

compelling and confronting in articulating and anticipating this gap in the promise of a harmonious, prosperous single, unified system and its realization. *Waltz* is simultaneously mesmerizing, enticing, haunting, humorous, and ultimately replete with pathos. If any initiation ceremony is implied, then it could equally be the precarious initiation both to the West and its contemporary situation, as well as to the global art world, to which Kovylina herself has been initiated, and thus to the global contemporary condition.

It is not too great a stretch to discern in *Waltz* a dynamic akin to the enthusiasms of the surpassing logic. Each new term is like being invited to dance with an enticing new conceptual partner. The encounter begins with much enthusiasm and expectation. The enticement of terminology invention – this waltz with thought – aims to transform our perspective each time. It wants to show us the world anew by asking us to challenge our previous conceptions and to relinquish them. Every turn offers the same promise of intoxicating renewal. Terminology invention was, at first, a buoyant quest because it was propelled by an awareness that the prevailing definition of modernism no longer adequately encompassed what was occurring (for instance, artistic practices transformed by a new transcultural and transnational environment, by new social practice, by feminism, and by anti-aesthetic ambitions). The quest had vitality as a genuine critical pursuit. Each time the effort at surpassing suggested a great reward. Ultimately, we have discovered that the outcome is similar to the performances of *Waltz:* we became intoxicated by terminology invention, and by the desire to escape apparently limited horizons, only to find the accumulated effect was just as debilitating. The intensification and multiplication of the effort has not yielded fresh stimulus, but a sense of weariness at a circuit that keeps bringing us back to where we started.

Despite creating a performance that manifests the gap between an ideal and its realization, it is interesting to note how Kovylina explains the influences informing her practice. In contrast to the strong demarcations between modernism and the contemporary erected by surpassing terminology, Kovylina notes her debt to not only female performance artist veterans (Carolee Schneemann, Marina Abramović, Yoko Ono), but also male performance pioneers, such as German artist Boris Nieslony, the Moscow Actionists, such as Avdey Ter-Oganyan, Anatoly Osmolovsky, the rather hysterical and perennially agitated Alexander Brener, as well as Oleg Mavromatti.

'Their actions in public spaces were conceived and performed during a very complicated time.' Kovylina explains (as if to suggest the situation since has become any less complicated). Furthermore, she insists on drawing on an artistic legacy stretching back to Arthur Cravan and drawing on the performative dimensions of Kazimir Malevich's abstraction: 'You probably know that his White Square was part of a stage setting. His own funeral was organized as a performance, with Black Square standing next to his coffin.'[9] No matter how one views this interpretation, it demonstrates how artistic legacies can be transformed by rethinking their impact inventively, such as viewing modernism through a performative lens.

Kovylina's nuanced linking of modern and near contemporary influences to explain her own artistic practice is not uncommon, but it jars with the surpassing quest, which challenges everybody to overturn their previous commitments and embrace a wholly new paradigm. This produces an irresolvable conundrum, if not ambivalence, because many contemporary positions are caught between dismissing the modernist legacy and, at the same time, relying upon it for most of their cultural justifications. Even though Kovylina's performance is highly critical of the present state of affairs (for instance, the 'post-Soviet feminine condition'), she has little trouble with drawing upon the modernist legacy. The surpassing quest, by contrast, defines itself by its ability to eschew such investments, which it implicitly identifies as inferior or otherwise stemming from a more reactionary cultural paradigm (read patriarchal, Eurocentric). The conundrum is not simply that the announcement of new paradigms now occurs regularly. It also raises the question of how it justifies its practices without recourse to the legacy it dismisses outright. Like each dance for Kovylina, we eventually reach a point at which we cannot grasp what is actually occurring anymore; the quest blurs with all the new announcements and becomes more and more indistinct (even without the aid of vodka). We become less convinced as the terms build up and accumulate. We are no longer able to discern what difference any of it makes because every new case put forward has to contend with a welter of prior surpassing propositions.

If there is a critical malaise today, however, it does not just stem from the proliferation of new terms. The malaise is equally the result of a kind of critical apartheid that ensues from reductive thinking.

It begins from the assumption that what has been surpassed is inferior to the new paradigm that supplants it. The modern is treated as the redundant forerunner in much contemporary discourse, and thus as a decrepit historical curiosity. It also implies a process of improvement and therefore assumes a successive model. The result is a dualistic discourse distinguishing between modernism – the redundant forerunner, something coercively reductive, if not an imperialist projection – and the contemporary, or (as one influential case puts it) contemporaneity – the new, more sophisticated, complex and dexterous paradigm.

The four chapters that make up this book do not amount to a conventional art-historical study that offers a chronological account of an artist or even a set of practices. Instead, the four studies probe conceptual impasses that permeate current debates as a result of this process of demarcation. My concern is that this process is producing stifling, rigid debate and diminishing art-historical inquiry. The surpassing quest leads to demarcations and, in turn, produces 'bad objects' or taboo terms (even though this is strenuously denied, for one of the chief dictums of contemporary discourse is that it does not rely on arguments based upon discursive 'bad objects' – that is supposed to be the blind-spot of modernist thinking). The resulting terminological divisions form blockages in inquiry because there is no way of triggering any elaborate or nuanced thinking around them. There is no possible way of accounting for all of these demarcations, but one can provide a selection.

Modernism	Contemporary (or 'contemporaneity')
Purity and rationalization	Paradox and ambiguity
Demarcation/binaries	Hybridity
Simplification/top–down hierarchy	Complexity
Eurocentrism, primitivism	Non-Western, transcultural
Elitist	Democratic
Universal	Cultural relativism
Aesthetic	Anti-aesthetic
Synthesis, resolution	Contradiction, antinomy

While this table of contrasts might appear far-fetched, this book provides many examples of rhetorical manoeuvres that employ such contrasts – especially in the second half of Chapter 1, which presents detailed discussions of two surpassing paradigms: the anti-aesthetic and contemporaneity. The argument for surpassing has not always required such a crude level of conceptual splitting, but that is where it has ended up. Its discourse has drifted over time into a set of dichotomies until it is now littered with broad sweeping assessments and definitions drifting into caricature. According to the surpassing mode of thinking, only the modern is reductive; only it relies on a successive, progressive model of evaluation, erects strict demarcations, or thinks in terms of cultural hierarchies.[10]

At the same time, this book shows many instances of common themes, principles, and justifications of art practices shared across both modern and contemporary explanations. These primarily involve a recourse to tolerance, free speech, critical autonomy, legitimate dissent, unmitigated questioning, testing untested assumptions, equality, the universality of civic rights and liberties, as well as generic references to 'hopeful anticipations', scepticism, articulating the unsaid or giving voice to the mute, and creative or critical re-imaging, including the capacity to go astray in art and cultural matters, and so on Chapter 1 therefore sets out to establish some framework for explaining a more complex picture of the modernist cultural paradigm than is permitted in many contemporary analyses, especially those based on a definition of modernism as a discipline-specific, successively reductive model of formal artistic innovations.

Chapter 1 aims to show how the peculiarity of modernist culture provoked committed and ambivalent responses in a constant struggle, starting with a well-known, but still complex, portrayal of modernist cultural possibilities and threats by Walter Benjamin. Benjamin was an early critic of the idea of heralding modernity as a continuous success story. On this point, however, he was ambiguous. He challenged Marxist and social-democratic orthodoxy on historical progressivism by offering an account of a 'dialectic of ambiguity', which as the Hungarian-Australian philosopher, György Márkus points out, 'disclosed the deep ambiguities of cultural modernity'. On the other hand, Benjamin fell prey to the urge to locate a new progressive model elsewhere, such as in technologically reproducible media and art forms that might

bridge the divide between the practical and theoretical components of his conception of modernity's divisions. The discussion therefore seeks to outline Márkus's idea of modernity as a culture structured and wrought by antinomies, which in turn offers a quite different explanation of modernist art of various forms. In developing this ambiguous account of modern experience, the first chapter aims to reconfigure the conventional Anglo-American depiction of modernism. The linking of antinomies to contemporaneity rather than to modernity leads to a discussion of two prominent models of surpassing typified by the terms, 'anti-aesthetic' and 'contemporaneity'. Because it is impossible to cover all examples of surpassing formulations, these two are highlighted in the first chapter, not because they are necessarily the most definitive, but because they do convey the tenor of the surpassing logic. The discussion shows that Hal Foster now regards the anti-aesthetic as an ambivalent or reticent surpassing model, whereas Terry Smith, the chief advocate of contemporaneity, remains adamant about its credentials as a model of surpassing.

Chapter 2 discusses a 'Polke & Co' exhibition, *Wir Kleinbürger! Zeitgenossen und Zeitgenossinnen (We Petty Bourgeois! Comrades and Contemporaries)* of 2009–10. This exhibition title suggests a joke. Who, after all, conjoins the collective, socialist greeting of 'comrade' with a call to arms on behalf of the petty bourgeoisie? No one thought Sigmar Polke was actually serious in his simultaneous appeal to the comrade and the petty bourgeois. It was a form of radical political blasphemy. But what if it was not a joke? What would it mean to treat the provocation seriously and to conjoin the radical rhetoric of dissent and demonstration with this appeal to a common petty-bourgeois cause, *Wir Kleinbürger*, as a culture or community of activists? The result would be an uneasy one. Yet, a case can be made that Polke sought to explore what such a dubious and confronting identification meant for artists. It undercut their usual presumption of being sheer autonomous outsiders, at the forefront of history as well as dismantling lingering presumptions of transcendence and higher unity. Class re-enters the discussion, but ironically. Modern artists always identified with the position that held transgressive appeal, hence the identification with the proletariat. Polke was provoked by Hans Magnus Enzensberger's essay of 1976, 'On the Irresistibility of the Petty Bourgeoisie', which re-evaluated the petty bourgeoisie as a fluctuating class confusing

traditional social theory by reinventing itself as an intermediate and more ambiguous creative entity (thus anticipating Richard Florida's account of the 'creative class' by decades, but without the social engineering dimensions). Polke appeared to enjoy the prospect of puncturing the artistic pretensions of being a seer, a rebel, or a perennial bohemian. This ambivalent identification as petty bourgeois undermined such presumptions, but did not eliminate them altogether. It was a much more nuanced strategy because it modified the stances by situating the dissenters, visionaries, artists, and intellectuals precariously, but firmly within the bourgeois world, as an in-between class. For that reason the provocation does not abandon the idea of critical autonomy completely, but it significantly reshapes its ambition. Identifying as being in the vanguard no longer meant being immune to contamination with more venal, middle-class temptations; one could no longer envisage such corruption to rest only with others. The radical position was mired in the system, a product of social forces and institutions that enabled this relatively autonomous state, while never fully determining all of its consequences. The argument of this chapter seeks to show that Polke did not devise this provocation in terms of a coherent philosophical system, but he did at least intuitively grasp its ramifications, revelling in exposing a class misidentification artists, intellectuals, and fellow travellers and exposing a more ambivalent class identification. It was a position stuck in the middle, so to speak, between, for example, the trajectory of the Marxist endpoint – the revolution and reaching a point beyond capitalism's perennial crises – and the alternative resolution proposed by the 'invisible hand' of capitalism as an unimpeded and uncontaminated force, which self-corrects, thus producing the ideal system without any coercion.[11] It is as if to say being stuck between these two most famous, purported resolutions of modernity is the usual state of affairs in which we find ourselves and thus it is important to derive an explanation for it.

The third and fourth chapters tackle a major consideration that has dominated discussion for the past few decades – the idea of transcultural awareness of contemporary art within an expanded worldwide terrain. The fondness for equating modernism with European imperialism implicitly aligns postcolonial discourse with surpassing strategies. Does postcolonial challenge necessarily suggest a paradigm break? The most commonly accepted answer is

'yes, of course' and at that point debate fizzles out. These chapters explore what legacies artists and the contemporary art world draw upon when seeking to legitimize their practices. This becomes particularly acute at times of threats of arrest or of censorship – or under the prevailing shadow of threats to art, free speech, as well as press and academic 'freedom', or the questioning of aesthetic autonomy (not simply within critical approaches to art and aesthetics, but also from despotic or autocratic regimes). If one dismisses aesthetic autonomy as redundant, or disparages it as just another universal projection limited to Eurocentric elites, then what other justifications will fill the void?

Chapter 3 shows that many artists and dissidents throughout the Arab world were not coy in heralding propositions that have been often dismissed as Eurocentric. The discussion pivots around two closely related cultural events that occurred against the backdrop of the widespread Arab uprisings – the opening of a dedicated museum to Arab modern art in Doha and a censorship case that erupted during the Sharjah Biennial of 2011. In Sharjah, an installation by the Algerian artist, Mustapha Benfodil, was removed from a public square and banished from the exhibition. Officials were sacked. Despite the tense times, the censorship controversy in Sharjah proved to be a minor hiccup in the art world, and was largely forgotten. Subsequently, the Sharjah Art Foundation has held subsequent biennials without significant problems. Why return to focus on this particular incident? The censorship case is not the pivotal focus of attention in this chapter – nor is Sharjah for that matter. In 2011 everything escalated as the shock waves caused by the increasing uprisings sent tremors around the world. Instead of ignoring a rather crude performance-protest by the group Pussy Riot, the Russian government imprisoned two of its members (thus perversely highlighting the group's point that their government was autocratic, repressive, and suppressed basic human rights and civil and political freedoms), while the Chinese government arrested Ai Wei Wei – thus helping to transform the three imprisoned artists into international celebrities. The key reason for examining these particular episodes is to examine the arguments used to justify contemporary art practices when under intense pressure. This includes the official rhetoric accompanying new cultural institutions of modern and contemporary art within the Gulf region, which celebrated cultural modernity within circumscribed parameters.

The social and political upheavals rendered the investments in modernist cultural propositions more stark and acute than would otherwise have been the case. The chapter seeks to delineate the differing investments in propositions, which are sometimes considered narrowly Western, and at other times, associated with cultural-economic hegemony, sometimes with more universal propositions. As a result, there is deep ambivalence about social and aesthetic propositions that do not seem to cohere. As one writer puts it, one of the key features in the non-Western world is a hatred of perceived Western values and simultaneously a celebration of specific modernist ideals. The upheavals and the implications of this episode remain complex.

For this reason, Chapter 3 finishes with a discussion that seeks to illuminate why it is necessary to complicate an underlying polarity – namely, between cultural universalism and the cultural relativism. The discussion concludes by referring to Leszek Kolakowski's nuanced and complex unravelling of the critical-cultural pieties associated with both propositions. On the one hand, Kolakowski shows how it is 'barbaric' to uphold a universalist position that one applies uniformly to all situations, peoples, and cultures without putting one's own conceptual parameters to the test and challenging them. On the other hand, he exposes the dilemmas of cultural relativism. The complication is that whenever either of these positions is presented as an absolute, then as Kolakowski argues, both lead to barbarous conclusions – even if cultural relativity is endorsed in the name of a postcolonial sensitivity to the history of colonialism and exploitation.[12]

This book does not dismiss the postcolonial challenge, however, only its implicit reliance on the surpassing model of argument. Chapter 4 shifts the focus to explore the available art-historical models conducive to an expanded global terrain of contemporary art. Postcolonial discourse sometimes suggests a straightforward shift from Western modernity to the transcultural diversity of contemporary art. This is a fraught assertion because the latter's justifications still often rest on the former. Postcolonialism is more challenging in dismantling the centre–periphery assumption behind many orthodox art-historical approaches to modernism. These tend to presume that there is an inevitable process of transmission from a few, select Euro-American centres to the derivative peripheries (that is, everywhere else is designated as more or less plagiaristic

offshoots of these centres). The final chapter therefore tackles the thorny issue of what happens when one decentres the hierarchies of centre and periphery. It highlights the conceptual simplicity of most directional models of artistic and cultural transmission. By contrast, it examines the artist and sometime art historian Ian Burn's consideration of this quandary and his exploration of a peripheral vision and of visual acuity found in his last writings, which to date are not as well known internationally as his 'ideology critique' of the art world in the 1970s. If decentring means everywhere becomes peripheral, then how does anyone recognize what is going on and what are the common forms of communicating? Are peripheral discourses and practices simply a mask for provincialism? Burn's last writings develop the idea of visual acuity as a way of avoiding the problem of relativism in the promotion of the culturally specific.

Burn's last writings explain how Conceptual Art sought to perpetuate some key tenets of the modernist legacy – of course, not uncritically. In Burn's case, he sought to re-engage inventively with this legacy in order to devise new models of cultural exchange and the formulation of visual acuity. The discussion in Chapter 4 extends Burn's insight by showing how an earlier artist like Malevich had considered similar questions, such as his thoughts on a microbial explanation of art. In returning to these formulations on the periphery of modernist thinking, the discussion seeks to accentuate the diversity of models beyond the narrow centre–periphery model. Chapter 4 concludes by using the analogy of a 'chemical' art history to suggest a more dynamic and diversified art-historical investigation, which hopefully paves the way for more nuanced models of inquiry. In this way, the challenge posed by this book is to consider the modernist legacy, not always as an impediment, and not as something fixed in time and geography, but as amenable to new imaginative transactions that remain fruitful in our contemporary situation.

Nonetheless, our ambivalence relates to the realization that modernity produces a wayward dynamic that seems to tear a culture apart while also triggering its drive and energy. At the same time, we derive our vocabulary from it. No general discussion of modernity, or even the culture of modernity, can therefore be adequately harnessed within narrow disciplinary or genre boundaries. Social and political questions intersect with aesthetic and cultural ones. This book attempts to explore the modernity question primarily

through the lens of art history, my own area of expertise. Yet, I do so in order to point to these wider ramifications that entangle aesthetic and artistic justifications (or propositions) with political and social considerations. The problem with the surpassing strategy is that it has unintentionally produced a stifling, rigid art-historical inquiry, as I mentioned earlier, marooned on rigid dichotomies. Yet, the process has wider consequences in diminishing our critical vocabulary. Only in the West can one indulge in the proposition that autonomy is a superfluous issue. Right-wing populism has soared while the whole spectrum from the centre to the left is muddled over terminology and equivocation.

While few people believe that any of the individual surpassing terms have made a convincing case for a cultural paradigm break, nonetheless rhetorically the situation is often treated as if such a break has occurred. Each chapter in this book examines some of the resulting unmentionable propositions – the bad words that designate the 'bad objects' of our critical discourse. Rather than persist with this contorted demarcation – the Checkpoint Charlie of our critical discourse – the ambition of this book is to try to prompt a more nuanced understanding of the wider complexity of an *entanglement* of issues, justifications, and propositions that we tend to treat as absolute oppositions. By returning to examine the modernist cultural legacy, we can see why these propositions are entangled, why we are entangled with them, and why we are still compelled to resort to these justifications, which remain the sourcebook of our critical vocabulary.

CHAPTER ONE

What are we talking about? Narratives of modernity and beyond

A landscape in which nothing was the same except the clouds

Stop for a moment to consider the sky. Watching the clouds roll by, it is easy to imagine a similar view having been enjoyed for centuries, even millennia. Clouds, of course, are ever changing, though a perennial feature of our atmosphere. Taking into account the tremendous changes that occur in contemporary life, it is easy to conclude that this might be the last sight that will remain vaguely constant and untouched throughout one's lifetime. In his essay, 'Experience and Poverty' ('Erfahrung und Armut') of 1933, Walter Benjamin invited his readers to picture such a scenario when recalling the experience of his generation born in the last years of the nineteenth century and just emerging into adulthood when the First World War erupted:

> A generation that had gone to school in horse-drawn streetcars now stood in the open air, amid a landscape in which nothing was the same except the clouds and, at its center, in a force field of destructive torrents and explosions, the tiny, fragile human body.[1]

Only a view of the clouds remained the same, whereas on the ground everything was in flux. Despite the triumphant calls of progress often associated with modern development, Benjamin's generation were treated to its stark duality. The collective experiences of his generation were felt as brutal assaults: 'Strategic experience … contravened by positional warfare; economic experience, by the inflation; physical experience, by hunger; moral experiences, by the ruling classes' (Benjamin 1933/1999: 732). This generation witnessed so many profound dislocations: a collapsing imperial order but still imperialism; the dramatic shift of economic relations between city and country; the attendant population concentrations in cities; the catastrophe of mechanized warfare, including chemical (or gas) warfare in the trenches; and subsequently the hideous travails of constant economic crisis. These were all factors, according to Benjamin, that had exposed a new physical frailty and further impoverished collective experience.[2]

For Benjamin, the problem is not simply the common perception that the pace of accelerating industrial, scientific, and technological change outstrips the capacity to grasp or accommodate it – or even that modernity has a dark side.[3] This is all taken as read. The nature of experience had been challenged and transformed. Benjamin delineates this concern from his earliest writings in which he suggests that experience has been devalued at the cost of certainty and a secure, standardized justification of knowledge in the modern world. By contrast, experience, being ephemeral, is reduced to the value of 'fantasy or hallucination' compared to the neo-Kantian focus, which for him represents 'the extreme extension of the mechanical aspect of relatively empty Enlightenment concept of experience'.[4] The 'coming philosophy', according to Benjamin in 1918, would set its philosophical compass in a different direction: 'Total neutrality in regard to the concepts of both subject and object' as well as based on the assertion that the 'conditions of knowledge are those of experience'.[5]

Looking back on both experience and his own contemplation of it, Benjamin declares that everyone once knew what experience amounted to: 'Older people passed it on to younger ones' (Benjamin 1933/1999: 731). Nowadays such an idea of a shared, communal experience has largely become a foreign concept due to the emphasis on personal experience and the waning of traditional customs. Modernity places great strain on the capacity to integrate the

vagaries of individual experience into a coherent set of inheritable customs, common experience, or collective memory. The profound rupture of the war of 1914–18 showed that if there was an endpoint to all this development and disruption, then it was not necessarily a human endpoint in the conventional sense. 'Nature and technology, primitiveness and comfort, have completely merged', Benjamin remarked elliptically (Benjamin 1933/1999: 735). The war of 1914–18 had already dispelled fanciful, near-utopian projections of technological change – or at least postponed them for another day. Mechanization and technology were reorganizing all relationships, rural–urban, human or otherwise. One form of fragility therefore was the malleability of human and technological boundaries. In a fragment ruminating on the popularity of Mickey Mouse cartoons, Benjamin suggested that the cartoon character's appeal at the time related to the fact 'that the public recognizes its own life in them'. But what they recognized in this mercurial creature was something miraculous that hinted at the eclipse of the human: 'Mickey Mouse proves that a creature can still survive even when it has thrown off all resemblance to a human being. He disrupts the entire hierarchy of creatures that is supposed to culminate in mankind.'[6] Two years later in 'Experience and Poverty', Benjamin observes that Mickey Mouse's life is 'full of miracles' because he refashions the 'wonders of technology'. Largely without employing 'any machinery', Mickey Mouse makes fun of technology; he improvises an almost Dada-like mechanical performance out of his body, 'out of his supporters and persecutors, and out of the most ordinary pieces of furniture, as well as from trees, clouds, and the sea' (Benjamin 1933/1999: 735).

Mickey Mouse could be pieced together a whole lot better than the unfortunate combatants of Benjamin's generation that 'from 1914 to 1918 had to experience some of the most monstrous events in the history of the world', referring to mechanized warfare and the extreme scale of losses of life caused by what would subsequently be called the First World War.[7] This is one source of the physical frailty Benjamin refers to: the tiny, frail human body thrown into 'a force field of destructive torrents'. Human malleability did not prove as miraculous as Mickey Mouse's improvisations. Charles Péguy – who thought that the world had transformed more in his own lifetime than in the previous 2,000 years – soon died on the battlefield.[8] August Macke, the German expressionist, died within two months of being enlisted and sent to the front; while Franz

Marc died in 1916. The futurists, who exalted speed, steel, and technology, lost Antonia Saint'Elia and Umberto Boccioni, who both died in 1916. Blaise Cendrars, who rejoiced in an image of creative fever and mobility before the war, lost an arm. Apollinaire was shot in the head the same year. He survived only to be claimed by the Spanish flu pandemic at the end of the war. The pandemic was truly a global phenomenon, assisted on its path by railways and shipping criss-crossing the world with goods and soldiers; it too exposed both a frail human body and the stark duality of an interconnected development.[9]

The war exacerbated the decline in 'communicable experience': soldiers returned from the front unable to articulate their experience of modern warfare. Instead, silence prevailed. Within ten years there was a flood of books on the topic – indeed a surfeit of information – but an incapacity to communicate such an experience. In fact, there was more and more information about everything, not just the war, but this was all unassimilable. Obviously there had been a 'tremendous development of technology', but at the same time 'a completely new poverty descended on mankind'. An 'oppressive wealth of ideas' – 'the revival of astrology and the wisdom of yoga, Christian Science and chiromancy, vegetarianism and gnosis, scholasticism and spiritualism' – had swamped people, Benjamin notes. Older ideas were revived and sat precariously alongside new ideas. For Benjamin, the resulting 'horrific mishmash of styles and ideologies', heightened modes of distraction, and the highly attuned personal investment in idiosyncratic activities or lifestyles, spells bankruptcy rather than enrichment because culture is also divorced from experience (Benjamin 1933/1999: 732). Benjamin's account speaks not only of industrial-technological transformation, which of course is pivotal, but a growing gap between private, individual experience and any collective, inherited or inheritable experience. Modern experience has instead made us view everything as if wondrously unique, expendable, atomizing, and unfathomable. If experience once connected communal and private life, now any coherence of cultural transmission between the two is lost. Thus Benjamin draws a distinction between two standard German terms for experience in order to point to the difference he believes is a defining characteristic of modern cultural life. *Erfahrung* points to experience as integral to lived common experience, 'organised and articulated through collectively shared, traditionally fixed

meanings'; whereas *Erlebnis* suggests lived moments of cultural experience that are essentially disparate, highly individualized, potentially vivid, but atomized.[10]

Nostalgia, Benjamin warns, is no antidote to the dilemma of the impoverishment of experience. On the contrary, it is necessary to confront the contemporary, bluntly and boldly, without any cultural facades. If modernity produces a surfeit of information and choices as well as an impoverishment of experience, then only a contemporary approach to the challenge will be feasible. Such a task will require both 'a total absence of illusion about' the age, and total allegiance to it. Benjamin concurs with Adolf Loos that there can be no return to previous times, only the affirmation of modern life despite all its travails. 'When I look back over the centuries and ask myself in which age I would prefer to have lived', Loos asks himself in his 1908 essay 'In Praise of the Present', then 'my answer is in the present age'.[11] In turn, Benjamin's 1933 essay quotes Loos's insistence that he writes only for people with 'a modern sensibility'. Benjamin links Loos with Paul Klee – a seemingly unlikely pairing, because they 'both reject the traditional, solemn, noble image of man, festooned with all the sacrificial offerings of the past. They turn instead to the naked man of the contemporary world who lies screaming like a new-born babe in the dirty diapers of the present' (Benjamin 1933/1999: 733).

Stripped of illusions, exposed to the raw and confronting aspects of modern life, Benjamin claims to follow the example of moderns like Klee and Loos by advocating for a 'new, positive concept of barbarism'. Such a strategy means starting 'from scratch; to make a new start' – a clarion call that recalls Bertolt Brecht's dictum of starting with the bad, new things rather than the grand, old things. It also echoes the tone of Benjamin's 1931 essay, 'The Destructive Character', in which he suggests ignoring the summits of cultural attainment and, as an alternative, clearing a path in order to make room in the culture. 'Some pass things down to posterity, by making them untouchable and thus conserving them, others pass on situations, by making them practicable and thus liquidating them.' It is the latter path that Benjamin calls 'destructive', which makes posterity accessible again and thus heralds a new role for art and culture in modernity. Even this destructive character is an odd blend of the transgressive and the traditional – 'The destructive character stands in front line of the traditionalists', Benjamin declares.

This is not atypical of his approach; Benjamin almost savoured placing antagonistic positions into dialogue, which was his primary way of dissecting and navigating such a culture. After all, Benjamin's reputation has been sustained by his incisive accounts of modern art and literature, as well as his inventive explorations of modern culture and experience. Anticipating his thesis on history, it also provokes 'an insuperable mistrust of the course of things' because, more ominously, it is forged by the awareness 'that everything can go wrong'.[12]

Benjamin refers in passing to Mary Wigman, the modern dancer, in his fragment on Mickey Mouse, which is apt. If Mickey Mouse improvises the technological in a way that conjoins the modern and the archaic, then Wigman performed an expressionist style of dance that was sometimes described as 'barbaric', sometimes as 'formless'.[13] The female pioneers in dance of the Weimar period conveyed human frailty to a new level of expression in which nature, the mechanical and the primitive found stark expressions. But if there was anyone to take Benjamin's dictum about starting with the discards, the detritus, then it was Anita Berber (1899–1928), who exemplified these barbaric tendencies. Berber left the stage and made her whole existence a kind of performance long before the time there was a term for performance art. She took expressionism to a limit – she mixed traditional, even delicate, traditional or classic dance movements with exaggerated gestures and forms: 'Aestheticizing the addictions, compulsions, and mechanized rhythms defining the modern body'.[14] No action was too extreme. It came at the cost of her life. Berber was a new barbarian in Benjamin's sense. She anticipated the cultural icons of the 1960s by dying before reaching thirty in a forlorn Dionysian spin out. Berber became the personification of the Weimar Republic by acting out its unlivable pressure points, its loss of civility and degradation. Her lesson was to light a fuse and run as fast as you can because it is true that, as Benjamin says of the destructive character, the alternative could be worse! She took every option open to her when few existed for women – or were only available in times of social chaos and collapse. Berber straddled high and low art. She was a trained dancer, and danced professionally while also modelling. She also appeared in film, did cabaret, and reportedly danced naked, which prompted accusations that what she doing was striptease.[15] Berber was probably too associated with scandal for Benjamin's

liking, yet her performances still resonate in their stark brutality, which transcends Toepfer's account of her as a case of 'textbook dysfunctionality'. She managed to personify the age: there is no mutuality of recognition, just an awareness of being an object, enticing and rebuffing attention from both males and females alike. Berber thus amplified expressionism in bodily form. By 1925 Otto Dix portrays her as a shrunken figure much older than she was with coarse features in a languid sexual pose. She died aged twenty-nine in November 1928. Berber may have personified an untenable place at a particular time and place, but she personified an implicit point that Benjamin seeks to make: there is no time that is one's own with modernity; it is always escaping everyone.

Benjamin's 1933 essay, 'Experience and Poverty', condenses many of his ruminations on modern experience up until that point. It was written under the pressure of a particular point in time: 'The economic crisis is at the door, and behind it is the shadow of the approaching war' (Benjamin 1933/1999: 735). It does not always pay to be right. The piece appeared in the short-lived émigré journal, *Die Welt im Wort,* published in Prague in December 1933.[16] As bad as the events had been between 1914 and 1918, even more monstrous events would unfold. Adolf Hitler had been German chancellor since late January and many writers like Benjamin were already in exile.[17] The situation in Germany would make anyone pause to consider how circumstances reached such a point – just as they had in 1914 when the world erupted into conflict seemingly sparked by the obscure byzantine politics played out in Sarajevo. The consequences meant that creative destruction was felt too literally for his generation. Benjamin was already warning of the next war and, like the writer Ödön Horvath and a vocal minority, was predicting that the rise of fascism made another major cataclysm inevitable. How did these destructive torrents relate to a purported poverty of experience and how did they provide an insight into how to ameliorate them? This consideration concentrated Benjamin's attention in late 1933 as he sought to grasp both the tentative and irresolute state of his speculations and the affirmative aspects of modern culture and experience in such a precarious situation.

There are several ways of understanding the image Benjamin wants us to contemplate. The first is of looking up to the sky to witness the last untransformed vista amidst a chaotic state of flux, a world being torn up, remade, and reconfigured. At the same time,

what was occurring on the ground could not be regarded as a straightforward sequential process. Clouds do change constantly, but Benjamin's basic meaning is clear: everything on the ground surrounding that generation had utterly transformed. To say that this generation had 'experienced' this upheaval would be a stretch, for Benjamin's major point is that such transformations challenged the very basis of experience. The image of living amidst 'a landscape in which nothing was the same except the clouds' is not one of peaceful repose set at a distance from upheaval, but that of a glimpse of one last constant within a whirlwind of events, explosions, destructive forces unleashed uncontrollably, transformation without rhyme or reason. It is only with modernity that one has to face the conclusion that looking at the sky would be the last sight to remain constant and untouched while everything else changed throughout one's lifetime. Benjamin places a question mark around the word 'experience'. What does it mean to 'experience' the ephemeral, the changing, that which disrupts you physically, propels you beyond your physical limits – or which alternatively instigates a process that far outstrips human limits?

Today it is no longer even possible to rely on the comfort of looking up to the sky for the last vestige of an untransformed, constant view in life. The once pristine glimpse of the sky is interrupted by airplanes, drones, telegraph poles (if they remain); in addition, it is pervaded by a vast repertoire of satellites, radio waves and signals, GPS systems, radio telescopes, UHF band transmission, etc. Would the difference today be one of intensity and extensiveness rather than the specific parameters outlined by Benjamin? The contemporary Berlin artist Hito Steyerl extends the metaphor of the clouds by focusing on this crowded skyline in her work. Steyerl invites us to contemplate the sky as a scene of vast dissection. As she notes in a 2014 essay, 'Too Much World', we refer now not only to clouds plural, but 'The Cloud' – a skyline overwritten by a largely invisible network, in which we store everything:

A vast quantity of images covers the surface of the world – a lot in the case of aerial imaging – in a confusing stack of layers. The map explodes on a material territory, which is increasingly fragmented and also gets entangled with it.[18]

Our view of the clouds is now one of 'a living and dead material increasingly integrated with cloud performance ... a sphere

of liquidity' (Steyerl 2014: 34). In exploring phenomena like transmissibility, circulation, excessive visualization (which probably should be called excessive 'imagization' today, except I am loath to contribute another neologism to the tortured language of contemporary discourse), and thus liquidity (financial, economic, image-laden or otherwise), Steyerl is a contemporary artist who continues to explore the nature of this 'experience', but with updated technology. She asks, for instance, 'what happened to the Internet after it stopped being a possibility?' (Steyerl 2014: 30). The answer – which she describes and explores in her art – could be said to be further evidence of lived experience as *Erlebnis* in the Benjamin sense: the internet is a mediated experience, once seemingly thriving on the idea of open communication, collectively shared, seemingly integrating everyone, yet resulting in ambivalent effects: of sharing photographic experiences, global contact as well as local isolation, the accentuation of feelings of being manipulated, escalating suspicion and evermore rampant conspiracy theories, alienation, a multiplication of everything, including imagery, but resulting in more fragmented experience. Even more disturbing, this is another experience that may prove incapable of being experienced. Between techno-evangelism and 'overexposed visuality' (thus, 'imagization'), as Svetlana Bohm notes, 'when captured on camera, it appears ambivalent, confusing, and barely readable'.[19] In seeking to capture this experience, it is possible to accentuate its inability to be comprehended.

In such a situation, Steyerl advocates, echoing Benjamin, an updated form of critical-cultural barbarism in the guise of a strategy of 'circulationism' – an emphasis on 'postproducing, launching, and accelerating' an image. Circulationism is the term Steyerl favours over the Soviet avant-garde's advocacy of 'productivism', which meant leading art into production by taking it into the factory. Circulationism also echoes Benjamin's thinking around the time of his technical reproducibility essay in the mid-1930s, because for her it means working within the tremendous proliferation of images in order to devise critical possibilities directed at

> short-circuiting existing networks, circumventing and bypassing corporate friendship and hardware monopolies. It could become the art of recoding or rewiring the system by exposing state scopophilia, capital compliance and wholesale surveillance. (Steyerl 2014: 37)

Reminiscent of Benjamin's warning about the destructive
propensity, Steyerl concedes that this too could all turn out
badly, thereby resulting in another 'Stalinist cult of productivity'
(Steyerl 2014: 37). The cult of productivity is not the exclusive
preserve of Stalinism though, but a more pervasive by-product of
modernity.[20] Steyerl's qualification reads like a gesture of humility
that acknowledges the long history of critical strategies being
appropriated for quite contrary ends, hence the realization that
vaunted ambition can realize contradictory outcomes. It is also
indicative of a claustrophobic turn in critical thinking in the wake of
the appropriation of once-fervent critical aspirations. This tendency
became most pronounced coincidentally at roughly the same time
that the surpassing quest emerged. While Benjamin's reflection on
modern experience contains surprising contemporary resonances,
he too faced a similar problem: how could you differentiate his new
positive barbarism from fascist violence?[21] Furthermore, if he had
differentiated between two types of experience in modernity, how
could one be sure that any alternative propagated – considering
he warned 'that everything can go wrong' and it did – would not
contribute further to the predominant tendency, the drift to an
isolating, fragmentary experience (*Erlebnis*)?

Narratives of modern art and life

The most famous contributions in many fields of inquiry since the
mid-nineteenth century (at least), particularly in philosophy or
sociology, have largely been attempts to grapple with modernity
and modern experience. Frequently they come down to the struggle
to define modernity or, alternatively, to find ways of mitigating or
evading its impact. Due to this oscillation, the standard accounts
of modernity usually tend to divide into two chief narratives: an
optimistic, sequential story of modern development; or its rejection –
an emphasis on its dark side, its failed promises, etc. Many political
programmes have oriented around similar divisions, particularly
those interpreted in economic terms. If the standard accounts of
modernity could be viewed in terms of conventional story lines, then
they would amount to quite straightforward tales. There is, on the
one hand, the narrative of progress, sometimes straightforwardly

linear, sometimes not, or critical denunciation: the apocalyptic scenario of imminent catastrophe and perpetual disasters that can only be resolved by advancing beyond modernity or retreating to an earlier, less alienated existence before modernity. For all the woes of modern development, the greatest social–political calamities of the twentieth century have ensued from programmes aimed at defying modernity and returning to a state before the division of labour (Year Zero in Cambodia) or otherwise a blood and soil racial-national unity.

The most common narratives of modernity therefore sit oddly against the usual definitions of modernism in art that emphasize how its practices eschew traditional expectations, academic standards, or even conventional knowledge or representation. At the same time, many modernist writers, artists, musicians, journalists, and free thinkers have allied themselves and their practices with one side of this equation or the other. There were modernists who yearned for a 'back to nature' simplicity and organic communities, and there were also enthusiastic advocates of a future-oriented art throwing off the cobwebs of tradition. Charles Péguy's breathless claim that the world had changed more in the thirty years of his lifetime than it had in previous two thousand years is emblematic of the narrative of swift transformation that is one of the most familiar characterizations of modernity. Péguy was referring to the same period as Benjamin – more or less, the thirty years leading up to the First World War – but today everyone thinks such an assessment applies to the thirty years around the last decades of the twentieth century and the first decades of the twenty-first due to the emergence of digital technology, the internet, satellites, the fall of the Berlin Wall, etc. A consequence of modern development is that both periods will look rather mundane and easily superseded in the near future. A sense of the redundancy of the near past, or just 'past' in general, becomes pervasive and is one reason this process is often linked to capitalist economics and commodity turnover.

Despite the 'destructive torrents' Benjamin warned about, it is thereby difficult to dissociate the popular definition of modernity from a linear, successive conception of advancement. This conception connects increasing technological sophistication and disruption, including its ever-encroaching integration into everyday life and living practices, with the tremendous medical advances over

the past century, including dramatically increased living standards and lifespans, as well as hard-gained social and civic freedoms. Such a narrative views modernity as a dynamic of constant change and creative reinvention as if there were no deficits, only gains. It renders what appears to be the unique experience of life speeding up and the increased pace of change and transforms it into a dull, commonplace assumption. Each subsequent generation feels its intensity as if it were the first to ever do so – and each generation feels that their own particular lifetime is uniquely complex, both more disrupted and more interconnected than ever before. The world always appears to shrink and at the same time the world will appear ever more foreign by the end of one's life. This is the 'driving force of technological disruption' narrative, which has never really gone away; in fact, it has intensified once again in recent decades – as if mirroring the rhetoric of the period that Péguy and Benjamin were reflecting upon, the cusp of the nineteenth and twentieth centuries.

Conversely, this emphasis provokes the reaction that collapses the definition of modernity into unsustainable, rampant development that is threatening the viability of the planet. The resulting dichotomy leads to a split that turns around Benjamin's dictum – a total absence of illusion about the age and total allegiance to it – and transforms it into a more straightforward choice: a total absence of illusion or a total allegiance. Similarly, the emphasis on a poverty of experience in the face of flourishing diversity can make Benjamin sound like a fatigued traditionalist bemoaning the loss of the old conservative social order. Yet, this kind of argument pervades the critical assessment of modernity, evidenced by the many accounts decrying the flattening effect of modern mass culture, or emphasizing the dual phenomenon of a heightened accent on individuality in modern metropolitan life, but equally a greater sense of dissatisfaction and anonymity (from Simmel onwards) – or leading to subsequent concerns with affluence, social media, and higher rates of depression and social isolation. When it becomes a straightforward opposition it trades the emphasis on individual agency, critical questioning, and a quest for freedom for its negative inversion: atomization, intense conformity, rationalization. The most influential strands of critical thinking began to narrow into a diagnosis of our incapacity to escape normative hegemony and the iron grip of the totally administered world.

In Benjamin's lifetime, certain avant-gardes were closely associated with the optimistic narrative of impeding social-technological deliverance. Due to the fact that these were often the interdisciplinary avant-garde groupings seeking to forge a nexus between art, architecture, and design within a comprehensive social vision, one might think Benjamin would be sympathetic to this ambition. His concern, however, was that the experience of the modern never constitutes a linear pathway, which explains his passing remarks on Paul Scheerbart with his visions of glass. Benjamin mocks his form of flamboyant utopianism: 'Scheerbart is interested in inquiring how our telescopes, our airplanes, our rockets can transform human beings as they have been up to now into completely new, lovable, and interesting creatures' (Benjamin 1933/1999: 733). For Benjamin, being attuned to a dialectic of ambiguity serves to expose the tensions in modern cultural developments, which leads him from Scheerbart to a discussion of the bourgeois interior of the 1880s. Whereas the bourgeois interior of that time was busy with the evidence of its owner and his material abundance, by contrast the slick modern interiors characterized by Scheerbart with his glass or the Bauhaus with its steel 'created rooms in which it is hard to leave traces' (Benjamin 1933/1999: 734). Glass denies secrets and possession, he postulates, 'nothing can be fixed', but the bourgeois interior of the late nineteenth century, despite 'the cosiness it radiates', has one message only: 'You've got no business here.' Both situations, Benjamin implies, contain their own degree of uninhabitability. Benjamin's argument that the modern and the primitive are not so distant qualifies one of the main characterizations of modernity: the triumphant narrative associated with scientific and technological advance, which still has not faded – it is just revived in the boosterish administrative rhetoric of Silicon Valley, IT evangelists, iPhones, with its insistence on digital technology, economic disruption (diminishing certainty and working conditions), as well as compulsory interdisciplinary creativity. It has been a long time since this has been the animating rhetoric of artists or of people envisaging an alternative future; even designers are recoiling from it.

In seeking to capture what is at the heart of the modern sensibility, Benjamin thereby rejects the automatic assumption of progressive development, which underpins many different considerations of modern transformation, whether technological, aesthetic, social,

avant-garde, scientific, or political. To his mind, this marks a distance from the conventional Marxist and social-democratic views of historical, class and political change, and transformation. Some of Benjamin's most famous statements emerge from his effort to distance himself from the narrative of progress:

> Historical materialism must renounce the epic element in history. It blasts the epoch out of the reified 'continuity of history'. But it also explodes the homogeneity of the epoch, interspersing it with ruins – that is, with the present. [N9A, 6]

> In every true work of art there is a place where, for one who removes there, it blows cool like the wind of a coming dawn. ... Progress has its seat not in the continuity of elapsing time but in its interferences – where the truly new makes itself felt for the first time, with the sobriety of dawn. [N9A, 7][22]

While the Hegelian–Marxist lineage is often associated with this narrative of progressive transformation – due to its optimistic investment in reason prevailing in history – Benjamin sees it as his task to distance the tradition from such a conception. Conversely, more recently, the philosopher Robert Pippin has sought to retrieve the Hegelian understanding of modernity and its progressive commitments from being abandoned completely. In particular, Pippin wants to rehabilitate attentiveness to the traces of reason (*Spuren der Vernunft*) that still 'operate in history'. Pippin's prime example is 'the end of a gender-based division of labour' – not that this division has been resolved once and for all and made exactly equal – but nonetheless, for Pippin, it is evidence that 'we are all living through perhaps the greatest social transformation in the history of the human race'.[23] The fact that the issue is not resolved makes the end of a gender-based division of labour an emblematic aspiration to be secured in society, whereas once the very idea was not even considered 'rational'. When Péguy and Benjamin were writing of the tremendous changes in the period leading up to the First World War, this did not include the right for women to vote (although this changed in Germany by the end of that war, whereas women in France had to wait until the end of the Second World War to obtain similar rights). Once an advance achieves a requisite level of acceptance then it soon becomes untenable to abandon such

a commitment; it sets a standard and sits alongside many other social advances, such as marriage equality for same-sex couples, that render possible what was once impossible. Explaining this is complicated: does abandoning a narrative of progress also mean abandoning an argument for social advances, including social justice? In recent times, the accent on identity politics and pluralism is usually viewed as antithetical to universal commitments. At the same time, it is not uncommon for the advocacy of a social-justice argument to be peppered with appeals to human rights, equality, non-discrimination, and social belonging, and these appeals are made without any hint that such principles might be considered relative rather than universal.

All this might indicate that advocates for such social advances implicitly endorse the concept of a historically evolving standard – as if we do believe that traces of reason do operate in history still – whether that proposition is regarded as politically correct or not, and whether they live in circumstances that make this remotely possible, or not. In these cases, we speak as if in a universal voice. Despite defending the Hegelian position that makes such commitments explicit, Pippin is equivocal on this point about historically evolving progress. While he wants to revive Hegel's considerations in order to demonstrate their relevance to the arguments we make about social recognition, including social recognition of the excluded, or about social belonging, and yet he also recognizes the many difficulties with the Hegelian approach today. Pippin points to many of Hegel's assumptions about modern progress that are considered extremely premature. Hegel overestimated 'humanity's movement toward freedom and rationality', Pippin offers, and he also presumed too much in considering the Prussian state of his day as a measure of this advance – the epitome of a rational state having been realized – a proposition that few people today would treat seriously. The chief difficulty with such Hegelian forecasts, Pippin asserts, is that the 'structure of mediations is very thin in contemporary society'. For Hegel, according to Pippin's interpretation, the mediation 'between the individual and the universal norms of society', as well as the embodiment of universal norms in 'concrete roles', is crucial, because this is 'the only way for finite human beings to ever instantiate' norms of mutuality and equality that Hegel regards as pivotal. The 'mass commercial culture' of today, however, renders such mediations far more precarious. Pippin's qualifications of

Hegel's original prognosis are not far removed from Benjamin's stance. Pippin declares that 'the degree of anonymization in contemporary society has called for a new form of analysis', which is precisely what Benjamin sought to point to in developing the conception of experience as *Erlebnis*. Pippin's explanation of this contemporary anonymity helps to explain what Benjamin means by experience as *Erlebnis*:

> The intense need for the constant expansion of the economy has created a culture that requires both saturation via need creation, or advertising, and new techniques and powers to create these needs. If you had confronted Marx with things like the billion dollar market in diet dog food that exists today, he likely would have thrown up his hands in despair, and justly so. Part of what we are discovering is that there is no limit thus far. When applied to contemporary society, the Hegelian framework, with its concentration on things like mediation, is in some ways just not going to fit. (Pippin in Hussain 2011)

Pippin goes further and candidly confesses that he does not possess 'an adequate answer' that can account for the 'vast mess of manipulation and desire creation that we have in the contemporary world' (Pippin in Hussain 2011). The difficulty is that Pippin's explanation equally focuses on what Hegel failed to take into account, and where he overreached, while also arguing that the Prussian philosopher still offers the most compelling insights into modernity, particularly the mediations between an individual and 'the universal norms of society'.[24]

Pippin's key challenge is to assert that there are some commitments that we are not willing to forsake, despite our best efforts to renounce them. This is becoming increasingly evident in contemporary analyses that compartmentalize positions, such as 'social justice' issues removed from any acknowledgement of universal or mutually shared commitments, as if to imply that the latter were an old friend or relative that has to be hidden away because they have become embarrassing. We want to defend achievements that have been hard won, otherwise no action is meaningful. For Pippin, if it is correct that we remain attentive to the traces of reason and seek to defend gains, then the same goes for the challenge to agency by an array of different influences. Pippin lists 'everything from structuralism and

various "anti-humanisms" in European philosophy to evolutionary biology and the neurosciences (experimental results, brain imaging, Benjamin Libet's famous experiment, and so forth)'. This tendency coincides with one of the most influential negative narratives tied to the consequences of modernity: the hegemonic account, which suggests that, rather than agents of our own creation or destiny, we are actually caught up in the grip of forces beyond our control. The intriguing question that Pippin poses to this increasingly common assertion is what happens when we give up on being agents.

> If these traditional assumptions about self-knowing, deliberation-guided, causally effective agents are becoming less credible and under increasing pressure, *what difference should it make in how we comport ourselves?* What would it actually be to *acknowledge* 'the truth' or take into practical account the uncertainty? It is difficult to imagine what *simply* acknowledging the facts would be, to *give up* all pretensions to agency.[25]

For Pippin, Hollywood film noir offered a better insight into agency in the modern world. The protagonist in the film noir genre does not assume they are free from restraint, from non-interference or from a constructed world with an already largely determined sphere of possibilities – that is the standard stock argument of the liberal democratic tradition or the neo-liberal position.[26] Rather the character in film noir, according to Pippin, concedes that there is limited room in which to move, which does not amount to concluding 'that he is simply "carried along" by the consequences of his history (his past) or his nature ("no good"). He ends up an agent, however restricted and compromised, in the only way one can be. He acts like one.'[27]

For Benjamin, it was not enough to set out problems and liabilities of the age, it was equally important to think through them and offer solutions. This is the key dimension of the original critical theory that is lost in current assessments that seem content to conclude with hegemonic assessments of power, conspiracies, and total manipulation. Of course, for Benjamin, the onwards and upwards rhetoric of perpetual progress was just as oblivious, therefore perhaps even less helpful in forging viable critical insights. For Pippin, on the other hand, it is hard to fathom what it would

mean to conclude that we have no agency at all and that we are just products of what happens to us. In the following chapters – particularly Chapter 3 – I provide instances of critics or writers upholding such a view, naturally accompanied by hegemonic analyses of society or culture, who nonetheless end up resorting to various appeals to agency. This is perhaps inevitable because otherwise contemporary analysis drifts from one polarity or the other to the point that everything becomes more inert, less certain of what to defend and how, and less certain there is anything to defend.

The antinomies of a culture of modernity

Benjamin's stated antipathy to the narrative of progress is not always consistent. The Hungarian-Australian philosopher György Márkus pinpoints where a recourse to progress can be detected in Benjamin's work. He succumbed to the temptation of inferring a progressive aspect to new, reproducible media and art forms that might bridge the divide between practical and theoretical components of his conception of modernity's divisions. These writings on reproducible media and decline of aura have, in turn, attracted their champions – in particular, the late 1960s student protest movement that charged Adorno with supressing the genuine Marxist version of Benjamin – and at the same time, it has attracted charges that Benjamin is a straightforward technological determinist.[28] Even while showing that Benjamin was susceptible to the notion of 'an accumulative change in the technical conditions of artistic production', to which he ascribes 'an unambiguously "positive" function' (Márkus 2011: 595), Márkus ridicules both these stereotypes as preposterous. In doing so, he offers an intriguing assessment of Benjamin's ambitions in exploring the poverty of experience that underscores the modern sensibility. He reveals the uniqueness of Benjamin's position, but also where he falls prey to the temptation for a progressive narrative in order to tie together the theoretical and practical aspects of his inquiry.

What Márkus finds most intriguing in Benjamin is his 'dialectic of ambiguity', which 'disclosed the deep ambiguities of cultural

modernity' (Márkus 2011: 600). The faith in progress and the 'idolatry of technology' found their endpoint in the 'growing mastery over nature "technocratic features later encountered in Fascism"' (Márkus citing Benjamin in *On the Concept of History*; Márkus: 559). On the contrary, Benjamin's approach welcomed 'seemingly irreconcilable extremes'. Hence, his conviction that 'the meaning of a concept/conception is to be found not in what all the subsumable phenomena identically share, but in the extremes it is able to encompass' (Márkus 2011: 560, n. 27). Márkus thus defends Benjamin on the level of his perceived contradictoriness, not on his projection of a technological advance. Instead, for Márkus, the most profound insight of Benjamin's oeuvre is the insistence on seeking in 'contemporary social reality' the basis for 'its own critique and the potential of its transcending' (Márkus 2011: 600). As he states in 'Experience and Poverty', there can be no turning away from the contemporary in order to challenge its limitations; that is no recourse to 'atemporal norms and values'. Thus, for Márkus, Benjamin articulates better than most 'the deep ambiguities of cultural modernity', that is 'the confluence of the most archaic and the most modern, of the unconscious and the conscious, atomization' as a new, unwieldy type of 'common bond' between individuals as well as a historical viewpoint that combines 'its cynical-apologetic or regressive' aspects with 'its utopian' or transcending perspectives (Márkus 2011: 600–1).

Márkus's own account of modernist culture equally emphasizes how it results in antinomies. His essay, 'A Society of Culture: The Constitution of Modernity' of 1994, first sets out the focus on such a culture as one pervaded by antinomies and also uses the awkward term, 'contemporaneity' that Terry Smith would later promote as a surpassing term.[29] Márkus's account of a culture of modernity follows the broad outlines of a familiar story, but with important qualifications. Modernity introduces a new framework for culture in that it emphasizes autonomy, critique, innovation and creativity focused on originality with a view to 'enlarging the scope of human possibilities'.[30] Modern culture understands itself as historical, thereby something capable of being remade or reconfigured. Modern science as much as modern art or culture plays a key role in promoting this critical volatility by eliciting a more dynamic conception of culture as well as society. University inquiry, with its focus on creating new knowledge and its aversion to plagiarism,

would be another factor, even though the institution of the university is a medieval one with feudal vestiges. The key components of this persistent questioning culture have been subsumed within liberal discourse, which asserts that continuous questioning and open inquiry are now crucial to society's functioning (by which they mean modern societies).[31]

Traditional or more communal cultures, on the other hand, emphasize different cultural characteristics. They uphold a vision of culture as normatively valid and internally binding, qualities that modernist cultures have difficulty replicating (Márkus 1994: 17). Traditional cultural events or ceremonies are marked and arranged around 'pre-given, externally fixed social tasks' and 'determinate social occasions', such as fixed around religious calendars, festive occasions, or ritual symbolic events. Modernist practices are, by contrast, 'socially dis-embedded' (Márkus 1994: 20). They are not organized around any culturally specific times or occasions – and besides, they depart from accepted norms. In contemporary terms, the prerequisites of traditional culture would be viewed as coercive.

Because modernist culture is most often defined in juxtaposition to the cultures of tradition, it has become common to think of these cultural terms as a straightforward passage of succession, one after the other. Márkus, by contrast, does not argue that modernist culture supersedes traditional or communal culture in the way that many describe the situation. These cultural propensities exist side by side. Elements of traditional cultural framework still exist in residual customs that are not immediately obvious to people living in a modern society, but they are quickly evident to newcomers who see them as foreign. They are more often than not only felt when visiting another culture that has different traditions (even in predominantly secular cultures these are conveyed in terms of customs, greetings, toasts, etc.). For Márkus, they are not straightforwardly successive, but persist side by side, often in an uneasy relationship. Furthermore, traditional culture is not primitive. Traditional cultures are in fact quite complex, which is true of all 'meaning-bearing and meaning-transmitting aspects of human culture' (a definition following the analysis of Clifford Geertz), especially when seeking 'universally valid ends' (Márkus 1994: 16, 18). For Márkus, the modern and traditional are cultural propensities that are closely associated but incomparable. This is the paradox of our cultural alignment, which is composed of conflicting propensities.

The Enlightenment heritage is crucial to the account that Márkus seeks to outline. The parody version of the Enlightenment characterizes it as a quest to order and classify the world – a favourite characterization of certain followers of Foucault – and thus the Enlightenment heritage is viewed as responsible for a world view that is crude, simplifying, and with a penchant for top–down monolithic systems. This is not the assessment fundamental to Márkus's outline of modernity. A common presumption is that no culture could prosper if it was constantly contorted by the continuous contestation of ideas and perennial questioning. Many proponents of Enlightenment felt similarly. The Enlightenment challenge made critical questioning a feature of modern expectations, but it always presumed some amelioration of endless critique. The goal was to bring some rationality into public discourse. Rationality, in its broadest outline, meant giving reasons for our actions so that they are justifiable to others, including providing some reason for our judgements, even our aesthetic ones – which gets more complicated.

Once the challenge of critique was inaugurated, more and more targets of the lingering feudal system and absolute state came under fire – precisely because they could not justify their persistence. According to Márkus, one visionary ideal of the Enlightenment was that once critique had been expended, then some new cohesive ordering, such as the framework formerly provided by tradition, would be inaugurated once again, but now in a superior form – realized in 'a never before encountered social cohesion, security and stability' (Márkus 1994: 18). Such a comprehensive social-cultural framework is unfathomable today, but the Enlightenment envisaged such a positive programme, not just the tearing down of the old order based on unquestioned authority and residual feudal social arrangements. 'Change would no longer signify the breakdown of the normative order and a loss of social identity and continuity', but instead provide some anchoring to achieve 'a unique direction charted out by reason upon the processes of change for which the path had cleared by the destructive force of critique' (Márkus 1994: 18).

Science was meant to be one such bridge that aimed to fill the vacuum opened by Enlightenment critique. Art and culture was another purported model for providing such a path and a new directionality. Neither exists in this way today. For Márkus, the

dualist structure of modern culture – 'its antinomistic division into the arts and sciences' – 'directly expresses the structure of everyday experience' (752, n. 64).

In modernist artistic practices, there have been many examples of attempts to overcome this divide, no matter how fabulous some examples may have seemed; indeed, some appeared to have sprung from fantastic phantasies of overreach. In art, the counter-narrative to sheer critique always emanated in the guise of various integrative and restorative ambitions. This is often associated with the utopian dimension of modernism that harboured grand ambitions of resolving all social-cultural tension and achieving a higher resolution in art, as well as at the social level. One eccentric and implausible example was the Russian composer Alexander Scriabin's score, *Mysterium*, which he envisioned to be a wondrous synesthetic experience performed over a week in the Himalayas, bringing all the arts together and peaking in a collective combustion. The work would culminate in the revelation of the final mystery in which humanity would dissolve and transform into another higher life form. The score remained incomplete at the time of Scriabin's death in 1915. In a more sober vein, the ambitions of the Bauhaus were similarly comprehensive in scope. Its founding ambition sought to overcome the divide forged by and between commodification, mass production, design, and art. In other words, it too held to a holistic vision in which division would be overcome, thus reuniting the medieval, at least gothic, ideal of all the arts, combined with the new realities of modernity, as they saw it in the wake of the First World War. By the end of their lives, the key Bauhaus pioneers were still decrying the fate of this holistic vision that appeared lost to modernity.

As Márkus argues, traditions and customs survive, but not with the full sense of being binding – and this is true of everyday formalities and customs. Similarly, the history of art persists, not as binding tradition, but more as a storehouse (as Hegel suggested) that an artist can pick and choose from (Márkus 1994: 17). In the arts, modernism accentuates alertness to art's own historical and stylistic conditions of possibility, and even to the question, *what is art*? At its frontier, this is a broadly testing culture – scrutinizing methods, presumptions, and practices, so that the limits to knowledge are as crucial to recognize as what is actually known. In the wake of modernism, for instance, it has become a commonplace assumption

that art will test established ways of perceiving things or even the establishment itself. Yet, this does not mean that such challenge is always welcomed. There is constant debate about whether challenge and disruption may have gone too far – and may risk tearing the idea of art or the social fabric apart. While he attempts to capture the fullness of experience against any narrowing of meaning either to the subject–object relationship (of Kantian philosophy) or of scientific observation, Benjamin also insists on the historical nature of experience and of art – it is not a timeless thing, but something that is always changing, and thus sense-perception changes too. Benjamin's ambition was to 'show how social transformations ... found their expression in changes in perception' (Márkus 2011: 566) and to retrieve the past as 'the test of contemporary action' (Márkus 2011).

In the nineteenth century, it was often raw naturalism or realist art practices that tested the boundaries of convention and sociopolitical acceptability. Gerhart Hauptmann's play *The Weavers* (*Die Weber*) of 1892 is a telling example. The Prussian authorities imposed a ban on it because it sympathetically portrayed the Silesian weavers' revolt of 1848. In fact, the play's major innovation was to feature the workers' revolt as its central 'character'. The Prussian interior minister complained that theatre should remain 'an educative institution ... promoting everything good and noble', whereas a liberal deputy countered that the principle of 'artistic freedom' should be defended as an important civic principle in defiance of despotic control. Nevertheless, *The Weavers* became a popular success because it was able to reach broader audiences in the then emerging alternative, working-class theatre network. (Hauptmann later won the Nobel Prize.) A 2009 work by Anna Molska restaged *The Weavers,* suggesting a change of sentiment by cutting out the central theme of the revolt completely. On the one hand, it could be read as focusing on the perennial issue of being rendered 'uneconomic' no matter what the industry (in Molska's version, the focus is on Silesian coal miners). On the other hand, it could refer to the level of passivity that exists once the central thread of change and transformation has been left behind, just as the outmoded labour force is left behind to contemplate their scarce options.

Following Márkus's account, it is possible to suggest different formulations of modernism. First, modernism does not mean that

the past is simply forgotten or eliminated. Instead, works of the past are no longer viewed as a binding tradition that must be followed in set ways. This is also true of modernist works. They are all treated as a type of 'archive' of possibilities to be freely adopted, re-evaluated, or even ignored, as changing historical and social circumstances permit. Second, if culture is historical, then it can also be transformed. The dictum, 'Make it new', is not only a cry for innovation as a core artistic goal, but also implicitly upholds the proposition that a culture can be remade and reworked according to changing circumstances. Some regard this as an important democratic commitment. Others suggest it is narrowly Western or Eurocentric because challenging binding commitments severely displaces traditional cultural imperatives that privilege shared norms and cultural maintenance. Third, modernism is part of a wider inquiry of self-reflexive scrutiny of one's practices and knowledge claims. In science, falsification becomes pivotal.

This might suggest there are different tendencies within modernism that in itself represent a tension that remains unresolved. It is now an open question whether modern societies can resolve their own tensions between testing assumptions and creating broadly coherent cultural meaning. None have to date – or indeed figured out whether it is desirable to do so. Márkus's wider point is that modernist culture results in apparently irresolvable antinomies – a conclusion central to some postmodern thinkers, but also to advocates of contemporaneity as a cultural paradigm shift. For Márkus, this was already a characteristic of modernist culture and it is something to contend with today. For Márkus, not surprisingly, it is Benjamin's 'dialectic of ambiguity' that shines through, underscored, as he suggests evocatively, by his peculiar charisma, which is enigmatic though highly suggestive of a personification of modernity's contradictory impulses: the combination of 'an immense receptivity with a most idiosyncratic originality, of an almost narcissistically sensitive defence of one's own individuality with the never extinguishable lure of community and with the deep moral earnestness of a thinking that is always motivated by a search for answers to the sufferings of anonymous others' (Márkus 2011: 600).

Art today appears far less impassioned. Others might refer to it as rightly more circumspect about utopias, given the history of

the twentieth century and its totalitarian nightmares. There is also awareness of the limits of perpetual change at the environmental level, which looms large over life today. By and large, art today is less programmatic. But is this a complete cultural paradigm shift? The difficulty is that central modernist tenets are difficult to overturn or exceed because critique necessarily confirms a commitment to the general modernist propositions of challenge, self-scrutiny, and dissent. Very few people willingly withdraw their right to dissent. One definite change, however, is that art today is more concerned with investigating society's failures, or exploring often-unacknowledged tensions, particularly at the periphery of society. This may signal that one aspect of the modernist drive remains undiminished – its critical side – while the more integrative, albeit utopian, side has waned.

Márkus's account of the antinomies of modernist culture suggests a more vivid conception of modernism with a culture of modernity that does not rely on establishing a discrete paradigm break, nor a successive conception. Each of the these accounts by Benjamin, Pippin, or Márkus requires a study in its own right. The task here is simply to illustrate the chasm that has developed between conceptions of modern and contemporary culture. The conventional depiction of modernism for the visual arts is still largely associated with a chronologically successive, formal-experimental trajectory from the mid- to late nineteenth century until approximately just over one century later.[32] This conception has been challenged for a long time with renewed studies of modernism in a variety of areas that challenge both the successively chronological model and its reliance on a hierarchical centre–periphery conception of culture and society. Ironically, it is the surpassing models that prove to be most invested in the successive model of stylistic progress, even if only to disparage it; they are not overly invested in dismantling the conception, but rather in bypassing it completely. What conception of modernism and modernity do the surpassing strategies find themselves invested in? Can they match the 'rare and remarkably stimulating' reconstruction offered by Márkus, for instance, or its 'theoretical vision, conceptual rigour and historical knowledge'?[33] Or do we find that the surpassing quest has led to an inquiry that is inclined towards stereotypes and caricature?

The ambivalence of surpassing and paradigm shifts: The anti-aesthetic

In 2013, a book-length reassessment of the impact of the term 'anti-aesthetic' was published by an inveterate explorer of contemporary art-historical terms, James Elkins, along with Harper Montgomery. The book was based on a number of seminars held over a week in Chicago in 2010 in order to review the repercussions of the term. The publication was further bolstered by wide-ranging reflections on the seminar deliberations, which were commissioned after the event.[34] This may seem like inordinate attention to be paid to one term, although it is indicative of the importance placed on terms of surpassing in recent decades. As with many surpassing terms, there was a time when the anti-aesthetic seemed to capture the mood of a whole zeitgeist. Yet, its original impetus was very local and specific. As James Elkins notes in his introduction to the 2013 publication, the anti-aesthetic began life in the New York art world associated with certain practices of the late 1970s and early 1980s. As Hal Foster puts it in the seminars, 'at the time, in 1980', it was 'a musket shot in downtown Manhattan'.[35] From this specific context, its broader appeal revolved around its capacity to devise fresh critical impetus from the analysis of what were then new forms of contemporary art – such as interdisciplinary or multimedia works, photographic based as well as appropriation practices.

This focus on practice gave the term slightly more coherence than the volume of essays gathered together by Hal Foster under the title *The Anti-Aesthetic* – an anthology that was too disparate to comprise any unified intellectual position.[36] The term enjoyed an extended critical life, Elkins argues, due to its being 'a historical document, a moment in the history of reactions against Modernism'. In other words, it is typical of the general tenor of surpassing terms. In the case of the anti-aesthetic, as the name suggests, the more familiar, broader term – the aesthetic – was dragged into the mix and identified 'problematically, as a near-synonym for Modernism' and its 'commitment to value'.[37] The antipathy to Modernism with a capital 'M' was thereby equated with an antipathy to the aesthetic. This leads one to ponder what modernism with a lower case 'm' means. This turns out to be rather complicated, even

inexplicable, in terms of how modernism was originally defined by the anti-aesthetic.[38]

In the seminars Foster explains that the 'anti-aesthetic' arose in response to the perception that the aesthetic functioned in a conservative, ameliorative guise signalling 'a space of resolution' or of symbolic unity.[39] Modernism had been too closely associated with this idea of the aesthetic. Foster links this idea to 'aesthetic discourse à la Kant' as a 'space of mediation', of reconciliation, and of resolution ('of subjective integration and social consensus').[40] Essentially, it is an equation of the aesthetic with unity and resolution, and thus with modernism. The case for this proposition unravels very quickly in the seminars. Foster now admits that there is always a danger in positing momentous breaks of this kind, which he discerns in other examples.[41] Foster criticizes Peter Bürger's notion of the neo-avant-garde, for instance, because it condemns all art in the wake of the historical avant-garde to 'mere farcical repetition'.[42] Similarly, in Kantian aesthetics the location of a 'redemptive imperative' within the aesthetic, Foster opines, has the effect of casting 'our everyday experience as always already fallen, as just not worth a damn'.[43] The anti-aesthetic therefore sought to devise a better alternative formulation, although in retrospect Foster concedes that it too viewed the aesthetic in an overly narrow manner: We totalized the aesthetic and reified it as a bad object. *Mea culpa!*'[44] One subsequent reaction was almost entirely predictable: a return to beauty.[45]

If, in hindsight, it proves impossible to define the aesthetic so narrowly, then what happens with its equation with modernism? Early in the seminars, Jay Bernstein counters the anti-aesthetic characterization of modernism and the aesthetic (though equally sweepingly) by highlighting its dissenting capacity: 'From the very beginning, aesthetics is about our dissatisfaction with modernity' (Seminar 1: 25). Aesthetics, Bernstein argues, should be considered a 'space-holder' for what is omitted from the emerging 'authoritative practices of reason'. In retrieving this history, Bernstein wants to assert a different claim: 'Artworks interrupt our merely instrumental engagement with objects' (Seminar 1: 25). This is a position informed by Theodor Adorno's work, which Bernstein regards as offering the most enduring and articulate insight into modernism and modernity. Bernstein thus reinforces this Adorno-inspired alternative understanding of modernism by stating that

it constitutes 'a rebellion … a return of repressed life against a dominating rationalization of everyday life' (Seminar 5: 70).

Similarly, Foster reconsiders his original characterization of modernism: 'Postmodernism was in part an effort to recover Modernisms, not to foreclose them, an effort to open up this reified category' (Seminar 1: 27, 32). He repeats the point in the following seminar: 'Postmodernism was also concerned to recover a different sense of modernism'. Craig Owens's exploration of the allegorical impulse in contemporary art, according to Foster, also led Owens back to modernism and to trace 'a Modernist genealogy of the allegorical impulse' (Seminar 2: 40). Even though Owens was criticized for this move at the time, Foster notes, it suggested an alternative path of inquiry not reliant on demarcations and strict separations. Viewed this way, certain subsequent formulations, such as the *informe* (formless), cannot be regarded as seeking to instigate a break with modernism, but rather they seek to tease out 'a more capacious Modernism', 'a broader kind of visual modernism', or, as Yve-Alain Bois puts it, of 're-dealing modernism's cards' (Bernstein, Seminar 3: 52).

In other words, an ironic outcome of the anti-aesthetic is that it has prompted a rethinking of modernism devoid of the narrower, restricted definitions of modernism that originally sparked the momentum of the anti-aesthetic. This reconsideration means abandoning the surpassing strategy in favour of reshuffling the conceptual cards. From these seminars, modernism emerges as an unlikely, but pivotal point of oscillation and vacillation in the understanding of what *was* the anti-aesthetic. In relation to modernism, the legacy of the anti-aesthetic is ambiguous. Oddly, the process of undertaking this intense review of the anti-aesthetic has the unexpected, but seemingly inevitable, consequence of heightening awareness of the heterogeneity of modernist practices. Inevitable because the original premises of many surpassing terms are so restrictive and limited that a correction usually follows. At the same time, one key consequence of the anti-aesthetic – at least, in its original surpassing guise – is that it has helped trigger the polarized attitudes to modernism that influence current understanding. The anti-aesthetic helped to seal the identification of modernism with the well-known idea of modernism as medium-specific, formalist, historicist (in the negative Benjaminian sense as successive and accumulative), constantly in search of plenitude

and purity, and exalting the aesthetic as a space of resolution at the expense of Foster's subsequent reconsideration aimed at dismantling this misconception by introducing a more slippery, ambiguous, mixed, or indeterminate version of modernism – allegorical, already postmodern (à la Lyotard), textual, spatial, even somewhat formless.

Thus, the original conception of the anti-aesthetic has reinforced the common assumption that there is one predominant orthodox art-historical model of modernism and it is one closely associated with the critic Clement Greenberg, and with what Foster calls Anglo-American formalism. According to most participants in these discussions, this particular conception of modernism is deemed too prescriptive today or no longer viable. Yet, it still seems to determine most people's impression of what counts as modernism. In the course of the discussions, Diarmuid Costello makes the valuable point that the term anti-aesthetic is already implicated in the aesthetic and thus argues that 'anti-modernism does not break with modernism ... the more it is predicated on overturning its precursor's terms, the more closely it is constrained by what it contests' (Seminar 4: 59). Terms of overturning are usually overly determined by what they contest; this is undoubtedly correct and it helps explain why the surpassing quest so often flounders. For his part, Costello favours arguments that tackle 'Modernist theory' in which the relation between terms is 'less over-determined' (Seminar 4: 59). He argues that the ambition should be 'to do away with claims that tie value to media', that is with attempts to ground claims about artistic value on the basis of 'medium categories' (Seminar 4: 62). This still presumes that 'Modernist theory' is tied to medium-specificity, which means that every contrary analysis can be considered 'in non-medium-specific terms' (Seminar 4: 59). There is an investment in this model of 'Modernist theory' because it assists in explaining any subsequent point of departure. It is, for instance, the first step in Peter Osborne's attempt to outline a philosophy of contemporary art:

> The dominant category of modernist art criticism was for many years, up until the 1960s, the category of the medium. The subsequent dissolution of the limits of mediums as the ontological bases of art practices, and the establishment of a complex and fluid field of generically artistic practices, has posed

new problems of critical judgement to which the concept of the
contemporary represents an increasingly powerful response.[46]

On this basis, Osborne concludes that '*contemporary art is
postconceptual art*'.[47] One definition permits the other, and while
it is indeed also correct to say that the category of the medium
preoccupied mid-century art criticism, it is still not the whole story.
For a start, it is characteristic of modern experience that no one
will ever say we have just entered a phase of greater simplicity
after having passed through a period of greater complexity. As a
formulation indicative of modern experience, it is indeed a one-
way street. The only consistent narrative of modernity is to perceive
greater complexity and uncertainty. Paradoxically, the perpetual
insistence on breaks, demarcations, and ruptures impedes – rather
enhances – our comprehension of such a quandary. It forces a rupture
with the past and insists upon the perpetual present or the 'glare
of now-ism': 'The spectacular immediacy of the contemporary art
world threatens to overwhelm our ability to think critically about
the relation of the current moment to the past.'[48]

 There are a number of points to be made in regard to this presiding
definition of modernism that informs the anti-aesthetic seminars
and 'Anglo-American formalism'. One is not solely theoretical, but
also importantly art-historical. This medium-specific definition of
modernism already excludes predecessors, such as – well, you name
it – Schwitters, Rodchenko, Lissitzky, Stepanova, even Popova,
definitely Tatlin, Huelsenbeck, Peri, Buchholz, Eggeling, Moholy-
Nagy, Schlemmer, van Doesburg, Duchamp, Picabia, Sophie
Täuber-Arp, and anyone mentioned previously. If they are not
modernists because they are not medium-specific artists, then they
can only be defined as anti-aesthetic before the fact, and therefore
anti-modernist modernist artists. You see the problem; it is not
uniquely theoretical or just historical, but also one related to the
bifurcated terminology that has acquired theoretical and historical
orthodoxy, and which is always regarded as a malign impediment
to better ways of considering things. Smithson, Rauschenberg,
Burn, Polke, Bourgeois, Hesse, Lygia Clark, Kippenberger, Matta-
Clark, Gonzalez-Torres, and others, seem more closely allied to
these predecessors – the 'non-modernist modernists' – than to the
mid-century formulation of modernism, which today looks more
like the aberration than the norm. It looks more like the brief hiatus

in the mid-twentieth century (and chiefly in the north-east United States) when this definition looked valid and plausible, which perhaps explains why a term like the anti-aesthetic could have such impact in that context.

Indeed, one has to question the centrality of this medium-specific narrative to all other accounts of modernism. A candid and surprising moment in the discussions occurs when Joana Cunha Leal notes that from the Portuguese perspective this particular art-historical model of modernism was alien:

> Apart from very rare exceptions, nobody knew who Greenberg was at least until the early nineties. It was through the reading of *October* criticism that Greenberg became an issue in Portugal. He didn't exist before in Portuguese accounts of Modernism. It was through October's writing that Greenberg became reified. (Leal, Seminar 3: 49)

To which Elkins delightedly responds, 'That is excellent!' whereas Foster quips forlornly, 'It makes me want to jump out of the window' (Seminar 3: 49). The observation does underscore the question of how central this conception of modernism is.[49] It also underscores the problem of developing arguments in the afterimage of a precursor, that is being overdetermined by what one contests, namely a Greenbergian conception of modernism. Another respondent, Eva Schürmann, notes this discrepancy: 'In Europe Clement Greenberg's concept of Modernism and the master narrative of heroic abstract art is not generally what one refers to in talking about the modern, whether conceived of as an epoch, a problem, or a project.'[50]

While the seminars on the anti-aesthetic focus on dismantling the successive, medium-specific interpretation of modernism, it proves very difficult to dislodge. It is invoked regularly and thus perpetuated in order to overturn it. There is an increasing discrepancy between a discourse that views the modern as a purely historical and a largely negative phenomenon (characterized by its monomania, and colonial-imperialist thinking) and a wider cultural exploration of modernity encompassing its philosophical, social, and political dimensions. Again, Jay Bernstein argues Kant's *Critique of Judgment* suggests 'something significant for human experience' has not been accounted for when examining the world comprised of Newtonian physics, reason and ethics, that is

'some abiding aspect of the human has been repressed' (Bernstein, Seminar 1: 25). His gloss on the third *Critique* is nonetheless quite conventional, but worth reiterating because it underpins the modern and contemporary ambition. For Bernstein, it upholds that 'every human being must be regarded as a self-determining agent, as autonomous'. This insistence, of course, enables 'the discourses of individual liberty, human rights, and the idea that the individual has a claim and standing apart from society' (Bernstein, Seminar 1: 24).

Despite its perpetual refutation of autonomy, the contemporary art world has completely subsumed these discourses in its vocabulary, its everyday ethos and in the content of much of its 'critical' practices. It thereby rallies to them in any controversy over the infringement of human rights or repressed minorities as well as in the routine supposition that art must expose hypocrisy in the world, including the art world. Despite its reliance on this critical vocabulary, contemporary art discourse has turned autonomy into another 'bad object'. Foster equates it with the quest 'to become an art in its own right' and even states 'that autonomy was a disaster' (Foster, Seminar 1: 29). This appears to conflate autonomy with the Greenbergian or Anglo-American formalist interpretation of modernism (in art) and thus with art for art's sake aestheticism. This is an association that Gustav Frank explicitly warns against. He points to the idea of autonomy that emerged in the mid-eighteenth century as a consequence of a 'rehabilitation of the sensual world'. Art was envisaged as a space in which the 'hierarchy of senses, bodies, and reason' could be inverted. Autonomy, in this case, meant that art no longer served as a 'mere illustration' of the then-dominant discourses of theology and philosophy; instead it was 'free to … ignore them, mix them up, or reverse their relations' (Frank, Seminar 1: 30). The inversion or reversal of conventional thinking is thus one source of art's critical value. Understood in this sense, the art world today retains its commitment to this understanding of 'autonomy'. Foster too harks back to long-standing legacies in the discussions. At one point, he counsels against assigning critical agency to things rather than to people.[51] The reason, Foster declares, is that this critique of fetishism is one aspect of the Enlightenment heritage that he still clings to. These efforts to bring attention to a legacy that remains active in contemporary discourse runs against the grain of the surpassing quest, which requires separation and rupture, thus contemporary now-ness. Such observations show

that any discussion of art's critical function inevitably leads the conversation beyond modernism back to its Enlightenment and romantic sources and forward again to the present. Yet, in the anti-aesthetic seminars any case raised for enduring legacies tends to constitute a dead end in the conversation; the discussion tends to proceed as if they were never mentioned or there is no way of comprehending them.

Many contemporary analyses have become accustomed to a demarcation that identifies the modern with crude and simplistic thinking and the contemporary with complexity. Of course, crude demarcations, according to this hypothesis, are a feature of the modernist mentality, so by definition contemporary thinking is free of such rudimentary thinking. If this were actually true, then you would think that all our troubles would be over. The difficulty is that many current debates about art and contemporary culture rarely go back to sources more than twenty to thirty years old, which suggests that the advocacy of surpassing terms works best when the originator is largely ignorant of what is to be surpassed. Furthermore, debate has proceeded by way of stereotypes for a number of decades now: for instance, the image of the Enlightenment as typified by a drive to order, classify, and categorize the world; in turn, the modernist drive is typified by top–down, one-dimensional, and monolithic systems (as if Taylorism and scientific management pervaded all thought up until say 1989). To raise doubts about this reduction does not mean to say that such propensities did not exist; they did, but it means acknowledging that such propensities *still* exist. Rather than following Bernstein's or Frank's assessment of modernism as a refusal of the hegemonic rationalizing structures of modernity, many current observers invert the proposition and conflate modernism with a dispiriting rationalization of everyday life. As Omair Hussain observes in the seminars, the 'modernist regime' is typically viewed as 'elitist, normative and oppressive' (Hussain, Seminar 8: 108). Contemporary art, he argues on the other hand, also constitutes a regime: one of 'continual uncritical celebration of pluralism as an end in itself'. The result is that Foster's ambition to retrieve modernism from its intellectual death sentence as a reified category seems to conflict with many of the commentaries contained in the book, which have become accustomed to identifying anti-aesthetic tendencies in direct antithesis to modernism, which remains resolutely the bad object.

For instance, while Eva Schürmann notes in her assessment how restricted the definition of the modern is when confined primarily to an association with Greenberg, she contests the generally 'faulty logic' of all modernist thinking because she argues it always seeks to divide and 'to purify'.[52] Relying on Bruno Latour's diagnosis that we have never been modern, Schürmann contends that modernist thinking relies on constructing the world in terms of dichotomies: for example, the distinction between 'nature and culture, the human and the mechanical' (143). Schürmann concurs with the view that the anti-aesthetic is negatively determined by what it opposes, but she believes that Foster's whole discourse proves to be quite modernist (in the derogatory sense she is outlining) because it is constructed around 'oppositions like abstract versus figurative or media-specificity versus non-specificity' (144). Is the problem that we are, to quote Schürmann, 'strangely pre-modern' and 'not enlightened enough' – thereby thinking 'in far too simplified categories' with 'reified oppositions' (143) or, alternatively, is the issue that we must *exceed* the modernist project (Schürmann citing Foster in his original introduction to *The Anti-Aesthetic*)? Schürmann's argument raises important points to consider—not the least the problem of such a compartmentalised understanding of the modern—but it also raises the question of whether it compounds the tendency it describes or escapes it. Do we need to return to a point somehow *prior* to the modernist divisions when everything was hybrid, more oddly whole and undivided (therefore never being seduced into becoming modern again because we see its danger)? Or do we need go beyond it, to exceed it and come out the other side (in other words, we have been modern, but it was a mistake)? It seems to be both. And perhaps we need to flagellate ourselves either way because we constantly risk the temptation of falling prey to modernist thinking. We must despise it because of its penchant for separations and ghastly demarcations, but we need it too, in order to make sense of our opposition to it. We frustrate ourselves by our constant urge to invoke it as the danger we must escape, but require the very thing we despise. Thus the critique of modernist thinking with its 'systems of demarcation', its need for separation and hierarchies, is opposed and contrasted with the contemporary, which is the preserve of the hybrids, 'less required to decide between strict opposites', and happy to embrace 'contradictions, ambiguities,

and indeterminacy' (144). Again, however, the same conclusion in the form of another separation and another division, another hierarchical distinction with the modern playing the role as the clear and irredeemable 'bad object'.

Yet, nearly all of the 'non-modernist modernist' artists mentioned above could be validly described in these terms – that is many forged practices that were happy to embrace contradictions, ambiguities, and indeterminacy. Doesn't the relentless association of the modern with the urge to purify therefore simply reinstall the restricted identification of the modern with Greenberg?[53] Frank's point about autonomy would seem to contest the proposition that there was a pervasive reliance on a simple distinction between nature and culture. This is Márkus's point too. It seems we can dismiss the urge to demarcate and to divide, but we still require a fundamental opposition and separation to secure our arguments and to establish our good thinking, which succeeds the fallacies of the modern. Judging by some of the more bizarre characterizations given by some participants in these seminars as well as in some of the assessments, modern people, particularly modernist artists, were unbelievably naïve and perhaps stupid people when judged by today's standards. They exalted in simplistically uniform models of art, epistemology, and politics – apparently without exception. This is what makes us, by contrast, so complex and intelligent.[54]

The surprise result of this retrospective scrutiny into the anti-aesthetic is that it not only tells us much about the heterogeneity of modernism, but it also continues to tell us a lot about how diminished conceptions of modernism have become – so much so that any discussion of modernism, or modernity, is often reduced to quite crude caricatures accompanied by the insistence that the idea of drawing crude separations and divisions is solely the preserve of modernists. At one point in the seminars, the conversation suddenly switches to zombies and it is not surprising for a number of reasons (Seminar 6: 88). Equating the critical role of art with the living dead hints at an interesting inversion. Like our fascination with zombies, this version of Modernism (with a capital M) appears to be something we continue to need in order to feel better about ourselves. This is because we want to presume we have surpassed it and thus are no longer compromised by its failures and its reductive conceptions, though really we might be concerned that we have not escaped its ambiguities and thus its conundrums. Even the

participants who offer more nuanced positions in the seminars still present the course of contemporary art after modernism as a kind of zombie world of dead and forlorn options. And still the discourse is haunted by the figure of Greenberg, who keeps returning and never seems to relinquish his grip on subsequent formulations, whether modern or contemporary. Yet, it is we today who are the zombies. How did this happen?

Even though Bernstein presents himself as the advocate for a more critical or complex account of the aesthetic–modernism link, he also ponders the question of whether the legacy of modernism should be considered remote and cast adrift from current reckoning. He asks, 'Is modernism alive? I would say, no, it isn't. Adorno thought it was dead or at least dying when he wrote his *Aesthetic Theory*' (Seminar 5: 68). In fact, Adorno argued that the high point of modernism had occurred a lot earlier – 1910 to be precise.[55] The heyday of modernism – alert with critical vitality in eschewing the 'rationalization of everyday life' – is remote from us today as a viable possibility. The only feasible conclusion to draw from the negative account of modernism is that the 'rationalization of everyday life' is today complete and without exception. Accordingly, we are thus taken back to Foster's rebuke of Bürger's assessment of the historical avant-garde and thus the prospect of 'mere farcical repetition' facing a critical-cultural void. The tenor of these discussions is to make all options appear equally forlorn – we are either forced to confront a zombie-like repetition, staggering around in a critical-aesthetic inanimate state, or committing to careers perpetually reciting the death of modernism by recalling faded dreams that occur to us only in their deathblows.[56] If Adorno thought the heyday of modernism was 1910, then why was he spending his remaining energy writing about it more than fifty years later when it could be considered long gone rather than simply in decline or dying (as puts it)?[57] For all his attempt to retrieve a more complex and critically viable explanation of modernism than that offered by Foster's original outline of the anti-aesthetic, the result of Bernstein's prognosis is nonetheless a melancholic one.[58] No matter how concerned we are at the present state of affairs, the best our critical discourse can do is to alert us to the remaining sources of critical-creative capacity, which necessarily turns between past and present, a legacy of possibilities and endgames and a critical vocabulary indebted to both. Timotheus Vermeulen's meta-modern approach is perhaps more helpful than

the complete deflation and loss of critical voice: he heralds artists who 're-signify their engagements with everyday reality as well as re-envision the pasts and futures preceding it, emerging from it by restructuring their experiences, interactions and choices'.[59]

In regard to the analysis of the anti-aesthetic, the key point is this: it is one thing to establish a critical position in opposition to modernism (no matter how that term or body of work is conceived) – even as a competing set of art sub-movements within the avant-garde, the 'isms' – but it is another thing entirely to suggest that such an opposition amounts to a wholly new aesthetic paradigm. In retrospect, the seminar discussions largely concede that the anti-aesthetic proved more reliant on the modernist paradigm – or at least on its key critical axioms – than first conceived, when it was envisaged in the basic framework of the surpassing quest.[60] The ultimate conundrum of the reflection on what the anti-aesthetic *was* for contemporary discourse is this: modernism is distant from us, but paradoxically every attempt to establish an irrevocable break from it only ends up in convoluted formulations that are meant to deliver us somewhere unique and fresh, a new zone of theory and practice. Inevitably, we end up where we started with the modernist legacy. This is our quandary: we inhabit this distance as well as the impossibility of establishing a break. While this is our quandary, our ambivalence is that we are attached to the very thing we either despise or seek to dispense with. We are not zombies because we keep returning to this living dead of modernism; we are more like zombies in that we keep being reanimated by this perennial quest to surpass that keeps taking us back to where we started, which we continually mistake for somewhere completely new.

Hal Foster launched a long and distinguished career in art history with the aid of a term of surpassing, the anti-aesthetic. Looking back, the retrospective appraisal is far more equivocal than the original case presented for a break. 'The celebration of rupture now seems long ago and far away', Foster declares early in the reassessments, 'many of us seem more interested in narratives of persistence and survival' (Foster, Seminar 2: 44). This is a fair call and probably pertinent. Public discourse has again become polarized and vicious. At the same time, the attempt to rally around a viable critical vocabulary appears to have diminished. The discourse of breaks and ruptures has thrown our critical vocabulary into a quandary. As Harper Montgomery notes in her 'Preface' to the

assessments written in the aftermath of the seminars, contemporary discourse appears rich with debates, propositions, and departures, but, as is the case in reassessing the anti-aesthetic, this makes for a 'veritable minefield of disagreement'. Consensus, she notes of the assessments, seems to form only 'around shared complaints [rather] than agreements'.[61] Yet, this is what the anti-aesthetic reviled the aesthetic for upholding: consensus. Despite the insistence on attempts to open up modernism as a 'reified category', all too often the result has been to establish another demarcation, this time between the contemporary and the modern (with modernism often deemed the 'dirty word', the bad object of discourse surrounding the contemporary, thereby designating the normative and oppressive, the quest to purify, etc.) – although they are essentially two terms for designating the current time or present. This is one legacy of the anti-aesthetic presented as a new paradigm. As a result, it has taken a long time to get back to themes of persistence and survival. Themes of rupture continue to garner all the attention.

The affirmation of surpassing and paradigm shifts: Contemporaneity

I wish to finish with a brief assessment of a less diffident surpassing model. This time found in the guise of Terry Smith's account of contemporaneity, which is his surpassing term. He does not baulk from the claim; there is no equivocation. Smith declares that there has been a momentous transformation: a 'world-wide shift from the modern to the contemporary'.[62] In fact, he asserts that the term marks the surpassing of both modernism and postmodernism.[63] For Smith, the retrospective focus on the anti-aesthetic would likely appear too much of a New York story, thus a centrist, insider narrative. Furthermore, its convoluted negotiation around modernism is just too messy. It is best to discard it completely.

To his credit, Smith's approach is more attentive to the point made by Joana Cunha Leal about the Portuguese accounts of modernism and thus attentive to the fact that there are different experiences and modalities of being 'modern' depending on geography and circumstances. At the same time, the emphasis on the term contemporaneity suggests a broader cultural simultaneity.[64]

In short, we have entered a new 'global circuit of cultural production' (Smith 2009: 151). Smith's horizon is therefore much broader. The world cultural map has been transformed and it ushers in a new transcultural world free from the narrow Eurocentric confines of Western European and North American perspectives (the traditional centres of art-world power, money, and influence). Biennials outside this Eurocentric world view are regarded as indicative of a larger trend towards a wider, more culturally diverse and inclusive contemporary art world, which in turn permits a much wider range of cultural perspectives.

Contemporaneity is such an ungainly term that it is difficult to imagine it rallying much interest, yet the opposite is the case. If we may be witnessing the decline of the surpassing quest, then Smith's contemporaneity may be its last hurrah, or even its revival, given the attention it has received. This is due no doubt to the fact that it announces the surpassing of both the modern and postmodernism, but also with its emphasis on a transcultural transformation Smith views it as a cultural paradigm shift in art. Contemporaneity marks the definitive transition from the modern – or from even the multiple modernities of postcolonial thinking – to contemporaneity. As a consequence, Smith argues, we encounter something very different: for the first time contemporary art becomes the world's art, a new level of global artistic simultaneity. There is much sympathy for the argument that we have entered a new postcolonial, global era free of the monocultural world of modernity equated with Western imperialism. Quoting Stuart Hall, Smith tells how it was prepared by 'years of resistance to colonization and globalization' (2009: 151), which eventually resulted in the margins challenging and occupying the centres. Previously excluded histories and experiences are now pivotal to the new global framework of artistic production and exhibition. As Smith pictures it, there is not much to dislike about the new directions in contemporary art. The new framework stimulates art practices that are extraordinarily nimble and adept: Smith describes them as 'locally specific yet worldly in implication, inclusive yet oppositional and anti-institutional, concrete but also various, mobile, and open-ended' (Smith 2009: 151).

Contemporaneity better describes our 'present constellation' than any previous term because it accounts for 'everyone's increased awareness of co-temporality', of 'being filled by a full consciousness of our connected planetarity', which means that

everyone also experiences this simultaneity 'in distinct ways and to specific degrees, local, regional, and international'.[65] It is not just a matter of garnering a more adequate term for being up-to-date on a global scale. Modernity is thoroughly compromised because it rests on universal assumptions that inevitably prove to be Eurocentric. While contemporaneity may sound like a universal description, Smith is quick to disassociate the term from universalism (which is another taboo term in contemporary postcolonial art discourse and the critical discourse more generally – it can only be used in order to be denounced). At the same time, he shies away from drawing any parallel between contemporaneity and cultural relativism. It is safe to assume, however, that the degree of distance from Eurocentrism and the curtailing of its universal pretensions are assumed to represent the best aspects of contemporaneity.

Crucial to Smith's account is his delineation of a number of key currents within contemporary art. At the 'top' end of the art-world scale lies the first current, and it is comprised of three further subcurrents: an uneasy mix of 'spectacular repetitions of avant-garde shock tactics' (think Damien Hirst, Jeff Koons, and Julian Schnabel or Takashi Murakami), a 'remodernizing' tendency (Smith lists Richard Serra, Gerhard Richter, and Jeff Wall in this category), and 'retro-sensationalism'.[66] Such art may look radical but it lacks the avant-garde's 'political utopianism and … theoretic radicalism' (2009: 265). This art attracts a lot of media attention because this is where the art market's attention is focused.[67] 'Spectacularism', as Smith calls it, isn't even limited to art; architects such as Frank Gehry, Santiago Calatrava, and Daniel Libeskind readily fit into this category. While this amalgam appears to have very little in common, Smith groups this whole current together under the umbrella of an 'aesthetic of globalization', clearly a derogatory bundling (Smith 2009: 7). In introducing his readers to this heady top-level tier of the art world, Smith reveals the bizarre overblown institutional edifices of late modernism in its monumental phase. Next, he moves to art with which he has been sympathetic for some time – postcolonial art, his second current. There are no monumental art movements here, but it is not exactly the province of 'one-hit' wonders either – instead it is shaped by 'diversity, identity, and critique' (Smith 2009: 7).[68] Further down the scale, Smith locates a more humble countercurrent that he characterizes as 'specific, small-scale and

modest'. Presumably this is the level of the counter-institutional, artist-run initiatives (ARIs), local collectives, social practices, and ground-level initiatives. Often current-cultural and counter-global, this level of operation is usually more transitory, or even virtual, in its practices and operations. It is a world far removed from the pre-GFC extravagances of Hirst and Koons, and as such is characterized not only by its cooperative and small-scale institutional set ups, but also by art and curatorial practices that are more interactive and open-ended (Smith 2009: 8, 266).

As a general account of the transformations that art (and culture) has undergone in recent decades, Smith's account is highly useful because it provides a clear structural outline of its categories and subcategories. Yet, Smith lets us know that these defining trends are far from coherent. While the currents are generated by the conditions of contemporaneity, they are more often competing or at odds with each another. They 'are only partially synthesizable into each other' because they are antinomies and therefore remain in friction (Smith 2009: 269). The overall argument rests on a cultural schism – the passage from modernism and postmodernism to contemporaneity – and thus Smith's contemporary art currents need to be successive and discrete. This is because some of the currents are contaminated by modernism – namely, the retrogressive current 'remodernism' – which means such practices cannot be aligned with the paradigm shift represented by contemporaneity. Each successive current departs more successfully than the previous one from this contaminated legacy. Smith's second current of art, for instance – a 'counter- or alternative modernity' – is explicitly defined against the modern by definition.[69] While in retrospect, some options may have led down dead ends, they were useful in the process of fully differentiating contemporaneity from modernity. Artists of Smith's second current are, for instance, important because they leave behind the 'late modern dilemmas' of striving to become '"contemporary with" the West' (Smith 2015: 167). As each current departs further from the modernist legacy, the implicit evaluation behind each current becomes more explicit. The power of the first current is characterized by the market-led hype surrounding retro-sensationalism and remodernism, but their 'power to define the agenda of world art is waning, fast' (Smith 2015: 167).[70] Only the third current can genuinely succeed

the trappings of the other currents and 'reach toward planetarity'. Planetarity is another awkward term, but it appears aimed at avoiding globalization, which is largely understood as another word for economic liberalization. For Smith, 'planetarity' seems to mean moving beyond the national–international framework to create 'platforms of connectivity' (Smith 2015: 167). Third-current artists are 'more naturally connected than the others with the search for planetarity' due to their elevating of 'issues of mediation, self-making, communality, and connectivity within an immobilised, fragmenting world political order and an increasingly fragile planet'. As Smith proclaims, 'They are already where the rest of us need to be, and soon' (Smith 2015: 167).

While the currents Smith outlines seem helpful, there is also a sense of world-shattering historical urgency behind some of his pronouncements. In assessing others who wish to undertake a similar task to his own, such as Paul Wood and Peter Osborne, he finds them all wanting, particularly in regard to having any functional capacity to transform the world they are describing:

> Paul Wood's *Western Art and the Wider World*, a study entirely devoted to the interconnections between 'the West' and 'the Rest' since the Italian Renaissance, quails before the challenges of grasping the structures generated by contemporary art's internal differencing on a world scale. Both he and Osborne retreat to a position where all that the best contemporary art can do is gesture, symbolically, against the ravages of globalized capital. The same, they seem to imply, applies to its theorization. The three currents hypothesis is posed precisely against this defeatism. A more adequate interpretive framework has yet to be proposed.[71]

This all sounds very poignant and urgent, but does this haste assist one in realizing how art and artists can save the world?[72] To make sense of this claim would lead the discussion back to points made by Bernstein and Frank within the anti-aesthetic seminars about autonomy and thus reiterate my point that to repeat such claims will inevitably lead the conversation through modernism back to its Enlightenment and romantic sources and forward again to the present. Does this occur with the discussion of contemporaneity too – despite its rhetoric of being in the aftermath of the modern?

One definition Smith gives of contemporaneity reads like an update drawn straight from the pages of Benjamin's 'Experience and Poverty' essay:

> Contemporaneity [today] consists precisely in the acceleration, ubiquity and constancy of radical disjunctures of perception, of mismatching ways of seeing and valuing the same world, in the actual coincidence of asynchronous temporalities, in the jostling contingency of various cultural and social multiplicities, all thrown together in ways that highlight the fast-growing inequalities within and between them.[73]

As an art historian, Smith has always favoured a taxonomic approach. He seeks to create a lucid understanding of a complex array of artistic practices and cultural conceptions by creating classifications and subclassifications. They are not meant to be ambiguous, but to aid comprehension. Once placed in a classification, the art discussed is meant to stay in place, not to provoke equivocation that would cause any ambiguity or hesitation with the overall argument. Smith's taxonomies aim to be distinct and final; they are the building blocks for a case that will hopefully prove irrefutable. Smith also has a penchant for terminological triads, which he layers one upon the other. Most of the time, this layering tendency does not hamper his approach; the process of subdivision helps the reader to learn a lot about the art being examined. However, as the argument for contemporaneity rests upon distinguishing contemporaneity from modernism, it requires clear demarcations. As a result, some of his specific descriptions of modernism and its surpassing are surprising, if not haphazard. For instance, Smith does not differentiate what distinguishes 'a naïve internationalism' from any other kind; he equates modernity 'with a kind of ethnic cleansing' and refers to the 'reduction of modernity to "the only remaining superpower"', whatever this actually means.[74]

Ultimately, Smith's definition of modernism in the visual arts also remains indebted to the same mid-twentieth century, largely American or 'Greenbergian', formalist account that pervaded the anti-aesthetic debates. This account, as we have seen, narrates a tale of abstract art that embarks on a quest to delineate an essential truth of art with each art discovering its medium-specific or essential conditions (painting, for instance, strips itself of all literary

or figural motifs in order to concentrate on the basic conditions of paint, line, colour, shape, etc). Smith first came to prominence as a formalist advocate of hard-edge abstraction in the 1960s – witness his writings in an art journal, *Other Voices,* and his art criticism of the time – but he also made his critical reputation by disputing this method of art inquiry. Ironically, the adoption of the formalist understanding of modernism, as well as its rebuttal, constitutes the formative points in his career.

This account of modernism is of course perhaps the narrowest available and for this reason it is the most seductive. For all that, the important assumptions underpinning Smith's assertion of contemporaneity also rely on certain modernist cultural values. His promotion of the postcolonial and multicultural coexistence implies an amalgam of Enlightenment and modernist cultural and civic commitments: the liberal value of tolerance (liberal but commonly held on the Left), a notion of the equality and universality of civic rights and liberties, critique and legitimate dissent, 'hopeful anticipations' and also cultural relativity, a mixture of modernist commitments drawn from liberalism, the Left, and the Enlightenment.[75] Furthermore, in elaborating on his third current of contemporary art – composed of artists who strive 'to grasp the changing nature of time, place, media, and mood today' – Smith explains that their circumstances 'of place-making' need to be thought in terms of 'dislocation' and in which we find that the 'fundamental, familiar constituents of being are becoming, each day, steadily stranger' (Smith 2009: 8).[76] Intriguingly, Picasso reminisced in 1964 that the whole point of Cubist collage was to place a 'displaced object' into

> a universe for which it was not made and where it retains, in a measure, its strangeness. And this strangeness was what we wanted to make people think about because we were quite aware that our world was becoming very strange and not exactly reassuring.[77]

The vocabulary is very similar. It suggests that artists then felt much the same way about their 'modernity' as today's artists feel about their 'contemporaneity'. This begs the question, why do artists and their fellow citizens not feel more at home in contemporaneity, given that it has overcome the demons of modernity?

In a subsequent overview of responses to his book, Smith generously notes that I 'astutely' pinpoint 'the modernist legacies' in his argument (Smith 2015: 168, n. 32). The point was not to score a victory in an idle, academic point-scoring exercise. It is aimed instead at demonstrating how all of us, not just Smith, remain dependent on this legacy in order to present our critical positions. A sheer cultural split is hard to fathom or imagine. If the legacy of modernity is indeed an anachronism, it should not be exerting such an influence over contemporary positions. Yet, due to the insistence upon a paradigm break, the case for contemporaneity must not only be successive, it inevitably introduces a bifurcated model. Smith's currents cannot cross because the most progressive currents must remain uncontaminated by the modern legacy. The argument for contemporaneity as a new paradigm change inevitably introduces a split, necessitating stark demarcations. This is necessary because the modernist legacy is defined as wholly pernicious – almost to the point of caricature or quick dismissals.[78] The detrimental effects of Eurocentric thinking still need to be adequately addressed and they include the inert centre–periphery hierarchies of artistic and cultural development. In the wake of these challenges, new thinking is required and new art-historical paradigms are required. The trouble with the insistence upon a cultural paradigm break is that it does not resolve these issues. It results in stark divisions between modernity and contemporaneity, between universalism and relativism, and so on, and a saints and sinners version of art history. The debate simply becomes a matter of picking sides in the knowledge that one side is always correct, nimbler, and free from any dubious contaminations, such as cultural or economic imperialism, and the other is clumsy, pernicious, and redundant. It is not really a choice.

Conclusion

The retrospective examination of the anti-aesthetic shows that a number of propositions masqueraded as ruptures or breaks, but they were actually more reliant on a group of propositions usually associated with modernity as a cultural paradigm. Their value relates to the capacity of these terms to articulate different, but

short-term, developments in artistic practices within the art world. If Terry Smith's account of contemporaneity applies Márkus's idea of a culture of modernity composed of, and plagued by, antinomies to contemporaneity, then its value is not as a paradigm break, but rather how it takes that idea and develops it in a globalized, transcultural situation, which is both valuable and no mean feat. This is not how Smith would position his accomplishment because he is wedded to the proposition of identifying contemporaneity with a cultural paradigm break. Acknowledging the modernist legacy in Márkus's terms as composed of, and plagued by, antinomies and without relying on a surpassing model is the shared theme (in different ways) of Chapters Three and Four. The overall point is not to elevate the modern over contemporaneity, or any similar, clumsy procedure of that kind. Contemporaneity may help to explain certain important transformations that have taken place in our culture of modernity (this is how I see Smith's contribution). It is just unnecessary and redundant to define it as a paradigm change. The same applies to the anti-aesthetic, but it seems this is a point that Hal Foster now seems to be the first to concede. This is a concession to more nuanced debate, though one less heroically charged than it was originally conceived. This is the cost of renouncing the surpassing quest.

What would it mean to inhabit a culture of modernity bereft of surpassing its impasses, whether in terms of simply assuming to have left its quandaries behind, or to remain in the wake of its grand visions of cohesion? The unlikely candidate to envisage such a possibility is the wayward Sigmar Polke, who plots such a course through his *We Petty Bourgeois* (*Wir Kleinbürger*) collection of works that formed an exhibition in 2010. And this is the subject of the following chapter. Polke's challenge was a reconception of a much-maligned class term, which thereby sought to situate the challenges of the aesthetic as neither a place of resolution, nor as a complete rupture, but without falling into the trap of declaring the present diminished or the product of a farcical repetition. The provocation was to revive a 'dead' term to enliven a seemingly moribund debate about the role and position of art, the artist and the aesthetic, but in ways that remain troubling and uncomfortable to this day. It thus provides an example of how to reinvigorate debate without resorting to a space of resolution or seeking lift off into a zone free from our quandaries.

CHAPTER TWO

We petty-bourgeois radicals:

Reflections on Polke's *Wir Kleinbürger!* (We Petty Bourgeois!)

'Radicality is never lonely. Radical modernism could not have existed without the phenomenon of identification between the artist and proletarian, regarded as the driving force of history.'

— NICHOLAS BOURRIAUD, *THE RADICANT*

'The fluctuating class is always the disturbing one. ... [It] injects confusion into theory and practice.'

— HANS MAGNUS ENZENSBERGER (1976), *TELOS*, P. 162.

'Freiheit ist immer Freiheit der Andersdenkenden' ('Freedom is always the freedom of dissenters' – or: 'Freedom is always the freedom of those who think differently.')

— ROSA LUXEMBURG

The puzzle of the 'we' in Polke's *'We Petty Bourgeois!'* exhibition, Hamburg, 2009–10

In March 2009, an immense, tripartite exhibition of Sigmar Polke's work opened at the Hamburger Kunsthalle. It was so large that its third section did not close until almost one year later in January 2010. Polke was ill at the time and died a few months later in June 2010. The kaleidoscopic exhibition had one all-encompassing title, *Wir Kleinbürger! Zeitgenossen und Zeitgenossinnen (We Petty Bourgeois! Comrades and Contemporaries)*. This cover title encompassed three subthemes that were displayed in separate sections over the long duration of the exhibition: Clique (March–June), Pop (July–October), and Politics (October 2009–January 2010).

Central to the show were ten large (300 × 100 cm) colourful gouaches by Polke. Otherwise a lot of material featured was collectively accredited to 'Polke & Co'. Even when select aspects of this ensemble were exhibited in 1976, four people were originally accredited as authors on that occasion.[1] Most of the work for the Hamburg exhibition was executed at a place called Gaspelshof in Willich, not far from Düsseldorf, between 1972 and 1976, where a type of countercultural community existed. Although Polke had become a famous artist in the intervening years, most of the material in this large Hamburg exhibition had not been exhibited since 1979. To complicate things further, it was not always clear what things produced and exhibited amounted to artworks or what was ephemera or documentation, or what ordering existed. This placed a question mark over the status of much of the material and yet, at the same time, this uncertainty seemed to be part of the ambition behind the whole ensemble.

The exhibition curators declared that their motivations were to bring to light a neglected period of Polke's oeuvre and to challenge the preconception that the 1970s was his lost decade (Lange-Berndt and Rübel 2011: 17). They wanted to contest the idea that during the early 1970s Polke experienced a stereotypical hippie fade-out in which he dropped out, travelled too much, or took too many drugs (or both).[2] Given that the Hamburg exhibition featured so much work, this dropout myth appears self-evidently false. Polke had

been as busy as ever. The curators instead pondered the question of how 'an entire decade of an internationally-renowned artist's reception' could disappear from view for so long? (Lange-Berndt and Rübel 2011: 30, 34). Their own assessment of the 'cycle', as they refer to it, suggests a difficulty with the work, which may explain why it has remained so 'invisible'. They hint, for instance, that it amounts to an unstable conglomeration of disparate subject matter: a 'visual cascade of magazines, yellow press, cinema, or television … transferred to paper in constantly changing hybrids and concatenations' (ibid. 31). This prompts the curators to ponder whether such a swirling cavalcade of individual motifs and visual ideas actually coheres. Instead, as they suggest, the content drifts 'without being clearly determined and controlled' (34); 'the series was meant to be constantly rearranged'; and that it is meant to be 'in permanent animation, in agitation, in flux' (33). Indeed, everything does seem boisterously exaggerated and undetermined: the vast array of material (as if too much to take in); the multiplicity of focal points, and the great, vivid washes of experimental colouring; and the bizarre materials, with some works composed of 'phosphorescent chemicals that magically glow in the dark' (31), a treatment which sometimes appears to devour any singular imagery at the expense of stable viewing. The resulting visual cacophony provokes an interesting, equivocal observation: *We Petty Bourgeois* both 'demands a vagabond way of seeing' (33), as Lange-Berndt and Rübel declare, and simultaneously it highlights 'images of various states of collective consciousness' (32).

For an audience trying to make sense of all this, discerning clues of collective solidarity from a distracted mode of viewing is just one puzzling feature of the exhibition. Polke erects his own banners, but they do not promise any surpassing. They are more like parodies of the surpassing mode, and yet they are not idle jokes either. Before one sees anything inside the exhibition, a collective 'we' is heralded by its banner-like title. The English translation conflates comrades with fellow contemporaries – a collapse implying a confounding complicity or a new situation built upon this complicity. But what kind of genuine comrades rally to a collective identification as petty bourgeois? Certainly not artists, but then again collective solidarity of any form is not their strongest trait. Although neither do progressives, intellectuals, radicals, bohemians, or the

counterculture identify as petty bourgeois. All of these groups or figures have traditionally been opposed to anything remotely associated with the label 'bourgeois', whether petty or grand.

Another banner is prominently depicted across one of the key large gouaches, titled *Giornico* (1976). The banner depicted in *Giornico* declares its opposition to the two duelling superpowers of the day – the United States and the Soviet Union – which many feared wanted to resolve their Cold War differences in the 1970s over German territory. Its ostensible subject matter is a political demonstration that carries this banner, along with the subtitle: for a red Switzerland (*Für eine rote Schweiz*). It is the most immediate and obvious gesture to some form of collective solidarity. Its bold, declarative style suggests rallying together in a common political struggle. In *Giornico*, however, the banner is represented backwards, which suggests that everything might be the wrong way round. And so it proves.

While banners abound in the exhibition, it is still unclear what one is asked to identify with. Due to the conventions of the day, the appeal to a collective 'we' of the petty bourgeoisie would automatically be regarded as some kind of joke. Petty bourgeois is simply one of those terms – like Eurocentric, anthropocentric, primitive, chauvinist, imperialist, reactionary or barbarian – that no one freely proclaims to be; they are labels always applied to others, rarely to oneself. Whenever such class terms are thrown around, a set of assumptions automatically falls into place. To be described as 'petty bourgeois' is to be defined as small-minded and materialistic, socially defensive, fearful of cultural sophistication and of social change, with a preference for kitsch sentimentalism or, alternatively, corny nationalism in cultural matters. Invoking the term instantly reads as a rebuke of an identifiable and deserving target. There is no need to think further.

If such a banner title were to be taken in jest, then it would constitute a very old joke by the early 1970s. For at least one hundred years previously, from at least the mid-nineteenth century, the avant-garde had defined themselves in opposition to bourgeois values. This stance persisted throughout the twentieth century. The accusation could even be levelled at other radicals or fellow avant-garde artists to indicate wavering commitment or a fall from a perceived set of critical standards. By the twentieth century, in 1922, to give just one example among many, the Czech avant-gardist Karel

Teige admonished the Bauhaus for 'its petit-bourgeois tendencies' (Forgács 1997: 116). Depending on one's position at any given time, such a charge could mean that the Bauhaus was not sufficiently focused on productivity, and hence too aesthetic (Teige's complaint) and not sufficiently proletarian. Yet, at other times, much the same accusation has meant that the Bauhaus's efforts were too complicit with dominant power, with design as a reflex of capitalism, and thus too functional and too aligned with instrumental outcomes (which is more the contemporary accusation). Both sides of this argument were raging simultaneously throughout the Bauhaus history – and, as we saw in the previous chapter, this oscillation is a symptom of the irresolvable dynamic of modernity.

In Polke's days as a student and young artist, accusations of petty-bourgeois behaviour persisted. This accusatory rhetoric would continue to permeate the ethos of the 1960s counterculture at both its militant end and also at its romantic ends (where even wealthy rock stars could still berate their peers for being too constrained and bourgeois in their cultural values or habits – although it could also be used to provoke women into being less constrained sexually). From early in the twentieth century, the label attracted so much vehemence that one term was not adequate and a proliferation of negative terms flourished to describe such a world view – like the German word, '*Spießer*'. Such a label conveyed a set of automatic assumptions designating an insular, anti-democratic, and repressive world view, which confronted the early avant-gardes in its full reactionary force. In its short six-month existence, the much-vaunted Dadaist Cabaret Voltaire, for instance, was regularly harassed by the police and the vice squad (*Sittenpolizei*), which closely monitored the dubious exiles that had congregated in Zurich during the First World War and threatened them with imprisonment or deportation. As Richard Huelsenbeck noted, women were rarely seen at the Cabaret Voltaire because polite society feared its negative connotations; its landlord constantly threatened the venue with closure because, as he complained, 'no person of any respect and dignity' could ever be found there (Bru 2009: 139).

The figure of the bourgeois or the *Bürger* was thus associated with a conformist, 'repressive imaginary', of which it was both a product and which it also used as a weapon to 'repress others in turn, in particular when it came to moral matters' (Bru 2009: 139).[3] To be petty bourgeois was to some degree worse than being bourgeois.

Over time, it simply stood for a vacillating, mean-spirited mentality, fearful of anything progressive, which it often disregarded as a symptom of social decay. To make matters worse, it was usually dismissed as a parasitic, waning, or redundant class, living in fear of losing its precarious status. Since the late nineteenth century, at least, such class descriptions therefore had long been identified with rigidity and repressiveness and its negative associations endured long after wartime Zürich in 1916. Historically, the general label represented everything the avant-garde and progressive forces stood against.

Such was the degree of venom directed against this social category that sixty years after Dada – against the backdrop of West German left-wing terrorism in the 1970s – any reference to the petty bourgeois could still be interpreted as predictably ironic, if not viciously sarcastic, even when addressing a collective 'we', as did Polke and company. It would still seem incomprehensible for recalcitrant individualists like Polke to utter any sincere appeal to fellow comrades as petty bourgeois. This is the consensus found in most commentary, especially in the large and impressive catalogue produced in the wake of the exhibition, which views the association as mocking and disparaging, hence also as distancing. And yet, it is hard to be sure. The exuberance of the works introduces a degree of uncertainty, notwithstanding the exhibition's ambiguous appeal to a *Kleinbürgerliche* collective.[4] If there is biting social and political sarcasm, then it is quite possible that it is located in an inverted, but buoyant allusion to a *revolutionary* petty bourgeois, comprising genuine comrades. It is this off-putting and deceptive collective address that complicates the reception of this work as much as the formal volatility of the vast, vagabond-like body of works that comprises the *We Petty Bourgeois* exhibition.

The irresistibility of the *Petty Bourgeoisie* and its cloak of invisibility

The exhibition title was a playful variation on the title of a 1976 essay by Hans Magnus Enzensberger, 'On the Irresistibility of the Petty Bourgeoisie', which was translated into English to coincide with its German publication.[5] Enzensberger's provocation was

to seek to resist the rusted-on assumptions about the petty bourgeoisie and insist instead that this lame class had transformed into a newly dynamic social entity. In particular, Enzensberger sought to overturn the contemporary taboo over the use of the term, petty bourgeois, which still persists long after his 1976 essay. Outrageously for the time, Enzensberger not only identified himself as petty bourgeois, but he began his essay by addressing his readers as fellow petty bourgeois. Polke appears to have read the essay shortly after its publication and freely borrowed from its direct mode of address to a shared, collective audience, so he cannot have been too upset by this group identification as a member of the petty-bourgeois class.

Because no one disparages the petty bourgeoisie more than the petty bourgeois, Enzensberger asserted, the people most passionately dismissive of any association with the class are in fact those people most likely to be petty bourgeois. Among the fellow self-deniers, Enzensberger includes writers like himself, academics, freelancers, designers, even artists – no matter how outwardly avant-garde or countercultural. 'The petty bourgeois wants to be anything other than a petty bourgeois' and for that reason 'the petty bourgeois is always someone else. This strange self-hatred acts as a cloak of invisibility' (Enzensberger 1976: 163). Enzensberger appears to follow the lead of Arno Mayer, who published an essay shortly prior to his own in September 1975, in which he declares that there is a need to tackle 'the benign neglect of this pertinacious social phenomenon' and 'to stop thinking about the petite bourgeoisie primarily or even exclusively in terms of other classes' (Mayer 1975: 409, 410). In his analysis, Mayer also numbers within its ranks social groups that would feel highly uncomfortable identifying as petty bourgeois, including intellectuals, the professoriate of the universities and professional schools, scholars, experts, and artists. The public image of the petty bourgeois 'set by its commanding figures', Mayer argues, is one of critical independence. Yet, this public image and rhetoric sits at odds with the economic realities of its precarious existence, namely temporary contracts, precarious employment, commissions, grants, integration within institutions or piecemeal work 'from established individuals, corporations, foundations, and governments' (Mayer 1975: 430). Its independence is both reliant on these conditions and tempered by them (they 'govern the world of the intelligentsia'),

Mayer writes in 1975, but even in this arena they would set the trend because these conditions would go from being a niche phenomenon to eventually typical of the working conditions of a major segment of the workforce in the future.

Back in the mid-1970s, however, Mayer, like Enzensberger, was emphasizing the mercurial and precarious nature of this social stratum. Mayer characterizes the class as having 'no fixed meaning for all times and places' – in fact, it 'differs from place to place, ... within any given country ... as well as with historical time periods' (Mayer 1975: 411). The key difference between their accounts rests on whether the class is progressive or not. By the early 1970s, according to Enzensberger, it has clearly become an innovative class. Whereas Mayer traces the development of the class from an intermediate, but independent status that 'still faced *both* ways' – both towards liberating moments of challenge and towards 'recoil and retrogression' – until it reached a period when 'after 1871, the petite bourgeoisie increasingly looked in one direction only: backward' (Mayer 1975: 416). Enzensberger seeks to update and overthrow this usual, condemnatory assessment of the class. While it is true that no one forecasts the demise of the petty bourgeois as readily and enthusiastically as the petty bourgeois, Enzensberger counters, there is also a need to confront the fact that the petty bourgeoisie has not only survived, but transformed itself and flourished. Thus, Enzensberger's ambition for his 'playful' essay is bold. He aims to defy the most influential diagnoses of class development in the modern epoch and to forge an alternative space for discussion that had previously been dominated by Marxist sociology. According to Marxist analysis, the petty bourgeoisie did not possess the historical agency of the proletariat; they were viewed as possessing no firm or stable economic role, which is why they were predicted to disappear as a class.

Enzensberger's essential message is that petty bourgeois has transformed into an innovative and experimental class – he thus anticipated crucial aspects of Richard Florida's 2002 formulation of a creative class by almost a quarter of a century.[6] Enzensberger insists that the petty bourgeoisie has thrown off the shackles of the 'smug philistine' and the 'nervous, irritable, easily incensed and outraged persona' of the late nineteenth and early twentieth centuries (Enzensberger 1976: 163–4). In transforming itself, the petty bourgeois has morphed from a malignant, obsessively

defensive class – one that Mayer felt had only gone backwards since 1871 – and turned into a newly dynamic, elusive and innovative class. In short, it has become an 'experimental class', 'swarming with progressives', and ever eager to 'adopt the latest trend':

> It is always up-to-date. No one can more quickly change ideologies, clothing, forms of communication and habits than the petty bourgeois. ... [It is a class] capable of learning to the point of losing all identity. Always fleeing from the archaic, he is always chasing himself. (Enzensberger 1976: 164)

Oddly enough, it has become extraordinarily successful in leading the cultural agenda and achieving cultural hegemony. Enzensberger claims that it holds this hegemony over cultural matters 'in all highly industrialized societies', but he goes on to say that this influence is now also being felt globally; it is the harbinger of a nomadic, highly malleable, experimental, cosmopolitan culture. 'Today there is no Oriental bazaar, no Malayan or Caribbean market where the advanced fossils of petty bourgeois culture have not long since overcome all resistance' (Enzensberger 1976: 165). By outlining previous forecasts prophesizing its imminent demise, Enzensberger's title underscores the 'irresistible' (*Unaufhaltsamkeit*) character of petty-bourgeois culture in the sense of being unstoppable or possessing an inevitable momentum, a depiction once associated with the working class in Marxist theory. Despite its precarious economic status, petty-bourgeois culture can be found everywhere and is becoming increasingly ubiquitous. The petty bourgeois did not create the conditions for a global economy, but they certainly are providing its cultural content.

Its success is a mystery. Enzensberger ponders what makes the petty-bourgeois cultural products so unique and seductive, both equally innovative and facile:

> What is so unique, so appealing about the automatic cigarette lighter, the taste of Pepsodent, concrete poetry, the home workshop, *Sesame Street*, concentrated lemon juice, behaviourism, *Emmanuelle*, deodorant, sensitivity training, the Polaroid camera, wall-to-wall carpeting, parapsychology, *Peanuts*, metallic paint, the casual shirt, science fiction, skyjacking, and the digital watch that no one, no nation and no

class from Kamchatka to Tierra del Fuego, is immune to it? Is there no antidote to those ideas that come to the minds of our class? Will no one, not even the Congolese, be saved the trouble of equipping themselves with underpants designed by a French couturier? Must even the Vietnamese take Valium? Is there no escape from behaviour modification, the Concorde, Masters and Johnson, suburban neighborhoods, and curriculum reform? (Enzensberger 1976: 165–6; incorporating updated translation from Lange-Berndt and Rübel 2011: 205–06)

The quandary is much the same forty years later, and will likely be the same quandary forty years further on, but the intriguing aspect to this account is the range of activities placed under the umbrella of petty-bourgeois culture – everything from concrete poetry to the latest gadget. According to Enzensberger's provocation, a whole new culture was (and still is) being created and re-created, traversing high and low culture, in which previously unknown desires and products would soon be considered so indispensable that it is impossible to imagine having ever lived without them. In such a consumer culture, everything at first appears glamorous and fresh, though inevitably it soon becomes familiar and is then quickly rendered archaic. Hence, the list of dazzling content is quickly superseded and the references become quite unfamiliar to successive generations; all that primarily changes is the product names, the programme titles, and the technologies. The general process actually intensifies with digital technology, YouTube, mobile phones, social media, and the endless surveys asking us how it is all going. In 1976, Enzensberger was primarily delighted in upsetting the critical pieties of the Left surrounding class identification, a provocation that Polke clearly enjoyed, because by that time it seemed formulaic and out of date – even nostalgic. In some key points, Enzensberger was really just updating Walter Benjamin's analysis of 1933 in which he raised the problem of the surfeit of options and information increasingly available to everyone without any adequate way of assimilating it all into any comprehensive framework for the wider culture. For his part, Enzensberger, like Polke, both delights in his inverted class tale and appears at times perturbed by its seemingly inevitable momentum, its indiscriminate nature, its intensification, and its ubiquitous reach.

Marxism and the petty bourgeoisie

To understand why Enzensberger's polemic touched on a controversial question in the 1970s, one has to grasp the strength of the lingering Marxist influence over considerations of class. Primarily its influence related to its forceful critique of the negative impacts of capitalism, which was as influential as ever with intellectuals and the counterculture. The case against the petty bourgeois is equally negative and vehement. Marxists regarded the class as an anachronism and thus as an economic and political waste of space. Worst of all, it was considered a barrier to profound, radical political change. The fact that the petty bourgeois persists not only defied Marxist orthodoxy concerning how classes should develop, but it was also a reminder that its panacea of class harmony and justice had still not been achieved. If the petty bourgeois persisted, then Marxism was failing in its forecasts. Despite this negative assessment, Marx himself did not always uphold such a blanket condemnation of the petty bourgeois. He observed that it could serve as a force for democratic change when it allied with the cause of the industrial proletariat. The qualifier, of course, is that the working class was the only class capable of genuine revolutionary agency due to its world-historical mission. The petty bourgeoisie could only choose the right side because, without such an alliance, the class found no progressive direction and could just as readily retreat into a reactionary social force (Wiener 1976: 667).

Mayer's observation that this transitory, melancholic class played a progressive role in 1848, but a reactionary one after 1871, became the standard Marxist reading. With this damaging association, the class label acquires wholly negative connotations. Lenin thus derided 'petty bourgeois intellectuals' because they kept shifting ground; they were more intent on preserving their autonomy than submitting to the historical destiny of class struggle as represented by the party. Petty-bourgeois radicals were the great equivocators, constantly prevaricating and being diverted by an elusive search for truth – thus ever preoccupied and swayed by the latest theory doing the rounds – when instead clarity and certainty was required. Writing in *The State and Revolution,* on what would turn out to be the eve of the October Revolution, Lenin disparaged any association with the term petty bourgeois as wholly

negative and identified its radicals with a 'philistine "reconciliation" theory' devoid of any resolute revolutionary ardour in the effort to overcome political and economic exploitation. Only a violent overthrow could end oppression and exploitation as well as yield a new society in which ordinary workers would assume responsibility for the crucial decisions governing their lives. The petty bourgeoisie would simply disappear because they stood in the way of this greater social transparency.

Nearly everything that went wrong with this forecast or diverted from this path was of course subsequently attributed to the petty-bourgeoisie recidivism – which actually cedes the petty bourgeoisie a surprisingly powerful role, considering their purportedly weak and fleeting social position. At the beginning of 1936, even though presiding over a massive state, Stalin felt obliged to turn his hand to art criticism in order to condemn the malign influence of the petty bourgeois on culture. Writing as an anonymous art critic for *Pravda*, Stalin decried 'petty bourgeois "innovation"', which he associated with 'leftist ugliness'. Not content with eliminating virtually all political opposition (most notably within the party itself) and notwithstanding his many duties as head of the Soviet Union, Stalin still found the pervasive influence of the petty bourgeoisie everywhere – across fields as diverse as opera, painting, pedagogy, poetry, and science. Leftist ugliness was most visibly evident in works like Shostakovich's opera *Lady Macbeth of Mtsensk District* – the chief target of Stalin's criticism. Works like Shostakovich's were erecting an ever-widening breach between petty-bourgeois innovations and 'true' art, science, and literature. 'This is playing at esoteric things', Stalin warned ominously, and it 'can end very badly' (cited in Volkov 2009: 105).[7]

'Leftist ugliness' could serve as another name for Trotskyism. By 1938, Trotsky was living in exile and had been banished from the Soviet Union for nearly a decade. Yet, despite his travails, Trotsky also took time out to denounce the petty bourgeois and he did so in equally vehement terms to Stalin. This seemed to be the one point they could still agree upon in the late 1930s. The context of Trotsky's remarks was a defence of his actions in suppressing the Kronstadt Rebellion of 1921. It had been a source of controversy ever since the moment he led its repression while still a prominent leader in the Bolshevik government under Lenin. According to Trotsky, the defeat of the rebellion was justified precisely because it sought

petty-bourgeois demands. The complication was that many of rebel demands were couched in terms that accorded with the original aims of the Russian Revolution, such as equal distribution of rations (they proposed exemptions only for those engaged in dangerous or unhealthy jobs); genuinely representative, self-governing soviets; freedom of assembly and of speech. Hence, the terms put forward by the rebels posed a considerable challenge and, in addition, their implementation effectively would mean the end of one-party rule as well as new elections for the Soviets. Notwithstanding his own struggle with Stalinist oppression, Trotsky remained absolutely strident in his denunciation of the rebellion. These were all petty-bourgeois demands, he still thundered nearly twenty years later, and this was sufficient to condemn their legitimacy.

The point of interest for this discussion is not the debate over the nature and legitimacy of the Kronstadt Rebellion, but the manner in which Trotsky denounces the petty bourgeoisie:

The petty bourgeoisie is ground economically between the millstones of big capital and the proletariat. ... [It] does not know concretely what it wants, and by virtue of its position cannot know. That is why it so readily covered the confusion of its demands and hopes, now with the Anarchist banner, now with the populist, now simply with the 'Green'. Counter-posing itself to the proletariat, it tried, flying all these banners, to turn the wheel of the revolution backwards. ... The insurgents did not have a conscious program and they could not have had one because of the very nature of the petty bourgeoisie. ... The decaying capitalism of our day leaves little room for humanitarian-pacifist illusions. (Trotsky 1938)

Trotsky provides a succinct and vivid summation of Marxist orthodoxy in regard to the petty bourgeoisie. And he was probably right; he did detect petty-bourgeois demands at Kronstadt. At the same time, the vehemence and absoluteness of his critique left him open to the accusation of his critics that he possessed no better, less violent means of securing the revolution and governing than Stalin.[8]

The petty bourgeoisie, on the other hand, were like cockroaches. They defied all efforts to explain them away and, worst of all, they actually seemed to be proliferating – one could spot them everywhere! Art criticism, artistic experimentation, and 'humanitarian-pacifist

illusions' – all at times singled out as despised symptoms of petty-bourgeois culture – had survived both Stalin and fascism and were proving equally persistent. This persistence defied the fact that the petty bourgeois remained an in-between class. It still lacked the latent collective power of the proletariat, and it was not fully bourgeois – that is not true capitalists, the owners of the means of production, the truly exploitative class, bankers, industrialists, moguls, among others. Seemingly oblivious to the intensity of the Marxist denunciation of the class, Enzensberger's essential point is that the petty-bourgeois 'illusions' derided by Trotsky would underpin its new *radical* status.

More disconcertingly for diagnoses of its imminent eclipse, Polke and his generation and the counterculture displayed petty-bourgeois traits even in their most radical stances. They would more closely resemble Trotsky's caricature – anarchist one minute, Green the next (although in a new guise), even populist at times. In fact, the pejorative terms Trotsky used against this redundant class are almost the mirror image of the reasons why Enzensberger would celebrate it almost forty years later. They even infused the critical vocabulary of Polke and his generation in their own struggles for greater liberty and less repression in West Germany.

Always changing ideologies, habits, and forms of communication, the malleable character of the petty bourgeoisie makes it the epitome of social fluidity and inventive exuberance in another era. Once marked for extinction like religion or the bourgeois state, this previously fearful transitory class had re-emerged barely recognizable as a flourishing new social-cultural entity. This revisionist assessment was a complete turnaround even for Enzensberger. In 1969, he had written a catastrophic and claustrophobic account of the 'industrialization of the mind' in modern society in which no redemptive capacity could be found at all, not even by a new, mercurial petty bourgeoisie (Enzensberger 1969). In a critical diagnosis so typical of its time (and which remains pervasive as a form of critical diagnosis), Enzensberger depicts a consciousness industry that arises as a corollary of capitalist industrialization. It manipulates pliable citizens, once it cottons on to the fact that consciousness 'can be induced and reproduced by industrial means'. Furthermore, it has a cannibalizing impetus: this industrialization 'must suppress what it feeds on: the creative productivity of people' (Enzensberger 1969: 102). Enzensberger's

account of this industrialization of people's creative productivity reflects the enduring influence of the Marxist critique of capitalist modernity, but it was written only a few years before his own petty-bourgeois essay, which would resituate 'creative productivity' in a less frighteningly coercive and deterministic framework.

Whether one regards the new petty bourgeoisie as the epitome of a new social fluidity and inventive exuberance – or the representative class of a crass, cravenly material and ultimately empty and alienating modernity – its persistence was nonetheless an affront to the predictive potential of Marxist theory. Its continuing presence was an irritating reminder of all that did not conform to its sociopolitical forecasts. As Enzensberger noted, the petty bourgeoisie was the class that threw theory and practice into confusion. Its persistence was an irritant because it punctured the dream of a messianic delivery from the struggles of modernity. Unlike the working class, petty bourgeoisie was a class that did not come with any promise of a world-historical amelioration of antagonistic class conflicts. Enzensberger clearly regarded his diagnosis as a provocative act because it turned prevailing social and cultural analysis on its head. At the same time, the essay could also be viewed as a genuine effort to come to terms with the reality of a transformed situation. The stark reality of petty-bourgeois persistence marked at the same time the sobering realization of persisting in modernity devoid of a redemptive promise that delivers us from its travails, its turmoil of abundance and environmental degradation, its promises and its contradictions, both a material affluence never before known so pervasively and still characterized by gross inequality and suffering.

Comrades and contemporaries, the 1970s, from the vanguard to intermediaries

Lange-Berndt and Rübel brand Enzensberger's account of the new petty-bourgeoisie 'complacent', thus implying that Polke did not fully go along with his proposition (Lange-Berndt and Rübel 2011: 39). They could be right. At the same time Polke clearly delighted in Enzensberger's incitement. For a start, Polke enjoyed how the provocation punctured lingering romantic assumptions about the special status of artists, whether as seers or as the advance guard of

history as proletarian fellow travellers. Polke practised art at a time seemingly devoid of heroic presumptions about historical destiny and ideological certainty, including lofty presumptions about art's mission or its redemptive qualities. There is a hedonistic as well as anarchist edge to his endeavours, which lends an unwieldy quality to his gestures. One can readily grasp from where this propensity to oscillation derives. Twice a refugee, Polke's early life was grim. The experiences of the Second World War and its ruinous aftermath – a destabilizing blend of fear, escape, deprivation, a lack of housing and sanitation, political and social uncertainty – pervaded his childhood. This was a generation that grew up with a sense of bewilderment and the collapse of German national self-respect, as Thomas Mann put it, a people 'bewildered about itself and its history'.

Born in 1941, Polke's fled Silesia (now Poland) in 1945 before the Russian military advance.[9] This placed him and his family within the mass forced migrations of populations from East to West. They were still coming, as Stig Dagerman observes, in the autumn of 1946: 'All autumn, trains arrived in the Western Zones with refugees from the Eastern Zone. Ragged, starving and unwelcome … . They became significant just because they came and never stopped coming and because they came in such numbers.'[10] Again in 1953, Polke was once again a refugee as his family escaped communist East Germany. The Soviet Union, and the divided state of Europe, was thus an enduring experience of Polke's life. During the 1960s, living on the frontier of the Cold War further compounded these early experiences because such a life offered its citizens the imminent threat of nuclear catastrophe as well as the incongruous contrast of a flourishing new consumer culture. This abundance was more like living on another planet compared to the widespread destitution in the immediate aftermath of the Second World War. If Walter Benjamin argued that modernity made common experience unfathomable, then the incongruity of Polke's childhood actually helps to clarify some of his pronouncements about drug use: 'I learned a great deal from drugs, the most important thing being that the conventional definition of reality, and the idea of "normal life", mean nothing.'[11] As the artist (and Polke's near contemporary) Jutta Koether notes, Polke was one of a generation of 'men whose access to the world was so damaged that I protected myself from them'.[12]

Still, the boisterous mood of *Wir Kleinbürger* does not suggest that contempt is being hurled at Enzensberger's proposition. Nor does there seem to be any concerted effort to expose the fragility and vacuity of a complacent conception. Rather, *Wir Kleinbürger* conveys a sense of being thrown into the chaos of myriad, competing possibilities, which seem devoid of any sense of rhyme or reason, or overarching order. The impression can be strident one moment, ambivalent the next. *Giornico* is a good example with its references to anarchism and fascism, to Swiss political independence, notably the superimposed figure striving to hurl a huge, gold boulder off a pedestal, drawn from a monument commemorating the Swiss political independence struggle. Other contemporary variations on the same subject matter appear against a backdrop of current newspapers featuring advertisements for a large array of consumer products.[13] Another gouache invites the association between visual art and magic acts and asks us: *Can You Always Believe Your Eyes?* (1976) (Figure 2.2). Here the association appears to suggest that visual art is a kind of performance of visual trickery akin to daytime television magic and cabaret acts.

The layering of different forms of content is akin to constantly switching TV channels, or perhaps mindscapes; except that the exuberant superimposition of different content on different content means that the memory of each image lingers and intertwines with the next rather than disappearing altogether. Polke is at once stridently anti-aesthetic, and yet cannot help being painterly to the end. This equivocal stance – and a certain blurring of images – is common to both Polke and his sometime friend and competitor, Gerhard Richter, both exiles from East Germany. In comparing the two artists, Rainer Rochlitz suggests that Richter lacks 'the wealth of graphic means and materials, the black and weird imagination borrowed from fairy-tale illustrations, from design and advertising, from archive photos, caricature, and all the things in the world' that is deployed by Polke.[14] Koether adds another comparison:

> Richter embodied rigor, order, concept, skill, rationality, discipline, obedience, growing up early, optimism, the project of self-definition; Polke, by contrast, stood for disorder, restlessness, play, the courage to blur boundaries, clownery, ambivalence, the project of self-differentiation.[15]

While many of these characteristics are certainly evident in *Wir Kleinbürger*, the conventional portrayal of Polke is that he was antiauthoritarian, confounding, ironic, humorous, and protean, a mocking artist as well as a thorough contrarian. This stance might be more conventional than expected given that Enzensberger and others suggest that such a cloak of invisibility is endemic to the petty-bourgeois class character. As Arno Mayer reminds us, the image of critical independence is a standard one for this class of individual. Any insistence on critical independence, Mayer continues, must be tempered by consideration of the actual, material conditions of the petty bourgeoisie's existence. Its intermediary status is underscored by its 'non-manual, modestly salaried, and totally dependent' working conditions (Mayer 1975: 422), and its independence is reliant on temporary contracts (Mayer 1975: 430), to which we can now add even more precarious labour conditions, short-term as well as long-term. Polke knew both these worlds, at least for a brief time: a world of critical aspiration and freethinking balanced against the beleaguered reality of a family man with commitments and an office job. If it is true that the petty bourgeois will always deflect attention away from their real status, then how willing was Polke to concede the clichéd character of many of the claims to independence made on his behalf? Perhaps he was not willing to go too far in debunking his own stance, but he does appear quite willing to contend with other aspects of the actual status or realities of the petty-bourgeois position – the fact that it is both more bourgeois than most were usually ever willing to concede, and its fierce restlessness and self-differentiation is dependent on an intermediary, compromised position. This acknowledgement does provide some explanation for the ambiguities contained in the *Wir Kleinbürger* works.

With the work, *Supermarkets* (1976), Polke adds to the banners already discussed – that is 'We, the petty bourgeois' ('*Wir Kleinbürger*'), in the exhibition title and the superpowers (*Supermachte*) in *Giornico*. This new banner is emboldened in capital letters, SUPERMARKETS! This title blazes across the top of the work like a banner headline in a newspaper. Polke thus trades the 'S' of the comic book hero, Superman, who appears to multiply while browsing down the supermarket aisle, to the superlative Supermarkets and their shoppers. The centrifugal movement of the dramatic perspectival framing appropriated from the source

image – a MAD comic by Jack Davis – is accentuated and appears to explode out from the centre of the image in a wild ambush of colours and overlaid imagery (Figure 2.1). The natural inclination is to regard, *Supermarkets*, as an ironic commentary on crass materialism. It is as if the once exuberant supermen are brought down to a mundane, everyday level from their otherworldly heroics in order to perform their domestic duties on the way home. Supermarket shopping emasculates the multiple supermen in the same way that Kryptonite does – the only substance that could enervate Superman to the same extent as shopping.

The complex layering in the key gouaches suggests, of course, that more than one thing is going on in any one work. Countering the overt focus on the political, such as in *Giornico* (1976), is the trend to treat all imagery in the large works in a similar manner. For instance, the pictorial treatment of political imagery in *Giornico* is not essentially different pictorially from that of the pop-like reverie found in *Supermarkets* (1976). The stylistic treatment is

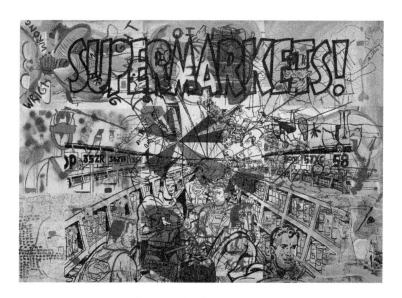

FIGURE 2.1 *Sigmar Polke*, Supermarkets! *1976. Gouache, metallic paint, enamel, acrylic, felt-tip pen, collage on paper 207 × 295 cm. photo: Peter Schälchli. © The Estate of Sigmar Polke, Cologne/VG Bild-Kunst. Licensed by Viscopy, 2017.*

consistent: the demonstrators in *Giornico* are delineated in a stencilled outline similar to the supermarket supermen and all the products surrounding them. Everything is outlined, but nothing 'filled in', and yet in all the works found in this series, there are overlaying colours, images, scribbles, and notations. It is as if each image constituted a jostling tableau of competing imagery as well as competing modes of representation: realist, abstract, cartoon-like, photographic, film-like. Everything competes at once for attention.

Indeed, Trotsky's evocative image of the petty bourgeoisie turning 'the wheel of the revolution backwards' is an uncanny anticipation of the central motif of Polke's image of demonstration in *Giornico* with its banner reflected backwards. If Polke is a petty bourgeoisie of the kind rebuked by Trotsky, then it is because his insurgency is also incapable of any consistent programme. Polke was not drawn to prophecy or prophetic roles, even though he was intensely interested in supernatural phenomenon. Of course, Polke and company were not seduced by either socialist or capitalist propaganda. By the early 1970s, the OPEC oil crisis meant that capitalism was undergoing one of its periodic crises, but the Soviet Union was already quite moribund by that point. For Polke, like his colleagues Richter as well as Blinky Palermo (all escapees from the East), the Soviet bloc was the epitome of Trotsky's dire prediction: an ossified bureaucratic-military monster. It is more apt to say that this milieu was not particularly invested in the utopian arguments of either capitalism (the invisible hand) or communism (the end of contradiction and alienation as well as unending economic and class conciliation).

Polke adopted a similarly nuanced attitude to another feature of petty-bourgeois existence: consumerism. Enzensberger relates the rise of this transformed petty bourgeoisie to a transformed social situation, in which the pivotal factors were the tremendous growth of higher education as well as the 'growth of tertiary and quaternary sectors of the economy' (Enzensberger 1976: 162). With the wanton proliferation of so many consumer goods, the joke behind *Supermarkets* seems to imply that everyone has suddenly become a capitalist super-consumer. Of course, such caustic humour is obvious. If Polke is genuinely a contrarian, then there must be more to it. Does he parody crass consumerism? Likely yes, but simultaneously someone of his generation could not also marvel at the scope of changes he had witnessed. The sheer proliferation

of so many goods was a dramatic enough transformation of life. It thus becomes increasingly difficult to tell whether *Supermarkets* (1976) signals that the new consumerism has transformed the population into a new super-people, or whether instead it drags the otherworldly aspirations and capacities of these multiple supermen back to earth and to the crushing banality of consumer life as the sole reality capable of fulfilling terrestrial aspirations.

The scope of these transformations for people like Polke who grew up in the rubble of defeated Germany cannot be underestimated. Polke and his generation did not grow up with material affluence and plentiful food. So many products did in fact appear as a miracle of sorts for anyone alive during this period, roughly from *Stunde null* (zero hour) to the subsequent economic miracles (*Wunderwirtschaft*) (including the GDR's consumer miracle). Underpinning these transformations were the influx of immigrant workers and rising productivity and real wages, in addition to the new phenomenon of consumerism. Until 1950, the experience for the vast majority of the European population was that 'disposable income' was a foreign concept with expenditure on food and clothes exhausting the bulk of most household budgets. Only a few items such as 'food, drink and tobacco', as Tony Judt wryly notes in his study, *Postwar* (2005), were viewed as 'necessities', but otherwise most people 'did not shop or "consume" in the modern sense; they subsisted', and once clothes and rent were accounted for, 'there was not much left over for non-essential items'.[16] Before 1953 and before consumerism, Judt contends, most people throughout recorded history knew only four sources of goods: 'Those they inherited from their parents; those they made themselves; those they bartered or exchanged with others; and those few items they had been obliged to purchase for cash, almost always made by someone they knew.'[17]

In a remarkable turnaround from the period before the war – which was characterized by political upheavals, mass unemployment, under-investment, and physical destruction – post-war Western European labour productivity between 1950 and 1980 'rose by three times the rate of the previous eighty years' (Judt 2005: 326) and for the next twenty years after 1953 'real wages tripled in West Germany and the Benelux countries' (Judt 2005: 338). Simultaneously, as available income increased, the cost of food and clothing began to fall (to 31 per cent of household budgets in Britain, for instance) (Judt 2005: 338). Hence, surplus incomes

were available to consume items, such as records and record players, washing machines and labour-saving devices, plus fridges, which meant that it also became possible to buy (and afford) 'a lot of perishable food [on] one outing' (Judt 2005: 338). Soon refrigerators became one of those items that Enzensberger referred to as never having existed before, at first almost unobtainable, but quickly considered a necessity.

And where else would one find all that perishable food except at a supermarket? This too was an indicator of profound changes. As Michael Wildt offers, the common experience from the nineteenth century until the 1950s, and even lingering up into the 1970s, was the counter shop: you asked the shopkeeper or assistant for what you wanted, which they weighed, measured, and even wrapped. 'Not only did the counter now disappear', as Wildt describes, 'the whole shop was reshaped for self-service. Now everything was within reach.'[18] This is precisely the kind of environment that Polke depicts in *Supermarkets* (*Supermarkt*), which would not be readily recognized today as a symbol of such remarkable transformation in everyday life. These changes were dramatic in West Germany for Polke's generation precisely because of its immediate post-war experience of extreme food and material scarcity, hunger and starvation followed by rationing and austerity. In 1951, there were only thirty-nine self-service shops in all of West Germany, whereas by 1965, there were 53,000. 'When people entered a self-service store for the first time', Wildt continues, 'they were overwhelmed by the wealth of goods on offer' (Wildt 2003: 110). This represented a seismic social and cultural shift because 'the memory of hunger, ever-present in the minds of the older generation, was disappearing' (Wildt 2003: 111). If these changes do herald a seismic shift, it is important to keep in mind how relatively recent they were, even in the West.

Enzensberger, of course, underscores the intimate relationship between petty-bourgeois culture and consumer society: 'The entire area of mass consumption is decisively shaped by the ideas of the petit bourgeoisie.' If Polke's natural inclination is towards cynicism, ambivalence, and clowning around, then it might indicate a certain detachment from the promises of lofty material fulfilment. Conversely, his stance is not nostalgic; he did not hanker for a return to any former glory, recent or distant, because he never experienced such a thing. Nostalgia simply does not pervade the mood of *Wir Kleinbürger*. Many commentators note how often food features

in Polke's various works, but the treatment is usually considered satirical without nuance because items of food are frequently depicted surreally as if proliferating out of control, seemingly almost endlessly. It is only when food becomes abundant that one is able to assume an ironic distance from the memory of hunger and to ridicule consumer excess. This affluence, of course, could not ameliorate every social dysfunction. The politics of food persists in the resurgent Marxism of the far left. Gudrun Ensslin for instance expressed her exasperation with the pacifying effect of this culture:

> I just can't believe that there won't come a day when people won't be fed-up with being overfed. That they won't get fed-up with the self-deception that all this fantastic food is the whole point of life. Wonderful, I like cars too, I like all the great things you can buy in a department store. But when you have to buy them in order to stay unaware, comatose, then the price you pay is too high.[19]

As a general sentiment, Polke no doubt agreed – to a certain extent. At times he might even have shared the exasperated despair of Ensslin. Polke also remonstrated against his parents' generation, and the ensuing silence over Nazism that cast an extraordinary pall over German life (before remembrance of that grim, entangled history became a compulsory feature of every subsequent generation's German school upbringing).[20] The *We Petty Bourgeois!* exhibition straddles two substantial gaps in time and in lived experience. The first is the gap between the bleakness of subsistence in wartime as well as in the immediate post-war years (Polke's childhood years) and the flourishing consumer economy of the early 1970s (*We Petty Bourgeois!* captures some of its exuberance). Hunger, deprivation, and subsistence did not yield easy didactic lessons. As Dagerman observed in the German autumn of 1946, war is an 'inept teacher' and 'hunger is a form of unaccountability'.[21] The overcoming of hunger, deprivation, and subsistence presented an irrefutable case of material progress. Moral outrage returns with affluence, however, and affluence does not solve all problems as soaring rates of depression in the West testify, thus confounding any straightforward correlation between progress and happiness. There is a second 'gap' between the realization and creation of the work for *Wir Kleinbürger!* in the early to mid-1970s and its

eventual exhibition in 2009–10. The passage of time between the two had seen reversals in all the areas of economic achievement that seemed inevitable in the first period, reversals characterized by declining real incomes, growing economic disparities in the West, and the rising unaffordability of many cities for people and families living on working-class wages. The sense of ever-forward momentum is one target of Polke's satire in the *Kleinbürger* series. The oil crises of the early 1970s were the first sign of the shock to inevitable Western material progress. Such optimistic presumptions have been a recurring feature of modernity, harbouring the sense that change was not only inevitable, but that it would lead to a necessary surpassing of any previous mode of doing things or any previous understanding that might impede such changes. This was the sense of the perpetual up and up!

For all his contrariness and his acidic humour, Polke was no theoretical purist. Having a programme meant having an answer for everything, and Polke clearly did not have a programme. Instead, he experienced the confusion of theory and practice as a given. Coming from the East, artists like Polke and Richter could not summon enthusiasm for any utopian projection that might suggest that the communist states offered a life so different to the capitalist economies – that is a life free from self-deception and free from existing in a comatose state, as Ennslin decried in her critique of the consumer state. Nobody believed that – aside from some exceptionally ardent ideologues, which makes it difficult to decide who is living in a state of self-deception and who is not. For Polke and Richter, their ironic detachment, and the oppressive Cold War atmosphere, is perhaps indicative of seeing many so countercultural ideologues uphold a rhetorical commitment to Marxism, while knowing they would never contemplate actually living in a communist country. If the ideas of the petty bourgeoisie decisively shaped mass consumption, they had infiltrated political thinking too: I want the revolution, but I also want my designer shoes! In a more complex, yet enduring fashion, the transit from East to West made people like Richter and Polke realize that they were not ready to relinquish their petty-bourgeois tendencies: among these could be found a commitment to the humanitarian-pacifist illusions derided by Trotsky (including free speech, freedom of assembly and association, genuine processes of representation, even self-governance, and finally environmental protection in defiance of boundless productivity – the commitment

to productivity being the shared goal that united capitalist and communist states alike, at least rhetorically).

The problem is that the petty-bourgeois stance lacked an incendiary radical vocabulary; its propositions were so familiar and taken for granted, so dull, but also part of the official discourse of the West (even if regularly qualified in practice). Thus, as Lange-Berndt and Rübel observe, 'the *Petty Bourgeois* cycle lays out an expanded field of possible countercultures and tries to display all that could not be absorbed into the philistine universe' of the petty bourgeoisie. They point to the abundant references to leftist and underground magazine material and they suggest that 'the *Petty Bourgeois* series investigates the possibility of antibourgeois cultures', except that it also includes fascist material, porn, comics, and low-brow culture (Lange-Berndt and Rübel 2011: 39). Yet, the anti-bourgeois intent is undoubtedly correct, there is an assertion of something quite countercultural within this exhibit – except to say it is doubtful whether this makes it any clearer who are the philistines, and who are not. The avant-gardes always pictured themselves in a struggle with bourgeois philistinism. By heralding the banner, 'We the petty bourgeoisie', Polke was at least engaging with Enzensberger's provocation. But that provocation, as we have seen, entailed overturning one core feature of the avant-garde's raison d'être. The figure of the petty bourgeois, Enzensberger insisted, could no longer be identified with the convenient typecast of the 'smug philistine'. This was an outmoded stereotype, according to Enzensberger, because the class was no longer recognizable as the 'nervous, irritable, easily incensed and outraged persona' of the late nineteenth and early twentieth centuries (Enzensberger 1976: 163–4).

Polke is happy to countenance Enzensberger's provocation that artists, intellectuals, and radicals should be viewed differently in terms of their social positioning, especially if this means upsetting some long-standing cherished beliefs about their lofty status and role. Rather than existing beyond the culture they challenge, these outsiders, no matter their status or wealth or lack thereof, persist in a complicit position with the very culture they might ridicule. Rather than aloof outsiders, or figures at the forefront of history, armed with a programme for how to get it right, artists should instead be considered petty-bourgeois rebels. Is it possible to see an affinity between the semi-heroic, semi-emasculated supermen, busily

doing their shopping chores, fulfilling their household duties, and that visionary seer, the avant-garde artist? The true avant-gardist could never be contaminated by the domestic scene. The bohemian, the radical, or the avant-gardist are like the multiple supermen in Polke's in *Supermarkets (Supermarkt)*, who are enervated by close association with commodities or the domestic. Their fate is to be brought down to earth and reconfigured as petty-bourgeois rebels – thus, ruthlessly dragged back to a profane level of existence, like their domesticated supermen counterparts, even though they still seek some realization or understanding that transcends everyday existence. The petty-bourgeois image of the robust outsider is humiliating because he is envisaged as trapped within this 'philistine' experience as much as he would like to pretend he is wholly separated from it. I say 'he' in these instances because they are always male; it is largely a masculine preserve. In Polke's case, he no doubt had in mind the persona of artists like Joseph Beuys and Yves Klein, the ultimate outsiders, who Polke admired, and yet nonetheless he was dubious about their transcendent mythical personas. Like many of his peers, Polke and his contemporaries felt that the new seers, like Beuys, traded a traditional form of authority for one associated with his own persona, in the process transcending the traditional art object for the word of the prophet at the centre of the circle, in Beuy's case the Ring Discussions in Düsseldorf and elsewhere.[22] So how did Polke escape the same fate? It could be that his embracing of Enzensberger's provocation was meant to be his safeguard against such hubris.

If a 'philistine universe' is pervasive, then an artist cannot presume to inhabit some pure space beyond its clutches. And yet it is not possible to find a space within it either.[23] Indeed, it is possible to modify Koether's insight that the access that Polke and his generation had to the world was damaged and – although this access was damaged – at some messy, intuitive level, this fissure also afforded them a more fractured, but nuanced perspective, even if often diffident or wayward, to wade into the mire and to see that they were mired. Without presuming to be outside of the enticements and dilemmas of philistine universe, *Wir Kleinbürger* returns to a question that plagued Nietzsche: how can the capacity for creative action be undertaken in such a culture? Here there is a lurking risk, as Steven Smith explains the Nietzschean dilemma, 'A people who believe that they can no longer create can only retreat

into self-absorbed irony.'[24] Is it possible to draw a line in the sand and to distinguish between what is genuinely creative and what is self-absorbed irony?

From supermarkets to supernatural: Vision, magic, and the mediated

Polke's fascination with insisting on some kind of cultural intermediate role also features in his last major work, a commission for a church, in which he returned to the theme of mediators (*die Mittlerfiguren*). It is also telling that Polke returned to stained-glass window paintings for this final commission with the Grossmünster church in Zürich, the city of Cabaret Voltaire and Dada, and to the medium in which he first trained. Mediators, in the Zürich case, meant those who mediate between man and God 'in anticipation of incarnation'. Rather than signalling a late-life turn to religion, the subject matter underscores Polke's prevailing interest in these intermediate positions. For the mediators are those struggling between seemingly incompatible realms, nonetheless they seek hope of surmounting a transitory moment of struggle and being delivered elsewhere.[25]

Polke's training in stained-glass work is said to have influenced his subsequent career, evident in the interplay between transparent materials (including plastics), layers of found imagery and drawn figures, which verges on the point of the opaque in order to conjure visual lucidity. Likewise, the ten central gouaches of the *Petty Bourgeois* cycle each feature outlines of figures drawn from mass media, television or comics, combined with intense washes of colour, but also sections of abstract painting, and sometimes the Benday dots from the sixties. The purpose of these bustling, competing treatments is to suggest a sense of visual instability whereby all the elements appear on the cusp of dissipating and losing form. The art critic Peter Schjeldahl recalls Polke mentioning an array of rich materials and pigments in preparation for the Grossmünster commission, such as cinnabar, alabaster, malachite, cobalt, and lapis lazuli. Schjeldahl's gloss is that Polke's 'alchemical romance of elements' reflected the idea of some '"mothering" substance – the *materia* – of the universe' and hence he conceived of the

windows 'as symbols of the creation, conjoining base matter and celestial light'.[26] Clearly, there is an intense focus on the materials of pictorial art – colour, line, support or media, even to the point of using corrosive materials that dissolve or disappear – but also on the traditional religious idea of art and philosophy as vehicles or points of transmission for the divine and the heavenly.

At first glance, the perpetuation of interest in these dual pictorial foci in the modern, secular age through a fascination with Kleinbürgerliche intermediaries seems both logical and puzzling. For instance, an intermediary position seems at odds with the impatient, escapist counterculture of West Germany and Willich, particularly at its more radical ends. By comparison, Polke's preoccupation with such a role is far too nuanced, at once esoteric and too compromised. It does not quite evoke the ardour of the avant-gardist or of a proletarian revolutionary. It does not separate from consumer or 'philistine' culture, though nor is it wholly absorbed by it. It insinuates a qualification of sheer aesthetic autonomy, but not its abandonment. Referring to the social tumult of the period with its student revolts, underground movements, the counterculture, and its splintering subgroupings as well as the subsequent radicalization of some into terrorist extremism, Jürgen Habermas suggested that 'their socialization seems to have been achieved in subcultures … in which the tradition of bourgeois morality and their petit-bourgeois derivatives have lost their function'.[27] Yes and no. Artists may have assumed the stance of dropouts, of self-absorbed irony or absolute cynicism, but as ever it is instructive to note how they sought to justify their claims and their practices. Even the seemingly nihilistic Martin Kippenberger dared to declare that art sought to 'keep humanity alive', despite all the apparently destructive or evasive ruses of modern or contemporary art:

Being able to obscure things, trivialising, exaggerating, these are all ruses for keeping humanity alive, as an individual and in confrontation with others. Anything you can do with language works just as well with pictures. Concealing, revealing, glossing over, leading people astray. You have to find a way through the game.[28]

The rhetoric contrives to be cynical, although it is just as much romantic. 'To keep humanity alive' is a big claim, especially when

the tactic of the art is to obscure things. The claim clearly falls back upon a deep legacy of artistic challenge, testing limits, critical autonomy, and so on, drawn from the core tenets of the Enlightenment, romanticism, and the modernist cultural legacy. It is a matter of negotiating a way through this 'game'. Kippenberger's justification for these tactics of evasiveness and accentuation are surprisingly similar to Polke's justification of drug use. In both cases, there is a gesture to conjuring different perspectives on life, humanity, or on the nature of reality. If such ruses involve negotiating a game, then one thing is clear: the ruse of maintaining a certain degree of distance, whether ironic or otherwise, is another word for establishing some degree or level of autonomy in order to provide different perspectives. The difference is that Polke envisaged this autonomy from the perspective of intermediary roles.

Of course, the keenest focus on the intermediary role in art after modernism is that of the medium. Polke explores this role in a number of ways that both obscure and help clarify the insistent focus on the intermediary position. First of all, he likens the production of art to a conjuring act. The artist is someone who deals in visual magic. One work, *Can you always believe your own eyes?* (Figure 2.2), explicitly hints at this association. The work's central figure is a vaudeville magician, who appears to make his female assistant hover in mid-air. The bringing to life of form represents a conjurer's trick on the part of the artist. Polke is not one of those artists who upholds the literalist credo that what you see is what you see, as Frank Stella once suggested. He is closer to the position articulated by Philip Guston in a 1978 talk: 'The painting is not on a surface, but on a plane, which is imagined. It moves in a mind. It is not there physically at all. It is an illusion – a piece of magic, so what you see is not what you see.'[29] *Can you always believe your own eyes?* prompts a variation on this theme as it seems to ask, Can you trust this magic that allows you to see what is not there?

In *Can you always believe your own eyes?* the figure of the magician and his floating assistant is joined by large brown blobs of paint placed regularly between rows of cells of the comic *Corbeaux*. These cells weave in and around, sometimes above, sometimes beneath, the magician and his levitating assistant, whose figure – due to Polke's employment of fluorescent chemicals – literally glows in the dark once the lights are switched off, hence adding a new perspective to the artwork that museum visitors would

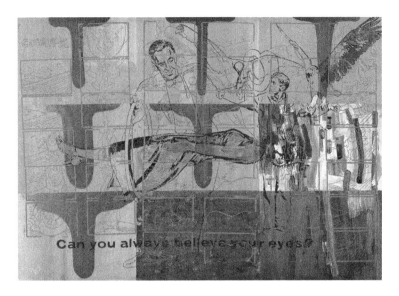

FIGURE 2.2 *Sigmar Polke,* Can you always believe your own eyes?
*1976. Gouache, enamel, acrylic, tobacco, zinc sulphide, cadmium oxide
on paper 207 × 295 cm. photo: Peter Schälchli. © The Estate of Sigmar
Polke, Cologne/VG Bild-Kunst. Licensed by Viscopy, 2017.*

not ordinarily see. The *Corbeaux* comic deploys a *tromp l'oeil*,
cinematic framework, which insinuates a different play of seeing
and unseeing. The first cells gradually reveal a landscape, while a
farmer walks over fields closer and closer towards the 'screen' until
a tattoo of a naked woman comes to life emerging from the farmer's
chest. She, in turn, acquires a cartoon, cell-like 'life' of her own as
she performs a kind of striptease before she is finally revealed from
behind in a reverse format as the farmer continues to walk across
the landscape, this time away from the spectator's sight. The viewer
discovers that the flipside of the portrayal is actually the reverse
position portrayed in the tattoo on the farmer's back as he walks
away from the viewer and out of the 'picture'. This meditation on
the play of vision and on the eye being directed towards particular
illusions or conjuring acts is difficult to discern because Polke again
places so many visual 'obstacles' in the viewer's path. All this visual
activity resides on an extremely bright yellow base and is overlaid
with the image of the magician, the glow-in-the-dark levitating

woman, two eagles, including one swooping on prey, plus overlays of paint strokes in the form of passages of gestural abstraction.

While the content is a tawdry male fantasy, sideshow version of optical effect, all of these forms of illusion – the *Corbeaux* comic, the entertainer-magician, and the visual artist – suggest illusions firmly understood as illusion. For Simon During, this is a chief indicator of what he calls 'secular magic', by which he means the 'technically produced magic of conjuring shows and special effects' without any 'serious claim to contact the supernatural'. During's 'simple proposition', as he characterizes it, is that 'magic has helped shape modern culture' through its role as 'a cultural agent' by which it heightens 'our sensitivity to the play of puzzlement, fictiveness, and contingency in modernity'.[30] This particular 'sensitivity' to such phenomena – a kind of uncanny visual delight – seems to be borne out in the *Wir Kleinbürger* exhibition, in which there are a number of references to television viewing, such as *Fernsehbild* (*Kicker*) ('Television Picture' in English) of 1971, but also a series of *Telephone Drawings*, essentially collage-like doodles, (*Telefonzeichnung*) from 1975. One of the satellite works exhibited is simply called, *Untitled (TV Room)* of 1999, which is composed of highly reflective surfaces that again render the picture quite difficult to see, once more reiterating the play of seeing and not seeing as a sub-theme of the ensemble of works exhibited. The basic image is composed of a cartoon-like nuclear family group gathered around watching a TV in a picture-perfect image of family repose. On the screen, a hand clutches a knife, awkwardly, if not precariously, hinting perhaps at some dark menace or simply the calm, detached thrill of watching popular suspense or crime shows.

All of these evocations of technological mediation convey the idea of odd projections transporting from one place to somewhere totally different. Then, as if dispersed, they appear elsewhere, in a non-place, overwritten by layers of competing emitted signals of additional transmitted information and carried to the winds of telegraphic modernity. In Polke's works, the strange proliferation of dots, collages, and juxtaposed images convey this strange process of emitted signals, of transmission and reception. This is not solely a question for art; the entire culture is a highly mediated one. Thus, the uncanny features of various modern media are attenuated – the dissolution of the relations of the far and the close by, the real and the spectacle, what is happening now, what is past, the live and dead,

in the blurring of the natural and supernaturally technological. The medium that once communicated with the dead, or intervened in life, as an intermediary between worlds, became the medium that transports invisible messages, everywhere from telegraphs from the early twentieth century, or reappeared in the form of spirit photography.[31] Radio waves were once even thought to transport through 'ether', which was 'a mystical substance' through which one could in turn contact the dead and even cure cancer.[32]

In his essay, 'Of other Spaces' Michel Foucault notes: 'The present epoch will perhaps be above all the epoch of space. We are in the epoch of simultaneity: we are in the epoch of juxtaposition, the epoch of the near and far, of the side-by-side, of the dispersed.'[33] Much the same proposition had been anticipated by Martin Heidegger, who spoke of the medium as a thing, when discussing the consequences of the emergence of media like television:

All distances in time and space are shrinking One now receives instant information, by radio, of events, which he formerly learned about only years later, if at all. The germination and growth of plants, which remained hidden throughout the seasons, is now exhibited publicly in a minute, on film. Distant sites of the most ancient cultures are shown on film as if they stood this very moment amidst today's street traffic. Moreover, the film attests to what it shows by presenting also the camera and its operators at work. The peak of this abolition of every possibility of remoteness is reached by television, which will soon pervade and dominate the whole machinery of communication. Man puts the longest distances behind him in the shortest time. He puts the greatest distances behind himself and thus puts everything before himself at the shortest range. Yet the frantic abolition of all distances brings no nearness; for nearness does not consist in shortness of distance Short distance is not in itself nearness. Nor is great distance remoteness.[34]

Heidegger outlines a phenomenon that miraculously escapes the limitations of physical boundaries far more profoundly than the levitating (glow-in-the-dark) woman in Polke's *Can you always believe your own eyes?*, who floats in the air unimpeded by anything except the magician's magical powers. The new powers Heidegger describes are profound. They escape the physical almost at will.

Heidegger's alternative to this horrid neo-Platonism writ large would be to seek the authentic in finitude.

Polke had little time for communal authenticity, aside from his stint at Willich; it is too dour for his sensibility, but most importantly the position Heidegger affirms is one of attempting to stand outside such a culture in order to seek the authentic. The esoteric elements found in the sweeping array of work and content found in the *We, Petty Bourgeois* exhibition again makes this difference difficult to discern. During's definition of secular magic is that it 'makes no claim to be in contact with the supernatural – it's not calling on hidden powers to act on the world'.[35] Polke does not tread such a fine line; in fact, he traverses it, thus extending a long fascination of the avant-gardes with alternative knowledge, particularly of paranormal activity.[36] The Düsseldorf scene from which Polke first emerged shared a penchant for experimenting with occult practices. As the art historian Anna Brus notes, this playful use of the occult allowed its group to conceive of the 'invasion of inexplicable powers and forces outside the artistic subject'.[37] In other words, it represented another avenue for displacing the centrality of the artist in creation, which is another way of reiterating the point about undertaking a qualification of sheer aesthetic autonomy, although it marks its reorientation, not its abandonment.

Such an interest reappears in the *Wir Kleinbürger* exhibition. The title, *Franz Liszt kommt gern zu mir zum Fernsehen* (*Franz Liszt Likes Visiting Me to Watch Television*) (1973), is actually taken directly from a *Der Spiegel* article published in July 1970.[38] In the picture, *Franz Liszt kommt gern zu mir zum Fernsehen* (*Franz Liszt Likes Visiting Me to Watch Television*), two women are featured in a communal setting, along with a bottle of wine. One is involved in domestic duties, this time ironing, while the other appears to be having an epiphany of some kind. The *Der Spiegel* article was a counterpoint to Enzensberger's essay in the *We, Petty Bourgeois* exhibition, which reflects on the changing significance of the petty bourgeoisie – to reiterate one final time: part avant-garde, part yuppie in the creation of new cultural parameters, drawing from bourgeois and working-class popular culture and yet also becoming the prime mover of new cultural content for both.

The *Der Spiegel* article also featured in the exhibition is quirkier by comparison. Its subject is an English medium, or spiritualist,

Rosemary Brown, who communicated with dead composers, chiefly through the intermediary of Franz Liszt. Immediately, we can see the links with the preoccupations that captivated Polke within the Düsseldorf scene, but it offers another more idiosyncratic take on the medium. Born in 1916, Brown reported that, when young, a spirit-figure with long white hair and a flowing black cassock appeared before her. He informed her that he was a composer and would one day make her a famous musician. It was only later, when she discovered a picture of the famous composer, that Brown realized that she had encountered Franz Liszt. Liszt only renewed contact with Brown decades later in 1964 after which he began to serve as a conduit to a remarkable line-up of famous fellow composers. As Brown reports it, Liszt became enamoured with aspects of modern life: he liked to go shopping (bananas were of particular interest) and also watching television. Their collaboration resulted in many new compositions by the great musicians of the past, who had all been busying themselves with new compositions since their deaths. Fortunately, all the composers had learnt English in the intervening period – in the great beyond – so they could communicate with Rosemary quite easily. When queried about this, Brown reportedly replied: 'Why shouldn't they go on learning on the other side?' The new compositions 'included a forty-page Schubert sonata, a *Fantaisie-Impromptu* in three movements by Chopin, songs by Schubert, and two sonatas by Beethoven as well as his tenth and eleventh symphonies, both unfinished'. Brown claimed that each composer had a unique way of dictating his 'new' music to her. Liszt controlled her hands for a few bars at a time, and then she wrote down the notes. Others, like Chopin, told her the notes and pushed her hands on to the right keys. Schubert tried to sing his compositions to her 'but he hasn't got a very good voice'. Beethoven and Bach simply dictated the notes – a method she said she disliked since she had no idea what the finished product would sound like. Of course, a record was produced, *The Rosemary Brown Piano Album*, and a number of books, including *Unfinished Symphonies: Voices from the Beyond*. Brown died in 2001.[39] While some find the music surprisingly credible, the greatest disappointment of the project for those interested in such esoteric things would be the realization that the great composers had achieved their best work only in their compromised terrestrial existences on earth, whereas the cosmic beyond had delivered very little divine inspiration.

 This is strangely similar to the promise of new technologies with its collapse of near and far, but also the alive and the dead. The odd thing about modern technology is that its devices are initially granted the aura of magical marvel, but, once accommodated, they soon lose their lustre and quickly look archaic. Nonetheless, they are seductive and catch everyone in their web – much like the fanciful never-ending structures found in works by Superstudio, virtual contemporaries of Polke's. The title of the work lifted from the *Der Spiegel* article, *Franz Liszt kommt gern zu mir zum Fernsehen* (*Franz Liszt Likes Visiting Me to Watch Television*), or alternatively, 'Franz Liszt likes to come to my place to watch television', recalls an anecdote about Heidegger and television. One of Heidegger's biographers, Rüdiger Safranski informs us that late in life, the philosopher had acquired the devious habit of visiting his friend's house to watch important football matches on TV.[40] Heidegger, of course, would not tolerate such an apparatus inside his own home. As we have seen, Heidegger ominously warned that 'the peak of this abolition of every possibility of remoteness is reached by television' – and, he warns, the elimination of distance cannot be equated with nearness (a point often borne out in contemporary accounts of digital culture, which links everyone near and far, and yet is accompanied by increasing social isolation). Yet, the philosopher had succumbed to the temptations of television nonetheless, but he compartmentalized the pleasures to be achieved from seeing distant events brought so close to him and his friend. The pleasure Heidegger drew from viewing football matches brought home from afar released boy-like pleasure and enthusiasm. Travelling on the train one day, Safranski details how the director of the Freiburg theatre sought to engage Heidegger in a conversation about literature and the stage, but all the philosopher could speak about that day on the train was the exploits of Franz Beckenbauer in an international match he had watched the night before. The philosopher was so excited he jumped up from his seat to demonstrate the sporting artistry of the player they called 'Kaiser' that he had witnessed the previous evening on TV. Television allowed him to indulge in his discrete pleasure at a safe remove (the apparatus of the television had to remain at a distance, quarantined in his friend's house).
 Curiously, no reference to television or football occurs in the biography's index, so it is clearly regarded as only of anecdotal significance in the greater scheme of things – that is the 'world

picture' of modernity, the history of great thought, and an intellectual biography that involves the times and greatest turmoil of the twentieth century.[41] When Polke and Heidegger reference television, it is at a point when TV ownership was not yet universal, yet it was a form of viewing often associated with images of the nuclear family – and thus subsequently a shared moment already becoming archaic. Still it provided Polke with the image of the picture-perfect nuclear family as they were absorbed watching a crime story together safely mediated through the television screen. What is picture-perfect after all? The medium was new and still fresh with suggestive connotations. Heidegger focused on the manufactured simultaneity that brings the far near, stressing that this does not necessarily bring nearness or intimacy. Polke nonetheless references television as a shared event, a convivial social activity, something that is somehow becoming normal. The spectral, as theory in the wake of Heidegger insinuates, also becomes more everyday. It exists in 'the intermediate or suspended state of the ghost ... neither dead or alive, neither here nor there', just more emphatic evidence of the 'immaterial, the virtual, and the unspeakable in our society'.[42] To Polke, it suggested a peculiar kind of 'logical' continuity with the séances that the Düsseldorf milieu engaged in with when they actively sought to conjure another kind of spectral presence.

By contrast, Heidegger's mountainside cabin represented the antithesis of fraternization with modernity's illicit spectral pleasures. Heidegger's hut, *die Hütte* as he referred to it, was his sanctuary from modernity. It was akin to a monastic retreat – the dwelling devoid of any touch of modernity and its cosmopolitan contrivances – the place set aside for pure and unimpeded contemplation in order to enable the most penetrating critical analyses of modernity to be conducted at a distance. Being so removed, the space of the hut permitted the philosopher to think about modernity's pernicious consequences more deeply. As a building constructed entirely devoid of its mark, the hut was a mini-monument to non-modernity, which positions it as a refuge harkening back to a pre-modernity – a symbolic resistance to modernity's interminable advance into every crevice of life. Yet, Heidegger proposed that the uncanniness of modernity indicated nothing other than the mode of the 'not-at-home'.[43] Television brought home the not-at-home, but rendered it close and comfortable, seemingly at ease, while disconcertingly prompting awareness of being unaware, even comatose, as Ennslin

feared. It was very much a case of being unable to live with television for Heidegger, while simultaneously being unable to live without it – particularly its major sporting broadcasts – which provided such relief from the brooding thought of our uncanny sense of the not-at-home.

Taking a cue from the title of the 'Franz Liszt' work in the *Wir Kleinbürger* exhibition, the anecdote could be called: 'Martin Heidegger likes to come to my place to watch the football.' While the philosopher revealed that the medium of nearness could also deliver remoteness, he never stopped to explain the value of these televisual pleasures in his later life – it remained an aberrant technological presence to be avoided. This clarifies the specific insight of Polke's focus on petty-bourgeois intermediaries: if one cannot deal with the contradictions, then one is not really dealing with modern experience at all. In an interview explaining his proposition of 'secular magic', During explains that his ambition is to counteract the fatalist account of critical agency found in the Marxist, Lacanian, or Debordian theories of ideology. His point being that it is possible to be 'critical and be under spectacle's spell simultaneously'.[44] For Polke, his life story told him that not all our experiences are reasonable. One had to find ways of feeling at home with the uncanny mode of the 'not-at-home'; one could even feel at home with the 'not-at-home'.

It is often said that art has been involved in a fascination with alternative forms of knowledge – it is virtually a common thread of art in modernity – which carries over into contemporary art, naturally enough. One disconcerting feature of artists and seers is their penchant for the unscientific and esoteric often combined with a fascination for the scientific and technological. Yet, During's wider point about secular magic is perhaps twofold. On the one hand, as he puts it, 'Why we feel ambivalent about magic is that it can remind us of a period of our life where we found it harder to separate the real from the amazing illusion. And magic always awaits us, whenever that distinction is weakened.' The irrationality of secular magic is the antidote to excessive rationalization. While Polke is content to blur the boundaries that During seeks to erect between the supernatural and secular magic, they do appear to concur in challenging the view that we are nothing other the deluded witnesses of the ghostly apparitions of representation, hopelessly confused between what is spectacle and what is not. In During's

account secular magic returns to and secures a rational verdict. For Polke the difference might be that magic acts as a contrary impulse to incessant focus on productivity as the sole measure of the rational. Art is one social space suspiciously close to superstition and medieval magic, but also entertainment, in that it fosters the illusion that there is still magic in the world. If there is a role for this, it is to suggest that the ordinary course of events does not have to be dull, drab, or inherently demeaning or exploitative. Art may no longer involve the quest to make a world on its own, but instead delights in revealing what is strange about this world we have created, which also has the potential to be uncreated by us, even though this capacity seems lost in conformity and the blanketing sweep of technological infiltration that reduces choice to logarithms. The flip side to this scenario is that if we find there are times when the distinction between the real and amazing illusion blur at the social level, then the magic that arises is one that conjures misinformation, a non-questioning scepticism, the blurring of spectacle and policy, real news and fake news. This is a constant peril.

Conclusions: Petty-bourgeois revolutionaries?

The portrait of Polke as a master clown or satirist remains deceptive. It presumes two things that are both erroneous: first of all, that Polke was always in control (an ironic conclusion) and, second, that he remained caustically aloof from the everyday conceits and enticements that seduce others (for instance, the enticement of consumerist spectacle and television). Having a programme meant having an answer for everything, and that still did not stop everything from turning to shit. And yet Polke clearly did not exactly give up on the critical ambition of conceiving things otherwise and how art might suggest a vision that runs counter to the normal course of events. To this extent, he is quite conventional in modernist terms, notwithstanding the ambivalence that accompanies this role, ambivalence which perhaps helps to explain the perverse attraction to Enzensberger's inversion of the petty-bourgeois classification.

The provocation involves a significant renegotiation of class alignment for artists, but also progressives, the intelligentsia,

architects, freelance designers, the 'creative classes', and others, which had mistakenly identified with the wrong position. Their roles serve to reinforce the social system of modernity with its quest for innovation and renewal as well as their positions reliant on 'polite society', the bourgeoisie, no matter their self-identified rebel status. If they had to articulate that radical status, the reflex was to identify with the revolutionary character of the proletarian, or somewhat, at a remove, as untainted bohemians. Even if they come from working-class or humble background, which Polke certainly did, then by way of education and cultural alignment, such figures become petty-bourgeois rebels, whether materially successful or not. This means adjusting its traditional avant-garde stance from one of cultural outsiders or being at the revolutionary forefront to a more compromised and complicit identity, one placed firmly within the social system, even though they may nonetheless remain resolutely at odds with it. They could still identify with the proletariat, but not be proletarian; they could still advocate for progressive positions, but they had to acknowledge their dependent place within the system that permits their innovations and transgressions.

This insight challenges the subsequent surpassing quest with its strategy of splitting into an identification with the compromised and redundant as against the progressive, purely transgressive and radically noble. The discourse surrounding the contemporary has been simplified in precisely this way. Another of its provocations is to complicate the typical accusation that all previous avant-garde groups end up complying with the very forces they set out to challenge. Again, this is an accusation made against all previous avant-gardes, neo-avant-gardes and the counter-avant-gardes, or whatever else. No matter who makes this charge, it is an accusation never made against one's own position; like some of the taboo terms that permeate contemporary discourse, this is an accusation that is always labelled at others. It is rare that an accusation of complicity is applied to one's own discourse, which is what is remarkable about considering a stance in which this would be considered a starting position. And what better way to forge this new consideration than by cajoling one's comrades to identify first as petty bourgeois in order to then contemplate what might be radical or challenging about their stance, their practice or their presumptions?

The accusation of complicity or being absorbed within the system suggests that every previous wave of radicalism, avant-garde

or countercultural revolt has failed because it was co-opted by the system or accommodated into orthodoxy – dismissed as simply another radical challenge that gradually paled into the very thing it sought to overturn. The story is well known: the once vibrant, challenging, and bold ends up in compromise, flaccidness, and insipid incorporation and denigration. Petty-bourgeois revolutionaries, by contrast, are never free from this dilemma. Petty-bourgeois revolutionaries are accused of everything from being extreme radical experimenters to promoting leftist ugliness, to being multicultural cosmopolitans, to being the ultimate forces of compromise, the unwitting (or otherwise) agents of liberal hegemony. By radically shifting the conventional class alignment of artists, Enzensberger's provocative inversion suggested to Polke that he could not view his efforts as uniquely escaping this perennial accusation without it becoming an absolute fatality of critical intent. Even more, it suggests that this process of accommodation should not come as a surprise. This is what is to be expected – unless one regards the very cultural fabric in which one is active as something that is entirely static, forever fixed, absolutely efficient to a degree never before realized, which means giving up on all struggles for democratic access and accountability. Countercultural challenge inevitably seeks to transform its own social conditions and presumptions, to carve a space for independent thinking, rather than being perennially excluded, ignored, or forever deemed irrelevant. The Surrealists, the Dadaist, and all the avant-gardes were successful cultural mediators – if identified as petty-bourgeois revolutionaries, compromised in their roles from the outset, their radicality considered genuinely transitory, but also potentially transformative, for a time genuinely challenging, though without any guarantees of success.

Either way, Polke did not assume a surpassing stance. Of course, legacies are not something to be assumed. Rather they are something to be critically engaged and grappled with – and this is what even a figure like Kippenberger was suggesting when justifying art's redeeming menace, seeking to revive and challenge the expectations of what was permissible – thus, 'keeping humanity alive, as an individual and in confrontation with others'. It is only when a legacy this complex has been completely exhausted and devoid of all future possibilities that it is possible to declare it dead, bereft of possibilities, to be left behind. Despite their despair at the social climates they experience, these artists did not make such a claim.

Surpassing strategies, on the other hand, lack this tension of having to grapple with a legacy that impedes their way, yet also fuels its justifications and motivations. The surpassing mentality allows its adherents to believe that their arguments arise afresh, as if *ex nihilo*. Thus, they do not see the need to revise or critically engage with the murky legacies that comprises its less than salubrious heritage. Polke's success, like that of Richter's, stems from confronting an apparent impasse in which particular strands of artistic practice stood as absolute contradictions. The crystallization of their efforts was to tackle what had not been regarded as viable because their formulations were viewed as too hybrid. They turned the impasses into new forms of possibility. A refreshing feature of Polke's waywardness was to admit that there is a lot of bumbling around when negotiating the contemporary cultural landscape, whose discourse can be as remorseless and pious as in medieval times.

What finally we learn from the wayward proliferation of Polke and company's wild visual polyphony that comprises the sprawling *Wir Kleinbürger* exhibit is to be alert to the worst of our petty-bourgeois instincts: to be aware of the narrowing of our parameters, of efforts to define rigidly, to be aware of this narrowing – whether it be in our institutions, in our practices, no matter how radical (or inert) we perceive them to be. If everything tells us that not all our experiences are reasonable, then this tells us that it is difficult to persist with strict bifurcations and its splitting that makes it safe to assume that the side we take is always the enlightened, transgressive side. *Wir Kleinbürger* marks a considerable attempt to reconsider the role of art and the artist within a compromised social configuration. This is usually interpreted as a break from the modernist legacy. In fact, it constitutes an extended grappling with this legacy in different circumstances. While ambivalent about the prospect of artists being viewed as seers, Polke's incitement in following the lead of Enzensberger was to regard these positions or roles more prosaically as vulnerable, compromised stances, but nonetheless as no less valuable for trying to keep such spaces of creative invention alive. To this extent, Polke resides firmly within the modernist cultural paradigm. The provocation of the *Kleinbürger* theme enabled a reconsideration of autonomy from the perspective of intermediary roles. This also means being alert to the creative reincarnation of the petty-bourgeois imaginary: to perceive things otherwise or to think things otherwise (paraphrasing Rosa

Luxemburg famous saying): 'Freedom is always the freedom of dissenters' – or: 'Freedom is always the freedom of those who think differently' ('Freiheit ist immer Freiheit der Andersdenkenden'). The difference is that the proletarian ideal pivoted on a point beyond which economic and class contradiction would be eradicated and subsumed, thereby social alienation would just disappear. Whereas the capitalist counter-utopia remains based on the ideal of the perfectly self-organizing and self-functioning metaphysical entity – the unimpeded market that freely realizes its own perfect functioning. The *Kleinbürger* provocation, by contrast, suggests being stuck in the unresolved position, thus sheepishly implying it is the residual element exposed to the lived reality of persistent contradictions without end. The petty-bourgeois radicals are those that articulate the failure of two peculiar pieties that structure all critical possibilities by still assuming a utopia. Inhabiting a precarious space devoid of the pieties of having the absolutely correct perspective, Polke remained resolutely an artist without a programme. Petty-bourgeois revolutionaries would be the residual element that persists even in the wake of the revolution, still thinking otherwise.

CHAPTER THREE

What is art supposed to do? The modernist legacy, the Arab Spring, a censorship case in Sharjah, and artist arrests in the Year of the Protester

30 December 2010, Qatar: Mathaf: Arab Museum of Modern Art, Doha

In late December 2010, Qatar opened Mathaf: Arab Museum of Modern Art, which it proclaimed to be the first Arab museum of modern and contemporary art. The new museum was heralded as an institutional testimony to an overlooked history – namely, the Arab contribution to modernist artistic endeavours. Explained this way, the endeavour accorded with a larger art-historical project to bring to light the ignored areas of modernism and its wider history. This has involved an extensive process of broadening the view of modernism than is possible from the concentration on a few traditional 'centres', primarily the Paris–New York trajectory favoured by the best-known historical accounts that developed

during the Cold War. Yet, there was more at stake than widening the scope of art history's conception of modernism. Statements issued at the time of the opening suggested that this new Arab Museum of Modern Art would not only 'celebrate art by Arab artists', but also compensate for a purely commercial interest in art. Thereby, some stated intentions envisaged the new institution as balancing the cultural ecology of artistic endeavour in the region. It would bring to light the previously ignored history of Arab modernism, but also 'offer an Arab perspective on international modern and contemporary art'.[1] Its focus was local and general.

The official rhetoric surrounding the launch was both exuberant and qualified. Located in Doha's Education City, Mathaf exists in a space dedicated to education, inquiry, and research. This special civic zone houses many branch offices of Western, predominantly American, universities and research centres (Northwestern, Carnegie Mellon, Cornell). The zone is akin to a creative hub – a seemingly ubiquitous feature of early twenty-first-century cities – bringing together institutions and bodies that stand for creative, economic, and technological innovation and exploration. In its exuberant form, the impulse behind such initiatives is attuned to a broader discourse that emerged in the 1990s linking the creative class, economic impact, innovation, higher education policy, culture, and the knowledge economy.[2] In the specific context of Doha, this policy embrace was channelled to position Qatar at the forefront of a newly modernizing agenda within a complex and troubled region; its banner edifices and emblems were meant to somehow transcend these limitations. These included not only the Education City, but also the broadcaster Al Jazeera and a controversially successful bid to host the football World Cup of 2022, supposedly during Qatar's searing summer heat.[3] Before any controversy arose, it was possible to state candidly that the impulse behind Mathaf was bridging a gap: it meant 'getting involved in the arenas of culture, the arts and education', the director of the Brookings Institute in Doha noted, areas in which the 'Arab countries have been lagging'.[4] 'Dialogue' was one of the favoured official terms used around Mathaf's launch, seemingly placing the emphasis on cohesion, but also standing for both the mitigation of sheer creative audacity and untrammelled questioning and innovation and its endorsement. This balancing act would prove significant in the dramatic period that followed the opening of Mathaf in late 2010.

In the West, the comparatively recent alignment of educational, economic, and technological innovation with cultural-artistic themes originally emerged from a focus on urban regeneration and the renewal of post-industrial cities. In the guise of the creative class, it was usually associated with art galleries, new museums, hipsters and hip consumption, modish lifestyles, design, social media, and creative hubs, and also with a vaguely 'democratic' agenda aligned with assumptions about tolerance. As Oakley and O'Connor note, this agenda did not translate so smoothly in the Asian and Middle East contexts where there was a more circumspect approach than the more triumphant, vividly progressive aspects emphasized by urban studies theorist Richard Florida with his proclamation of the creative class as an emblem for social as well as economic innovation.[5]

The official rhetoric at the launch of Mathaf thus loosely heralded select modernist cultural commitments, but always as a qualified endorsement. This is unsurprising, given the preponderance of debate in the region about the cultural clash between modernizing forces and Islamic tradition. Many in the region have argued that modernity developed from the historically and culturally specific context of the West, if not Europe in particular, and therefore should not be universally replicated, or replicated indiscriminately.[6] At the same time, there is a degree of quiet, marginalized advocacy of modernist civic and political commitments, which are deemed an antidote to tyranny and autocratic rule in the region. In such a climate of debate, it is not surprising that the Qatar pronouncements insisted that the new museum was not a branch of a Western museum – no matter how much a museum of modern art might seem a Western idea – but instead it was an Arab Museum of Modern Art. In an interview on the eve of Mathaf's opening, Wassan Al-Khudhairi, the museum's chief curator, and then acting inaugural director, tried to clarify what this meant by again emphasizing both the institution's role in promoting dialogue and the role art played as a mediator: 'Whenever there are problems and challenges in different places people want to understand those challenges. Art can help mediate those challenges.'[7] When asked about censorship and the fear of offending devout Muslims, she offered:

> We're hoping to tackle this question, to foster an open dialogue with our public and to be able to host these discussions. We don't

know how we will be received until we open because this is the first time anybody has done something like this here.[8]

In the few years since opening, Mathaf has certainly exhibited some challenging, though well-known, contemporary art practices. Examples include Mona Hatoum, who explores social and cultural displacement in stark, confronting, yet often eloquent installations. Hatoum's work evokes the tensions in the region, its violence and conflict, the plight of Palestinians, but also refugees and exile, the struggle of individual identity and contradiction, in an often poetically oblique manner. Mathaf has also hosted Egyptian artist Wael Shawky's ever-popular *Cabaret Crusades* (2010–2014). These films enact an Arab understanding of the Crusades performed by marionettes inspired by Amin Maalouf's 1983 book *The Crusades Through Arab Eyes (Les Croisades vues par les Arabes)*. These works aim to challenge and invert the West's self-identification as an unequivocal force for good and for progressive civility in the world by uncovering its brutal history in the Crusades. At the same time, Maalouf's book and, in turn, Shawky's visual realization of it do not downplay a history of Arab duplicity, and thus tribal or clan in-fighting, that undermined its cause. Until its exhibition at Mathaf, *Cabaret Crusades* was previously shown primarily in the West.[9]

Shawky's highly reflexive approach explores fiction, popular history, and historical narration. Both his puppet-based narration of the Arab perspective on the crusades and Hatoum's work provide surrealistic perspectives on contemporary matters. The series of films dramatizes how Arab chronicles represent the Europeans as violent and debased barbarians, typified by the moment when they achieved their goal of 'liberating' Jerusalem in 1099 by exerting maximum carnage on the city's inhabitants, both Jewish and Muslim alike. Shawky explains that the impetus for the work arose from the realization that there are four versions of Pope Urban II's speech in 1095 launching the Christian Crusades. This historical uncertainty prompted him to consider the general politics of retelling.[10] Shawky used antique Italian marionettes for retelling this saga in the first film; for the second, he designed ceramic puppets that exude a sinister, almost bestial, form; the third film explores conflict within Islam through glass puppets.[11] The result is a highly evocative mixture of music, the use of classic Arabic, and a dramatic shadowy lighting, which captivates audiences and

has an overall impact that Shawky likens to a 'Surreal language'.[12] The overriding theme is (like Maalouf's) one of an unresolved conflict between the monotheisms – Islam and Christianity – but it also manages to convey how violence renders every consideration tenuous. The visible strings of the marionettes may accentuate the constructed nature of the narrative, but they also suggest the compromises, complicity, and fragility of the key players and their situations, which dissipates the sense of upholding a noble intention free of compromise.[13]

Even though the exhibitions of Hatoum and Shawky address controversial content, though highly pertinent to the concerns of the region, their works are so inflected and exploratory that any potential offence is minimized or obscured. Such art appears to confirm the presumption that dialogue is being enhanced. And why not? Yet, if it is 'dialogue' between cultures and experiences that the works promote, then they do not achieve this aim by mediating challenges, as the official rhetoric surrounding such institutions likes to insist. Instead, they confront what cannot easily be appeased or what cannot be faced without confronting massive contradictions. What's in a name, therefore, when a museum contains the term 'modern' in its title? In the visual arts and elsewhere, the term is indeed a volatile one and has acquired many derogatory associations – one of them being a belief in absolutes. If the presumption of contemporary Western art criticism is that modernity has been surpassed, then any commitment to the modern can only regarded as deluded, at best a misguided enterprise, or simply passé. One justification for the surpassing logic is that it constitutes a necessary step in the process of challenging and eschewing Western or Eurocentric cultural assumptions (thus, entertaining the presumption that only modernists possess Eurocentric assumptions).

The pronouncements accompanying the launch of Mathaf: Arab Museum of Modern Art in Doha expressed some caution about the wider ramifications of what could be understood as 'modern' propositions or ideas, especially in the purportedly neglected spheres of 'culture, the arts and education'. The story that follows explores an unexpected storm of upheaval and unrest that momentarily rendered these investments more starkly explicit than is usually the case. These events exposed many contradictory formulations arising from the act of compartmentalizing certain modernist propositions, while endorsing others. The events would also show

that the hesitant official rhetoric concerning the modern displayed a better awareness of their full implications – politically, culturally, and socially – than is evident in much art-world discourse today.

17 December 2010, Tunisia: A protest leads to uprisings

Barely two weeks prior to the opening of Mathaf in Doha, a protest arose in the Tunisian town of Sidi Bouzid after a young, struggling street vendor, Mohamed Bouazizi, set himself alight in exasperated rage against official mistreatment. Seething collective resentment against a range of issues surfaced at once – unemployment, chronic economic inequality, corruption, official abuse, and police brutality – and they suddenly found a tragic and startling trigger. The resulting uprisings did not follow the pattern of previous decades in the Arab world, in which isolated incidents of protest against much the same grievances would be swiftly and brutally repressed. This time the unrest continued to gather momentum and escalated into mass mobilizations that spread across all sectors and classes of society that shook the very foundations of oppressive rule – not only in Tunisia, but also soon across an astonishingly wide area. The protests seemed to ignite a fuse across the region by pointing to disconcerting parallels between familiar complaints – primarily over poverty, corruption, arbitrary arrest – and broader political concerns, such as autocratic government, repression, and a lack of representation and of civic rights. This dissent cumulatively became known as the Arab or Jasmine Spring, or simply the Arab uprisings.[14]

Bouazizi survived for more than two weeks in hospital until 4 January 2011, when he died as the result of burns to 90 per cent of his body. Ten days later, Zine El Abidine Ben Ali, who had been president of Tunisia since 1987, fled the country for exile in Saudi Arabia. This expeditious regime change triggered hope that this might set a similar pattern elsewhere. On 25 January there were protests throughout Egypt and by early February Tahrir Square in Cairo was occupied by millions of protesters defying government policies restricting freedom of assembly. Another autocratic president, this time Hosni Mubarak, was forced to step down from office. By April 2011, uprisings had erupted across northern Africa and the

Gulf peninsula. Regime change was only partial in Egypt, however, and there were ferocious suppressions in Saudi Arabia and Bahrain. In the case of Syria, just as in Libya, the rulers would not budge. Yet, blunt suppression failed to quell the initial revolts. The subsequent violence in Libya and Syria proved to be brutally protracted. In the case of Syria, the conflict was unresolved for so long, with so many twists and turns along the way, that the original connection to the uprisings of 2011 seemed completely lost. Like the European uprisings of 1848, the challenge to autocratic rule did not result in the immediate achievement of democratic rights, but instead resulted in far more repressive outcomes once the struggles for greater liberty were suppressed.[15] Enduring tyranny and autocratic rule secures its persistence by repressing any viable opposition that can organize itself, and sabotaging any countervailing institutional framework. It thrives by creating a chasm between itself and any alternative. This breach ensured the – at least, short-term – success of fundamentalists, which caused even further upheaval, violence, and disorder, without alleviating poverty, while horrendously escalating repression.[16]

Within a few short years of providing the trigger for the Arab Spring, Tunisia represented the rare case of a partial transition from dictatorship to some kind of post-revolutionary democracy, securing some degree of constitutional reform. Still, Tunisia has endured violent attacks by fringe, ultra-conservative Salafists and other militant Islamic groups since the downfall of its dictatorial president, Ben Ali. Salafists targeted anything they regarded as corrupting Islam – which included Sufi shrines and secular politicians (notably, the assassination of Chokri Belaïd in February 2013) – as well as, as one might expect, the perceived pillars of Western modernity, which included contemporary art exhibitions, the US embassy in Tunis, the selling of alcohol, and tourism. Attacks on tourist sites were particularly vicious. In March 2015, a terrorist attack on the Bardo National Museum in Tunis resulted in twenty-two deaths – the majority being European tourists – followed by an attack that almost doubled the death toll later in June when a gunman shot tourists relaxing at the beach resort of Sousse. The Islamic State group claimed responsibility for the Sousse massacre. The attacks on tourist sites were clearly aimed to disrupt a key pillar of the nation's economy and thus undermine Tunisia's future recovery.

Art had been attacked previously. In June 2012 the *Printemps des Arts* fair in Tunis was the subject of violent protests. Salafists complained that a painting of ants emerging from a child's schoolbag and spelling the name of Allah had insulted all Muslims. In the subsequent protests, close to seventy people were injured and one person was killed before a curfew was imposed. Over one hundred people were arrested, and sixteen were imprisoned for a month in January 2013 as a result of these 'art' protests.[17] In this contorted atmosphere, art was rarely considered a neutral mediator capable of appeasing tensions, or helping us to understand one another. Instead, it was viewed as partisan; aligned with one particular side of this social division – the side of secular values, open inquiry, aesthetic and social challenge, as well as cosmopolitanism. Contemporary art was strictly identified by agitated traditional segments of society with Western modernity and thus the challenging of religious and traditional cultural imperatives. In the context of the Tunisian 'art' protests, the championing of artistic freedom was interpreted as yet another way of attacking Islam.[18] Mathaf, with its explicitly modernist agenda, was suddenly supporting values that were no longer viewed as generic or neutral, or even helpful. Instead they were considered a battleground. These tensions would come to the forefront not in Doha or even in Tunisia, but in Sharjah.

April 2011, Sharjah: A censorship controversy

If an Arab Museum of Modern Art was meant to place Qatar at the forefront of a modernizing Arab cultural initiative, the nearby Sharjah Biennial (under the serious-minded guidance of Western-trained Sheikha Hoor Al-Qasimi) was committed to exhibiting the latest forms of contemporary art, which, as one art observer subsequently noted, has opted to flirt with 'the deeper, more disruptive powers of contemporary cultural production'.[19] While this assessment is not incorrect, it fails to consider the perplexing question of why anyone in a position of relative authority would seek to introduce 'disruptive powers' into their society, even if merely an aesthetic disruptive capacity. At the 10th Sharjah Biennial, the

support of 'contemporary cultural production' was sorely tested as a result of the censorship controversy. This episode remains illuminating because it brought to light many implicit assumptions about the compartmentalized boundaries of social and aesthetic disruption that were in play.

In April 2011, the Sharjah Art Foundation announced that its director, Jack Persekian, had been dismissed by Sharjah's ruler, Sheikh Sultan bin Mohammed Al-Qasimi. The stated reason was that the 10th Sharjah Biennial that year had exhibited an artwork deemed offensive to Islam.[20] At the centre of the controversy was Algerian artist, Mustapha Benfodil and his installation, *Maportaliche/Écritures Sauvages* (*It Has No Importance/Wild Writings*) (2011). The installation was riskily situated in a public square located in the vicinity of a mosque. It was removed from the site. The work was deemed both blasphemous *and* obscene – thus anticipating the same charges that would be laid against the members of the feminist punk rock protest group Pussy Riot in Russia later in August 2012.[21] The ramifications of the Arab Spring

FIGURE 3.1 *Mustafa Benfodil*, Maportaliche 1, 2011, *installation view, Sharjah. Photo: courtesy of the artist.*

meant that it was becoming difficult to compartmentalize aesthetic disruption from social disruption – and some artists were being increasingly caught up in the repercussions as these boundaries were blurring.

Benfodil's installation brought together an unwieldy cocktail of references encompassing sex, politics, and religion into the Sharjah public sphere. The primary focus of the work lay elsewhere, however, far from the UAE or Sharjah and distant in time from the popular uprisings flaring up all around the region in April 2011. The installation sought to focus on the ferocious escalation of violence by Islamic rebel groups during Algeria's civil war in the 1990s, which led to widespread massacres, kidnapping, and rapes. Ordinarily, one might suspect that rulers in the UAE would be sympathetic to such a bleak portrayal of fundamentalist rebels, given their antipathy to the Muslim Brotherhood, but by the time the 10th Sharjah Biennial opened the Arab uprisings were at their zenith. The scale of the protests and of their demands seemed wholly at odds with the appeasing modernization rhetoric favoured at the launch of Mathaf with its soft emphasis on art as a mediator of tensions. Even before the censorship controversy arose in Sharjah, a small protest in support of the uprisings briefly erupted at the biennial opening. Security forces swiftly quelled this protest. As Hanan Toukan reported soon after, two curators of the exhibition were taken in 'for questioning'.[22] Tensions were running high and Sharjah could ill-afford to upset sensitivities both within the UAE and the wider region.

The month before the opening of the 10th Sharjah Biennial, in March 2011, the Gulf Cooperation Council (GCC) – of which both Qatar and the UAE are members – sent forces to suppress the uprising in Bahrain in order to solidify the regime. The resulting crackdown in the neighbouring state led to a brutal suppression and the imprisonment of human rights activists and protesters, including doctors and health workers who were treating the injured. The GCC also sought to bolster Mubarak in Egypt. The brief protest at the Sharjah Biennial opening attempted to draw attention to the brutality of the suppression in Bahrain by distributing the names of the dead. At the time, as Christopher Davidson noted, the UAE were also arresting human rights activists, who had agitated for nothing more than 'a fully elected parliament and universal

suffrage', which were hardly revolutionary demands, but they were made to appear potentially disruptive due to 'the UAE's complete lack of democratic institutions'.[23]

This air of suppressed dissent and political turmoil explains the strained circumstances of the Sharjah Biennial opening in 2011, even though it is notionally an exhibition celebrated for featuring cutting-edge art in the region. Hanan Toukan described the demonstration, in which one artist and a 'very small handful of people' attempted a protest by naming 'those killed in Bahrain':

> Most participants went on with the business-as-usual of discussing works, networking, and accepting awards from the Sheikh. ... The fact that there is neither a history of activism nor a developed civil society on which one can fall back during such challenging moments, makes it rather uncomfortable to make or to hear about possible forms of expression of anger.[24]

The unfolding situation highlighted compromised motivations all round – and not only those of the international art-world as it mixes with regional elites in celebrating cutting-edge art or aesthetic disruption. Qatar and the UAE (to varying degrees) were presenting themselves as regional leaders in art, culture, education, and communications, while at the same time punitively suppressing calls for political liberalization at home and in Bahrain. The United States was lending rhetorical and strategic support to the uprisings as emblems of democratic principles, while at the same time were concerned that any uprising could threaten the situation of its Fifth Fleet, based in Bahrain. Complicating matters further, Qatar sent troops to aid suppression in Bahrain, while it simultaneously supported France's efforts to overthrow the Gaddafi regime in Libya. In those heated days, compromised positions were being exposed to international attention, but so too were those of Western governments and institutions. In particular, the prestigious international institutions accruing in Qatar and in the UAE – the branch offices of institutions like New York University and the Sorbonne, as well as museums and galleries, such as the Louvre and the Guggenheim – also came under the intense scrutiny because they were notionally meant to be expressive of 'democratic principles and human rights'.[25]

As if to make this connection explicit, it was left to the group GulfLabor, largely composed of artists, to raise concerns about negligent and exploitative labour practices during the construction of these citadels of culture (the Guggenheim and the Louvre in particular). GulfLabor sought to ensure that the institutions were upholding 'uniform and enforceable human rights protections for the workers working on their sites', such as at Abu Dhabi's Saadiyat Island.[26] GulfLabor were not averse to appealing to universal principles, in this case equity and human rights for all. When the Louvre Museum in Abu Dhabi eventually opened in November 2017, Abu Dhabi Tourism Authority chairman Mohamed Khalifa Al Mubarak was quoted as informing journalists gathered for the opening: 'When you're in this museum, we're all connected, we are all one. It's a centre of acceptance, it's a centre of tolerance.'[27] Tolerance, like dialogue, seemed to imply leaving politics behind, or perhaps compartmentalizing demands and adherences.

But what happens once one leaves the museum? The demarcation between what is permissible *within* the museum and what is tolerated in the wider sociopolitical discourse *outside* the museum seemed to be colliding dramatically. If most participants went about business-as-usual in the face of the Sharjah Biennial censorship dispute, as Toukan reports, then the 'business-as-usual' approach can also be unsettled in such a situation because it involves stumbling along with a mixed bag of justifications that at once purport to uphold ideals of tolerance of difference and cultural relativity, but also of human rights, free expression, and the importance of unimpeded critical questioning, while also critically dismissing anything deemed modernist or Eurocentric. If the contemporary art presents the first example of *world art*, as Terry Smith (Chapter 1) declares, because contemporary art has become *the* world art because artists everywhere are producing it in widely diverse parts of the world, then it is not a uniform culture that contemporary artists inhabit, even though a certain wired, skyscraper version of modernity tends to be omnipresent today in all major cities around the world. Some artists have dubbed this state of affairs 'gulf futurism' – that is a cultural space caught improbably in the gap between what Toukan describes as a lack of a 'developed civil society' and what Fatima Al Qadriri and Sophia Al-Maria also describe as 'the region's hypermodern infrastructure'.[28]

In such circumstances, what justifications are viable in defending art when it pushes certain limits in this situation? This question becomes more pointed in moments of severe pressure – whether that pressure is due to the threat of censorship or even imprisonment. These possibilities were not merely hypothetical in the period immediately following the Arab uprisings. Yet, one consequence of this newly expanded transcultural horizon of artistic production – especially when combined with the forceful influence of postcolonialism – has been to sway much art-world discourse and cultural theory from universal propositions. Eschewing universal notions is regarded as analogous to openness to different cultural possibilities. It is also considered analogous to setting oneself free from an incriminating past of Western influence that has divided people and cultures along ethnic-racial lines. Universalists are thus viewed with suspicion as dogmatic and mostly Eurocentric because they apply universal standards today irrespective of local cultural imperatives and also irrespective of a Western history that rarely applied them consistently in a discriminatory manner. Cultural relativism thereby seems a better fit for responsiveness to different cultures. Once again, the reality is more complicated than this implicitly surpassing discourse allows. What forms of response can one rely upon to justify practices if you are arrested, or your artwork is seized? The almost reflex resort to universal propositions can be found in a number of situations. They underpin the proposition that Western cultural institutions should logically, even intrinsically, uphold the principles of 'democratic principles and human rights' as well as the almost casual insistence that contemporary art involves 'deeper, more disruptive powers'. GulfLabor clearly appealed to universal propositions when condemning the failure to uphold 'uniform and enforceable human rights protections for the workers'; of course, it did so in order to exert pressure on Western cultural and educational institutions active in the UAE. The art world assumes such propositions all the time, particularly when it comes to assumptions about human rights and freedom of expression, which it takes as a given. But even if you disparage this resort to universals, what do you replace it with? The aim of this discussion is therefore to render these rhetorical investments more explicit when frequently they are elided or understated. Subsequent events would expose the tremendous fissures underlying this assumption of a correspondence between aesthetic and

social–political principles, but this should have been expected because the discourse surrounding the worldwide framework of contemporary cultural production is similarly ambivalent about what it upholds. It becomes clear that different parties surveyed in this discussion were talking about different cultural propositions with different emphases, sometimes talking of disruption, sometimes of dialogue and unity ('we're all connected, we are all one', 'we're all in this together'), sometimes of the need to compromise between the two in a kind of pragmatic relativism.[29]

There were no compromises when it came to the removal of Benfodil's installation. Its key components were primarily literary, or literal, and audio as much as visual. The installation utilized sound and text with an array of headless mannequins dressed like two football 'teams', one in white, the other in the Algerian national colours of green and red. The white team featured material drawn from Benfodil's play *Les Borgnes* printed on their shirts, which highlighted, in the artist's own words, a 'hallucinatory account of a young woman's rape by fanatic jihadists'.[30] The green and red team, by contrast, displayed texts drawn from everyday Algerian culture, such as jokes, recipes, proverbs, and songs (Toukan 2011). Because this elusive mix of references appeared in a public square – not sequestered away in the halls of a museum or the designated, non-public spaces of an art biennial – the resulting confusion amplified the sexual references. This cacophony of references was compounded by the fact that the surrounding walls of the square contained graffiti in Arabic, accompanied by audio evoking slogans, protest chants, and actions from the upheavals then occurring in Tunisia and Egypt. In the process, Benfodil had extended his focus beyond the earlier Algerian civil war to encompass the current popular uprisings spreading across Arab nations – the *printemps démocratique arabe*, as Benfodil referred to them.[31]

By conjoining sexually explicit material with religious and contemporary political references in a public space, Benfodil's installation was simply deemed too provocative. The artist defended himself on a number of grounds. For a start, the seemingly offensive aspects of the artwork largely referred to the brutality of Algeria's civil war, not Islam in general. Drawing attention to the violence perpetrated against Muslim women by Islamic zealots, Benfodil retorted:

The words may be shocking but that is because nothing is more shocking than the rape itself and all the words of the world cannot tell the atrocious suffering of a mutilated body – and what is told here is sadly not a fiction.

In the end, it was difficult to ascertain which aspects were considered more offensive: the sexual, the religious, or the potentially inflammatory political overtones – most likely the combination. In the circumstances, no one was going to deliberate on the original sources of these references or the subtle nuances of each component, especially not in the tempestuous political atmosphere of early 2011. The basis for the most provocative aspects of the installation may have been specific events in Algeria's recent civil war, but Benfodil confessed that he had in mind a broader theme: exposing

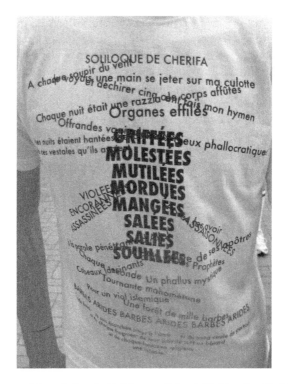

FIGURE 3.2 *Mustafa Benfodil*, Maportaliche 4 (T-shirt detail), *2011, installation view, Sharjah. Photo: courtesy of the artist.*

'a pathological revolutionary paradigm' that sought legitimacy behind the figure of 'a phallocratic, barbarian and fundamentally liberticidal God'.[32]

Benfodil therefore suggested that his prime concern related to the warping of an ideology that could justify inflicting atrocities on the population in the name of God. This 'pathological paradigm' – an apt description – has been a recurring theme of modernity. The frequently observed disruptions prompted by modern development with its concomitant displacement of more communal bounds has regularly elicited a variety of anti-modernist fundamentalisms intent on purging society of its harmful dislocating effects. There have, of course, been both modernist and anti-modernist fundamentalisms, both Occidental and Oriental examples. The anti-modern variety invariably takes the form of a quest to restore a vision of authenticity that lies beyond or before the modern. The desire to retrieve an archaic, more cohesive, purportedly pure, integrative pre-modernity has been ever-present and highly seductive whether it be certain forms of agrarian socialism in the nineteenth century, the blood and soil racial essentialism of fascism, primitivist cults, or communal collectivist utopias. In most cases, these restorative fundamentalisms have resulted in unimaginably worse outcomes than the malign symptoms they were meant to redress.[33]

Benfodil drew attention to yet another case of this perennial, but pathological response to modernity – except that it referred to a Muslim variety of this pathological paradigm and he was critiquing this destructive 'pathology', not from the perspective of the West, but from within the region, specifically from the Algerian perspective. By concentrating on what is frequently referred to as the 'dark decade' of the Algerian civil war, Benfodil's concerns proved prescient in the years following with the declining, even catastrophic, situations in Libya, Egypt, and Syria, and the subsequent rise of Islamic State. Yet, in April 2011, the specific combination of targets evoked in Benfodil's wayward installation – sexism and sexual violence, Islamic theocratic extremism, autocratic regimes, and the lack of democracy – were likely too confusing and too provocative to remain in a sensitive public space and in the context of the unfolding context of the Arab uprisings. The act of censorship, however, greatly escalated the attention paid to the work.

What is art supposed to do? Art, civil action, doing one's job, and the enduring assertion of aesthetic autonomy

Whatever the virtues of the banned installation, Benfodil's justifications of his practice were consistent and erudite. Of course, the coherence of his aesthetic argument did little to help his case and it did nothing to mitigate the cultural clash stirring the censorship dispute. If anything, the terms of his defence accentuated the divide. Benfodil's target may have been the pathological purism, which had wreaked havoc in Algeria, but his aesthetic stance was explicitly transgressive. Benfodil was clear about where he was making a stand and the grounds for justifying his art installation. Benfodil's transgressive stance also has resonances with a vaguely cosmopolitan, critically robust, rights-based agenda that does not sit comfortably with concerns for cultural mediation, attention to local sensibilities, or appeasement with traditional perspectives when it comes to repression.

Largely unobserved during this year of protests and uprisings was the explicit recourse to modernist cultural justifications in the rhetoric of artists when defending their practices. The Tunisian artist Héla Ammar, for instance, ardently proclaimed in the face of fundamentalist assaults on contemporary art exhibitions: 'Artists are free and their freedom of expression is indivisible.'[34] Many Western artists today would recoil from making such a forthright statement about sheer aesthetic autonomy. Decades of critical theory have ingrained a highly circumspect attitude to such a strong statement. Yet, for all the talk of the death of the author, the piercing of absolute autonomy for its strident humanism, the deconstruction of the binary opposition between modernist and traditional cultures, between subject and object, claims of the post-human, and so on, such qualifications of an over-reaching modernist ambition do not exactly offer a compelling defence when an artist – or any other citizen for that matter – is faced with censorship, arbitrary arrest, or the threat of imprisonment. Instead of equivocation, the more familiar discourse of aesthetic autonomy was heartily endorsed as other countries became spooked by the Arab uprisings and the fall of dictators. Nadezhda Tolokonnikova of Pussy Riot in her trial statement in Moscow in August 2012 before being imprisoned even

conceded that her group's practices followed well-identified and familiar precedents:

> What Pussy Riot does is oppositional art or politics that draws upon established forms of art. In any event, it is a form of civil action in circumstances where basic human rights, civil and political freedoms are suppressed by the corporate state system.[35]

Perhaps inadvertently Ai Weiwei drew a similar parallel. Arrested in April 2011, he declared that the specific circumstances of today's communist China rendered him political by default because – while his aesthetic commitments were equally familiar in the art world – in China they were viewed as directly hostile to the regime.[36] Ai Weiwei bravely underscores the cultural-civic disjuncture in which he is forced to operate as a contemporary artist. He uses aesthetic autonomy as a weapon, but equally as a way of justifying everything he does, not only in terms of defying the government, but also in relation to most other artists in China, who he often depicts as more compromised. This is the assertion of autonomy as an act of purity at the opposite end of the scale to the entreaties about an aesthetic space apart in which 'we are all one' and tolerance and acceptance prevail. The only space apart for Ai Weiwei is that of his own autonomy, hence the standard justifications of art expose stark, seemingly irreconcilable oppositions.

Ordinarily, however, contemporary art is confined to highly circumscribed and specific contexts, such as art fairs or biennales, so this is never an issue. It is now appearing in places where the civil framework for its discourse is quite different. Despite the fact that many practices seek to extend into the social and public realms – sometimes, as we have seen, into public spaces – it is only in unique circumstances that such practices are deemed aberrant, criminal, or branded an unwarranted form of dissidence. On these rare occasions, the disconnect is laid bare, but so too is the reliance on the discourse of autonomy, civil action, and critical questioning to defend artistic practices. Yet, prior to his sacking, Persekian, as the director of the Sharjah Art Foundation, declared that the 10th Biennial would 'explore the broader historical, political and aesthetic terrain' by engaging 'with the fabric of the city of

Sharjah'.[37] Benfodil's installation certainly did engage with the fabric of the city.

In this context, Benfodil's defence is worth exploring because he argues that art's autonomy serves the purpose of giving voice to those who are voiceless or in creating a space to articulate what otherwise cannot be expressed. Art, according to this explanation, can give expression to victims' distress in the face of unfathomable violence. Art can go further, he suggests, and expose how the incapacity to articulate such horrendous experiences is compounded by strict social prohibitions around discussions of sexuality in customary cultural settings. In short, Benfodil defends a notion of art pitted against its culture or, at least, to the degree that the culture excludes equal recognition of its female citizens. Art interrogates the awkward questions. Clearly this is what Benfodil was seeking to bring to attention with his Sharjah installation. Thus, he insisted that his motivations were sincere because he was seeking to confront the limits of the socially permissible:

> In Sharjah, people should know that my purpose wasn't to shock them. It wasn't my intention to incur a fatwa, or to set up a form of marketing for my work. I write using hard words; it is a way of making literature. My writing directly references the body because the body, in our world and in our imagination, is invisible. It has no status. By naming organs, and of course sexual organs, I say that sex can't be hidden anymore.[38]

It reads like an echo of Anita Berber, yet sincerity is not the issue. While it is likely that he did not deliberately seek to trigger the controversy that led to his work's removal from the Sharjah Biennial, Benfodil's declaration – as with Tolokonnikova's trial statement – made an explicit connection between conventional, seemingly overly familiar, modernist aesthetic commitments and a wider set of sociopolitical ramifications. By focusing on civil and social deficits, the artists' emphasis jarred with the preferred equation that aligned art events with cultural spectacle, economic prosperity, the creative ambience associated with the knowledge economy, and an emphasis on an aesthetic that harmonizes rather than challenges. This requirement has not been active in art for a long time (if one takes into account the broad span of modern, avant-garde, and contemporary art).

The 2011 statement issued by the International Association of Art Critics (AICA) in response to the Sharjah episode also drew a direct parallel between aesthetic autonomy and democratic social and political values:

> We strongly condemn the censorship of Algerian artist Mustapha Benfodil's installation *Maportaliche/It Has No Importance* during the Sharjah Biennial. Art that is socially and politically engaging often raises difficult, challenging and provocative questions but in an open and free society the right to freedom of expression has to be respected.[39]

The AICA advocates for the defence of art criticism as well as critical independence. The statement continued that it supported the sacked Sharjah Biennial director, Jack Persekian, because he was in the process of creating a 'space for free expression'.[40] The espousal of such principles may sound routine or inoffensive when written from the office of the AICA. Yet, no matter how carefully framed and diplomatically conceived, the AICA statement (just like those of Ammar, Benfodil, or Tolokonnikova) automatically equates aesthetic autonomy with democratic, liberal-social and political goals. It also assumes that the UAE (or even Qatar) is hosting contemporary art events because they aspire to create an 'open and free society' (or indeed may already be one). In reality, nothing could be further from the truth.[41] They are necessary defences that ought to be made, but it cannot be assumed that everywhere that contemporary art appears today is necessarily willing to become or is a free and open society. There is a disconnect.

The sacked director may have been seeking to forge a 'space for free expression' in Sharjah, as the AICA confidently assumed. Nonetheless, the role for art outlined by Benfodil and others in the region is at odds with the official rhetoric. At a cultural forum the Foundation sponsored before the 2011 Biennial opening, its prevailing theme was far more circumspect and carefully delineated: experimentation, yes, but once again only in the context of collaboration, dialogue and exchange. In 2011 Persekian was still publicly upholding this idea of art. He praised the Foundation's regionally specific forums as hubs of creative, cross-cultural exchange. These commitments generally appeared to conform to postcolonial ideals that meshed with the floating transnational and

transcultural circuits of the contemporary art world. Yet, nowhere did the official rhetoric extend to holding up a spotlight to what was 'unsaid' in society, or giving voice to the voiceless (which would amount to the majority of the population working in Sharjah and the UAE in general). No doubt the official view was inclined to assume that what was unsaid was best left unsaid, or, if mentioned at all, then it should be closeted away and certainly not appear in the public spaces in the vicinity of a mosque.

The commitment to the culturally mediating stance left Persekian with few convincing critical commitments to defend. In statements in the wake of his dismissal, Persekian certainly did not say that the advocacy of such an event might eventually entail the forging of a free and open society. In the area in which he was working censorship is regarded more as vital social glue rather than as unbridled questioning or dissent. Thus, Persekian's initial response was not remarkable in the context in which he was operating, even though it proved a shock to the art world. The ousted director suggested that he would have removed the offending work himself – if he had the opportunity. The problem? He was simply too busy at the time, he confessed, and the offending artwork escaped his attention.[42]

True or not, Persekian publicly defended his role in managerial terms as a go-between who did not push boundaries needlessly. His statements made it clear that he never sought to become a martyr for the causes of cultural contestation. He did not want stand out on a point of principle; it was imposed upon him. His fate recalls the well-known scene in the Monty Python film *The Life of Brian* in which the central character, Brian, strives valiantly and unsuccessfully, to shed the evangelical status projected onto him by others. In his exasperation, Brian urges his followers to realize they are all individuals, not meek followers. The crowd, of course, responds in unison that they are indeed *all* individuals – except for one timid voice who defies the crowd to protest that he is *not* an individual. The joke captures the irony of Persekian's situation. He did not want to stand out from the crowd either; he did not want to cause offence and become a cause celebre at the centre of an art-world storm. There was no overt intention on his part to push cultural sensitivities in the direction of unfettered artistic freedom – far from it. Nonetheless, it was Persekian who became the central figure in the controversy due to his leadership role. He

was portrayed as a victim of censorship and repression, even though he never voiced any public utterance of defiance or of dissent. This public stance was entirely consistent with his position and its stated commitment to art as a mediator, fulfilling the role of appeasing tensions and upholding traditional cultural expectations.[43]

Persekian's most pertinent point was that as director in Sharjah, his role in promoting art that is challenging was highly circumscribed and his working situation less than ideal. Of course, this is correct: what job anywhere is not highly circumscribed? Maintaining a job means coming to terms with the limits in which one operates and finding a way to negotiate around them – and, in the best of situations, striving to achieve some degree of critical autonomy within those circumscriptions. As is the case within academia, everyone in the art world assumes critical autonomy is fully justified. Sharjah would not be the first (or last) place to find difficulties in balancing cultural specificity and communal justifications in the face of more transgressive and critical assumptions about art as well as the demands of critical-cultural autonomy.

The legacy of testing cultural limits

Even on the occasions when modern or contemporary practices have desired to achieve some accommodation with local presumptions when customary culture and authority persist, the values contemporary art transmits usually conflict with such an ambition. This is true even when particular practices are sympathetic to traditional forms of art and draw inspiration from them, or even seek to support them. As we have seen, the entourages of the international art world that descend on various biennales around the world tend to have their eyes attuned to the 'deeper, disruptive powers' of art.

Are the artists (and activists) therefore right to challenge a society's traditional cultural imperatives wherever they come across them? What validates the assertion of their demands – such as the right to articulate what has no status – in defiance of local cultural sensitivities? Even artists who might state that their work has no right to upset local cultural sensibilities still do not produce genuine communal art (at least, not in the sense outlined by György Márkus – see Chapter 1 – of an art that is customary or traditional,

which would be normatively valid and internally binding. The conditions of modernity make this impossible). This is where a form of critical separation occurs in which one endorses both a critically independent, autonomous stance and traditional customary practices (although this too is often qualified depending upon what it relates to – for instance, animal welfare or the treatment of women and then a line is drawn). On the other hand, the critical stance would insist that there is a genuine validity in opposing corruption, widespread repression, and especially autocratic rule, which often shields behind the cover of traditional values. Advancing these critical imperatives in defiance of the local environment or culture, however, inevitably leads to the accusation of perpetuating essentially Western or Euro-American assumptions. People in the critical camp are just as likely to disparage Eurocentric assumptions and the fallacy of Enlightenment values (even if implicitly upholding them). Ironically, this charge of Eurocentrism was an accusation made by regimes when challenged by the Arab uprisings in 2010: some governments responded to the escalating upheavals by appropriating postcolonial arguments and asserting that the propositions of protesters were foreign and inimical to their cultures and thus represented the indiscriminate imposition of Eurocentric assumptions.

Benfodil nonetheless stood defiant: art should not be compromised when it comes to addressing what remains unsaid in society. He, like many artists in the region, insists upon aesthetic and critical autonomy to a degree of frankness now unusual in the West (though if you scratch the surface, practitioners everywhere inevitably uphold the same stance on this issue). Benfodil drew a link between this insistence on exploring the unsaid and the demand for a genuine democracy in Algeria. Does this mean an Algerian or a Tunisian artist is effectively Eurocentric in advancing these types of claims? Up until this point, it would have seemed fanciful to remark, as Eysteinsson and Liska did in 2007, that the concept of modernity constituted 'a vital link to salient aesthetic, ideological, and historical issues which have still not been closed'.[44] Yet, it took a period of extreme social pressure to show that this discourse and its issues were far from superseded. When pressed to defend their practices in the face of political authoritarianism and the threat of incarceration throughout 2011–12, artists resorted to explicit modernist cultural claims as the only means available of explaining

and defending their purported offences as legitimate practices. Of course, this can be a precarious exercise in many circumstances.

Artists' appeals to such axioms do, however, challenge the terms of recent debates about contemporary art and its modernist legacy. As we have seen, the question has been framed in terms of a strict dichotomy between this legacy – deemed largely redundant and wholly dubious – compared to a postcolonial understanding that is conversant with the global scale of contemporary art. Instead of a strict dichotomy, however, we find artists' rhetoric continually resorting to the modernist vocabulary of challenge, disruption, and reconfiguration as well as postcolonial standpoints. This is evident even in the critical responses to the Sharjah incident that seek to account for the new transcultural situation of contemporary art.

Toukan's account of the Benfodil incident offered a nuanced assessment of the particular circumstances of Sharjah, both as an autocratic system of governance and as an emirate seeking to forge an alternate identity in its immediate locality. At the time (2011), she referred to the Sharjah incident as 'arguably, the post-1990 contemporary Arab art world's most challenging moment to date' (Toukan 2011), which is ironic in retrospect because the subsequent arrests of Pussy Riot and the artist Ai Weiwei overshadowed events and turned those artists into global celebrities in what *Time* magazine later dubbed the 'Year of the Protester'.[45] Throughout 2011–12, as we have seen, touchy and nervous regimes made art an explicit political issue by prosecuting and imprisoning artists as part of a wider crackdown on dissent that included journalists, academics, bloggers, and political activists. This 'most challenging moment' in Sharjah further receded into the background as the most pernicious forms of religious fundamentalism and terrorism hijacked the agenda of the Tunisian revolt and subsequent uprisings. The Benfodil incident was obscured by an escalating list of atrocities.

Nonetheless, Toukan counts among the Sharjah Art Foundation's beneficial outcomes the provision of 'the space and money needed to forge a new place for art and its relationship to society', particularly for young Middle Eastern artists who are seeking 'to engage with a significant sample of the "global" art-world's institutions, curators and critics' (Toukan, 2011). In other words, there are undisputed benefits to emerge from the activities of the Sharjah Art Foundation and it is providing this artistic and curatorial infrastructure from within a highly circumscribed, conservative framework. Despite

this beneficence, it is important to be clear that, as Toukan simultaneously warns, one cannot '"stray" from the terms of the "social contract" drawn by the rulers' (Toukan, 2011). If, indeed, a new relationship is being delineated between art and society, then one cannot presume that its implications extend to any redrawing of a social contact that currently includes censorship and various strict prohibitions. There is always a delicate dance required when upholding traditional cultural expectations and simultaneously supporting challenging art practices. No one is fully autonomous in this situation, however, not even the Sheikh Sultan in Sharjah, who may support and endorse the Sharjah Art Foundation and its programme, but he cannot ignore an imam who raises the concerns of the local population attending a mosque in the vicinity of Benfodil's work who are troubled by its content. The sultan's job is to mediate between obligations to the local Muslim community – thus, appeasing the offended local sensibilities – and managing the liberal attitudes of the art world with its attendant critical claims. The cosmopolitan, Western-educated elite in Sharjah cannot advance too far beyond the traditional expectations of their own community – and it is not clear that they are seeking to do so, even though brokering some accommodation with contemporary culture.

It is therefore not surprising that Toukan's assessment of the Sharjah episode oscillates between competing possibilities. On the one hand, she suggests that the incident exposed the uncomfortable interrelation of art and politics under the guise of cultural diplomacy. Its preferred model is not incompatible with the programme that Persekian and the Sharjah Art Foundation followed prior to its fateful biennial in that year of the Arab Spring. According to Toukan, the cultural diplomacy model stems from the 'transnationalization of contemporary arts production', within a wider neo-liberal framework that transmutes art into the 'art of display' (2011).[46] A few years later, Hito Steyerl took this assessment further – brutally further – in her usual rapid-fire conjunction of a lot of contemporary art-world grabs of arguments and terms:

> To brutally summarize a lot of scholarly texts: contemporary art is made possible by neoliberal capital plus the internet, biennials, art fairs, parallel pop-up histories, growing income inequality. Let's add asymmetric warfare – as one of the reasons for the vast redistribution of wealth – real estate speculation, tax evasion,

money laundering, and deregulated financial markets to this list. ... It is defined by a proliferation of locations, and a lack of accountability.[47]

This is the usual account of contemporary art, proliferating locations, and no accountability. Except that is not how it worked out in Sharjah this time and all the scholarly texts about contemporary art were not that helpful.

Despite saying that 'art and politics do not mix well in Sharjah', Toukan nonetheless endorses the view that Sharjah earned a reputation long before the censorship incident of fostering art that 'was deemed politically relevant, critically compelling, and intellectually charged by the biennial's participants' (2011). Hence, the duality upon which Toukan's analysis of the Sharjah incident pivots: the collapse of all artistic endeavours into cultural diplomacy and, at the same time, an endorsement of the capacity of art to go 'astray', and to set 'in motion a productive capacity to dismantle the conflation between intellectualism, radicalism and diplomacy' (Toukan 2011). Although Toukan does not spell it out, and would likely be reticent to do so, this productive capacity to go astray or to dismantle is ultimately much closer to Benfodil's position. Let's not be coy and declare its name: this is a transgressive model of art that draws from the modernist cultural legacy. It suggests that, even in the contemporary transnational situation, art will maintain one consistent characteristic: it will seek to establish a critical distance from its local culture in order to effect a creative or critical re-imaging of that same culture. Thus, in principle, art is inclined to stray from 'the terms of the "social contract" drawn by the rulers' because it is inclined (almost by definition) to challenge and defy local cultural sensitivities in order to redefine them in the ultimate cause of furthering tolerance, equity, and inclusiveness.

An example of work of this kind that gathered a lot of attention at the following 11th Sharjah Biennial was young Saudi artist Sarah Abu Abdallah's *Saudi Automobile* (2011). The video featured the artist solemnly painting the exterior of a wrecked car pink, thereby transforming it into a peculiar kind of monochrome abstraction. This act of painting was, in her words, 'like icing a cake' – a domestic activity transposed to an outdoor setting. Performed like a ritual exercise without any discernible purpose, Abu Abdallah explained

that the seemingly incongruous action of 'beautifying' the exterior of an abandoned vehicle might

> help fix the lack of functionality within the car. This wishful gesture was the only way I could get myself a car – cold comfort for the current impossibility of my dream that I, as an independent person, can drive myself to work one day. (cited in Edge of Arabia, n.d.)

In the act of painting the abandoned car pink, Abu Abdallah – dressed in a traditional (black) abaya cloak with sneakers – references feminist art, performance art, and modernist abstract painting, while alluding to social prohibitions that prevent her from driving. Like Elena Kovylina's *Waltz*, her performance also focuses on the heavy circumscriptions placed on the circulation of the female body in social space. Once again we witness the Sharjah Biennial exhibiting a contemporary artist from a Muslim culture highlighting severe social restrictions – although at the 11th Sharjah Biennial this work was exhibited safely indoors (within an old, disused bank building no less). The video work appears deceptively simple but, nonetheless, it strikes a chord due to the humility of the gesture, the stark means, and its simple oddity.

Abu Abdallah's seemingly illogical gesture enacts a symbolic magnification of her own lack of 'functionality' within Saudi society, as if to accentuate the absurdity of its prescribed gender roles. There is no squeamishness here about rallying to the demand of what Robert Pippin terms a fundamental stance of cultural and civil modernity: 'To detach herself (at least in principle) from her on-going commitments and desires and to be able to "reattach" her ordinary commitments (or not) on the basis of some deliberation about whether she ought to do so' (2005: 15). Although in this case, Abu Abdallah is stepping back from the premises of Saudi Arabian social expectations in order to deliberate about whether she can find a place within such a culture. For Pippin, the proposition underpins the central proposition of a 'philosophical modernism' as it emerged in the West. Clearly it still informs aesthetic justifications of artistic practices in the face of censorship, but now it is being appealed on a much wider stage. Thus, the principle underpins most defences of artistic practice covered in this discussion. The proposition presumes a tolerance for the act of stepping back in

order to examine received opinions and assumptions as well as to test the relevance and boundaries between censorship, authority, and shared or collective norms. Such an axiom presumes a critical relation to one's own culture and society: to be able to step back from one's commitments with impunity in order to pose questions about whether certain practices can be considered legitimate.[48]

Such a proposition clearly informs much of the art exhibited in Sharjah, and not just the banished Benfodil installation or Abu Abdallah's performance (safely exhibited indoors away from an audience that might find it offensive). She dissents from her culture in order to imagine somehow an eventual reshaping of it, which is a seemingly absurd gesture when faced with the weight of the Saudi state. Yet, this performance was all about absurd gestures. To put it another way, it meets the demand that Paul Wood poses, perhaps more assertively than Pippin, that art should address 'the mutable, real world' and that it should also seek to produce 'a different sense' of it (Wood 2014: 287). Again, this gestures to the possibility that underpins one pivotal aspect of modernist cultures: to imagine living life a different way, which is implicit in contemporary art, and is one way it is perpetuating the modernist legacy.

Such work justifies Toukan's contention that the Sharjah Biennial sponsors 'politically relevant, critically compelling, and intellectually charged' works. The presence of such works also supports Oliver Marchant's highly enthusiastic contention that biennials of contemporary art act as sites of cultural resistance. Marchant does not mean resistance to the artists' own cultures, but instead restricts his assertion to the safer ground of arguing that they challenge the capacity of the West to define cultural affairs. Yet, there is no necessary reason why there should be such a circumscription – except for reasons already discussed. The focus on the West as the sole legitimate critical target limits the critical legitimacy of non-Western artists who wish to critically scrutinize features of their own (non-Western) cultures. It also goes against the key tenet of Marchant's argument for biennials. While biennials of contemporary art operate within a transnational field of arts production, as Toukan and many others assert, Marchant insists that they constitute sites of resistance because they are actively rewriting global culture from the perspective of the periphery.[49] Despite all the attention paid to biennials as emblems of cultural

diplomacy, soft power, and the emphasis on display and spectacle, Marchant concludes that we are witnessing a redrafting of the cultural and 'imaginary cartography of our world' (Marchant 2014: 1). Biennials aid 'in constructing local, national, and continental identities' – which could be what is in evidence with the aims and aspirations of the Sharjah Art Foundation – and for this reason Marchant believes it is wrong to conflate them with the usual agenda of marketing cities, 'the consolidation of cultural infrastructure in metropolises', or 'the accumulation of capital' (Marchant 2014: 2).

The limits of critical determinism

Is contemporary art really such a force of disruption, resistance, and cultural realignment? Why do so many autocratic regimes tolerate contemporary art fairs, biennials, and exhibitions? Such cultural events signal a level of cultural aspiration parallel to economic prosperity that defies the old designation 'third world'. In this case, there is no perceived contradiction between a lack of democracy and the contemporary emphasis on the free market, creativity, and innovation. Rather, there is a new alignment being sought: flourishing capitalism yes, contemporary art and fashion yes, but devoid of much of the agenda demanded by the artists.

Another argument would pose a different explanation for doubting art's powers of disruption. In a 1980 talk, the Polish philosopher Leszek Kolakowski suggested that tolerance comes easily in the arts 'because we see nothing logically wrong in the confrontation of different aesthetic criteria'.[50] We can tolerate each other's differing aesthetic tastes or appreciation of art, but this does not extend every far. Kolakowski warns, 'There is a difference between artistic expression on the one hand and moral, legal, and intellectual rules on the other' (1990: 21).[51] This might suggest that the arts are perfectly suitable for cultural window dressing, which is the conclusion drawn by Angela Harutyunyan's in her assessment of the Sharjah affair. While Marchant warns against it, Harutyunyan's account is not hesitant to associate biennials with 'the consolidation of cultural infrastructure in metropolises', and 'the accumulation of capital'.[52]

While biennials of the periphery create 'the illusion' of achieving greater 'singularity and local contextual specificity', Harutyunyan argues that the real goal is an economic 'opening up' agenda in sympathy with the 'globalization of financial markets'. It is a privatization programme that accumulates wealth and 'the public good' into the hands of 'ruling elites in various post-peripheries' (2011: 1). Harutyunyan's critique includes virtually all the art world under its umbrella of the creative economy, financial capitalism, and a 'liberal discourse of cultural politics' (Harutyunyan 2011: 2). From this perspective, any emphasis on the disruptive capacities of art is largely downplayed: 'These newly emerging economic structures seek cultural representation in the public sphere in order to render themselves concrete and visible, while translating material struggles into the domain of cultural representation' (2011: 1). Within the seemingly floating, transitory realm of the art world a liberal framework presides, which stresses innovation, creativity, and critical questioning, but 'once it vacates the site, it gets transported into another temporary space of debate on censorship, free expression and the artist's right to act radically' (Harutyunyan 2011: 5). After its departure, the reality of the 'locality becomes manifest' (Harutyunyan 2011: 4). The only enduring redrafting of the world's artistic and cultural map that occurs is one in conformity with the imperatives of the ever more predominant economic liberalization policies.

In other words, there may be a commitment to forging a new cultural space in the region for the 'politically relevant, critically compelling, and intellectually charged', admirable funding support for the arts and education – even toleration of 'the deeper, more disruptive powers of contemporary cultural production' – but at the same time it must coexist with – and never impinge upon – the existing conditions of autocratic governance, censorship as well as extremely curtailed rights for migrant workers. Harutyunyan's argument magnifies one point in Toukan's account in which she notes how contemporary art is transformed into an 'art of display'. Harutyunyan's account also amplifies what Terry Smith detects as his first current of contemporary art, which he associates with an aesthetic of globalization typified by the mode of spectacular display.[53] For Harutyunyan, it is virtually the first and last option of contemporary art. Her counterargument therefore punctures the image of a peerless postcolonial redrafting of the contemporary

cultural cartography, which Marchant for instance associates with biennials located beyond the traditional centres of influence. Extending the rigorous reality check, Hito Steyerl develops the debunking portrayal of contemporary art's entanglements:

> Art's conditions of possibility are no longer just the elitist 'ivory tower', but also the dictator's contemporary art foundation, the oligarch's or weapons manufacturer's tax-evasion scheme, the hedge fund's trophy, the art student's debt bondage, leaked troves of data, aggregate spam, and the product of huge amounts of unpaid 'voluntary' labor – all of which results in art's accumulation in freeport storage spaces and its physical destruction in zones of war or accelerated privatization. (Hito Steyerl (2015), 'Duty-Free Art)'

There are two virtues to such hard-nosed, demystifying analysis. First, in Harutyunyan's case, it focuses on the specific 'material conditions upon which art is represented and consumed' in the UAE as well as the broader region encompassing locations such as Beirut, Cairo, Ramallah, and Tehran (2011: 5). Second, it points to some of the disquieting aspects of the fly-in, fly-out contemporary art world that floats around the globe espousing its radical credentials, presuming its transformative capacities, consumed with talk of politics, resistance, and where to locate the best coffee, while jetting off again to the next venue. As such, it shares much in common with the other prominent, but transitory international circuits, such as grand prix racing, the tennis tour, or trade fairs. The satellite circuits of art are largely removed from the realities of any particular local situation – despite its current emphasis upon scrutinizing the local within the global context. Harutyunyan's assessment is thereby an important reality check for many inside the art world, who can sometimes feel that the fate of the planet depends on issues being worked within art.

For all the benefits of this piercing commentary, the definition of cultural politics provided by such analysis inevitably results in a terminal endgame. From this perspective, cultural politics is a matter of naming and of excluding. It manufactures certain forms of identity and recognition, but these are wholly circumscribed by a governing hegemonic framework that determines what is to be included. It legitimizes what is said by whom, in what way, and

to what extent, which in turn is formalized 'in societal, cultural, institutional and legal frameworks' (Harutyunyan 2011: 1). According to this scenario, the idea of an open and diverse critical space is largely a myth, even though this is constantly exalted in art-world rhetoric. The transnational, transcultural art world is actually more like a choreographed game in which all the moves have been determined in advance and autocratic rulers parade as modernizers by utilizing the façade of the liberal art event or 'of contemporaneity' in general (Harutyunyan 2011: 2).

Arguments about such complicity are not new. The collusion of the West with despotic regimes had been a preoccupation of discussion well before the Jasmine Spring, but the uprisings reinvigorated its charge. Western complicity with many dubious regimes in the Arab world was noted, particularly because many Western countries seemed motivated more by economic calculation as much as any impulse to help restore basic human rights or achieve fundamental democratic freedoms.[54] Perry Anderson was blunt on this matter: 'Where democracy is reckoned any threat to capital, the United States and its allies have never hesitated to remove it' (Anderson 2011: 8). In his 1980 essay, which is examined further below, Leszek Kolakowski notes wryly that the curtailing of a rights agenda had a long history, especially throughout the Cold War, which led to any ugly, but frank conclusion: 'The first thing the rest of the world expects from European culture is military technology; civic freedoms, democratic institutions, and intellectual standards come last' (Kolakowski 1990: 23). The charge has long been a feature of critical accounts seeking better Western accountability to propositions it purportedly upholds and constantly espouses.

Moreover, the neo-liberal hegemony that Harutyunyan describes does not mean that its cultural politics proceeds with such smooth efficiency, especially during periods of unanticipated and profound unrest, as the first outbreak of the mass Arab uprisings testified. Artists, musicians, intellectuals, journalists, and human rights activists became prominent in the ensuing crackdowns on dissent, while bloggers and dissidents, who had earlier received training and funding support in the West, were now in the vanguard of the challenge to governments in which the West (and also Russia, China and India) had firmly established economic and geopolitical interests. The governments in question usually did not lose sight of

economic and geopolitical calculation, but autocratic governments began to view many of the trappings of Western modernity with suspicion and even as a surreptitious form of Western cultural imperialism.[55]

The emergence of a deterministic strain within critical inquiry emphasizing complicity roughly coincided with the emergence of the surpassing quest in the arts – that is they can both be traced back half a century to the 1960s. The parallel is intriguing. One strategy provokes a seemingly endless succession of new terms of surpassing, each supposedly offering fresh updates on art and society in order to explain why a new conception is necessary; whereas the critical strategy associated with determinate critique has one conclusion, known from the outset: complete hegemony. It views all developments in rather claustrophobic terms – the expanded global circuit of art, for instance, is testimony not to cultural diversity but instead the ultimate victory of a pervasive liberal cultural framework that serves the agenda of a neo-liberal economic hegemony. It looks like choice is proliferating, but essentially the overall agenda is narrowing. In reaching this point, any analysis becomes a redundant exercise: once it has been determined that all positions are compromised, fixed, and complicit, there is no need to keep reiterating the dilemma any further. There is nothing left to say; the conclusion must be the same every time. Everything is subject to the same fatal complicity in exactly the same way. Such analysis lacks the capacity to explain how this hegemony can be disturbed because it cannot offer an explanation of why the hegemonic 'domain of representation', or the highly managed 'liberal discourse of cultural politics' falters at certain points in time and why it may be disputed. Ironically, the debunking exercise can just as readily turn into a recipe for acquiescence and passivity, thus defying the original ambitions of critique – challenging accepted wisdom in order to prise open new horizons of possibility and to transform one's vision of the world. Viable alternative options may indeed be negligible in certain contexts, but cultural critique originally sought to distinguish options in order to disable hegemony. Determinant critique may have been necessary, but it is also too easy and has become formulaic.[56] Of course, a critical account of art and the cultural spheres must highlight where lofty sentiment is betrayed by significant, vested interests. And, crucially, it should

also articulate the discrepancies between the rhetoric of autonomy, liberty or free expression, and the apparent hegemony of a neutralizing, global neo-liberal economic discourse.[57]

By defining cultural politics as one of naming in terms of demarcating the included and excluded, Harutyunyan's account accords with philosopher Jacques Rancière's explanation of politics as 'the act of naming'. For Rancière, the process also delineates both 'what is to be included' and excluded, that is left unnamed. Therefore, while any redrafting of our cultural and imaginative cartography entails an achievement, it does not conclude the struggle over representation. There is no resolute hegemonic eclipse of all other options. The equation of cultural politics with hegemony accords more closely with Rancière's notion of 'policing', which sets the parameters around which society's order is maintained (while relegating the rest to the domain of the marginal, the outcasts or non-citizens, the prohibited, which may or may not stand up to reasonable justification). Yet, for Rancière, the aesthetic involves another dimension – it is capable of a redistribution of the sensible, that is, a reordering of these exclusions – and this assertion is virtually paraphrased by Benfodil when he argues that art must articulate what is 'unsaid' in society and, therefore, must contest what would otherwise be buried under a repressive silence (the repression of women and sexual violence, the curse of autocracy, and fundamentalism). Conversely, Harutyunyan's conception of cultural politics curtails the analysis at the point that Rancière defines as 'policing' – an established order that has been secured and maintained with no hint of ever having been disturbed, let alone redistributed. Even in Rancière's account, it is not clear why such achievements may be identified only with 'policing'. If any successful challenge to the social order can only be translated into a coercive social apparatus, then it permits no way of accounting for what has been achieved in the wake of earlier struggles that prompted such redistributions. Policing as an explanation of the status quo precludes being able to account for earlier efforts that transformed what was previously regarded as unacceptable or non-permissible.[58]

It is telling that during the period of the 2011 uprisings and their immediate aftermath so many commentators, journalists, activists, critics, and artists across North Africa and the Middle East resorted to defences of activities based on not only autonomy

and freedom of expression and liberty, but also cultural critique: articulating the unsaid, giving voice to the mute, creative or critical re-imaging, conjuring the capacity to go astray, and so on. On the other hand, the institutions supporting contemporary art exalted it in terms that suggested they would prefer it conformed to the premises of customary or traditional culture. There are many ways of explaining this situation, but few singular, causative explanations are convincing. The argument about market complicity is not altogether wrong, nor is the emphasis on cultural redrafting. What is convoluted escapes straightforwardly adamant explanations, even though such explanations abound. One version of postcolonial criticism rebukes the language of universal empowerment as evidence of Western constructs denied to populations outside the West. Now non-Western artists and intellectuals are upholding the very same claims. They resort to such justifications, while often concurring with the proscriptive postcolonial view which argues that this whole bundle of propositions were never intended to be extended to anyone beyond a narrow privileged, white European male elite in the eighteenth century, who were for instance duplicitous slave-owners.[59] While explaining that this is the source of global discontent today, such an argument would be news to other postcolonials recruiting such rhetoric for their own ends and for their local struggles. It also fails to explain the extension of such claims of empowerment, for instance, to women, who were also excluded originally.

When artists or dissidents face censorship or imminent arrest, then there are few substantial justifications to fall back on when defending one's right to challenge cultural authority. To give an example, while Hito Steyerl depicts the highly compromised state of contemporary art, she does offer a critical alternative with her idea of 'duty-free art':

> The idea of duty-free art has one major advantage over the nation-state cultural model: duty-free art ought to *have no duty* – no duty to perform, to represent, to teach, to embody value. It should not be indebted to anyone, nor serve a cause or a master, nor be a means to anything. Duty-free art should not be a means to represent a culture, a nation, money, or anything else. Even the duty-free art in the freeport storage spaces is not duty free. It is only tax-free. It has the duty of being an asset.[60]

It is virtually inevitable that alternative possibilities will be proposed in order to avoid the stifling dead end of deterministic thinking. Instead of saying that this idea of duty-free art offers a playfully inventive reworking of artistic autonomy, however, Steyerl insists that it owes nothing to the original conception – 'duty-free art' is not 'a reissue of the old idea of autonomous art', she claims. This is indicative of the pervasive influence of the surpassing rhetoric in contemporary discourse; it cannot abide acknowledging any debt to the modernist legacy and its critical vocabulary, even when it is self-evident. Of course, Steyerl's formulation is in fact a hyperbolic endorsement of autonomy, this time with no qualifications, not even to the nation state. In other words, it presents a case for total autonomy – an art 'set free both from its authors and owners'! What this resort to a concept (while denying it) shows is how pervasive this evasion is, but also how the 'empowering' discourse (dismissed as a fraud by the extreme end of postcolonial discourse) continues to inform contemporary justifications attempting to justify cultural acts that may prove discomforting – hence the persistence of rhetoric about autonomy, cultural critique, articulating the unsaid, or endorsing the cultural capacity to go astray. For his part, Benfodil was rigorously consistent in his adherence to such commitments; he was not inadvertently Eurocentric or unaware of his stance. His art, he declared emphatically, stands for the extension of claims of empowerment to those that have to date been denied this possibility. His was an art that declared 'no duty' except to this principle, yet ironically it was a work set free from its author and its 'owners' (in this case, the Sharjah Art Foundation). In this case, it was not grounds for the claims of any achievement of autonomy.

Eurocentrism, cultural universalism, or cultural relativism?

The paradox is that the artists had an ally in perpetuating this kind of discourse and practice in the guise of the Sharjah Art Foundation, but there is a social chasm between the artists and the local enlightened elite – and Benfodil fell into this chasm with his installation. Because the situation is complex, the usual adamant, though bifurcated, explanations did not bring any clarity

to its consideration. The most unsettling conclusion would be that the discourse of contemporary art is perpetuating modernist cultural propositions in many new and diverse locations. It is unsettling because it disrupts the postcolonial interpretation of contemporary art as a passage from bad Eurocentric modernity to a more diverse, fully enlightened transcultural situation, which is another expression of the surpassing mentality. The incidents examined in this chapter – involving censorship, arrests, revolts, competing justifications of cultural practices – do not indicate that a neo-liberal hegemony is absolute, yet it does not mean it does not exist either. Steyerl and Harutyunyan are right to point out that contemporary art's discourse of challenge and dissent may even rely on it. Further complicating the situation was the appropriation of the rhetoric of postcolonial resistance by autocratic rulers when faced with widespread unrest, thereby imploring their citizens to resist this hegemony, though only the hegemony found in the guise of Western cultural imperialism.[61] The ambition was to dismiss the ideals upheld by protesters as foreign aberrations. While not new as a tactic of the repressors, this attempted appropriation of anti-imperialist rhetoric was forced and unconvincing. It has, however, produced an impasse. There is an equivocation between upholding a critical vocabulary of dissent that aims to hold regimes to account for abuses and that legitimizes freedom of expression, but also scepticism about the duplicity that often accompanies the espousal of 'Western' values, particularly from a continent like Europe's whose economic advance was tied to a race-based imperialism.[62] Or as Nasser Rabbat qualifies the point, modern Arab culture is seeking to achieve what to date has often proved elusive: 'How to reconcile a heritage overloaded with strong notions of identity and particularity with a modernity that is essential for contemporary life, but is nonetheless imported, sometimes imposed, and allegedly manipulated in ways detrimental to indigenous self-expression.'[63]

Of course, this is not a new dilemma, but part and parcel of modernity everywhere. While the tension Rabbat identifies may be currently prominent in the Muslim world, it has never been fully resolved in the West either – at least, not in the form of a pacific and harmoniously coordinated, wholly cohesive system. The cultural propositions of modernity create deeply ambiguous outcomes. Hence, the typically ambivalent result of the positive and negative conjoined: both celebration and hatred; the positive appeal mixed

with deep negativity and suspicion about the very same thing; the investment in propositions, which are sometimes considered narrowly Western, at other times, more universal propositions. This ambivalence relates to the assumption that the modernist legacy must be combatted – due to its narrow Eurocentric origins – while also conceding that it provides the requisite critical-cultural vocabulary that enables this rebuke. One way of negotiating such an impediment is to address a polarity central to some of these justifications – namely, between cultural universalism and the cultural relativism. Leszek Kolakowski sought to do this with a thoroughly nuanced and complex unravelling of its polarity, thus offering a piercing insight into the ambivalent attachments of modernity.

First of all, it is important to outline the problem. Enrique Dussel, like Rabbat, focused on the contrary impulses of modernity, while still endorsing the postcolonial critique of its Eurocentric presumptions. On the one hand, its Eurocentrism amounts to presuming that the West is the driving force of world history, thereby presuming to lead the cultural and intellectual destiny of the entire world. Drawn to its ultimate (culturally myopic) conclusion, this type of Eurocentrism deludes Europe into thinking it has 'nothing to learn from other worlds, other cultures' (Dussel 1993: 65).[64] On the other hand, Dussel notes, modernity has produced 'a rational "concept" of emancipation', which even the most vociferous opponents of Eurocentrism usually 'affirm and subsume'. Dussel's outline proposes that there is a rational component to modernity (emancipation) as well as an irrational counterpart (Eurocentrism) – although he notes that this rational programme of emancipation is accompanied by 'an irrational myth, a justification for genocidal violence' (1993: 66). In other words, the emancipatory agenda of modernity was regularly compromised and curtailed by European imperialist aspirations whenever it collided with Europe's expedient ambitions, primarily the urge for profits (a factor that continued long after Europe's empires disappeared). The Eurocentric fallacy derives from the grandiose assumption that Euro-America is the sole preserve of the emancipation programme and everywhere else is defined as peripheral to its centrality (whether in art, politics, or culture generally). This Eurocentric centre–periphery bias regards Europeans, or Westerners generally, as the privileged agents of historical, cultural, and technological progress. Everyone else is

reduced to a bystander role as the Europeans chart a course at the forefront of human development, while diminishing all other histories that contradict its historical narrative.[65] As Dussel quips, Eurocentrism is one way for Europe to ignore its own 'partial and provincial' status (Dussel 1993: 65).

The concern with the Eurocentric viewpoint arises from its automatic identification with an enlightened, rights-based agenda without acknowledging its own curtailing of this same agenda (for instance, when it is economically expedient to do so – a familiar complaint raised about the West's responses during the Arab uprisings) or, otherwise, when it glosses over European colonial violence as well as its horrendous treatment of indigenous populations. When it comes to presumptions about modernity, it is difficult to countenance Eurocentric assumptions about being the advance guard of civilization and history considering Europe's own convulsive, traumatic, and wretched passage to modernity (which is not an ideal example to emulate as a pathway of transition to modernity).[66] A qualified explanation is therefore needed, which takes into account this complex history.

Gerard Delanty declares that European specificity does not necessarily stem from being at the forefront of championing democracy, human rights, republican government, liberty, or even freedom, which are often exclusively regarded as 'the core of European values'. Instead, the specificity of its engagement in the modernization process emerges from the way these generic ideas 'have been taken up in social struggles as well as in the institutional forms that followed from such struggles'.[67] This is another way of saying that any 'redistribution of the sensible' – meaning challenges that permit other voices to be heard or represented, or otherwise permits new actors and actions to acquire some social recognition – only proves significant for Delanty when they are reconfigured and consolidated in institutional frameworks. Such institutional recognition of previous struggles explains why GulfLabor was able to confront Western institutions about undermining their own principles in the quest for money. It also explains why, for all the talk of individual autonomy, institutions were the predominant arena around which such debates unfolded – from the opening of Mathaf, to the Sharjah Art Foundation, to the universities and research institutes of Doha, to biennials, to Saadiyat Island and the opening of Louvre Abu Dhabi.

While conceding 'there is much truth' in Delanty's point about what is specific to the European situation is the institutional recognition of struggles, Patrick Pasture questions whether this 'longing for social justice was so exclusively European'. Instead, Pasture asks whether the paths to democracy, rights, and freedom have been pursued differently elsewhere.[68] Rabbat provides an example by pointing to the more communal spaces of the mosque (the traditional site) and the square (a space of modernity) as the key sites of the Arab civic sphere. These were briefly reclaimed by the Arab uprisings, he claims. They are both places of reflection and for the exchange of ideas, which in more conducive times could act as sites of civic argument and contestation within communal settings.[69] Such a counter-tradition would mitigate the liberal individual emphasis that many claim leads to atomization, although it is not clear how amenable this model is to securing institutional consolidation of social struggles for rights and recognition. It is still an evolving situation. As these sites were quelled as places of protest, it is ironic to think that the spaces of contemporary art could perhaps be part of a wider process instigating new spheres conjoining art, culture, and education. In Rabbat's terms, they may well constitute a third social space that could perhaps help to reclaim this long-repressed tradition of civic argument and contestation in the region. Where this addition of a third space of politics, contestation, contrary voices, inquiry and questioning will lead, nobody knows, but the episodes examined in this chapter suggest it is best to remain circumspect about such a prospect.

Pasture is nonetheless wary that Delanty's cosmopolitan reading of European modernity privileges only the positive features of its heritage, particularly the focus on a 'cosmopolitan heritage of interaction and dialogue' (Pasture 2015: 84). He is equally wary of the proposition that stresses human agency is capable of transforming 'the world in the image of a possible future' because he regards this as easily leading to a 'Whiggish representation of history as one of progress' (albeit a learning process that takes into account 'regressions') (Pasture 2015: 77), which is another way of putting Benjamin's objection raised in Chapter 1. This progressive narrative too frequently envisages European culture as uniquely open and welcoming to others when its history shows it has been often closed and insular. Earlier incidences of 'cosmopolitan interactions', such as the world fairs and similar

exhibitions of the nineteenth and early twentieth centuries, showed that Europeans could only process these experiences of the 'other', Pasture contends, through the lens of 'European superiority' and a 'racist division of the world' (Pasture 2015: 81).

Another consequence of the persistence of Eurocentrism is the hierarchical evaluation of cultures that demotes so-called peripheries to the status of 'belatedness'. This model of reception has been particularly influential upon the study of modernism, particularly in the second half of the twentieth century, which has largely been underwritten by a conception of centre–periphery relations, even though, as Nada Shabout notes, early modernists were committed to 'transnational evolution of art'. Contrary to such early ambitions, however, the Eurocentric conception of modernism treats Western art as if it is 'synonymous with universal art'.[70] The pervasiveness of this centre–periphery model is one reason behind the founding of institutions like Mathaf and the Sharjah Art Foundation, although this pejorative centre–periphery mode of evaluation impacts upon the artistic peripheries of the West as much as elsewhere.[71] For this and similar reasons, the critique of Eurocentrism endeavours to puncture its definition of universal as superior as well as its image of history, human rights, culture, and society, by showing how it is limited to the guise of European singularity or, as Dussel puts it, European provincialism. It also seeks to expose how Eurocentrism serves to deny that its lofty projection is anything less than unblemished or coherent.[72] This is clearly part of the shared ambition of Wael Shawky and Amin Maalouf in articulating an alternative history of the Crusades that punctures the Western progressive narrative.

Given the myriad, valid objections to it, who would willingly identify as Eurocentric? Like 'bourgeois', 'fascist', or 'reactionary' in former times, Eurocentric is a derogatory term applied to others, but never to oneself. The resulting stark divisions triggered by Eurocentrism and its allied debates (for instance, between cultural relativism and universalism) left the way open for the kind of critique launched by Slavoj Žižek in his provocative piece, 'A Leftist Plea for "Eurocentrism"' of 1998. In this essay, the Slovenian philosopher gleefully inverts Dussel's duality and sides with the universal over postcolonialism, which he associates with an over-emphasis on specific identity claims, which evacuates any appeal to universal commitments.[73] Someone, for example may be a strong

advocate for particular rights, for instance law reform recognizing gay couples or for rights of recognition for LGBTQI people in general, while remaining impervious to migrant rights, racial discrimination, or economic exploitation and inequality because it does not directly relate to them – or their politics endorses the free market. For Žižek, there are a variety of forms of evasion that lead to various depoliticized views of society, such as the right-wing insistence on 'a *particular* communal identity'; the 'globalization without universalism' propagated by the new economies of Asia that accentuate so-called 'traditional Asian values of discipline, [and] respect for tradition' incorporated into the global capitalist framework with the 'political dimension suspended' – this Žižek dubs the 'Singapore model' (capitalism without democracy); or, alternatively, postmodern identity politics in which struggles for particular forms of recognition (sexual, ethnic, lifestyle) make their claim without transforming the whole.[74] Another way of putting this, although Žižek would not put it this way due to his politics, is that this allows for economic modernity without the institutional realization of political and civic modernity. Politics proper, Žižek counters, means that 'a particular demand' aims at a 'global restructuring of the entire social space' (Žižek 1998: 1006) or the specific predicament of inequality is raised to 'stand-in for the universal wrong' (Žižek 1998: 1002). For Žižek, this is the importance of retaining the significance of the universal in politics. Conversely, the demand of the particular claim for representation or equality is stranded as a fragment divorced from the 'universal' demand. The universal claim, he asserts, is impossible to accommodate within the existing world order without transforming it totally (Žižek 1998: 1009).

The propensity to reduce the definition of modernity to a one-sided emphasis on its 'irrational' aspect, Eurocentrism, is what permits Žižek to equate the disparaged term, 'Eurocentrism', with the vacated space of universal emancipation. By contrast, postcolonial critique conforms to the postmodern fragmentation of struggle into particular demands and this is because, according to Žižek's Marxist all or nothing approach, these particular demands do not insist upon the wholesale restructuring of society. Žižek's audacious defence of Eurocentrism elevates Dussel's 'second' characteristic of modernity – the concept of emancipation – over postcolonialism, although it leaves us with another dichotomous

formulation.[75] It reverses the postcolonial relativist drift by instead privileging universalism.

The dualistic outline helps to explain the broader ambivalence surrounding the term modernity. Many discussions of contemporary art and culture are construed as if the quandary presents a choice between being Eurocentric (and universalist) or postcolonial (and thus the politics of the particular, identity politics, as well as cultural relativism). Faced with such choices, Žižek's provocation is to argue for universalism. The schisms sharpen the questions: Is the core complaint that the modernist cultural-critical language should be dispensed with? Or does the complaint relate to the fact that its agenda has been so regularly curtailed (the negative account of Eurocentrism) when it should be made properly universal and not limited to an elite minority of the world's population? If it is the former – which asserts that we must abandon this critical-cultural framework because it is patently Eurocentric in origin – then this objection is clearly at odds with all the examples of artists, writers, and art historians who are continuing to resort to its critical conceptions (i.e. the appeals to critique, transgression, rewriting one's culture, etc.). If it is the latter complaint – and we are objecting to how this critical capacity has been regularly curtailed and made less than universal (Pasture's argument can be read in this way) – then this means seeking to gauge where this critical mission curtails its universalism – that is perpetuating and extending its reach (Žižek's provocation).

If the artists, writers, and activists of North Africa and the Middle East examined in this chapter espouse these critical conceptions, does it mean that they have now become Eurocentric too? The question of how different cultures relate and engage with each other remains as significant as ever, even though different cultures are brought into sometimes-abrupt proximity. Although Kolakowski remarked that we can differ in our opinions of art without causing profound social upheaval, this chapter has considered some cases that defy this prediction. This comment appeared in Kolakowski's 1980 lecture, 'Looking for the Barbarians: The Illusions of Cultural Universalism' (1990: 14–31), which anticipated the provocation of Žižek's 1998 essay in reclaiming the critical value of Eurocentrism. Kolakowski brings considerable nuance to the discussion by exploring the conundrums of both of cultural universalism and cultural relativism in a more exacting way. He underscores the

dilemmas of both positions. Kolakowski, for instance, is warier of universalism than Žižek, but he does not rebuke it completely.[76]

One way of understanding modern art is to think of it as an attempt to transform the Western canon by engaging with cultures other than its own in order to decentre its classical-academic orthodoxy. The first efforts at achieving this aim were infused with a kind of pan-universalism of many varieties; subsequent engagements placed the accent on cultural difference, or alterity. In response to this history, contemporary debates remain divided between the merits of universalism or of cultural relativism. In fact, they are treated as absolutes. Depending on your position, one or other of the options is simply the wrong option, a grave error reflective of bad judgement. Yet, this effort to step outside one's own culture, to escape 'the closed confines of ethnocentricity', to embark on this 'epistemological impossibility', which characterizes the efforts of artists as much as anthropologists, has a deeper history and it is an 'impossibility' that Kolakowski defends (Kolakowski 1990: 19). Kolakowski links this effort to the Western tradition, which would immediately raise the suspicion of anyone wary of Eurocentric positions, but he is far more willing to explore the paradoxical aspects of this stance than many quick to judgement. He is particularly interested in how the European cultural tradition devised ways of confronting different cultures, which he believes set an important precedent for a universalist stance, even though it was not a culture particularly prone to do so (which is why he likely would not object to Pasture's characterization of the default European attitude as predominantly closed and insular).

Kolakowski is no conventional advocate of Eurocentrism. He is frank about the limitations of the European legacy. He finds few redeeming features and many terrible aspects of the culture. He is dubious about any chauvinistic attempts to trace European uniqueness and singularity to any essentialist definition associated with race or culture (whether geographically, chronologically, or content-wise) (Kolakowski 1990: 15). These propositions are sheer invention, according to Kolakowski. There is only one distinct feature that Kolakowski is concerned to rehabilitate and that is its tradition of critical self-examination (compared to Dussel's emphasis on emancipation). The irony, according to Kolakowski's outline, is that this relentlessly inquiring aspect of its tradition did not stem from a sense of European superiority or strength. Instead,

it derived from a moment of weakness. Kolakowski has in mind the moment when Christian Europe felt encircled and diminished by 'the Turkish threat', a level of self-doubt compounded subsequently by the Reformation and the beginning of the seemingly intractable religious wars, all of which provoked intense scepticism about the robustness and worth of European culture. The sense of Christian Europe being encircled by a more prosperous Muslim culture sowed the seeds of doubt and prompted much self-questioning about what was wrong with Europe. For Kolakowski, scepticism became the first articulation of the self-questioning approach. It became a 'tradition' – for him, its most notable cultural contribution. Through the voices of Montaigne, the Libertines, and precursors of the Enlightenment, Kolakowski maintains, an unbridled contempt pervaded European thought about its own culture. It developed to such an extent that Montaigne (following Rosario)

> compared man to animals only to concede superiority to the latter, and thus initiated the trend, later so popular, of regarding the human race as a whole with contempt. Seeing one's own civilization through the eyes of others in order to attack it became a literary mannerism prevalent in the writings of the Enlightenment, and the 'others' could equally well be Chinese, Persians, horses, or visitors from space. (Kolakowski 1990: 18)

Seeing one's 'own civilization through the eyes of others in order to attack it' has long been a feature of this radical questioning, not only during the Enlightenment, and with Rousseau, but also with the Cubists, Expressionists, and the avant-gardes continuing into the twentieth century. Indeed, the same issues and ambitions remain relevant to artists seeking to inhabit the precarious transnational, transcultural realm of artistic production today.

The irony Kolakowski seeks to draw out is that the self-questioning pivotal to its cultural model actually mitigates Eurocentric grandiosity and it also rests in tension with its inclination towards exclusivity.[77] The sense of threat and perceived diminishment of European culture actually elicited its most redeemable cultural feature, which Kolakowski identifies as: 'Its capacity to step outside its exclusivity, to question itself, to see itself through the eyes of others' (1990: 18). The Europeans did not embark on this introspective questioning voluntarily or altruistically; it was

triggered by its tenuous circumstances, a perceived sense of near complete collapse, and trepidation about how it had reached such a nadir. The true strength of this tradition – its questioning mode – derives from a state of crisis and anxiety. According to Kolakowski, it provoked Europe 'to question the superiority of her values, thus setting in motion the process of endless self-criticism, which was to become the source not only of her strength but also of her various weaknesses and her vulnerability' (Kolakowski 1990: 18).

The barbaric side of the European cultural tradition is there for all to see and Kolakowski does not shy away from confronting it. Indeed, certain barbaric traits are 'indigenous', that is specific to European culture: the 'sources of totalitarianism are largely European', Kolakowski declares, traceable to 'the whole history of socialist utopias, nationalist ideologies, and theocratic tendencies' (1990: 25–6).[78] Rather than an emblem of a smooth progressive passage through modernity, Europe is the scene of some of the greatest disasters of the twentieth century and Kolakowski warns that 'Europe has not developed an immunity to its barbaric past' (1990: 26).[79] Few of its exacting critical standards were on display during the period of European colonialism when, instead, economic self-interest and a smug racial superiority held sway. Kolakowski admits all of this. Nonetheless, Kolakowski is willing to propagate a qualified universalism, which amounts to this: a persistent and troubling endeavour to critically confront one's own culture, to refuse 'to accept any kind of closed, finite definition' of it, and to affirm cultural 'identity in uncertainty and anxiety' (Kolakowski 1990: 18–19).

While it is challenging for any culture to uphold such testing principles, there cannot be quick applause for this inclination because Western universalism has a dangerous counter-propensity. The most worrying aspect of the European tradition, Kolakowski notes, springs from religious sources, particularly its pantheistic side. It is located in its penchant for 'total perfection', along with 'the wild certainty of our infinite capacity for perfection' (1990: 30–1).[80] This is the affliction of both Marxist thinking (the key target of Kolakowski's 'mature' thought), but also the utopian defenders of capitalism – the 'invisible hand' mythology of liberal economics – who, by definition, also believe in a perfect system, the market, that if left alone will move towards 'total perfection'.[81] This propensity is both complemented and compounded by the urge to uniformity,

and the eschewing of everything that does 'not contribute to the progress of science and technology' (1990: 23). This is a familiar complaint. Again, the consequences are ambiguous. For Kolakowski, the ambition results in achievements battling 'misery, sickness and suffering', but also a propensity to 'a barbarian unity built on the forgetting of tradition', the erosion of many languages around the world, including 'classical languages and historical disciplines', and an unremitting quest for standardization that is annihilating 'cultural variety' in the name of 'a planetary civilization' (Kolakowski 1990: 25). One cannot ignore the homogenizing propensity of modernist development. For Kolakowski, on the other hand, the commitment to critical questioning is the most viable feature of its legacy, the sole aspect of the European tradition 'suitable for propagation' precisely because it does not entail 'believing in an ideal world of uniformity' (1990: 23). The urge for uniformity is the reason he believes it is necessary to combat both absolute universalism and exclusive insularity.

To this point, Kolakowski's principal claims are not that different to those of Jacques Derrida in his last articulations on similar issues. When Derrida complains about the reduction of the European heritage to the 'scene of its crimes', it is because it contains an alternative possibility (again much like Dussel's second feature of modernity, the prospect of emancipation). 'Since the time of the Enlightenment', Derrida expands, 'Europe has undertaken a perpetual self-critique, and in this perfectible heritage there is a chance for a future.'[82] This roughly echoes Kolakowski's argument, although he would be cautious about the language concerning a 'perfectible heritage'. Nonetheless, Derrida aligns deconstruction with this double movement of the critique of Eurocentrism – 'since the very beginning of my work – and this would be "deconstruction" itself – I have remained extremely critical with regard to Europeanism or Eurocentrism', yet at the same time it means advancing 'a relation of Europe to itself as an experience of radical alterity', that is against hegemonies, American or otherwise, and also 'an Arab-Islamic theocratism without Enlightenment and without political future' (Derrida: 40–1).[83]

To put Kolakowski's provocation more boldly, it could be interpreted as saying one can only be postcolonial by first being Eurocentric. Kolakowski endorses 'an act of renunciation', one of suspending judgement in order to continue questioning, to

show that one's culture is 'capable of the effort of understanding another' (Kolakowski 1990: 19). A strict universalism contradicts this commitment to sceptical doubt by refusing to question itself. A strict universalism is difficult to maintain without reverting to a contemporary version of barbarism, most evident in its intolerant streak, but also evident when one believes oneself to be upholding a system beyond questioning, especially true when it is a system based on the presumption of the ultimately correct or of ultimate perfection (for who can dissent from perfection or the true?).[84] 'We behave fanatically, if we protect our exclusivity', Kolakowski contends, and this is because we presume to act in the name of the universal – again a perfected universal can only be considered 'superior' and therefore irrefutable. When we become incapable of self-questioning, of even probing the superior position, then that is the point at which we must consider that 'we are behaving barbarically' (1990: 22).[85]

Kolakowski is not squeamish about articulating the debt that contemporary thinking owes to this self-questioning attitude. Despite the various apparent schisms in contemporary debates about art and culture, a quasi-universalism prevails in its fundamental intellectual propositions. According to Kolakowski, its core commitments are the 'ability to view ourselves at a distance, critically, through the eyes of others'; tolerance in public life; scepticism in intellectual work; to confront as many opinions as possible; and to leave 'the field of uncertainty open' (1990: 22). This qualified universalism commits us to perpetual questioning, scepticism, and inquiry, which means, according to Kolakowski, not only upholding uncertainty, but also being 'able to preserve that uncertainty' (1990: 22–3).

If one was to eschew universalism completely, then the alternative might be to say that all cultures are equal and it would be improper to discriminate between them. It is a proposition that appears self-evidently fair and reasonable. But Kolakowski argues that the relativist position is regularly put to the test and found wanting when it has to confront absolute cultural relativity. For Kolakowski, there always comes a point when 'we cannot avoid having a preference' (1990: 21). Kolakowski's piercing rebuke to the proposition that one must not take sides when it comes to other cultures is that, taken to its logical conclusion, it suggests: 'That would be dreadful if it happened here, but for those savages it's just the right thing' (1990: 21).[86] In other words, we might wish to uphold cultural

specificity as an ideal, but we would not want the consequences applied to ourselves in our own situation. This is the contradictory dead end, according to Kolakowski, when declaring all cultures are equal. Conversely, the same formulation could just as easily be taken to mean that 'all other cultures are of no interest to me, and I am satisfied with mine own' (Kolakowski 1990: 21). As Nasser Rabbat (2012: 198) notes, this is precisely the conclusion drawn by some Islamic thinkers in response to the argument that modernity is so pernicious to the non-Western postcolonial world that the only feasible thing to do is to seek a return to an uncontaminated past.[87] While Kolakowski remarks that the view is 'quite prevalent', and potentially internally consistent, it is 'probably impossible to maintain coherently' (1990: 21). Besides, as we have seen in so many different examples throughout this discussion, especially with writers, activists, artists, and (some) curators, no one is freely or willingly keen to renounce their own questioning attitude, at least, not entirely.

For Kolakowski, the only way of negotiating these quandaries – strict universalism or cultural relativism – is 'inconsistent scepticism and inconsistent universalism' (Kolakowski 1990: 22). This means, as he puts it, remaining 'within certain limits, beyond which the difference between these qualified positions and barbarity becomes blurred'. It means not only maintaining a sceptical 'uncertainty' (Kolakowski 1990: 22), but also a 'double movement of … self-questioning' that preserves a state of 'uncertainty and disarray' because it denies the temptation to fall prey to beliefs in 'ultimate solutions and despair' (Kolakowski 1990: 30). As Kolakowski famously concluded, our choice is not between 'total perfection and total self-destruction' (i.e. striving to reach the end of one's culture in its ultimate realization or achieving a position fully outside it); instead, our lot is 'cares without end, incompleteness without end' (1990: 31), thus preserving this exacting scrutiny, perpetual questioning, which does not satisfy the polar positions of the complete universalist or of the complete relativist.

Virtually every artist, writer or activist discussed in this chapter is a quasi-universalist of the kind described by Kolakowski. They practise a form of inconsistent universalism insofar as they are sceptical about the Eurocentric projection of European culture as consistently progressive, uniquely at the forefront of history and holding the perfect resolution to the dilemmas of modernity with its

dual propensity to absolute uniformity, the homogenizing aspect of modernist development, as well as open and continuous questioning. Like Kolakowski, they are sceptical about the 'monstrous conquests' of the West's 'barbaric past', as well as its delusions of grandiosity (1990: 26). If we are to be consistent, however, we should maintain this scepticism whenever and wherever we discern the drift towards grandiose, homogenizing tendencies. For many, this scepticism leads to cultural relativism, which Kolakowski argues will reach untenable conclusions that even the relativist will renounce. The cultural relativist artist, writer, or activist rarely retreats from a quasi-universalist stance of commitment to sceptical questioning inquiry with its attributes of criticizing one's own culture, of submitting its assumptions to rigorous examination, and being prepared to look outside of it. It is this aspect of a self-questioning in which they confirm their qualified universalism.

In terms of this larger discussion, the challenge requires the effort to disentangle the modernist cultural legacy from Eurocentric presumptions of superiority and absolute chauvinism, its barbaric propensity according to Kolakowski. At the same time, this legacy cannot simply be dispensed with as an idle anachronism without abandoning the most active critical resources still available today. Kolakowski's provocation helps to articulate the perplexities of encountering and embracing a transcultural situation without evacuating the critical vocabulary that contemporary discourse still demands and utilizes.

Conclusion

Debates about art, aesthetics, modern and contemporary art, and so forth, are usually too arcane to attract widespread public interest. They seem too far removed from everyday life, from general social or political concerns – that is until something exceptional happens and circumstances fleetingly propel their apparently obtuse, subterranean commitments to the forefront of public attention. The series of controversies involving art in the wake of the Arab uprisings in 2011–12 provided such a rare exception and transformed a select few of the protagonists into international celebrities, whereas the others languish largely unrecognized, still engaged in local struggles.

The commitment to opening a museum of modern or contemporary art emulates the model of many rapidly expanding economies throughout Asia and the Middle East that seek to match their economic and technological modernization with cultural equivalents. Sometimes, even when everything seems so perfectly stage-managed, we find there are still struggles worth pursuing and critical assumptions worth defending. Situations are rare that can unsettle familiar patterns of discussion and lay everything bare for renewed scrutiny. As we have seen, a seemingly minor incident concerning a largely unknown installation piece by Benfodil became magnified against the backdrop of unprecedented social unrest and disrupted 'business-as-usual'. We can clarify a few things from this investigation into a sequence of disparate events that revolved around civic zones and civil action as well as the justification of questioning practices (considered more broadly than just artistic practices).

First of all, during the period of the upheavals, artists of the so-called 'peripheries' no longer felt that the commitment to challenge Eurocentrism was their sole priority – in fact, the priority of decentring the West or challenging its hegemonies could even be interpreted on occasion as a way of deflecting critical attention from pressing local considerations. Efforts both to decentre the West *and* to reckon critically with their local situation were no longer considered by artists as mutually exclusive pursuits. It is as if artists were straitjacketed; the challenge to Eurocentrism cancelled out by the accusation of resorting to purportedly Eurocentric justifications of their actions. There was a refusal to bow to this divide. The question is whether this demarcation will prevail again, as it is most likely to; all we can say is that critical demarcation accompanying this straitjacketing can no longer be considered tenable.

Second – somewhat complicating the first point – while we have been taught to be alert to the critical blind spots behind assertions of autonomy, at the same time the critical attitude to differing institutions is remarkable for its lack of nuance. In art, the prevailing attitude comes down to an opposition between either the complicity of institutionalization or freedom and critical distance. It is a simple choice, which implicitly reinstalls autonomy as an absolute. Yet, the consideration of institutions played a prominent part in the disputes and debates examined in this chapter. Depending on the stance taken, particular institutions were defended or rebuked, considered

hegemonic or anti-hegemonic, sometimes even both – as for instance was the case of the role played by the Sharjah Art Foundation, which was examined both as the repressive censor and as the harbinger of values that Kolakowski would have admired (which made it both an opponent and an ally of the critical propensities privileged within the art world). This analysis began with discussions of special civic zones linking art, culture, and educational institutions, revealing differing justifications of their purpose. Art institutions, foundations, and museums, as well as universities, no matter where they are located, are not especially immune to critical stasis, inertia, or hierarchies that breed acquiescence and reactive decision-making. Yet, they are worth defending in one respect: as arenas or civic spaces in modern life dedicated to and fostering critical questioning. At the end of the last chapter on Polke, I stated that institutions could be assessed as retrogressive by the degree to which they narrow parameters that they are ordinarily meant to enhance and expand. Now, in the wake of Kolakowski's contribution to this present chapter's discussion, we can further develop this thought. Art, culture and educational, even science and research institutions can be rightfully defended – even considered variously hegemonic or counter-hegemonic – by the degree to which they foster: the 'ability to view ourselves at a distance, critically, through the eyes of others'; tolerance in public life; scepticism in intellectual work; the confrontation of as many opinions as possible; and the capacity 'to leave the field of uncertainty open'. While some might dismiss these criteria as evidence of a prevailing hegemony, the burden of proof would rest with showing how hegemony could be sustained on this basis. Rather such an assessment would help break the automatic equation of institutionalization with complicity, and open up considered analysis to a more nuanced consideration of institutions.

Three, we have also been conditioned to think of modernism as naively bolstering absolutes. Yet, Kolakowski has shown that the two of the pivotal oppositions driving contemporary debates – cultural universalism as opposed to cultural relativism – are all too frequently considered as critical absolutes. Kolakowski disputes whether they should be considered polar opposites at all. To uphold them as sheer absolutes, as most current discourse does, is to yield to muddle-headed thinking oblivious to the barbaric propensity when taking such stances to their full conclusion, as well as to the

wider tensions in both Eurocentric approaches and the modernizing impulse. In the wake of Kolakowski, the challenge is to dismantle this strict dichotomy, which begins when cultural sensitivity is linked to cultural relativism. Cultural universalism is just as barbaric at a centre point. It is a sobering assessment, which also calls for more nuanced consideration.

When absorbed with the fluxes and flows of trends in contemporary art, it is possible to lose track of the much longer, enduring legacies. Crises can sometimes clarify what is at stake in critical axioms in an exemplary manner. This chapter is about the continuing fate of modernist cultural discourse and its legacy. Kolakowski's explorations into one aspect of this legacy offer a useful antidote to the prevailing pious discourse that pits contemporaneity against modernist anachronism, cultural relativism against universalism, saints against sinners. The dilemma is that contemporary critical inquiry relies on this legacy, but at the same time it also requires the rethinking of how they have ended up as binary oppositions that petrify inquiry. This ongoing process of elaboration requires new art-historical models and conceptions – and this is the topic of the final chapter.

CHAPTER FOUR

Inversions and aberrations:

Visual acuity and the erratic chemistry of art-historical exchange in a transcultural situation

The previous chapter began with a story about a new museum of modern Arab art, which was heralded as an institutional testimony to an overlooked history – not a late history, but an overlooked one: Islamic modernity in an intercultural framework. This process – alongside the widespread biennials of art from Gwangju to Sharjah, and from Istanbul to Dakar – is often considered evidence of an expanded global terrain of contemporary art practice. As we have seen, many observers have declared that the period of the extreme geographical confinement in which 'all stories of modern art have been told by Europeans and Americans about Europe and America' is emphatically over.[1] The new transcultural configuration has been dubbed the 'internationalism of the regional', if not the triumph of the provinces, elicited by the biennials of the 'south' over many decades that have forged multinodal points of interaction and experimented with 'alternative modes of cultural exchange'.[2]

One presumption that follows this expansion of transcultural awareness is that there might be a concomitant diversification of art-historical approaches in response to this proliferation. For his part, Paul Wood attempts to undercut the constant promotion of this fictional geographical confinement of the world to a Euro-American standpoint by showing that a much wider art history of cultural interaction was more the norm for Europe than it was the exception. Similarly, in the previous chapter we saw that Leszek Kolakowski disputed that European distinctiveness can be traced to any unique cultural, historical, or racial source. With such decentring, it might be possible to declare that the moment of this particular cultural hegemony might be over, but it does not mean that narrowly based North American–Western European perspectives have suddenly disappeared. As Anthony Gardner observes, this does not mean that asymmetries of power between centres and peripheries have dissolved – rather, such asymmetries have instead become 'more flexible and more slippery'.[3]

But what does the idea of a centre imply, even if it is somewhat displaced and more flexible? Scepticism about a renewed and expanded global terrain suggests that an expansion and diversification of art-historical approaches is not occurring. The rise of institutions dedicated to developing global networks in an expanded cultural terrain is simply producing standardized programmes of exchange and all the frenzied travel of art curators and directors is equally yielding a homogenizing approach. In other words, as James Elkins asserts, the limits of a new global art history are the 'unacknowledged dissemination of European and North American models of art-historical writing (including the symposium and seminar formats, the institution of departments of art history, and the de facto definitions of the discipline) and the global use of principally western European theoretical models'.[4] Despite all the emphasis on alternative, transcultural modes of exchange, such sceptical warnings puncture the postcolonial art-historical counter-image of a flourishing receptivity to diversity by instead asserting that all that we are witnessing is the perpetuation of the same – the projection of Western frameworks of understanding in the absence (or sparseness) of viable alternative formulations.

The implications of this assessment are not as obvious as they first sound. For a start, how would anyone coming from a Euro-American centre recognize these alternative modes if they came

across them? After all, the argument is implicitly suggesting that a cultural hegemony is in place from which they will discern an alternative only with great difficulty. At the same time, there may be an unacknowledged point to such an argument. If every place in this 'global circuit' were locally specific, thus singular, how would anyone determine whether its cultural achievements were 'worldly' as Terry Smith insists? And how would someone grasp and interpret the distinctiveness of a local specificity if it departed too far from familiar, more widely familiar frameworks of recognition? 'Worldly' sounds like another name for some degree of universality (except that prospect cannot be acknowledged due to its Eurocentric connotations). Of course, one immediate retort would be to say that the North American–Western European framework of understanding has always masqueraded as universal when in fact it is far from this and, furthermore, it is *not* a consistent entity in itself, even when assuming to speak in a purportedly universal voice. Who is at the centre of everything? After all, even those who presume to be at the centre are plagued by the idea that they are missing out on something because the projection of coherence eludes even the centre. This kind of debate suggests an impasse rather than any opening up to greater diversity.

The previous chapter not only told a story about new institutions of modern art, but it also explored the types of discourses purportedly attendant with such institutions. Themes of modernist belatedness rarely entered the discussions. Instead, the complexity arose whenever considering whether we are encountering a new 'internationalism of the regional', the internationalism of various specific cultures, or even an internationalism of various specific histories of modernism. Hence, Chapter 3 explored the consequences of equating the transcultural position with cultural relativity, while abandoning any hint of cultural universalism. Were artists of the Arab and Asian worlds inadvertently upholding Eurocentric positions when resorting to universal propositions to defend their practices in the face of censorship or arrest? In considering the reasons why contemporary art might pose particular difficulties in these contexts, the discussion explored Kolakowski's defence of critical questioning. Clearly contemporary art regards itself as a key avenue of critical questioning in our world today. But just like other such avenues of exploration, including the free press (whatever that means today), universities, and research institutions,

this is often more the ideal than the reality, with plenty of compromises involved. For some, this idea of contemporary art would simply represent the extension of liberal Western hegemony. On the other hand, the resort to such propositions – even their critique – exposes the indebtedness to a legacy that many prefer to repudiate than to acknowledge. Despite the denials and critical demarcations, the quandaries that Kolakowski is willing to explore and tease out are better regarded as still pivotal to these discussions, including those seeking to foster transcultural awareness, because he confronts the polar stances of cultural relativism and cultural universalism as critical absolutes. Kolakowski's keenest insight pertinent to this discussion is in pinpointing where and how justifications rely on the very same set of propositions they presume to have surpassed – for instance, the example of critical, postcolonial informed attitudes circulating around contemporary art that presume to have escaped any reliance on universal propositions, which renders many of their positions nonsensical.

If one is sympathetic to advancing a new transcultural understanding of contemporary art then such a schism is not only untenable, but also unnecessary – although that is where the complexity really begins. But what of the other key opposition: between cultural centres and peripheries? These are all difficult and complex considerations – especially if they require unravelling the seemingly firm oppositions that secure certain cherished critical positions. Similarly, the dismantling of this hierarchy demands an imaginative diversification of art-historical approaches that is capable of reconceptualizing the model on which it is based.

The problem of centres and peripheries

The once red-hot question, 'What was modernism?', as the philosopher Robert Pippin observed, 'has not been on the front page of aesthetic theory for some time'. The effort to explain away modernism, Pippin notes in passing, has been overtaken by the inquiry into '"alternate" or basically non-Western, non-canonical modernisms'.[5] The waning of this once-intense interest perhaps suggests the waning of the quest for surpassing terms – although the influence of postcolonial and post-Western presumptions did prompt

a resurgence of the quest. Ironically, the prospect of an expanded global terrain as well as notions like the 'internationalism of the regional' has been accompanied by a renewed inquiry into modernism and modernist culture in general. But this inquiry also regards the centre–periphery hierarchical distinction as an impediment to the flourishing of a more open and diversified inquiry, which is why any perceived attempt to reinstate the former orthodoxy of stories of modern art 'told by Europeans and Americans about Europe and America' necessarily attracts intense scrutiny. A flashpoint for these debates in the first decade of the twenty-first century was the study of the 'advanced art' of the twentieth century produced by the art historians Hal Foster, Rosalind Krauss, Yve-Alain Bois and Benjamin Buchloh, best known for their collective editorship of the journal, *October*, which originally presented itself at the forefront of equally advanced and innovative art-historical inquiry.

Their book of 2004, *Art Since 1900: Modernism, Antimodernism, Postmodernism*, was condemned by Polish art historian Piotr Piotrowski for ignoring local art production in favour of reinstating the old centre–periphery model with its 'hierarchically defined art geography'.[6] For Piotrowski, this approach meant a 'vertical' model of art history in which everyone follows the leader. Instead, Piotrowski advocated a move to a more polyphonic, horizontal inquiry characterized by attention to stylistic heterogeneity. The horizontal approach instead sought to explain how a combination of styles could transform into idiosyncratic local mutations that remained inexplicable to a centralized system of evaluation. Horizontal art history would seek to accommodate 'local canons and value systems' as well as to discern what 'a given influence meant in a specific local context'.[7]

In a similar vein, Geoffrey Batchen argued that if one wished to proceed with a 'business as usual' approach to art history, then *Art Since 1900* represented its retrograde prototype. For him, the book was not only culturally myopic, but also constituted a belated attempt at a canonical and restricted vision of modern art. Another irony is that, if this charge is correct, it went against the impetus of a renewed inquiry into modernism that was more attuned to Piotrowski's call for a more polyphonic, horizontal inquiry attentive to stylistic heterogeneity. For Batchen, the book's essentially chronological account of 'advanced art' fails on two fronts. Naturally, its most obvious shortcoming, Batchen believes, is

the geographically restrictive concentration on Europe and the United States. This in turn perpetuates more telling conceptual shortcomings, such as the idea of 'a one-way flow of power' and a traditional privileging of *transmission* at the expense of *exchange* (this one-way model of dependent transmission had already been the subject of criticism since the late 1960s and early 1970s, as we will see below). Tied to this geographical constriction are theoretical assumptions that Batchen regards as equally odious. It presents 'history as a natural process: organic, inexorable, inevitable'. Yet this inexorable vision of twentieth-century art progress subtly reinforces an adversarial conception of art: artists compete in 'a percussive, survival-of-the-fittest, evolutionary model of history'.[8] *Art Since 1900*, according to this assessment, rejoices in a hermetic model of art that privileges art criticism over art history, transmission over exchange, art disconnected from life, and a definition of modernism disconnected from the more complex reality of modernity 'as a complicated and heterogeneous economic and cultural phenomenon'.[9] The trigger behind such dismissals is that the perpetuation of such models of art history serves to impede or obscure more diverse models of inquiry and assessment.

One tactic is to switch the power axiom around by suggesting instead that the peripheries are central today, in the process pointing out that the presumed centres have always been to a greater or lesser extent provincial in their outlook. Is this simply an inversion tactic? Or is the general proposition simply true? If so, the question is how this reconsideration can be effectively managed without repeating the conceptual failings mentioned so far, but in reverse. It prompts more questions than it resolves: How does someone – by weight of where they live – grasp the true situation better than someone else? How could a person coming from a North American–European art-historical perspective ever recognize a model that is so different than anything else they have previously encountered? If the argument is that the global, transcultural trend is simply an implicit extension of the same narrow North American–Western European framework of comprehension, then how would someone from outside that familiar ground of recognition know this for sure, even if they were willing to question these limited parameters? By definition, the centre only recognizes the evaluative criteria of the centre. It is much easier simply to presume that familiar ways of operating remain unchallenged and in place.

To say that a work is derivative or provincial is one of the most familiar ways of pronouncing a negative aesthetic judgement.[10] By derivative, the suggestion is that the work is relatively easy to discern because it is clear what is going on, and the sources of its influence are obvious. The implication is that such a work is routine, and an almost unthinking recapitulation or reflex of familiar influences, thus lacking genuine spontaneity or innovation. This point is actually acknowledged in the literature striving to dismantle the grip of the North American–Western European cultural hegemony (as we will see below). At the same time, how can anyone be completely confident that his or her judgements and pronouncements remain safely immune from the accusation of being derivative or provincial? The great advantage of centrist thinking is that it can apparently remove such doubt. As with the terms like the cultural barbarian, the Eurocentric, or the petty bourgeois, the designation, 'derivative provincialism' always applies to elsewhere, usually to those people found in less culturally 'central' locations, and rarely to the person making the charge, of course. We will wait a long time before reading of a critic or art historian confessing their incapacity to pronounce judgements due to their derivativeness or provincialism.

It is not surprising that this conception derives from an imperial model in which the aim was to ensure the transmission of authority from the centre to the remote colonies or the peripheries. In the obscure, far-flung outer regions it was feared that cohesion and authority could always be undermined, even if inadvertently. (Of course, history shows that imperial centres are just as culpable of inadvertently undermining the whole scaffolding of empire, sometimes even more so!). Many forms of political organization have since replicated this centrist model (whether official, including diplomatic channels, or in clandestine or underground organizations). Their consistent goal was to ensure 'discipline', which meant that unreliable or wayward outliers did not go off-message or rambling in their own independent paths, thereby diluting central authority. The centre thrived on dependence; without it the whole structure could not be made secure.

In a purportedly more diverse and global cultural scenario, the differentiation of the culturally central from its derivative, the provincial or peripheral, seems clumsy and mono-dimensional, if not extremely patronizing. Of course, it is the cultural and

geographical 'peripheries' that are invariably tainted with the association of 'derivative provincialism'. Power relations remain intact, but one could argue that this is because the centres have lacked the imagination to devise more dynamic and exploratory alternatives. Switching the emphasis to the 'locally specific' does not therefore mean that the 'worldly' implications of every specific location are instantly acknowledged. In fact, due to the negative connotation of the specific as peripheral, it means that the worldly aspect of such art needs to be more keenly and imaginatively justified by peripheries.

Is standpoint aesthetic new and how would we know?

A recent account of 'standpoint aesthetics' seeks to delve into the realm of alternative modes of cultural judgement. It primarily responds to the challenges resulting from what Terry Smith identifies as 'the postcolonial turn', which he presumes to have reshaped the contemporary art world.[11] Standpoint aesthetics assumes that 'knowledge is always socially situated' and therefore, as authors David Gandolfo and Sarah Worth contend, it incorporates power relations into aesthetic considerations.[12] Power relations pervade one's cultural perspective, no matter where one is situated. Therefore Gandolfo and Worth claim that 'circumstances, fortunate or unfortunate, centered or marginalized, give legitimacy to one's standpoint' (2015: 251). Although the key tenet concerning power relations and the socially situated would be recognizable to anyone familiar with the legacy of the social history of art, the benefit of the standpoint aesthetics approach is in attuning aesthetic inquiry both to a transcultural condition and an inquiry into alternate, non-Western or non-canonical modernisms and thus in suggesting that these alternatives are as valid as any other consideration because it is the standpoint that confers the legitimacy of the work.

By locating culturally or socially situated standpoints firmly within aesthetic thinking, the argument implies that cultural standpoints stand as the sole measure of aesthetic and cultural worth. Of course, this raises the immediate objection that this amounts to an argument for cultural relativism and the justification of everything anywhere

as equally valid and legitimate. Gandolfo and Worth, however, rebuke the claim of cultural relativism. Not everything said or done from a marginal standpoint is automatically correct or convincing; hence, they argue it would be pointless to proclaim that 'only art that comes from, or is informed by, the margins is legitimate' (Gandolfo and Worth 2015: 242). This difficulty is well recognized. On the one hand, it points to an artistic-cultural hierarchy that remains comfortable with the established order; on the other hand, it points to the defensive reaction to this hierarchy—the extreme reticence to differentiate between any works or practices from the margins, particularly if the art comes from indigenous artists or communities. In theory, it is different though. Even though agitating for the switching from a model of cultural transmission to one of exchange, Batchen concedes the drawbacks of cultural relativism in advocating for the 'locally specific'. He notes two: first, such alternative strategies may 'celebrate mediocrity in the guise of defending regional specificity'; second, they may 'explain away the distinctiveness of regional art practices as an exotic form of isolated primitivism' (Batchen 2014: 11).

To avoid the trap of relativism, Gandolfo and Worth declare that standpoint aesthetics does not presume that 'whatever the marginalized hold to be true is indeed true' (Gandolfo and Worth 2015: 246). Despite this qualification, the authors simply reorient the discussion by arguing that standpoint aesthetics seeks a place at the table for art from the cultural and artistic margins because it does what art does best: It discloses in a particularly poignant way an insight or vision that would otherwise remain hidden' (Gandolfo and Worth 2015: 242). While the aim of standpoint aesthetics is to advance an understanding conducive to a new transnational situation, the core claims about art's purpose are not new or unique. First of all, it relies upon a transgressive model of art, even if it now associates this transgressive propensity with marginal positions. In addition, as we have seen in the previous chapter, the assertion that the role of art is to reveal the hidden or unseen constituted a major justification of art throughout the turbulent period of the Arab uprisings throughout 2011–12 (witness the example of the Algerian artist Benfodil in defending his work when it was withdrawn from the Sharjah Biennial, although this aesthetic justification of exposing the hidden made no difference in the end). The emphasis on exposing the hidden is not only a

transgressive, non-traditional conception of art, it conforms to the general outline of Jacques Rancière's conception of the aesthetic regime and the redistribution of the sensible (Rancière 2004). For example Gandolfo and Worth argue that the benefit of highlighting the point of view of the marginalized is that it exposes what is 'actively hidden by the standpoints of the powerful' (Gandolfo and Worth 2015: 245). What is primarily hidden is how 'the distribution of power in society affects what is accepted as "known"' (Gandolfo and Worth 2015: 245). Standpoint aesthetics thus emphasizes how art disrupts the status quo by making us acknowledge 'the existence of the margins'. In addition, it also seeks to expose the partiality of the centre by allowing it to be seen from the perspective of the margins (Gandolfo and Worth 2015: 246).

While references to 'glocalization' (simultaneously local and global) have become common rallying cries in this debate, standpoint aesthetics nonetheless seeks to develop an alternative to the centre–periphery transmission of artistic influence.

Gandolfo and Worth argue that the insertion of the marginal into the centre of cultural discourse is likely to provoke reticence and resistance because it is disruptive of unquestioned assumptions, and it exposes 'a reality that is ugly' and unjust (2015: 246). This disruptive approach is one that Batchen would also like bring to art-historical inquiry in general because it exposes how art and its study remain indebted to a neo-colonial vision amenable to 'the world's economic and political centres'.[13] The intrusion of this alternative, marginal perspective, Gandolfo and Worth insist hopefully, inverts the usual reference points of the aesthetic: 'Viewing the center from the margins casts the former in a different light, highlighting truths that the center does not want acknowledged' (Gandolfo and Worth 2015: 246).

Even when favourable to such a dismantling of cultural hegemony, many take the attitude that it is better to idealize faraway places than actually visit them; theory is best left intact and undisturbed if it is envisaged from North America or western Europe. It is possible to extend Gandolfo and Worth's point and to argue that the key thing that any centres do not want acknowledged is an alternative framework to their own. Traditional cultural and intellectual-academic centres are happy to embrace marginality, so long as it is within their own terms and remains affirming of their centrality. The idea of emphasizing cultural peripheries

from the perspective of their respective standpoints is therefore very useful. Yet, it is surprising that no one has ever thought of it before. What if there have been precedents to this alternative conceptualization, how would anyone know? If it is true that the traditional intellectual, academic, and artistic centres still control the debate, then it is likely that the history of attempts to address the topic of art from a peripheral standpoint will remain obscure – even to people promoting this argument.

Aberrations and inversions as alternative art-historical models

Positions envisaging an alternative to the centre–periphery transmission of artistic influence have been around for decades.[14] So what explains the continuing obscurity of counter-models to the centre–periphery? While Brazilian counter-models belatedly captured attention with the vivid example of '*Antropofagia*' (cannibalism), which aimed to herald some degree of autonomy from the dictates of foreign cultural impulses by accentuating their own exoticism with a precarious juggling of the primitive and the modern, it is indicative of the scarcity of strong cultural counter-models that to date an art-historical south-south dialogue has yet to develop in any sustained manner.[15] For instance, Geoffrey Batchen's claim for the importance of cultural exchange (over a model of transmission) occurs within the context of an exposition of antipodean art-historical inquiry, which has long been preoccupied (if not obsessed) with a geo-cultural framework of understanding.

Of course, it is thoroughly inconspicuous internationally, even though it anticipated the arguments of a standpoint aesthetic by forty years. Its guiding frameworks are largely based upon time–space metaphors: time lag, delayed transmission, tyranny of distance, strange inversions, and, naturally enough, the diagnosis of a centre–periphery model of dependent influence.[16] Batchen's condensed account of antipodean counter-models daringly suggests that they possess universal significance because they indicate how critical formulations can be conducive to 'our permeable, post-colonial, global present'.[17] Part of its challenge involves an overhaul of the history of modernism, not in order to dispense with

it, but to make it more conducive to the contemporary situation. In Batchen's words: 'The call is for a history of modernism that ... can effectively tell the story, not just of the origins of modernism, but also of its production, dissemination, transformation and rejuvenation in places other than the world's economic and political centres' (2014: 12). The gold standard of such an alternative inquiry is, not surprisingly, to demonstrate how 'modernity ... is simultaneously local *and* global'. Batchen thus approvingly cites Okwui Enwezor's call for a 'provincialized modernism', which would acknowledge that today the art world is comprised of 'multiple centres', characterized by a variety of 'local modernisms' (Batchen 2014: 13).

Pivotal to Batchen's exposition is the alternative art-historical inquiry proposed by Ian Burn, who was primarily associated with minimal and conceptual art, in particular Art & Language, before returning to Australia to work in trade union media services and to develop an independent art-historical writing.[18] Burn's analysis of Australian artist Sidney Nolan's painting *Railway Guard, Dimboola* (1943), first published in 1984, explains how the artist sought to integrate both a 'cubist and naturalistic pictorial space' in his work. This seemingly incompatible mixing is often regarded as a quintessential hybrid, off-centre formulation, primarily addressed to resolving provincial artistic issues. Nolan tackles this kind of provincial-centre juxtaposition, Burn argues, in order to engage with the particularities of his local context, while still managing to stay within a resolutely modernist conception. Rather than disparaging local concerns and practices as derivative or provincial, Burn asserted that Nolan's maintenance and accentuation of such contradictions has proven an impetus to local 'cultural expression'.[19] Through examples like Nolan, Burn was anticipating Gandolfo and Worth's argument by a few decades: like them, Burn asserts that the telling consideration is the engagement with the particular circumstances of local conditions that gives 'legitimacy to one's standpoint'. These may not look like adequate resolutions to the centre, however, so the simple act of explaining the complexity of these examples is not sufficient to be convincing. Unequal power relations need to be explained too.

A decade prior to Burn's essay, an article by Terry Smith published in *Artforum* in 1974 presented Nolan's career as exemplary evidence of unequal cultural transmission and thus of the 'provincialism problem'. Nolan's recognition is always qualified; he is regarded

as a 'great Australian artist', Smith argued at the time, whereas Jackson Pollock is simply viewed as a great artist, being American is 'a secondary aspect of his achievement'.[20] When a national description accompanies the mention of a notable artist, it invariably serves as a qualification indicating a secondary level of esteem. The provincialism problem sets out to explain how a cultural-national hierarchy relegates anything unfamiliar to a subsidiary level and thus how the centre–periphery model of transmission runs 'one-way'.[21] At the peripheries, Terry Smith contends in his influential essay, the problem impacts in the form of 'an attitude of subservience to an externally imposed hierarchy of cultural values'.[22] The model for the provincialism problem drew from economic analysis – the political economy of international relations that diagnosed the perennial inequity in international trade and economic relations (e.g. underdevelopment thesis, the north–south divide), which perpetuated inequality due to differential terms of trade favouring the advanced industrial centres.[23] According to Smith's cultural-artistic inflection of this problem in 1974, the cultural centre sets the agenda, both culturally and critically, spreading word on the latest critical insight or aesthetic breakthrough and transmitting it back to the peripheries to emulate. One always remains provincial in relation to the dominant centres no matter how hard one tries to escape the clutches of this dynamic. Influential centres like to determine what art practices are significant as well as the manner in which they are interpreted and understood – that is they seek both to be the centre of artistic attention and of debate. The centre–periphery structure of interpretation inserts power relations at the centre of art-historical inquiry, thereby showing how artistic and cultural relations can be just as pernicious as economic ones.[24]

In the decades since the publication of Smith's article, the economic focus of the world has shifted dramatically, so wouldn't one expect the same of the cultural scenario too? That said, the limitation of the centre–periphery interpretative model is its stasis and, like many methods drawing from ideology critique, it can presume too much power. The powerful centres exert their power completely and they never change because the system sustains itself almost perfectly. There is no outside to this dynamic and no possibility of transforming it from the periphery. As Ian McLean observes, whether it be the 'relentless entrapment' of provincialism or the 'hegemony of Eurocentrism', a critical diagnosis that was

originally 'meant as a provocation … only confirms the ideology each protests'.[25] Just as the economic framework of the world has transformed dramatically since the 1970s with the shift to the Asia-Pacific region, so too new art-historical models need to be developed to accommodate changing circumstances.

This does not necessarily require an argument for a cultural paradigm, even though this would be the route ultimately taken by Terry Smith with contemporaneity. Batchen's solution is to seek a new art-historical inquiry that regards modernity as a phenomenon 'happening everywhere at the same time, even if to different degrees and with different effects'.[26] He upholds Burn's reading of Nolan as an exemplar due to the way it mediates between the local idioms and modernism in general, thus emphasizing cultural exchange as the pivotal aesthetic provocation. For Burn, by this point, it was no longer adequate to decry the inequities of the centre–periphery model, but instead it was necessary to think through the restrictiveness of this model from which it never seemed possible to break free once it was encapsulated in this manner.

The analysis of Nolan's painting was a step on this path. His work at a particular point in time, according to Burn, conjoins unfamiliar pictorial elements from competing traditions: bold modernist abstraction, containing sections of stark primary colours, intersecting a pictorial template drawn from a specific pictorial language, the local Australian pastoral landscape tradition. This local tradition is in turn dissected by the industrialization of the landscape, which intrudes into the local rural economy as much as it does into the pastoral landscape genre.[27] The central figure is a railway worker staring blankly out of the picture plane at some vague point in the distance. His vacant expression suggests there is no one with whom to reciprocate, although Burn's analysis suggests there is everything to see. Behind the guard, the dry yellow–brown landscape stretches flatly, almost vertically, up the expanse of the canvas and thus the picture surface, both mimicking the view of an extended landscape and the bare plane of the painting's surface. The parched, sunburnt skin of the guard actually appears as if a continuation of the arid landscape behind the figure, although the face also appears intrusive because it is pressed as if against the pictorial surface and smothering every viewpoint. A slender, light blue bar of colour evoking the skyline at the top caps the chaotic jumble and, as Burn suggests, secures the entire scene from

complete fragmentation.[28] These features Nolan draws from the visual schema of the pastoral landscape tradition, particularly the framework developed by his forebear Arthur Streeton, in order to work through it as an impediment.[29]

As a consequence, figure and ground are deliberately confused in Nolan's painting. While the guard's portrait dominates the centre of the work, the visage is dissected by the railway signals that stand simultaneously and incongruously both in the background behind the figure and in the foreground before the worker's face. The signals, tracks, and other rail yard implements cut across the surface of the painting leading the eye in certain directions, while also jarring it with a jumble of oddly intersecting physical features and industrial equipment. The resulting picture seems impossible to stabilize. While the railway network, as mentioned, quite literally denotes the modernization of the rural countryside, Nolan revels in the pictorial dissection of the idyllic pastoral landscape depicted by an earlier generation of artists, a genre that was largely devoid of any human (white settler) or industrial impact. Nolan instead brutally rams these features into the heart of the local pastoral landscape painting tradition.

None of this would be evident to a viewer unfamiliar with this specific art-historical context. If there is some wider significance to be drawn from these ruminations into a peripheral art history, as Batchen hopes, then it stems from the fact that Burn detects a different orientation to modernism found in the pictorial aberration produced in Nolan's painting.[30] It is not passive in its reception and it is not derivative. It does not act as if there were only one direction to follow. Instead, its pictorial deviation derives from drawing together seemingly incompatible pictorial and cultural standpoints to reach a new solution. As Burn puts it:

> The spatial complexity of *Railway Guard* ... is neither a mess nor confusion. ... Nolan has not tried to supress or gloss over incompatible elements: different intentions, artistic conventions and even cultural needs coexist and are set side by side. The picture has a richness, which allows us to relate to quite contradictory factors, with enthusiasm and self-confidence.[31]

The result looks like a mess because it contains a jumble of visual references lacking any ostensible pictorial resolution. Yet, Burn

contends that this apparent irresolution betrays a keen visual awareness that, in turn, articulates a wider cultural complexity. Nolan is alert to visual attentiveness at the margins – that is at the cultural periphery – by combining modernist impulses with local traditions, such as the Australian landscape painting tradition, that are unknown in the pivotal centres of influence.

Nolan's painting is evidence of 'an ironic relation to European modernism', Batchen argues, but he goes further: 'Nolan takes whatever he wants, with no particular subservience to chronology or style or respect for context.'[32] This is perhaps more exuberant than Burn intended, but he is correct to discern in Burn's reading of Nolan's painting nothing less than an attempt to offer an alternate, non-canonical, yet nonetheless sophisticated art-historical inquiry into a 'provincialized modernism'. For Batchen, Burn's insight is to '*exacerbate into visibility* the peculiarly uneven development of modernity across the globe' by developing 'an historical model attuned' to 'negotiations of centre and periphery' (Batchen 2014: 11) and this negotiated condition of cultural exchange is far more prevalent than the usual one-way mode of transmission. Indeed, we can understand the ambition behind Burn's analysis of Nolan – he was writing ten years after the 'provincialism problem' – as an attempt to conceive a new critical path that engages with the dilemmas of provincialism, but also thinks outside its binds and limitations.[33]

Burn's reading of Nolan moves beyond the abstract outline of standpoint aesthetics or the centre–periphery dynamic to provide insight into a concrete example of a counter-model in practice. Rather than position a marginal or provincial position as an insurmountable cultural impediment, Burn's reading of Nolan shows how a nuanced visual attentiveness arises from alertness to geo-cultural specificity as well as confronting seemingly contradictory pictorial systems. The visual attentiveness at margins that Burn detects in Nolan presents a vivid alternative form of art-historical inquiry emanating from the negotiation of cultural peripheries that grapples with modernist impulses and local traditions. At the same time, Burn recognized the potential problems of the alternate system he was demanding. On the one hand, an increasingly decentred world would require more agility in explaining a wider range of contexts, each with different traditions, experiencing vastly different circumstances of modernist reception, 'production, dissemination, transformation

and rejuvenation' (Batchen 2014: 12). This was no minor challenge. On the other hand, he anticipated the dilemma of relativity much earlier: that is the problem of presuming that 'only art that comes from, or is informed by, the margins is legitimate' (Gandolfo and Worth) or, otherwise, of celebrating 'mediocrity in defending regional specificity' (Batchen). For Burn, one's cultural standpoint could never be a sufficient factor in itself. He was highly critical of visual art that was not 'visually intelligent' – that is art that did not engage sufficiently and strenuously on a visual level – but instead relied on rhetorical justifications for its validation.

Ian Burn on visual acuity

Ian Burn wrote a number of articles after publishing his collection of essays, *Dialogue* (1991), which maintain the geographical or cultural location focus of standpoint aesthetics, but extend the proposition about visual attentiveness at the margins well beyond a cultural-geographical consideration.[34] The tenor of these pieces differs from the writings for which he is best known, whether they be the essays on centre–periphery relations or his well-known pieces on the political economy of the art world, such as 'The Art Market: Affluence and Degradation' (1975) or 'The 1960s: Crisis and Aftermath' (1981), the latter introducing the question of the deskilling of art.[35] Burn's last writings address ways of overcoming the pitfalls of arguing that the marginal or peripheral is important simply because it is overlooked, while still advancing the cause of alternative art histories. At the same time, the rhetorical stance of much postmodern work and theory as well as many post-conceptual art practices prompted Burn to reconsider the legacy of conceptual art.[36] There had to be alternative criteria for assessing the visual perspicuity that did not reduce the work to a cipher for arguments – the latter meant that works just had to be recognized and a viewer could quickly discern the point. The archaeological turn has further accentuated a process of moving away from looking to reading – what in 1991 Burn called 'the tendency for the art to be read and not looked at' – by presenting viewers with meticulously researched individual components within an exhibition, yet which often (at least, at its worse) presents little sense of visual coherence or relation between the various objects on display. In other words, such artists

may be judged by their incapacity to visually communicate. Writing in 1991 about an early form of this tendency, Burn complained:

> Many works of art today are conceived to be only read and are designed to function only as such surfaces. An analogy that keeps coming into my head is of a painting being designed like flypaper, grabbing at bits of text as they fly past; then someone comes along and writes about what has stuck to the flypaper but does not bother to look at the flypaper itself. Personally, I prefer an art, which generates its own options and is in control of its rhetoric.[37]

An artwork being in control of its rhetoric is an almost utopian ideal that Burn retained, but the significance of his last writings is to confront the counter tendency to regard works as surfaces for arguments. This small group of writings from the early 1990s revisit the legacy of minimalism and conceptual art in order to show that its legacy should not be understood, as is almost taken for granted, as a shift from a perceptual to a conceptual emphasis. Rather, his

FIGURE 4.1 *Ian Burn,* Five Glass Mirror Piece, *1968, glass and wood, 40 × 27 cm. Courtesy of the Estate of Robert Hunter and Milani Gallery, Brisbane.*

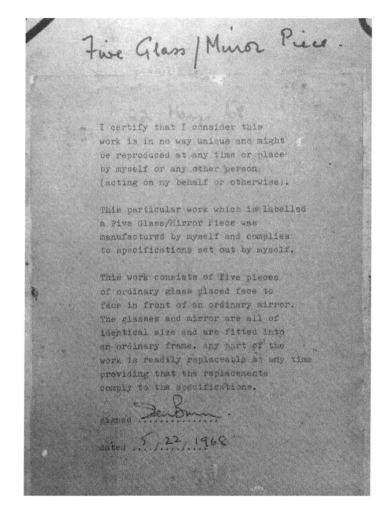

FIGURE 4.2 *Ian Burn,* Five Glass Mirror Piece *(reverse), 1968, glass and wood, 40 × 27 cm. Courtesy of the Estate of Robert Hunter and Milani Gallery, Brisbane.*

aim is to show how such work grappled with both dimensions to an almost exaggerated degree.

By working scrupulously at the edges of the visual, Burn argues that visual art displays its 'acuity' – a term Burn developed to explain the retention of a focus on the perceptual (or sensual) in

the *wake* of the challenges of conceptual art.[38] The challenge lies in being willing to risk one's expectations about how and what one might see. Artworks that stall or hinder the propensity to overlook the visual equally seek to stall the temptation to look *through* the visual, as if it contained a clear and transparent 'message'. Such a presumption assumes that the visual requires no more than a passing glance. Burn explains how the act of dense overlaying in Jasper Johns's *0 through 9* (1961) influenced his thinking about how visual art works in the opposite direction when at its best:

> You *can* read each numeral, but it takes a considerable effort, and after you've gone through that process it's as if you've gained nothing. Perceiving it is like a process of retrieval – seeing what you can read and reading what you can see. … What interested me about the work was the way it managed to position the viewer in conflict between looking and reading, which encourages a critical awareness about what your eyes are doing.[39]

For Burn, the most valuable works of art interrogate 'the visual in quite specific and profound ways', often at the 'borders of perception', and the ability to do so 'gives the work its acuity'.[40] This point about an accentuated visual 'awareness' reappears in an observation about testing the limits of everyday perception:

> It's easy to take for granted how we see things. But if conditions are placed on my seeing – say, I'm asked to look at an object for one minute without blinking my eyes – then the object shifts out of focus and I become more aware of certain physiological sensations associated with perception. Such awareness can also be induced by works of art, which make unexpected demands on the visual competences of the viewer.[41]

Many of Burn's writings begin by addressing a similar set of everyday propositions concerning visual perception, including the familiar supposition that the visual is a transparent, automatic phenomenon summed up by the ever-seductive dictum: 'Seeing is believing'.[42] In direct contrast, the 'visual intelligence' that Burn finds genuinely engaging accentuates visual awareness by challenging it and putting it to the test. Here, Burn returns to themes that had fascinated him since the mid-1960s, such as visual illusions, limit conditions for viewing, and 'what happens when you paint such an illusion' and

include it in a painting.[43] Burn equates the seemingly cryptic nature of the minimalist and conceptual art strategies of the 1960s and 1970s with subtle quandaries about the limits of everyday visual perception.

Such art stems from a confrontation that impinges upon one's ordinary expectations of the visual. This visual acuity can be discerned in the most extenuated of circumstances, such as being forced to extend one's visual focus for a long time – or in confronting a work that does not reveal its visual intent so readily, or brings together precepts that are not readily familiar. Visual acuity functions at the edges of visual perception by testing, teasing, and even straining it. Good visual art exerts a different order of challenge at the level of the visual. Art displays its intelligence visually – even if the work seems to downplay or deny the visual. This is the consistent theme of Burn's last writings – and this is what he retrieves from the legacy of minimal and conceptual art. The art of 1960s was 'rediscovering the beginnings of modernism', Burn argues, but ultimately it sought to bring attention to visual straining and intense looking. Such art presents different challenges:

> Within the process of looking, the object becomes ambivalent and the viewer is left uncertain, off balance. It imposes a particular kind of structural and categorical ambiguity on the viewer's perceptual experience ... which underpins its rhetorical manoeuvres, importantly. In other words, something happens when we look at it.[44]

Art-historical analysis cannot avoid the perceptual-aesthetic dimension of its inquiry. In Burn's terms, however, this challenge presents a quandary. His reading of the minimal-conceptual legacy does not require a paradigm shift. Instead, it requires the patience for deepening attentiveness and the openness to respond to that which does not readily lend itself to the disclosure of meaning. The dominant tendency, however, is to presume that discerning visual meaning is a relatively straightforward exercise. Even a so-called 'critical' stance can render visual arts into a transparent tool that denies any critical force of its own. For Burn, visual acuity presents a barrier to this form of 'criticality' – understood as recognition of what is already known. The express route to a critical position anticipates the conclusion of visual analysis too presumptuously. This is a politically earnest endeavour, but it falls prey to the

temptation to contrive the meaning of works directly from their marginal-peripheral context, or from the artist's identity, or by a quick reference to a (sociopolitical) stance already familiar to a viewer. Burn's emphasis on the visual acuity of practices meant that he was responsive to artists' practices that did not necessarily exemplify Burn's best-known preoccupations, for instance, with the art market's appropriation of critical discourse or the centre–periphery analysis, but were instead adept at exemplifying visual perspicuity at the margins (of the visual).

One artist who readily epitomized Burn's extolling of visual acuity in his art practice was Robert Hunter, perhaps the most persistent and insistent Australian practitioner of abstract painting in the wake the minimal-conceptual legacy – and one supported by Burn.[45] In 2011, a few short years before his death in 2015, Hunter returned to the roots of his international emergence as an artist and recreated a wall painting, *Untitled*, which he first exhibited in Melbourne and then subsequently at the Second Indian Triennial in New Delhi in 1971.[46] Neither portable nor permanent, Hunter's wall work persists as a notional painting to be executed anew each time within set parameters. While such austere and seemingly provisional art had become familiar by 1971, its status remained divisive. It could be interpreted in broadly countercultural terms as a Zen-like abandonment to a contemplative immateriality or as a defiant act of resistance against relentless commodification.[47] Alternatively, some viewers found such work threatening and alien because it was so white, so monochromatic, and so apparently empty.[48] It reduced painting to the barest trace, to its most negligible condition of possibility, to mark marking, and even to a purely conceptual level of painting; for some, it was testimony to the emptying out of art. Yet, as with all of Hunter's work, *Untitled* focuses intently on the basic tenets of painting and drawing – line, simplified colour, a flat surface – and reduces them to the primal state of mark-making on a wall. The result is simple, insistent, but curious. We see a sparse composition, line and paint on a flat surface – nothing more than an unadorned demonstration of the power of painting, though in a strangely unfamiliar way because it is so reduced.

Internally divided into cellular divisions of seven horizontal and vertical lines intersected by seven diagonals, this wall painting is exceedingly simple and sparse. Yet, on closer inspection, this regularized format is composed of subtle variations of line and

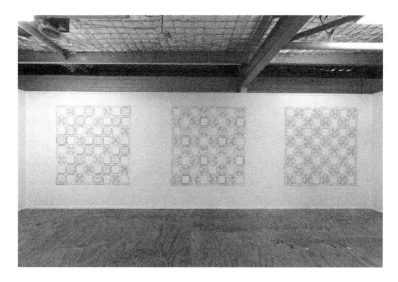

FIGURE 4.3 *Robert Hunter,* Untitled, *1971/2011 (installation view), acrylic on wall, dimensions variable. Courtesy of the Estate of Robert Hunter and Milani Gallery, Brisbane. Photo: Carl Warner.*

colour that betray their execution by hand. These individual lines reveal a wavering, awkward, even slightly equivocal, treatment, which are further distinguished only by the variation offered by lighter and darker dull-grey colour contrasts. When installed in a sequence, however, the viewer becomes aware of a visual sparkling that emits from these rudimentary means. The piece simultaneously emphasizes the austerity of the serial, geometric pattern and works against it. Clearly, it is a very reduced and minimal work, yet the viewer's eye quickly becomes alert to its shimmering optical effects, which seem incongruous because this unexpectedly captivating visual experience emerges from such a sparse and obdurate pictorial structure. The consistent feature of Hunter's entire oeuvre is the testing of vision or, as Tom Nicholson noted in an obituary for Hunter, 'His work flowed from and into what exists at the limits of our looking.'[49]

Nicholson's observation about Hunter's art reads as if it could have been taken from Burn's definition of visual acuity. This is not a criticism, but an indication of the suggestiveness of the insights developed in Burn's last writings. For Burn, the propensity of artists

FIGURE 4.4 *Robert Hunter,* Untitled, *1971/2011 (detail), acrylic on wall, dimensions variable. Courtesy of the Estate of Robert Hunter and Milani Gallery, Brisbane. Photo: Carl Warner.*

to explore a peripheral vision, to work at the edges of the visual, or at the borders of looking, underpins his reassessment of the minimal-conceptual legacy. In fact, he was pursuing a re-evaluation of modernism's legacy into present times, but through the lens of conceptual art. Thereby he contests the common assumption that conceptual art is simply an anti-aesthetic, postmodern counterpart to the modernist legacy. In the wake of such an orthodoxy emerging, Burn was resolute in retrieving this critical-aesthetic dimension that he subsequently associates with visual acuity; although it is another matter to establish a link between this accentuation of visual probing and the concern to develop and establish alternative art-historical models that respect cultural and visual art peripheries. In his 1973 essay 'Art is what we do, culture is what we do to other artists', Burn suggests that in striving to account for clashing contexts, localities, and different considerations of reception and art practice – or, as Batchen puts it, differing processes of 'dissemination, transformation and rejuvenation' – the 'missing element' in these discussions is

some sense of interplay between divergent contexts and ideologies, of dialectical opposites to one's own beliefs and concepts. It is also the strength of the interplay which counts and in turn strengthens and develops divergent contexts. Rejuvenation and

the genesis of new ideas depend largely on cultural cross-fertilizations. ... It means accepting other contexts for what they are, for what we can learn from them in contrast to what we can learn from ourselves, and not accepting them on the basis of how well they mirror (reinforce) the dominant program.[50]

Burn had long been preoccupied with working out critical alternatives to the dominant framework of the centre–periphery model, but it would be accompanied by increasing attention on the earliest phases of his career. The surprise of his writings in the early 1980s was to seek a new way of revisiting modernism through the minimal-conceptual legacy in order to salvage its critical-visual experiment.[51] Alternative forms of engagement with the visual had featured in his practice from the 1960s up until the mid-1970s, and eventually it would lead to a way of thinking about peripheral vision, not at the margins, but as lurking at the heart of the most challenging art no matter where it is located. If peripheral contexts could be considered in terms of the conceptual exploration of peripheral vision (and thus of limit conditions and the edges of

FIGURE 4.5 *Robert Hunter, Untitled, 1971/2011 (single panel), acrylic on wall, dimensions variable. Courtesy of the Estate of Robert Hunter and Milani Gallery, Brisbane. Photo: Carl Warner.*

visual perception), then they could no longer be relegated to a marginal or provincial concern.

In a 1992 article, for instance, recalling the influence of Alain Robbe-Grillet for art in the 1960s, Burn noted that the French writer thoroughly unsettled the role of description. With Robbe-Grillet's writing, according to Burn, it was difficult to differentiate what was descriptive gloss and what was substance; so if one skipped the descriptive passages, one was incapable of following anything. The conventional spatial–temporal and descriptive frames of reference were displaced, and yet unexpectedly they were displaced to a central position. Just like perceptual testing – or with Burn's minimalist paintings, his mirror pieces, as well as his *Xerox Books* – what comes to the fore is that aspect most frequently overlooked: the critical awareness of what your eyes are doing. In Robbe-Grillet's case, the displacement of the seemingly peripheral to a central position makes it all the more difficult to discern what's happening: 'Imagining they [the readers] have been dealing hitherto with nothing but the frame, they will still be looking for the picture.'[52] This was a 'world without adjectives', because Robbe-Grillet 'rejected all associations, references and sensations, and his description acknowledges objects as merely the occasion of a certain optical resistance'.[53] One could say that all art is peripheral vision after the departure from centre-point or linear perspective, but this refocused scrutiny on the legacy of minimalism–conceptualism provoked Burn to seek to forge new art-historical understanding of marginal or peripheral aesthetic axioms and critical concepts that he had been mulling over for decades. The displacement of the peripheral to the centre, optical resistance, taking into account divergent contexts as well as their precarious points of interplay, provide some of the ingredients for encouraging counter-models amenable to a more decentred art-historical conception in a broader cultural terrain.

Malevich's organic model and a chemical art history

While arguing for a more complex model of art-historical exchange, Batchen voices his antagonism to the reliance on organic metaphors

(which he feels underpins the approach of *Art Since 1900*). While the appeal to organic metaphors might seem conducive to 'centrist' thinking, the provocation of Burn's last writings is to assert that centrist thinking is primarily based on the assumption of advances and gains that can only be regarded as successive, otherwise all one is left with is retreat and betrayal.[54] For this reason, it is important to consider counter-frameworks of analysis that may have been bypassed without adequate attention paid to their inventive possibilities. Thus, it is possible to suggest that early modernists may have adapted organic models, not simply as forms of appeal to greater immediacy or symbolic transcendence, but also in attempt to concoct alternatives to narrow and rigid cultural frameworks, such as the kind of centrist thinking on art that constructed orthodoxies of reception that elide more dynamically aberrant models.

Kazimir Malevich, for example, developed a curious theory of artist development in terms of microbes, antibodies, and infections that has strong correlations with Burn's reading of Nolan. For Malevich (in Galvez 2002), the basis of any artistic style is a single essential element, which he likens to a microbe.[55] He may have picked up this idea from Filippo Tommaso Marinetti who, between 1909 and 1915 was developing his ideas about words-in-freedom (*parole in libertà*), in which he also likened the components of his texts not only to microbes, but also to molecules and body parts.[56] For Malevich, an example of a particular element might be the straight line in Suprematism. The introduction of a new additional element is akin to the intrusion of a foreign body, which is attacked by antibodies that act to reject and annihilate its intrusion. Occasionally, as in life, the foreign body (the new artistic element or idea) withstands the antibodies and develops into a full-fledged infection. In artistic terms, this affliction is 'settled' by the emergence of a new compound formulation or a new art. In the interim, however, there are awkward compromise formations. Never attaining aesthetic purity, the addition of further elements (microbes) is never simply progressive, it fails to follow a linear stylistic chart of development, never simply an Oedipal struggle between master and student, never inexorable or inevitable – which are the conceptions that Batchen argues underpin the organic analogies that he conceives to be central to the interpretative model of modernism found in *Art Since 1900*.

To quote one of its editors, however, Yve-Alain Bois, in turn citing Paul Galvez's reading of Malevich's late works, Malevich's alternative formulation suggests a very different proposition of art as a struggle fought on many fronts because 'at any given moment there might be several additional elements fighting to become the next norm'.[57] Accordingly, it is possible to find several pictorial styles simultaneously residing within the one work, although not necessarily always resolved. While seemingly an eccentric interpretation, Malevich's thinking on this matter anticipates Piotrowski's subsequent call for a polyphonic, horizontal inquiry attentive to stylistic heterogeneity and to idiosyncratic local mutations that remained inexplicable to a centralized system of evaluation. Such a proposition also has strong affinities with Burn's analysis of Nolan's 'aberrant' painting of the sun-drenched railway guard: the half-being, half-technological signpost (which in turn echoes Benjamin's account of Mickey Mouse from Chapter 1). Central to these alternative models of art history is the defiance of any linear or straightforwardly directional analysis of art in favour of more complexly varied distributions of relationships and exchanges – and relationships are not transparent or self-evident, which is why they can be so easily missed or misread.[58]

Bois asserts that Galvez's elaboration of an alternative reading of Malevich's last figurative works rests on noting the presence of the cruciform composition in most of Malevich's post-1927 works. Bois argues in the wake of Galvez that, on the basis of the Malevich's microbe theory, his last works can be viewed quite differently. They are not necessarily a sad and awkward abdication to the dictates of the commissar of socialist realism, Andrei Zhdanov, or even Stalin, for which purposes the late Malevich paintings still appear ill-suited. Instead, if one takes Malevich's dynamic immunological system of culture seriously, then what we witness is another phase of his thinking about art prompted by the insertion of an additional element, or bacillus; in this case, the Suprematist cross introduced into 'the visual culture of the Renaissance in order to clinically observe what such a violent bacterial invasion would produce'.[59] In other words, late Malevich reached a similar conclusion to Burn, albeit at a quite different point in time. Malevich's formulation yields an equally evocative model of art-historical aberration to that which Burn discerned in Nolan. They both remain eccentric formulations on the fringes of art history. They are testimony to the

many evocative, alternative conceptions that defy the still rather narrow art-historical conceptions available. They are only aberrant in relation to the mythology of the projection of a steady, cohesive, and stable centre.

The challenge to shift these parameters underscores how limited art-historical thinking has become in considering the dynamics of cultural connections and interactions, especially when it has come to rely on unidirectional flows of stylistic development. In fact, the conception does great disservice to our understanding of modernist practices with their diverse and dynamic conceptions of art history and practice. For his part, Batchen briefly gestures to the currently popular alternative of 'a narrative that traces a rhizomatic flow of bodies, images and ideas'.[60] Yet, the vitalist dynamics of the rhizome model may risk simply swapping the rather mechanical model of centre–periphery transmission for one of free-floating self-organization. If so, it would not offer a formulation that adequately differentiates between differing points of impact, nor would it differentiate between differing intensities of contact with sufficient attentiveness. It also would lack attentiveness to the vagaries of where and how these impacts occur.[61] Nolan, for instance, does not just engage with any possibility; he engages with specific parameters in order to tease out new possibilities. Power relations do pervade one's cultural perspective, no matter where one is situated and irrespective of any free-floating alternatives rejoicing in multiplicity. To reiterate, as Gandolfo and Worth claim, power relations need to be taken into account, whether they be 'circumstances, fortunate or unfortunate, centered or marginalized, [that] give legitimacy to one's standpoint' (2015: 251). The focus on nomadic, rhizomic conditions of possibilities obviates this need for attentiveness to specific conditions of negotiation and interaction, even if they create ambivalent possibilities – as Burn suggests when he argues that his relational model of visual acuity may leave a viewer uncertain. This uncertainty is the basis for suggesting new critical ways of seeing that may countenance engaging with the unfamiliar or what does not conform to what is already known.

It is therefore not temporal or spatial distance alone that always proves significant, but the catalytic impact of contact between very specific, yet differing – sometimes even tangential – cultural and artistic frameworks. Some may be more central than others, but this is not always the telling point. If we have been asked to consider

eccentric biological models of art, then why not also chemical models because they refer to a wide-ranging set of capacities – folding, self-assembly, 'reactive intermediaries'. Many of these will be of limited use to art history, but they help to evoke a wider range of artistic and cultural interplays (to recall Burn's favoured term from 1973). A 'chemical' conception of artistic exchanges does not imply an underlining structure of cohesiveness – in the reductionist sense of inferring a 'whole' to be reconstructed – but instead suggests more diverse entities that interact in a multiplicity of ways (though not necessarily in random or inchoate ways, thus rhizomic and ever fluid). Chemical processes suggest a wide variety of interactions, which have complex results – even when originating from seemingly similar elements or when similar mechanisms are at play, which may sometimes produce quite unlikely or unexpected results (as suggested by Burn's reading of the aberrance in Nolan or Malevich's theory of pictorial microbes). One model for the seemingly unexpected is Julius Rebek's model of self-replication, which describes how molecules sharing criteria can replicate 'according to novel kinds of molecular interaction rather than mimicking the complementary base pairing of (their) nucleic acids'. This hints at the ultimate way of departing from a centric, successive model in art history. Other examples might not be as stark, such as the apparent affinity of an artist such as Hunter to Robert Ryman or Agnes Martin, who through different coordinates, such as Hunter's fascination with Sol LeWitt or his contact with Carl Andre, or through emerging new nodes of artistic-cultural exchanges, such as the Second Indian Triennale of 1971, introduced Hunter to not only a quite different artistic sensibility, but also a wider network that served to initiate new points of contact far from the conventional centres. The context in 1971 was merely a microcosm of a much broader and diffuse artistic and cultural network to come (one of these examples is, of course, examined in the previous chapter and at the outset of this chapter).

In Hunter's case, India was an early example of a newly emerging non-Western art world context that establishes affinities between practices from quite different and distant contexts, even if they were then primarily still Western. A chemical-cultural model of art history might help to convey how points of intensity or intensity of interaction can be fierce, sometimes partial or fleeting, thus not always occurring in any expected, uniform or even enduring

pattern. Yet, wherever these interactions occur they may be capable of eliciting quite richly deviating possibilities. This might explain the puzzle of Hunter's career that was marked by highly intense periods of interaction and celebration early on, before settling upon fixed, but subtly mutable parameters of artistic practice (especially after 1985 when he set upon a standard format of painting).[62] The intensity of interaction with minimalists in a fluid, international setting settled, in Hunter's case, into a practice that long deliberated on minor permutations within the limit conditions of seeing as looking – one strong example of visual acuity, but not the exclusive one.

Such examples might help to provide insight into quite different forms of exchange – sources of complexes within complexes, a picaresque cultural economy. This alternate chemical-cultural model concedes there is power because power – generative as much as regressive – is always present in such a system, albeit always unevenly distributed, sometimes permitting the unforeseen, even if not always intentionally, thus producing unique combinations from strange interplays. For instance, the type of 'world art' discourse that Batchen champions is a 'form of art history that represents modernity as a phenomenon that is simultaneously local *and* global … a mode of art history … responsive to our permeable, post-colonial, global present'.[63] We can all join him in welcoming such a consideration because of the nuanced, geo-critical framework it ought to entail. Yet, if it is to prosper, then this inquiry must encompass the full array of challenges that Burn poses in seeking more attentiveness to visual acuity. On the one hand, such a renewed inquiry would explore the forms of visual acuity evident in his reading of Nolan – visual attentiveness at margins, that is at the periphery, in which a jumble of well-known and quite local influences collide to stimulate new understandings of a broader relationship of interactions and approaches that ultimately unravels the strict distinction between centre and periphery. Conversely, the other side of Burn's challenge is to suggest that good works of art are ambivalent about the urge for legibility and thus defy the urge for immediacy or simplification. They test viewing and ask a viewer to persist with this challenge in risking what is familiar. This is a challenge that requires staying alert to the challenges of visual acuity posed by the seemingly impervious abstraction of Robert Hunter – a practice that does not offer any identifiable content in terms of standpoint aesthetics, a

politics of exchange or transcultural interplays – but which Burn would nonetheless suggest is a practice that explores the peripheries of visual attentiveness in vividly intense and sustained interplays that do not take for granted the process of viewing. Even if we agree with the content of a work, Burn will still assert that we need to find the work visually demanding.

If an overhauled framework for assessing diverse cultural exchanges is to prosper in our world of interconnected societies and cultures, then we require more dynamic ways of assessing that diversity without reducing the visual to a set of taken-for-granted themes that are easily framed within familiar nodes of recognition. Yet, Burn's development of visual acuity suggests we should also have criteria for assessing this engagement in the visual arts. At the same time, the strange and unpredictable chemistry of this renewed art-historical inquiry should make us pause to consider what may have been passed over too hastily as quirky or ill-fitting. Malevich's attentiveness to foreign bodies no longer appears as an idiosyncratic remnant from the archive of modernism; Burn's dual criteria for exploring visual acuity as a peripheral vision is no longer restricted to anti-aesthetic conception of conceptual art. Along with Piotrowski's call for a polyphonic, horizontal inquiry, they become central features of an invigorated inquiry open to unexpected cross-fertilizations and challenging practices.

If there is such a critical reckoning occurring today, then it no longer should preoccupy itself with the waning exercises in cultural surpassing. That quest itself now constitutes the problem rather than the solution. Because it is ambivalent about negative connotations, it seeks purity by divorcing itself from the impurities. It also divorces critical discourse from its most viable critical vocabulary. Because it positions the modernist legacy as a phantom presence both haunting and undermining its critical discourse, it treats it as something to be ignored. The result is that contemporary art discussions often rejoice in a perpetually adolescent discourse of unbridled radical purity. On the contrary, being immersed in the complications of these legacies means being able to discern what is credible and what is worth defending, which is how one negotiates a path through its quandaries. It is not easy, but sometimes a complicated and frustrating task because one needs to be constantly attuned to elements of critical vitality when least expected and when seemingly least viable – and even then one has to make a case for its

validity. The bifurcated thinking of modern versus contemporary, centre versus periphery, however, has the effect of curtailing such possibilities of nuanced reflection. It is not alert to its ambivalence because it regards the bad legacy as something to be disposed of, to be sealed away in the dustbin marked 'never to be contaminated by again!' Now is the time to consider what emerges from a reconsideration of these ambiguous commitments in order to devise more dynamic aberrant cultural models attuned to a legacy that continues to underpin our critical vocabulary, but one that can be receptive to a much more diverse cultural imaginary.

Conclusion

The vocabulary of the contemporary is full of references to turns, ends, and surpassing. A consequence of this emphasis is that something must play the role of the fall guy or scapegoat because with such language there is always an impediment to be overcome. Over the past thirty to forty years, modern and modernity, and sometimes even modernism, have become the umbrella terms expressing such dissatisfaction. They have become taboo terms because they are primarily associated with pernicious outcomes: Eurocentrism, imperialism and colonialism, capitalism and globalization, misogyny, instrumental attitudes to both culture and nature, thus planetary destruction.

Simultaneously, we uphold commitments that we view as critically essential – not least because they aid in challenging the drift into such insular or myopic frameworks. In Chapter 3, Leszek Kolakowski is cited as listing the following indispensable commitments: the 'ability to view ourselves at a distance, critically, through the eyes of others'; tolerance in public life; scepticism in intellectual work; the willingness to confront as many opinions as possible; and to leave 'the field of uncertainty open' (Kolakowski 1990: 22). To which we might add Ian Burn's stipulation about peripheral vision: the acceptance of different cultural contexts 'for what they are, for what we can learn from them in contrast to what we can learn from ourselves', as well as being attuned to the 'interplay between divergent contexts', including acknowledging a 'certain optical resistance' (Chapter 4).[1] Acknowledging this resistance led Burn to re-evaluate modernism in the wake of conceptual art. It also led him

to forge the idea of visual acuity in which optical resistance forms a crucial criterion. In art-historiographical terms, I sought to develop this insight by offering the idea of a chemical art history in order to shift the preoccupation from a centre–periphery model of artistic and cultural influence, which is, after all, quite limited. It presents a way of acknowledging the persistence of power relationships, while allowing for more 'compound' processes of interaction and alignment (for instance, where the modern and the customary may still rub together in awkward interactions).

The attempt to develop alternative models of art history is a defiance of any linear or straightforwardly directional analysis of art in favour of more complexly varied distributions of relationships and exchanges. Terry Smith's idea of 'planetary' co-temporality would also set out a useful alternative model – except that he insists on delineating his argument in terms of a cultural paradigm change. Given his analysis is peppered with the vocabulary and insights garnered from others primarily investigating modernist culture, it is difficult to find his case for a cultural paradigm break convincing. It presents a classic case of the surpassing formula – one that is constantly drawn back to the paradigm it is meant to be surpassing.

The irony is that the commitments Kolakowski lists are part of the modernization process. The difference is that we do not denounce these commitments: in fact, we tend to cling to them. We require them in order to make any confident critical assertion today. Rather than grapple with this complication, debate has drifted into a pick-and-choose scenario in which a critic will only identify with whatever qualities are deemed best at any given moment. The emphasis on turns, ends, and surpassing not only seeks to identify redundancies, it also aims to save us from having to recognize any complicity with the pernicious outcomes. This makes sense. Everybody wants to be pure and uncontaminated, and it is preferable to point instead to the myopia, chauvinism, and failings of others. Kolakowski's observation is a complication we do not need. It shows that the byproducts of modernity that we denounce are registered in the language of these core commitments deriving from the same legacy.

As early as 1933, Walter Benjamin felt that people were no longer yearning for new experiences. 'The small change of "the contemporary"', he wrote, is a temporally restricted experience fixed in an eternal present oblivious to history or the recognition of any

divided or complex legacies. Dead in the present, the poverty of the contemporary means having '"devoured" everything, both "culture and people", and they have had such a surfeit that it exhausted them' (Benjamin 1933/1999: 734). The perhaps unintended consequence of the surpassing momentum is this malaise. Ironically, Benjamin was referring to the contemporary situation that we now call modernity. It was just that people could not imagine it could keep going on like that.

In his programme of the 'Coming Philosophy', Benjamin wanted to rescue the idea of experience from a conception that is 'singularly temporal' and at the same time 'temporally restricted' (to quote György Márkus from Chapter 1). Because the epistemological priority of our age is overwhelmingly focused on proof, as well as the empirical, the consistent, and achieving certainty, the question of experience was reduced to an afterthought, if not 'fantasy or hallucination'.[2] In a very intuitive way, I believe, Sigmar Polke strived to retrieve this element of experience in much of his artistic enterprise. The difference is that Polke's emphasis on the petty bourgeois (*Kleinbürger*) status of artists seeks to reposition the place of art as both implicated and dissenting. Nearly all of the key figures discussed in this book critically evaluate their own modernist cultures. The difficulty with the contemporary–modernist split is that one is almost forced to choose as if they constituted differing options, one better than the other. Polke's restitution of these peripheral aspects of modernity in the guise of a petty-bourgeois radicalism represents an attempt to reposition autonomy as dissenting (or questioning) and implicated, but also to avoid the worst excesses of modernist zeal.

Kolakowski clearly delineates the excesses of modernity in its Eurocentric grandiosity and its inclination towards exclusivity; what he calls its pantheistic penchant for 'total perfection', along with 'the wild certainty of our infinite capacity for perfection', the unremitting quest for standardization that is annihilating 'cultural variety' in the name of 'a planetary civilization'. Polke's inkling was to envisage a more complicit model in order to diminish this side of modernist thinking. To recall Kolakowski, we behave fanatically if we are preoccupied with protecting our exclusivity and if we presume to act in the name of the universal – again a perfected universal thus considered 'superior' and therefore irrefutable – because then we are incapable of self-questioning, even of probing

self-important presumptions, and that is the point at which we must consider that 'we are behaving barbarically'.

The point is not the elevation of the modern over the contemporary or the contemporary over the modern. At their worst, one offers proliferation, fragmentation as well as historical blindness; and the other, delusions of grandeur and a propensity to monomania in its dominant conceptions. The excessive and dazzling 'present-ism' of the contemporary makes us accustomed to the expectation of the new term, the next hot thing in art, another art fair or biennial – the constant obliteration in the quest for immediacy, vibrancy, and relevance. Most contemporary art discussion rarely refers to any analysis ten years prior to its writing, and most only relate to debates of the past few years, which are endlessly recycled. All are vigorously critical of something; they tend to exist in a whirlpool of a whipped-up frenzy of newness with a short concentration span.

Our quandary is that we presume to have long surpassed modernism, but we still have recourse to modernist presumptions. Not only are we ambivalent about this, even in denial, we cling to these commitments. We cannot live without them, yet they do not ensure a sense of being at ease or of resolve. Our ambivalence is that we are surreptitiously drawn to the very thing we seek to rebuke. Recognizing this ambivalence is helpful, not a hindrance. I would argue that a more critically engaged interaction with both the modern and the contemporary is required for a more astute and nuanced analysis. It might even help to think some things differently and to envisage our prospects more inventively. It is not only the loss of deep historical perspective that is lacking. It is the diminishment of our critical vocabulary that is also an issue. The surpassing quest leads us to assume that we have left these modernist commitments behind. Not only that, these presumptions are characterized as forming part of a pernicious heritage. Leaving these critical investments behind is nonsensical because everyone relies upon them in order to make an effective critical point.

The alternative to a modernist conception of culture would be the idea of achieving a cultural model that is internally binding and normative. This supposition is highly unlikely in any modernist society. It is not only unlikely, but it raises the question of whether we would like to see it achieved, the answer to which is most likely no. Most theories of cultural hegemony describe their worst nightmares in these terms, as if a cultural model of conformity and

duplicity has been imposed on its unwitting citizens. If it were ever to really happen, we would thus most likely view the imposition of anything remotely resembling traditional or customary culture as an unmitigated disaster. Hence, this is no way back: another source of our contemporary ambivalence.

This book does not present a conventional art-historical chronological account, nor does it constitute a monograph of an artist. Instead, it presents four studies exploring critical investments that inform such examinations, particularly at the nexus of the terms 'modern' and 'contemporary'. Who would have thought so much could be invested in such a distinction? Yet, the book probes the investments in such distinctions. If anything, it explores a chronology of increasingly confused and floundering critical investments. At the same time, it constantly seeks to point to the wider relevance of these critical commitments, which are highly contested, and remain a key point of vexatious dispute. The aim of this study has been to try and move debate beyond caricature in order to seek a more elaborate, and critically nuanced assessment of modernity as a cultural proposition. The wish is to advance more subtle and intricate assessments of the *relation* between the contemporary situation and the modernist legacy, and to think outside the parameters of the surpassing mode, which once had important contributions to make, especially about the expectations of modern progress, but has declined to such an extent that it now forms a barrier to understanding. Increasingly, the result of this is discussions that are content with clichés as arguments.

If there is a reason to engage with this legacy it is to tackle and rejuvenate this critical discourse by retrieving propositions or outlines that have been passed over too quickly. By pointing to some critically fruitful accounts, this book does not tackle every issue related to disputes over the status of modernist culture; it simply aims to make a contribution to this re-evaluation. The task it presents is of reinvention as much as remembering; it involves the creative task of 're-wiring' a debate that has proven faulty or in need of recalibration, or which point to a way beyond an impasse. As such, this effort is a modest one of contributing to this wider reconfiguration of a critical vocabulary that requires renewal rather than wholesale disposal. The surpassing ambition has much to recommend it, but historical amnesia is one of its biggest pitfalls. We need to be cautious of surpassing conclusions whenever they

become automatic. They manifest themselves in everyday rhetoric, such as glib rhetoric that 'our time is more complex than any previous time in history'. This can be taken to mean that the present situation presents such unique circumstances that previous ways of thinking and operating, as well as previous forms of education, need to be abandoned or completely overhauled in favour of a pragmatic accommodation with fast-changing, irresistible, and inevitable transformations. This diagnosis persists. Apart from falling back on the rhetoric of late-nineteenth/early-twentieth-century accounts of modernity with its pervasive emphasis on the speed of change, dislocation, technological renewal as well as saturation in everyday life and the experience of greater perplexity, the unintended presiding inclination of surpassing assumptions is to denude its discussions of historical memory, but also an urge to move beyond when in fact we find we are only repeating things that have been said before. Maybe it is time to consider our lack of uniqueness or our incapacity to invoke new horizons without ridiculing what we still have not adequately come to terms with. And if we did resolve it once and for all, what would that mean? Would we like it?

NOTES

Introduction

1 Of course, the drive to discern the new is usually said to define the modern, but this is one of the ironies of this surpassing model.

2 If a key surpassing argument is that the original formulations of modernist culture were misconceived, as per one strain of the postcolonial–postmodern challenge, then the protest does not amount to a surpassing formulation. Rather, it throws the spotlight on the misconception – and I suggest this is one form of legitimate response that avoids the dilemmas of a surpassing formulation.

3 See, for instance, Terry Smith's formulation of 'contemporaneity', which is discussed in the final section of Chapter 1. Smith regards contemporaneity as coming in the aftermath of both modernism and postmodernism, and even the contemporary.

4 Sorokina (2006).

5 Sorokina (2006).

6 Fukuyama (1992).

7 See Belting, Buddensieg and Weibel (2013). The most straightforward articulation of this assertion is by Alexander Alberro: 'The years following 1989 have seen the emergence of a new historical period. ... Within the context of the fine arts, the new period has come to be known as "the contemporary".' This argument appears at the outset of his essay, 'Periodising Contemporary Art', which appears in a number of places, including online: http://www.globalartmuseum. de/site/guest_author/306 (accessed 11 May 2015). See also Alberro (2008/9). See also the equally conclusive opening assessment offered by Ian McLean: 'Modernism's crisis of legitimization (i.e. postmodernism) made one thing very clear: what had previously been given was taken away. This given – the ideology associated with European imperialism and its particular form of modernity – was forever rescinded at the close of the 1980s with the end of the Cold War.' McLean (2009: 625).

8 The sense of a profound transformation in art remains tied to strong declarations of periodization. See, for instance, Terry Smith's overview of Peter Osborne's account of the contemporary. What is orthodox about Osborne's account is its reliance on plotting three distinct moments: 'The neo-avant-gardes emerged after 1945; contemporary art appears around 1960; as did, in 1989, the post-avant-garde, the cultural industry, and transnationalisation.' What is unorthodox, that is for Smith 'bold and original' is the observation verging on a paradigm shift, which means identifying these moments as the last to chart 'periods within the history of modernism more generally'. Because these three phases mark the last vestiges of modernism, what is crucial, thus truly 'bold and original', is the identification of what comes after, which is what Smith offers – in other words, the true demarcation and surpassing. Refer Smith (2014: 85). See also the final section of Chapter 1.

9 Sorokina (2006). It is revealing that such an interest in this legacy can only be presented as incongruous and as a puzzle and only in terms of artworks that appropriate modernist sources rather directly in order to underscore their failed utopias. See for instance Claire Bishop's quizzical blog post, 'How Did We Get so Nostalgic for Modernism?', 14 September 2013: http://blog.fotomuseum. ch/2013/09/1-how-did-we-get-so-nostalgic-for-modernism/

10 If modernist thinking is defined as being wedded to a progressive, successive model of time and history, then a common argument is that the contemporary is much more content, for instance, to conjoin past and present – at least, in theory, this is the claim, thereby implying that this never happened with modernist practices. This is an argument difficult to sustain with rudimentary art-historical information.

11 Modernism can be linked to the former as much as the latter. For an illuminating study of modernism and 'its "selfish" streak', and its investment in 'rational self-interest', see Ashford (2017). In contrast, this study would regard Ashford's emphasis as just one part of the antinomy of modernity.

12 One further paradoxical insight in Chapter 3 involves the significant role played by institutions in these debates. Art is commonly viewed as compromised by institutions – with the prevailing assumption being that art ought to be anti-institutional by its nature. The discussion touches on the significant stake in institutional infrastructure within the region, which is not always necessarily conservative, neither simply hegemonic nor counter-hegemonic. Again, this requires more nuanced and finessed inquiry, not one predisposed by theoretical polarities.

Chapter 1

1 Benjamin (1933/1999: 732). Subsequent references to this essay appear in the text.

2 This was further underscored by the concern of the belligerent governments with the state of physical fitness of large portions of the male population deemed unavailable for conscription into the war effort.

3 Alexander (2013). Discontent with modernity is not simply the product of the horrors of the twentieth century. As most philosophical or historical accounts seek to show, discontent with modernity emerges virtually simultaneously with the progressive Enlightenment or positive account. Refer Smith (2016), a comprehensive study, which takes both sides of this reception into account. Smith's account is only marred by his occasional insistence that America is epitome of modernity.

4 Benjamin (1918/1996: 104–5).

5 Benjamin (1918/1996: 104).

6 Benjamin (1931: 545).

7 Estimates vary, but a common estimate is that twenty million military and civilian deaths resulted from the conflict of the First World War with an additional twenty-one million wounded. See, for example, the introduction to Clark (2013).

8 Charles Péguy's much-cited quote of 1913 is: 'The world has changed less since Jesus Christ than it has in the last thirty years.' Cited in Shattuck (1968).

9 Estimates of infection and deaths caused by the pandemic of 1918 are that roughly 'five hundred million people contracted it … and between fifty and a hundred million of them died'. It impacted upon not only the warring countries in Europe, but also far and wide with Western Samoa suffering one of the highest fatality rates (20 per cent of the population). It gained the name 'Spanish flu' after the Spanish king, prime minister, and entire cabinet were struck down by it in May 1918. See Francis (2018: 3, 6).

10 Márkus (2011: 572, n. 64).

11 Refer McBride (2004). Loos decried the infatuation with past ages, which led people to believe that they could 'add luster to their homes by clothing them in pompous period styles'.

12 Benjamin (1931).

13 Toepfer (1997: 109).

14 Toepfer (1997: 91).

15 Toepfer suggests that Berber inverted the association of naked with health in the Weimar Republic. She engaged, he asserts, in an 'almost

satiric critique of the pretensions to a healthy, modern identity that both eurhythmic consciousness and *Nacktkultur* sought to achieve' (Toepfer 1997: 91).

16 *Die Welt im Wort* began operation in late 1933 and ended in early 1934. It was founded by Willi Haus after he returned to Prague after departing Nazi Germany.

17 Hitler became head of a conservative coalition government on 30 January 1933, but had already initiated the Reichstag Fire Decree (*Reichstagbrandverordnung*) by the end of February, which suspended civil liberties as well as freedom to organize and assemble, and installed widespread censorship, soon followed by the Enabling Act (24 March 1933) that permitted the enacting of laws without being passed by the Reichstag.

18 Steyerl (2014) in conjunction with Van Abbemuseum, Eindhoven, and Institute of Modern Art, Brisbane: 35.

19 Boym (2017: 172). She adds: 'I want to catch the digital gadgets unawares, confront them with each other with the alchemy of cross-purpose uses, to counterpoint different forms of modern and premodern experience, technological, existential and artistic.' I would suggest Sigmar Polke advocates something along similar lines; see the following chapter.

20 It now extends to areas, such as art, education, and health services, which seem unlikely prospects for the application of such productive logic. The arts, for instance, are sometimes criticized in terms of their 'cost disease'.

21 McCole (1993: 157). See also his elaboration of this point: 'Why prefer the nihilism of Benjamin's new barbarism to that of Ernst Jünger's warrior figures if politics comes down to a contest over which of them most decisively liquidates bourgeois culture? Until the mid-1920, Benjamin lacked an effective response to this dilemma' (166). Below I explore this question in relation to György Márkus's account.

22 Benjamin (2003: 474).

23 Hussain (2011).

24 I do not have sufficient space here, except to sketch Pippin's argument in its broadest outline. My point is primarily to gesture to a number of analyses that present a more nuanced account of modernity without the need to resort to the surpassing strategy; in fact, they render these surpassing tracts superfluous.

25 Pippin (2010a: 543).

26 Pippin extends this point further in a commentary comparing American Western movies to neo-liberal fantasies about non-regulation and complaints about the infringements of civil society. The John Wayne character in the film *The Searchers* fulfils this ambition, but tragically: 'He stands outside the civil community in that famous scene at the end,

but knowingly and with no illusions. He knows that as an unredeemed Confederate and racist, he is not fit for the civilized world and must wander off alone.' Pippin (2010b).

27 Pippin (2010b: 544); see also Pippin's comments in Hussain (2011).
28 This points to fundamental ambiguity in Benjamin and why he can appeal to so many tendencies (a proliferation he condemned in the 'Experience and Poverty' essay) and why student radicals in the late 1960s could accuse Adorno of hiding, or downplaying, the truly Marxist Benjamin that no one had ever told them about.
29 A consideration of Terry Smith's account of contemporaneity follows below.
30 Márkus (1994: 19).
31 See, for example, Sunstein (2003), who argues that dissent and conflicting opinions and advice is an affirmative quality. Thus, he suggests that the 'greater ability of citizens in democracies to scrutinize and dissent and hence to improve past and proposed courses of action' explains the Allied victory in the First World War and the 'failures of Hitler and other Axis powers' (p. 8).
32 See the comments of Pam Meecham, for example, as a testimony to how this conception was inaugurated and still prevails:

> Chronicled through stylistic experimentation with form (line, shape, color and texture) and through the exploration of the properties of materials (largely paint and canvas) modern art's traditional narrative broadly ran from French nineteenth-century Realism through to American Abstract Expressionism of the 1940s and 1950s. Such a story, never without its critics, has since the 1960s been subject to transformations that challenged the identification of unbroken, stylistic experimentation as modern art's primary priority. The unalloyed history … was questioned by historians, sociologists, theorists and artists working from diverse perspectives emanating from the emancipatory forces set in motion by the civil unrest of 1968.

Meecham (2018b: 1). My update would be to say that, while the questioning of this formalist, successive model of modernism has been crucial, the origin challenge has run its course often resulting in clumsy conceptual oppositions.

33 Grumley (2013: 156, 159).
34 Elkins and Montgomery (2013). The theme of the original seminars was Beyond the Anti-Aesthetic, held as part of the Stone Summer Theory Institute in Chicago, 18–24 July 2010. The seminars were held in July 2010 in Chicago, almost thirty years after Foster's anthology of essays was published. I was one of those asked to

contribute a reflection based on the discussions, and this section is
largely based on that contribution.

35 Foster, Seminar 2, in Elkins and Montgomery (2013: 41).

36 Foster (1983). Ironically, the 'assessments' commissioned in the
aftermath of the Stone Summer seminars on the anti-aesthetic are
equally diverse and contested in 2013, thirty years later. See Harper
Montgomery's 'Preface' and the assessments running from page 117
to 204, in Elkins and Montgomery (2013).

37 Elkins (2013: 1).

38 Another point to consider here is that the history of reactions to
modernism, as Elkins puts it, extends far beyond the surpassing quest
and far beyond the advent of the anti-aesthetic because they are
characteristic of modernism from the outset.

39 How this trajectory became identified solely with a conservative
connotation is interesting. Within the modernist avant-gardes, it was
identified with radical or Left, if not communist positions – witness
the more programmatic avant-garde movements linking art, design,
and architecture. It is one of the major transformations in modernist
culture, but it is not examined from this perspective.

40 Foster uses all three terms in the one explanation. Foster, cited in
Elkins and Montgomery (2013: 26).It is possible to suggest that Paul
de Man prepared the groundwork for this particular critique of the
aesthetic, notably summed up in his *Aesthetic Ideology* (Minneapolis:
University of Minnesota Press, 1996). This is implied, but not fully
acknowledged (39). Although largely criticized in the seminars, this
point is also made in relation to the thought of Jacques Rancière,
who is characterized at one point in the discussions as offering
a counterview of aesthetics that does not equate it as a mode or
surrogate of 'social cohesion' (Millner-Larsen, Seminar 6). This is to
beg the question of how there are competing conceptions of both
modernism and the aesthetic. See the response of Toni Ross (2013:
159–63); in particular, her remarks about reframing 'the aesthetic
and anti-aesthetic as historically consubstantial, but not necessarily
reconciled' (159). Finally, it is noteworthy that this is more or less
ground on which Robert Pippin seeks to revitalize the Hegelian
account of modernism.

41 It is interesting to observe that these remarks appear in a book with a
title that gestures '*beyond* the aesthetic *and* the anti-aesthetic'.

42 Foster, in Elkins and Montgomery (2013: 32).

43 Elkins and Montgomery (2013: 26). Bernstein replies immediately
that he does not 'see the difference between taking experience to be
fallen and to be pledged against social consensus' – a statement that
leads to Foster's mea culpa (27) .

44 Elkins and Montgomery (2013: 27). Foster argues that 'we weren't *so* stupid as to conflate with Anglo-American formalism, nonetheless he does point to 'our superficial reading' of aesthetic discourse (26). 'There were conflations, to be sure, some of which were stupidities, but some were strategic, too, in a polemical way.' 'It was reductive at times because it was polemical at times; you can't revise that now – and I certainly wouldn't want to.' Elkins and Montgomery (2013: 31, 33).

45 Further to Toni Ross's comment above, she notes that the beauty revivalism in the American art world of the 1990s was unlikely to be able to deal with the proposition of the aesthetic and anti-aesthetic as consubstantial, though not reconciled: 'This largely classically derived "return to beauty" not only privileged artistic and societal harmonization, but also simply inverted the polarity between aesthetics and politics established in anti-aesthetic frameworks' (159).

46 Osborne (2013: 3).

47 Emphasis in original; Osborne (2013).

48 Meyer (2013: 281).

49 Again, this is the topic of Chapter 4.

50 Schürmann (2013: 143).

51 The context is Foster asserting that he sides with Brecht against Benjamin in calling 'aura "creepy mysticism"', Foster in Elkins and Montgomery (2013: 88–9). I am not even sure if this is wholly correct. Márkus quotes Brecht as arguing: 'The recasting of spiritual values into commodities … is a progressive process'; cited in Márkus (2011: 557). The larger point is, however, the necessary recourse to broader legacies that are too often treated schematically and therefore considered redundant.

52 Schürmann (2013: 143). Purify what? That is the difficult question.

53 See the contribution of Timotheus Vermeulen, who discerns something similar: 'The purism, if I may call it that, the-saying-what-it-is of Greenberg's Modernism, is anything but aesthetic.' Refer Vermeulen (2013: 169). I do not necessarily disagree, although Greenberg is being reduced too, but I cannot see why the discussion of modernism must constantly return to a reductive account – that is unless there is some gratification in going through the act of constantly dispensing with it.

54 See in this context, the similar characterization of the modern; refer Ang (2011).

55 Refer Adorno (1998: 41). His key aim was to debunk the mythology surrounding the 'roaring Twenties', particularly as it related to Berlin, thus his counterargument: 'The heroic age of the new art was actually around 1910 – with synthetic Cubism, early German expressionism,

the free atonalism of Schönberg and his school.' Because Adorno's pivotal reference points are largely determined by his consideration of music, then jazz can be regarded as part of the demise.

56 While always eloquent, this appears the curious course followed by Clark (1999): one can only continually remark upon and bear witness to the fading of potential and mourn what never was, the height of modernism and its ultimate aspirations. See his analysis of a Richter (2011) retrospective in 'Grey Panic'. Clark offers many incisive remarks: that Richter's abstractions reveal 'abstract art's original false confidence', which suggests pursuing a course of practice that was once overloaded with consequence, but now stripped of any weight entirely. Except that the overriding story for Clark is this loss, passing and faded potential. Nonetheless, he offers fascinating observations, rich with possibilities, such as that Richter disavows Adorno's key prognosis for art in modernity that it must 'instantiate … concrete particularity in a world of false vividness'. He goes on: 'Vividness for Richter, if it comes, will have to have falsity written deep within it. I guess this is the strong side (the genuinely disabused-of-illusion side) of his Duchampianism.' It is tempting to think what might be made of this insight and what possibilities it opens up, but the momentum of Clark's analysis is not directed to articulating more humble possibilities, that is once unrealizable utopian aspirations are removed. Instead the momentum is entirely directed to the blanket proclamation of the end, the terminal point: 'The death of tonality', 'the lost territory of painterly "expression" (or immediacy, or individuality, or sheer delight)', Boulez's *Pli selon pli* as the 'last intransigence of modernism on the wing', etc. While eloquent, this can only produce a discourse of redundancy. Unfortunately, if uncharitable, one cannot evade the suspicion that this is the generation who came to maturity in the 1960s, 1968 in particular, and who have fallen prone to the temptation to regard the course of history and human possibility in light of their own retirements.

57 Adorno worked on his Aesthetic Theory throughout the 1960s, but it was only published posthumously in 1970 with an English translation appearing in 1984.

58 While Vermeulen disputes Bernstein's 'alternative way of thinking about modernity, his own outline is similar in terms of how I have outlined the contributions of Bernstein, and Frank, here. Vermeulen's strongest challenge, to my mind, is when he too challenges Bernstein on his dour endpoint full of "hopeless failures".' His meta-modern approach points to artists 'attempting to construct another everyday within the everyday'. Refer his 'As If', in Elkins and Montgomery (2013: 169–70).

59 Elkins and Montgomery (2013: 170).
60 The question is whether it is any less problematic to pose the subsequent publication as somehow going beyond both the anti-aesthetic and the aesthetic. Where would this leave art-historical inquiry – in sociology?
61 Montgomery (2013: 117).
62 Smith (2011: 8). See also Smith's question: 'In the aftermath of modernity, and the passing of the postmodern, how are we to know and show what it is to live in the conditions of contemporaneity?' which opens his 'Introduction: The Contemporaneity Question', in Smith, Enwezor and Condee (2008: 1).
63 At the outset of *What Is Contemporary Art?* Smith dismisses postmodernity quite perfunctorily, if not obscurely: 'The counters posed by postmodernity have become consumed in self-fulfilling prophecy' Smith (2009: 2). Subsequent references to this book appear in the text.
64 Contemporaneity in law usually refers to the coincidence of an act and an intention, or actus reus and mens rea. Smith admits that the task of pinning down the contemporary is notoriously slippery; in tones reminiscent of Baudelaire on modernity, he confesses it is like trying to pin down the 'quickly passing present' (2009: 254). Such an admission recalls Eric Hobsbawm's remark about Tony Judt's history that traces post-war Europe from 1945 to the present: 'Any work taking the story up to the present has obsolescence built in, its future is uncertain' Hobsbawm (2012). See Judt (2005). While apt, I prefer Judt's own opening citation of Heinrich Heine: 'Every epoch is a sphinx that plunges into the abyss as soon as its riddle has been solved.'
65 Smith (2014: 86–7).
66 Smith (2009: 7); Smith (2011: 11, 65–70).
67 Penny (2017: 31–4). Smith links 'retro-sensationalism' to 'remodernism' in making a similar point: 'This anachronistic operation persists above all because a small but outrageously wealthy bubble at the top of the market still sets the key terms of visual arts practice at the key distributive centres' Smith (2015: 167).
68 There is an implicit progression until one reaches the art Smith prefers. Smith regards postcolonial art as a defining and differentiating commitment. In *What Is Contemporary Art?*, he notes for instance, that, while the group associated with the journal *October* has challenged 'narrow views of modernism' (which is evident in Foster's contributions to the anti-aesthetic above), it has shown little 'interest in art that has resulted from the postcolonial turn' (Smith 2009: 252).

69 This second current is divided into three further phases: 'A reactive, anti-imperialist search for national and localist imagery; followed by a rejection of simplistic identarian citizenship and corrupted nationalism in favour of a naïve internationalism; then, more recently, toward a search for a critical cosmopolitanism, or worldliness in the context of the permanent transition of all things and relations'. Refer Smith (2015: 167).

70 In a review of Smith, Nikos Papastergiadis observes that 'the concept of the contemporary can signify both complicity with and critique of global capital', which is true, except Smith envisages his preferred categories as free of such complicity, unlike the more modern, less postcolonial currents, which is perhaps the key issue. Papastergiadis (2012).

71 Smith (2015: 166).

72 See the comment of Robert Slifkin in his review of Smith's *What is Contemporary Art?* in which he observes that Smith bases 'his evaluations upon the long-standing avant-garde criteria of resistance to convention through new and emerging modes of production', Slifkin (2012).

73 Smith (2008: 9).

74 Smith (2008: 5, 6).

75 This last claim is one that most people do not ordinarily associate with modernist culture, but György Márkus is adamant this is an oversight that misses one of its core features as a culture: 'It is only under conditions of modernity that the ways people live and act in the world, and also the manner they understand this world, are conceived by them as constituting a form of culture, that is, as not being simply natural, or God-ordained, but as something man-made', which provokes the realization that one's culture is capable of being remade. 'Cultural modernity is a culture which knows itself as culture and as *one* among many.' Márkus argues that this produces two cultures within one: a generic, shared culture and a critical, 'autonomous' sphere tolerating and promoting creativity, challenge, and innovation. Márkus adds that this does not achieve some uniform, top–down, consensus model usually identified with modernist culture, but instead, 'these two ideas of culture' form a 'paradoxical relation of close association of incomparables'. Refer Márkus (1994: 15–16).

76 Smith makes an almost identical point in 'Contemporary art and contemporaneity': artists 'make visible our sense that these fundamental, familiar constituents of being are becoming, each day, steadily more strange'; Smith (2015: 700). Nikos Papastergiadis finds that Smith is arguing something very different from this quote – and again it is interpreted in order to inaugurate a profound break.

Papastergiadis asserts that Smith is arguing 'the diasporic
consciousness of contemporary artists is not reducible to the
alienation complex that was typical of the modernist period. Smith
argues that these artists are not simply torn from their roots'.
Papastergiadis asks, 'Can there be a history of contemporary art?',
p. 154. While I concur with the two key criticisms that Papastergiadis
makes of Smith's approach (one, that the concept of the contemporary
can signal both critique and complicity; two, Smith argues that what
distinguishes the contemporary is its diversity and complexity while
at the same time striving to plot it in terms of a conventional (art-
historical) tools of narrative development and of periodization), in this
instance, Smith's emphasis on dislocation and a diversity of localities
aligns more closely with the evidence of contemporary practices rather
than a pre-conceived discourse favouring diasporic 'rootedness'. Yet
again, Smith in accentuating 'strangeness' reveals that contemporary
practices continue to share much in common with aspects of the
modernist legacy rather than simply breaking with it.
77 Picasso (1964) cited in Perloff (1986: 44).
78 Continuing the zombie theme, the influence of postcolonial criticism
and Smith's account of contemporaneity can lead to flippant
assessments typified by statements of the kind that 'the legacy of
the European avant-gardes is a curiosity at best, and an imperialistic
projection at worst', both redundant and imperialist; Barikin
(2014: 58).

Chapter 2

1 An exhibition titled, *Wir Kleinbürger! Zeitgenossen und
Zeitgenossinnen*, was held at the Galerie Toni Gerber in Berne from
27 November 1976 until 31 January 1977, and accredited to 'S. Polke,
K. Steffen, A. Duchow, A. Heibach' (apart from Polke, this means
Katharina Steffen, Achim Duchow and Astrid Heibach). Refer Lange-
Berndt and Rübel (2011: 31, 37).
2 See, for instance, Gerhard Richter's comment that the main difference
between him and Polke was that Polke 'took drugs, and I did not.
That's all. And if you take drugs, then you have these strange
friends around you. He continued to be wild and cynical and happy.
[Laughter]', cited in Storr (2002). Subsequently published online:
http://www.artinamericamagazine.com/news-features/magazine/
gerhard-richter-robert-storr/ Furthermore, see also the remarks of
Benjamin Buchloh, for whom the 'end of Polke' was already reached

by 1971. 'I thought he had gone off into the world of drugs, and I didn't want to have anything to do with that, not out of moral or ethical reasons but out of aesthetic principle, because I thought it was just hippie stuff. For me, in these works there was no cutting, biting, aggressive political dimension at all' (cited in Halbreich, et al. 2014: 203). Buchloh describes Willich as an overhang of the '1960s motivation for alternative life-styles', and also that there 'were a lot of hangers-on'. Polke was much admired, yet 'he undercut' that role, Buchloh continues, Polke's political sympathies probably lay with 'radical anarchist aggression', though he also infers that Polke and the Gaspelshof community probably would have harboured 'people connected to the Baader-Meinhof group'. Although he adds, the 'organised political left probably was always alien to Polke' (2014: 203–4). This sequence of answers, ironically, provides some of the scope for discerning where to locate that biting political dimension that Buchloh felt was missing in Polke's work after 1971 and, in the guise of *Wir Kleinbürger!*, it just might not take the form of the political dimension Buchloh was expecting.

3 Complicating this adverse association is the lauding of the *Bürger* in the German understanding as well, which as Steven B. Smith notes, meant seeing 'themselves as bearers of a distinctive culture and way of life possessed by neither the nobility nor the common people'. As Smith cites George Lichtheim, the crucial distinction is no longer exclusively related to one's wealth or 'socioeconomic standing', but to a cultural world view (Smith 2016: 159–60). These differences relate more to the differences over time and different historical periods.

4 In the publication, *Polke & Co*, which documents the exhibition, it is suggested that the work exhibited amounts to a 'search for alternatives to a (petty) bourgeois existence' (Rübel, et al. (2010: 7). In the subsequent catalogue, Lange-Berndt and Rübel state: 'It is clear, though, that Sigmar Polke shares Enzensberger's complacent view only up to a certain point' (39). They do not spell out why it is a 'complacent' position. More revealing is the oscillation around this term in the short discussions at the end of the catalogue by Vera Wolff ('Polkographies: On the Difficulty of Writing a Biography of Sigmar Polke, the Contemporary': 456–65) and Michael Liebelt ('Harlequinades Made of Nothingness': 469–72). Liebelt's final line repeats the key question: 'Can it always be that the others are the petty bourgeois?' in Lange-Berndt and Rübel (2011: 472).

5 Enzensberger (1976).

6 Florida (2002).

7 By the end of 1936 (November), Goebbels declared that art criticism was over, a thing of the past. Critics in Nazi Germany would thereafter

require special licences. Art criticism would be restricted to descriptions (*Kunstbetrachtungen*) because the standard of art was set according to a National Socialist viewpoint of culture (Welch 2002: 35).

8 This point is most forcefully put by Leszek Kolakowski in his chapter, 'The Marxist Roots of Stalinism', in Kolakowski (2012: 92–114).

9 In October 1944, Soviet forces began to enter East Prussia and news of atrocities soon followed, particularly in the wake of the advance towards Gumbinnen where most of the local population had already fled. The events in the village of Nemmersdorf were quickly adapted by Goebbels for propaganda purposes to terrify and rally the German population, despite the futility of the war. While aiding recruitment to the *Volkssturm*, the propaganda campaign also prompted the large-scale evacuation of the German population along the Eastern front. On 21 November 1944, Hitler himself evacuated the Wolfsschanze headquarters in East Prussia. Polke's family would have fled in this period between November 1944 and final defeat in May 1945.

10 Dagerman (1947/2011: 5).

11 Cited in Sigmar Polke obituary, *The Telegraph*, UK, 13 June 2010 http://www.telegraph.co.uk/news/obituaries/culture-obituaries/art-obituaries/7825072/Sigmar-Polke.html

12 Koether (2014, *Alibis*: 192). The context of her remarks is her ambition to keep a safe distance from Polke and this generation of wartime men with their ruinous humour, which she observes 'tended to be machines for the production of injuries'.

13 For the full account, refer Rottmann (2011: 120–7).

14 Rochlitz (2000: 118).

15 Koether (2014: 191). Drawing such distinctions is a type of art-critical sport, see also Peter Schjeldahl: 'Both live and work in Cologne. But their differences are profound. Richter, reflective and deliberate, is a family man of temperate tastes and orderly habits. His studio is one of two elegant rectilinear buildings – the other is his house – in a large, walled, lushly gardened compound. Polke, restless and impulsive, is an unreconstructed bohemian, inhabiting cluttered expanses in a shabby industrial building.' Schjeldahl (2008).

16 Judt (2005: 337).

17 Judt (2005).

18 Wildt (2003: 110).

19 Ennslin reportedly made these remarks in 1968, which were broadcast after her trial for an arson attack on a Frankfurt department store. Cited in Zielinski (1999: 215).

20 When asked about Polke's installing of the phrase, 'Kunst macht frei' ('Art makes you free'), Buchloh replies that despite increasing

awareness of 'the recent German past – and the fact that the student revolts in 1968 were partially a critique of the fathers who repressed German Nazi history – to do what Sigmar did in 1976 was still completely unthinkable in terms of cultural production. To confront a well-established audience of newly rich and socially high placed collectors with a cultural object that publicly reminded them of Auschwitz as part of their own recent and now repressed history; which no amount of cultural cosmetics could cover up, was a strike that most people were not willing to take at that time.' Buchloh, in Halbreich, et al. (2014: 204); see also Halbreich (2014: 70).

21 Dagerman (1947/2011: 14). Dagerman quotes the famous line, 'Erst kommt das Fressen, dann die Moral' and notes the enthusiasm for the staging of *The Threepenny Opera* that autumn, but 'what had been seething social criticism, a pungent open letter calling for social responsibility, was transformed into a celebration of social irresponsibility'.

22 Refer Robins (2018: 429).

23 Which is why Lange-Berndt and Rübel are correct to say that Polke explores what cannot be absorbed into such a devouring culture.

24 Smith (2016: 248).

25 For Zürich, Polke chose five of such figures: the Son of Man, Isaac, the Prophet Elijah, King David, and the Scapegoat. See the discussion by Jacqueline Burckhardt and Bice Curiger, 'Illuminationen/ Illuminations' in *Polke: Fenster-Windows, Grossmünster Zürich*: 48, 66.

26 Schjeldahl (2008).

27 Habermas (1971: 121).

28 Martin Kippenberger, interview with Daniel Baumann, cited in Krystof and Morgan (2006: 64).

29 Guston goes onto explain that the works that followed had a profound impact: 'It was as though I had left the Church; I was excommunicated for a while.' Refer Guston (1978: 283). See the interesting discussion of these points: Eleanor Ray (20 November 2013), 'Temporary Equilibrium', http://thisrecording.com/ today/2013/11/20/in-which-we-look-under-the-shadows-of-natural-objects.html#references

30 During (2002).

31 Jolly (2012).

32 Cited in Maxwell and Miller (2011: 585).

33 Foucault (1986).

34 Heidegger (1950: 165).

35 Najafi (2007). During also asserts that the basic claim of his book 'is that secular magic – that is to say, magic that doesn't claim to be supernatural but has a relationship with the fictional and the

emergence of show business – has had a greater effect on culture and society than we usually grant'.http://www.cabinetmagazine.org/issues/26/najafi.php

36 Hegel suggested there was a line to be crossed too when dealing with esoteric matter (though it had its appeal!). Noting in relation to Christian ideals in art, Hegel notes the presence of apposite figures – 'Christ, Mary, other saints, etc.' – 'but alongside it imagination has built up for itself in related spheres all kinds of fantastic beings like witches, spectres, ghostly apparitions, and more of the like. If in their treatment they appear as powers foreign to man, and man, with no stability in himself, obeys their magic, treachery, and the power of their delusiveness, the whole representation may be given over to every folly and the whole caprice of chance. In this matter in particular, the artist must go straight for the fact that freedom and independence of decision are continually reserved for man.' (Hegel 1988: 230–1).

37 Brus (2015): 'Der Einbruch von unerklärlichen Mächten und Kräften die außerhalb des künstlerischen Subjekts liegen ist ein häufig anzutreffendes Thema, das bei Johannes Brus und Anna und Bernhard Blume vor allem im Medium der Fotografie, bei Sigmar Polke auch in Aktionen und Filmen verhandelt wird.'

38 The cover story for this issue was 'Urlauber Überall' ('Tourists everywhere', or: 'Holiday-makers everywhere', *Der Spiegel*, 1970: 138).

39 See the obituaries: 'Rosemary Isabel Brown, a musical psychic, died on November 16th, aged 85', *The Economist*, 29 November 2001, which mentions a debate on whether globalization is being driven by "psychic energy"'; Ian Parrott, 'Rosemary Brown', *The Guardian*, 11 December 2001; Martin (2001).There are no reports of Brown being in contact with anyone since her own death, let alone whether Brown and Polke are in contact.

40 Safranski (1998: 428).

41 The original German title is far less loaded: *Ein Meister aus Deutschland: Heidegger und seine Zeit* (Safranski 1994). The original German subtitle of the biography actually emphasizes Heidegger and 'his time', which suggests a wider compass: politics, cultural issues, and modernity, as well as the twentieth-century history – the century that brought us mass production as well as mass consumption, applied technology, incredible medical and scientific advances, but also its converse with the Holocaust, and the gulags.

42 Masschelein (2011: 139).Interestingly, Masschelein notes that this phase of 'hauntology' in theoretical inquiry represents 'a mix of Heidegger's ontological category of "Unheimlichkeit" and the Freudian uncanny'. Although she goes on to note that 'the mild

effect of the Freudian "uncanny" would at best be a *Stimmung* in Heidegger's view', while conversely 'it is unlikely that Freud regarded the uncanny as the existential condition of mankind'.

43 Masschelein (2011: 140).

44 Najafi (2007).

Chapter 3

1 See the statement on its website http://www.mathaf.org.qa/en/ themuseum 'About Mathaf', which focuses on the institution providing an Arab perspective on art with an emphasis on dialogue and scholarship. As the museum's then chief curator Wassan Al-Khudhairi explained in an interview on the eve of the opening:

> There is quite a lot of interest in contemporary art for art from the Arab world. The modern period was less studied because it was hidden away in private collections. So, it is very exciting to finally have these works be accessible. … what makes it hard is that the ecology in the Arab art world is unbalanced. There are art fairs, auctions, galleries, but there are no institutions. We're hoping Mathaf can be a balance to other commercial based activities in the region. Cited in Colhoun (2010).

2 As Oakley and O'Connor note, this configuration sought to align the cultural with the knowledge economy, but this transmuted into a vision of harnessing creativity in a different guise – namely, 'the heroic entrepreneurial energies eulogized by the Californian ideology', Oakley and O'Connor (2015: 3).

3 The corruption controversy surrounding FIFA in the case of Qatar's bid relates to the fact that Qatar's temperatures can reach a physically draining peak of between 40 and 42 degrees Celsius during June and July, and thus the questions surrounding the decisions behind this process.

4 Shadi Hamid, the research director at the Brookings Institution's Doha Center, stated at the time that Mathaf was significant as an institution because 'it's not just about diplomacy or traditional foreign policy. … It's about getting involved in the arenas of culture, the arts and education, and this has been the area where Arab countries have been lagging' NPR (30 December 2010), 'A surgically implanted camera and more at new Arab art museum', *The Picture Show*. www.npr.org/132450434/mathaf. Hanan Toukan (2011) puts a different spin on this assessment by focusing on the emblematic

role that art plays within the framework of both cultural diplomacy and the 'trans-nationalization' of contemporary arts production. She notes that Gulf cities, in particular Dubai, are regarded as 'a necessary component in developing a regional arts scene' due to 'their unrestrained liberal economy, aggressive take on societal development, and self-appointed position as a center for arts of the region' Refer Toukan (2011).

5 See Oakley and O'Connor (2015: 4):

> Eagerly adopted in Hong Kong, it [the creative class] quickly ran into problems when the persona of the 'creative' and the kinds of cultural ambience they required – ethnic diversity, gay (friendly) businesses, bohemian enclaves – were deemed less than desirable. The new creative economy was to be run by serious people in nice suits and dresses, not BoHos. More popular was the older 'high culture' or arts-led regeneration.

6 For a considered, but irresolute, overview, see Poljarevic's (2015: particularly 39–44).
7 Colhoun (2010).
8 Al-Khudhairi cited in Colhoun (2010).
9 It was subsequently exhibited at the Istanbul Biennial in 2015.
10 This attitude is also close to Amin Maalouf, who states: 'You can't say history teaches us this or that; it gives us more questions than answers, and many answers to every question', cited in Jaggi (2002).
11 Cotter (2015).
12 Bodick and Anna Kats (2015).
13 This theme runs through the work of Mona Hatoum, a Palestinian born in Lebanon, who became an exile while studying art in London when the Lebanese civil war began in 1975 – a fate and history she shares with Amin Maalouf whose work (as stated) was the inspiration for *Cabaret Crusades* and who was also an exile as a result of the same civil war.
14 This is a contested label. For instance, the Tunisian blogger, Lina Ben Mhenni, declared: 'I am against the notion of an Arab Spring, because I think that each country in the Arab world has its own characteristics.' Nonetheless, she notes some common demands that were not exclusive to Tunisia: the demand for 'employment, freedom and dignity', Mhenni (2015). Closer to the time of the uprisings, Perry Anderson noted the 'volcanic social pressures' that underscored the conditions for the unrest: 'Polarization of incomes, rising food prices, lack of dwellings, massive unemployment of educated – and uneducated – youth, amid a demographic pyramid without parallel'

as well as a 'lack of any credible model of development, capable of integrating new generations' Anderson (2011: 10).

15 As Anderson (2011: 5) noted of the protests:

> The Arab revolt of 2011 belongs to a rare class of historical events: a concatenation of political upheavals, one detonating the other, across an entire region of the world. There have been only three prior instances – the Hispanic American Wars of Liberation that began in 1810 and ended in 1825; the European revolutions of 1848–9; and the fall of the regimes in the Soviet bloc, 1989–91. Each of these was historically specific to its time and place, as the chain of explosions in the Arab world will be. None lasted less than two years.

An important factor in the Arab situation has been 'the longevity and intensity of the assorted tyrannies that have preyed on it since formal decolonization' (Anderson 2011: 5). In the case of Syria, the upheaval produced extreme reactions.

16 Despite drawing a parallel to Europe in 1848, Anderson could still envisage a hopeful outcome for the uprisings – 'when the last sheikh is overthrown' – of a revolutionary realignment with 'the equitable distribution of oil wealth in proportion to population across the Arab world, not the monstrous opulence of the arbitrary few and the indigence of the desperate many', Anderson (2011: 15). Instead, the pendulum swung in a contrary direction, as Hugh Roberts notes:

> The movement sparked by the Tunisian revolution has ended up consigning Egypt to a new phase of military dictatorship bleaker than any before and precipitating the descent into mayhem of Libya, Yemen and Syria. The most substantial beneficiary in the region of this turn of events practises the most zealously intolerant, retrograde, vindictively sectarian and brutal form of Islamist politics seen in our lifetimes.

Of course, Roberts is referring to the Islamic State group. See Roberts (2015: 5).

17 See Beaumont, Kingsley, and Chrisafis (2013: 1, 4–5). See also Borzou Daragahi, 'Tunisia restores tense calm after riots' (13 June 2012), and 'Tunisia jails 16 Islamists over art riots' (2013), *The Financial Times*, www.ft.com/intl/cms/s/0/8f4a050c-b527-11e1-ab92-00144feabdc0. html#axzz3eDJdagPE

18 One of the exhibiting artists, Héla Ammar, noted that extremists made death threats against the artists: 'It is impossible to believe that a few small paintings exhibited on the edge of a northern suburb of

Tunis provoked all this violence across the country. In reality, the artists have been used as scapegoats'; cited in Ryan (2012).

19 Wilson-Goldie (2013).

20 While stating she was not interested in the reasons why Persekian was dismissed, Angela Harutyunyan nonetheless outlined a couple of alternative hypotheses: 'inner or inter-Emirati politics that conspired against the powerful director of the Foundation, or it was simply time to de-identify the institution from the person'. The latter seems implausible at that point in time because the timing of the dismissal caused maximum disturbance to the biennial and also brought the maximum of unwanted publicity to the Art Foundation. Refer Harutyunyan (2011).

21 It should be noted that Benfodil's work was simply removed from the biennial, but the artist was never arrested. This would seem small comfort at the time, but subsequently events escalated (for the worse) and two members of Pussy Riot were imprisoned in Russia, while Ai Weiwei was arrested in China and later placed under house arrest. These extreme measures transformed Pussy Riot and Ai Weiwei into international celebrities, while Benfodil remains relatively obscure by comparison.

22 Toukan (2011).

23 Davidson (2011).

24 Toukan (2011).

25 Davidson (2011).

26 See GulfLabor (2013) and Stoillas's (2011, 2013).

27 McNeil (2017). McNeil's report noted that the French president Emmanuel Macron was the guest of honour at the Louvre UAE opening, but her main point was that the country's 'last remaining human rights defender', forty-seven-year-old Ahmed Mansoor, had been imprisoned since March 2017 with little access to the outside world, http://www.abc.net.au/news/2017-11-12/the-forgotten-story-of-ahmed-mansoor/9142004

28 See the work and themes of Sophia Al-Maria and Fatima Al Qadiri; refer Orton (2012).

29 For a good example of this, see the rather glib concluding comments of Sam Bardaouil on the Sharjah saga, taking the perspective of the pragmatic curator, whose comments are very similar to the Abu Dhabi Tourism Authority chairman Mohamed Khalifa Al Mubarak at the opening of Louvre Museum in Abu Dhabi: 'No one is perfect or has all the answers, neither the "censored" or the "censorer". We are all in this together and the only way forward is to continue talking to each other, all of us, always.' (Bardaouil 2011).

30 Benfodil (2011).

31 Milliard (2011).
32 Benfodil (2011).
33 The frenzied case of the Khmer Rouge in Cambodia in the early 1970s exposes the depths of the extremist zeal to start all over. Their goal of returning to a 'Year Zero' aimed to return Cambodia to a classless, self-sufficient, pre-industrial peasant collective, thereby correcting the wrong of an inequitable class division prompted by modernity, capitalism, and technology. This meant eliminating all traces of modernity, as well as purging society of its contaminants. In Cambodia, the tell-tale signs of such impurity were a professional education, the wearing of spectacles, a lack of capacity to do agricultural work, and knowledge of a foreign language such as French or English (irrespective of the French name of the Khmer Rouge and the Western training and background of most of its leading cadres). The result was a death toll that reached almost a quarter of the country's population. Like Algeria, it has proven difficult to account for all the deaths. When these rabid tendencies reach their fanatical tipping point in ideological amplification, they implode in frenzied violence. This is the pathological tendency that Benfodil refers to in the Algerian instance.
34 Cited in Ryan (2012). It is worth noting that a few years afterwards the Tunisian blogger Lina Ben Mhenni decried the fact that despite the removal of the dictator, many of the original aspirations of the Tunisian uprising had still not come to fruition. At the same time, the agitation for democracy persisted through the same alliance of agitators, human rights activists, and 'young artists who continue to express themselves freely through painting or song' (Mhenni 2015). It is this alliance of themes and this rhetoric that, once identified solely with the West, is informing the voices of dissent against repression.
35 Tolokonnikova (2012). As mentioned, similar to Benfodil, the charges against Pussy Riot originally related to blasphemy, but in Putin's Russia they were transmuted into 'hooliganism motivated by religious hatred'.
36 Whittaker (2013). See also Martin (2013).
37 See 'Sharjah Biennial 10: Artists and Participants Announcement', 21 December 2010, http://sharjahart.org/press/sharjah-biennial-10-artists-and-participants-announcement
38 Milliard (2011).
39 'Protest against the dismissal of Jack Persekian (15 April 2011)', AICA, https://aicainternational.org/en/protest-against-the-dismissal-of-jack-persekian-15-april-2011/
40 Ibid.

41 While Hanan Toukan notes that 'censorship and art have a long history in democratic and non-democratic settings alike', in her assessment reacting to the Sharjah incident, she argued that the reality of the situation means recognizing that 'UAE is a dictatorship – albeit an arguably benevolent one with a veneer of civility about it'. It would be foolish, in other words, not to appreciate that Sharjah operates in a context in which 'the very act of censoring is enshrined as a necessary cultural norm and a social value by regime and society alike'. On the other hand, in Sharjah this 'veneer of civility' extends to the support of scholarship into the history and culture of the region, notably calligraphy, as well as investment in cultural heritage and tertiary education (Toukan 2011).

42 Persekian spoke to the English-language newspaper, *The Nation*, published out of Abu Dhabi, which may have influenced the overall tenor of his remarks. These comments were reported on numerous websites of journals, such as *Art in America*, *Artforum* and *Flash Art*. Persekian was quoted as saying:

> It was foolish of me, I had not looked at it carefully because I couldn't, there were so many works and so many things to produce – films and books and publications and videos, a million things I didn't go through. I'm not in the habit of checking everything, and people just didn't like what they saw in that work and took it out on me personally.

43 Toukan contends that Persekian acted most consistently of all – perhaps a long bow to draw – but her account clearly outlines the limits within which Persekian was operating (Toukan 2011). In contrast to the two members of Pussy Riot as well as Ai Weiwei, Persekian never went to prison in 2011, which is perhaps why Pussy Riot and Ai Weiwei attracted much more publicity. Persekian subsequently took the role as director of the Palestinian Museum in Birzeit, north of Jerusalem. In December 2015, Persekian announced he had stepped down from that role too. In May 2016, the Palestinian museum opened without any art or artefacts on display. Both dismissals likely indicate the thresholds in which a culture of questioning can prevail in a region characterized by largely autocratic governance that is challenged by fundamentalism, on one side, and an urge for economic justice and liberal democratic reforms on the other.

44 As opposed, that is, to being confined to the study and appreciation of culturally valuable works of art from the near past. Refer the opening remarks on the topic by editors Eysteinsson and Liska (2007: 1).

45 In its December 2011/January 2012 double issue, *Time Magazine* named its 'Person of the Year' simply 'The Protestor' with the subtitle

'From the Arab Spring to Athens, from Occupy Wall Street to Moscow'. Curiously, in this year of the anonymous protester, it was the imprisonment of artists – and thus the chronic overreach of their respective governments – that turned them into celebrity protesters.

46 In relation to this neo-liberal framework and the focus on display, Toukan refers to Julian Stallabrass's book, *Art Incorporated: The Story of Contemporary Art* (2004).

47 Steyerl (2015).

48 This is not to suggest that censorship and authority do not exist in liberal democratic societies; instead, it constitutes a standard against which it can be opposed. Of course, such critical aspirations took a long time to achieve in Europe.

49 Marchant (2014: 11).

50 Kolakowski (1990: 21).

51 Márkus notes a similar sentiment in Lukács: 'His critique of the "aestheticism" of Schiller and the young Schelling is based … on the argument the aesthetic attitude necessarily remains both a derivative and contemplative, merely ideal relation of the isolated subject to reality' Márkus (2011: 555).

52 Marchant (2014: 2).

53 To reiterate, in Terry Smith's account of contemporaneity, he outlines a few certain key currents within contemporary art, one of which is 'spectacularism'. It is characterized by the work of architects, such as Frank Gehry, Santiago Calatrava, and Daniel Libeskind. While this amalgam appears to possess very little in common, Smith regards them as collectively contributing to an 'aesthetic of globalization' (Smith 2009: 7), which is where they fit in with Harutyunyan's assessment.

54 At the height of the uprisings, Tariq Ramadan argued that, while the governments of Europe, Britain, and the United States supported the espousal of democratic ideals heard within the protests, they had also for decades 'been visibly supporting dictatorships in the name of frequently undisclosed economic and military interests' (Ramadan 2012: 32). 'Behind the celebration of the values of freedom, dignity and the struggle against dictatorship is concealed a battle for economic domination, control of oil production and reserves and coldly cynical geopolitical calculation' Ramadan (2012: 39). Ramadan offers the example of France negotiating with the National Transitional Council to acquire '35 per cent of Libya's oil exports after Ghaddafi's anticipated downfall' – an agreement that Qatar 'knew of and approved' (Ramadan 2012: 38). Regarding support for cyber-activists, see Ramadan (2012: 21–31).

55 While China had been busy hosting the Olympics, biennials of art and expos, the uprisings clearly provoked consternation and

prompted then-president Hu Jintao to draw the equation between
soft power and cultural imperialism. In his statement of January
2012, he decried Western cultural influences in China as pervasive
and insidious: 'We must clearly see that international hostile forces
are intensifying the strategic plot of Westernising and dividing
China, and ideological and cultural fields are the focal areas of their
long-term infiltration.' In the aftermath of the far-distant uprisings,
crackdowns on civil rights and dissent followed – in Xinjiang and
Tibet, the arrest of Ai Weiwei, and also of Nobel Peace laureate Liu
Xiaobo. Certain risqué television programmes exposing the sexual
and consumer mores of young Chinese participants were restricted.
As Joseph S Nye (17 January 2012), noted at the time in his 'Why
China Is Weak on Soft Power', *New York Times*:

> What China seems not to appreciate is that using culture
> and narrative to create soft power is not easy when they
> are inconsistent with domestic realities … in the aftermath
> of the Middle East revolutions, China is clamping down on
> the Internet and jailing human rights lawyers, once again
> torpedoing its soft power campaign.

Things move quickly and China is moving on soft power once again.
At the same time, Nye also notes impediments to US soft power: the
invasion of Iraq, its highly partisan political culture, and the inability to
fully come to terms with the consequences of the global financial crisis.

56 Even Ramadan, whose analysis unremittingly focuses on the
complicity of Western governments with dictatorships, resorts to a
culturally transgressive model (the original axiom of cultural critique)
in order to envisage a way out of the impasse:

> Identifying the spaces and historical opportunities that
> peoples can grasp in order to turn the meaning of history
> to their advantage, to seize control of that which their
> would-be masters cannot control at the heart of the
> historical dynamic, and to shape its order and substance.
> Only in this way will they be able to attain true liberation,
> to accede to autonomy and to bring the liberty of the
> world's peoples. The mass movements in the Arab world
> prefigure the advent of these unexpected elements, of an
> impulse borne by the popular will that neither the ruling
> powers nor their media can contain. (Ramadan 2012: 51–2)

57 Ironically, the conclusion that all critical options are deluded and
lack viability tends to confirm the supposition of a conservative
counterargument that regards the entire project as a metaphysical

contrivance that critical theory has inherited from German idealism. It declares instead that it is time to dispose of the grand, deluded, and ultimately fraudulent claims of critical autonomy and finally begin to realize our place.

58 Despite the nuanced model offered, it is still Marxist in orientation. All that counts is the big bang of revolution, which reaches a point beyond exclusion, thus transcending liberal politics and the politics of incremental gains.

59 Refer Pankaj Mishra, 'Why are people so angry? Blame modernity', *BBC Newsnight*, https://www.youtube.com/watch?v=b4FgzAe2MF0

60 Steyerl (2015).

61 This mirrored the tactic of the communist regimes of Eastern Europe who, before the fall of the Eastern bloc, belittled protesters against their regimes as having been deluded by 'bourgeois propaganda'. Patrick Pasture notes that other countries find 'the EU's complacent attitude with regard to human rights, and its self-proclaimed moral superiority' a constant source of irritation (Pasture 2015: 84). The trap, he adds, is that such irritation 'sometimes may be an easy way of condoning human rights abuses as well' (2015: 84). This aside is no easy factor to ignore. For the artists and other dissenters in the Middle East and northern Africa, the uprisings presented an occasion when they could insist that the human rights agenda could no longer be treated as an insignificant matter or, far more challengingly, no longer a consideration to deflect in the face of offending cultural tradition or for fear of assuming moral superiority.

62 This is one factor that Hannah Arendt notes as an origin for European totalitarianism. See the discussion in Pippin (2005: 149). As a consequence, the ambivalence is stretched between polar identifications. As Ramadan characterizes it: 'On the one hand, hatred of Western values; on the other, the celebration of those very ideals.' Ramadan (2012: 52).

63 Rabbat (2012: 208).

64 Here Dussel argues he is paraphrasing Hegel.

65 Refer the counter-narrative offered by Hobson (2004).

66 In regard to Eurocentric hubris, it is sobering to note that 'settler' nations, such as Canada, New Zealand, and Australia, are longer continuous democracies than most nations on mainland Europe.

67 Cited in Pasture (2015: 83).

68 Pasture (2015: 83). Pasture's review passes over this point too quickly. It is interesting to contrast it with Tolokonnikova's point that highly familiar avant-garde provocations only become matters for imprisonment when the civil framework is missing.

69 Nasser Rabbat paraphrases the argument of the exiled Libyan thinker al-Sadiq al-Nayhum to make this point. The protesters, he adds,

were seeking to reclaim the Islamic tradition of civic argument and contestation associated with such sites. Rabbat does note, however, that al-Nayhum concluded that 'modernity had failed to take root in the Arab world because in large part it had grown out of Western history and developed in a Western cultural and epistemological context', Rabbat (2012: 198). Rabbat continues: 'Al-Nayhum, predictably, advocated a return to a pure, foundational Islam to rebuild the battered and confused Arab societies' (2012: 198).

70 Shabout (2015: 488).

71 This centre–periphery model of evaluation, with the periphery defined in terms of belatedness, is scrutinized more fully in the next chapter.

72 While paraphrasing a similar argument, Arif Dirlik argues that 'there is no recognition in this account of the incoherence of Eurocentrism as a historical phenomenon', Dirlik (999: 4).

73 For instance, Žižek refers to the increasing preoccupation of the 'postpolitical liberal establishment' on identifying the 'specific problem of each group and subgroup (not only homosexuals but African American lesbians, African American lesbian mothers, African American single unemployed lesbian mothers, and so on)'. Žižek (1998: 1001). Žižek's point is that this qualification remains particular and therefore never challenges the system as a whole.

74 Žižek (1998: 1009, 1008, and 1006 respectively).

75 Žižek perhaps revealed his stance too candidly in this acerbic dismissal in a subsequent interview: 'Postcolonialism is the invention of some rich guys from India who saw that they could make a good career in top Western universities by playing on the guilt of white liberals'; cited in Engelhart (2012).

76 Even though Kolakowski's argument is different to Žižek's, it is also his style to elicit similar provocations. 'Looking for the barbarians: the illusions of cultural universalism' was delivered as a lecture in 1980 and first published in French that year; it appears in Kolakowski (1990: 14–31).

77 The tragedies of the convulsive European passage through modernity in the twentieth century tend to underscore Kolakowski's point; its barbarism was most apparent when self-questioning had been eclipsed and suppressed.

78 Here Kolakowski appears to be confirming Hannah Arendt's argument in *The Origins of Totalitarianism* that totalitarianism is the twentieth century's macabrely unique contribution to political formations (alongside the republic, monarchy, and despotism) and one that arises in technologically advanced societies. Kolakowski's explanation for why this occurs overlaps with Arendt's account, though not completely.

79 In fact, Kolakowski's warning remains salient considering subsequent developments. For example Pasture contrasts the image of European moral superiority in regard to diversity and progressiveness with its rising 'xenophobia and racism' arising from economic insecurity and stagnation since the global financial crisis, which arose in 2007; for Pasture, this economic trauma exposes a 'deep-rooted longing for similarity and homogeneity' (Pasture 2015: 84–5).

80 For Kolakowski, this is the chief failing of Marxism, which is why Žižek emulates Kolakowski's provocative 'defence' of Eurocentrism while drawing a different conclusion and never mentioning him. While Marxism provided an incisive critical discourse for western Europeans in targeting the excesses of capitalism, the lived reality of its system comprised an inversion of utopian perfection. As early as 1956 in an essay titled 'The Death of Gods', Kolakowski bitterly noted that, instead of a classless utopia, the Eastern bloc created a harsh, dystopian inversion of it:

> [Generating] its own social classes, its own system of privileges, drastically at odds with the principles of traditional egalitarianism ... serving to perpetuate an ossified hierarchy and caste system ... exploit[ing] the most absurd forms of chauvinism and blind nationalist megalomania ... a system of total police terror, a military dictatorship of lawlessness and fear ... a radical autocratic or oligarchic centrism, more crippling to social initiative than any form of bourgeois democracy. (Kolakowski 2012: 6–9)

In a similar vein, Tony Judt refers to Andrei Zhdanov's notorious 'two cultures' dogma, which after 1948 insisted 'upon the adoption of "correct" positions on everything from botany to poverty', Judt (2005: 202). Judt notes how enforcement of such a brutally proscribed path of thinking came as a shock to many in Eastern Europe in the first years of the Soviet bloc.

81 Kolakowski's sceptical stance about the perfectibility of any of the prevailing ideologies can be found in the paper, 'How to be a Conservative-Liberal-Socialist: A Credo', chapter 19, (1990: 225–8).

82 Derrida (2007: 44–5). The concept of a perfectible heritage is perhaps better understood in terms of his idea of a 'democracy to come', which suggests that democratization or progress is never finalized or complete, thus avoiding the temptation to declare any period or culture as the rational realization or culmination of this process.

83 It is significant because Derrida is often considered one of the thinkers most often associated with a break from this tradition – for example modernity, Enlightenment, and so on – and instead the grand philosopher of difference. Yet, this is an endorsement of this

'perpetual self-critique', which Kolakowski is pointing out is essential to the sceptically vivid side of this legacy and, one could argue, is what separates Derrida's defence of difference from an absolute relativism.

84 Kolakowski toys with the proposition that the Spanish conquistadors in Mexico and South America, while obviously barbaric, were consistent; they held their Christian beliefs to be universal and true, thereby they 'saw no reason to safeguard pagan idols' (1990: 16). They were absolutely resolute in their belief about the one true path to redemption. Teasingly, Kolakowski suggests that they may have been the 'last true Europeans' (1990: 16) because they held no equivocations about their culture; they were not indifferent to it, they were not cultural relativists, they did not harbour any doubts. Ultimately, his point is to show that this vehement universalism ends up being barbaric and intolerant; it justifies extreme actions where economic exploitation and religious belief are blurred. Kolakowski regards the Marxist tradition in this light because it upholds a form of absolute or strict universalism, which justifies all its actions – this is another point of difference between Žižek and Kolakowski in their re-examination of Eurocentrism. Kolakowski is disdainful of the idea that Stalin is simply an aberration from the good guy, Lenin.

85 The focus of Benfodil's installation was precisely this propensity in Islamic form: 'a pathological revolutionary paradigm' that sought legitimacy based on 'a phallocratic, barbarian and fundamentally liberticidal God'.

86 Kolakowski presses this presumption in such a stark manner because he appears particularly sensitive to this proposition. He raised the same complaint a few times in different contexts. He felt Western Marxists resorted to platitudes when defending the ultimate, higher goal of Marxism, that is a classless society, irrespective of actual life behind the 'Iron Curtain' in the Warsaw Pact nations of Soviet-ruled Eastern Europe – with his homeland of Poland specifically in mind. Thus, he repeats the same ironic proposition, but in a slightly different way in his pithy reply to E. P. Thompson during their exchange of 1974. Kolakowski is taking aim at the attitude of both progressives and conservatives:

> We cannot be blamed for not taking seriously people who … teach us how liberated we are in the East and who have a rigorously scientific approach for humanity's illness and this solution consists in repeating a few phrases we could hear for thirty years on each celebration of 1 May and read about in any party propaganda brochure. (I am talking about the attitude of progressive radicals; the conservative attitude to the problems of the East is different and may be

summarized briefly: 'This would be awful in our country, but for these tribes it is good enough.') (Kolakowski 1974: 11–12)

87 As we have seen, Benfodil drew the opposite conclusion and asserted that the Algerian civil war showed that the ideal of returning to a pure and uncontaminated Islam resulted in a pathological outcome. The subsequent rise of Islamic State bears out Benfodil's concern about the prospect of a descent into a 'pathological revolutionary paradigm' (2011).

Chapter 4

1 Wood (2014: 101).
2 Gardner and Green (2013: 453, 447).
3 Gardner (2011: 143).
4 Quoted from the lecture abstract, Elkins (2017).
5 Pippin (2014: 1, n.1). This revised focus on modernism would no doubt be cautiously welcomed by someone such as Pippin, whose sustained ambition (over many publications) has also stressed the complexity and vitality of the modernist legacy, both philosophical and artistic; refer Pippin (1991, 2005). His work might suggest that we dispense with this legacy at our peril. At the same time, Pippin's quoted comment is interesting because he has also referred dismissively to 'the rather thin theoretical dimensions of postcolonial theory and New Historicism' in the context of a discussion about 'non-being' and his account of 'what isn't in the what is'; Pippin (2004). Pippin's primary focus is a reworking of Hegel and thus of philosophical modernism. In the visual arts, he tends to follow the example of Michael Fried, his 'favorite art historian', by following highly demarcated models of artistic worth based on medium, primarily based on the model of painting, albeit conceived on the basis of 'visual intelligibility': 'What an embodied mode of vision and the intelligible presence of the world to a mind is like', Pippin (2007).
6 Foster, et al. (2004).
7 Piotrowski (2008–2009: 4). Gardner and Green also appeal to the horizontal emphasis that they believe can be found in biennials of the south 'during the second wave of biennialisation from the 1950s onwards'. The shift is 'toward more horizontal axes of dialogue and engagement across a region', and the more horizontal, they exuberantly declare, the more 'transcultural, even egalitarian … attempts at commonality'; see Gardner and Green (2013: 453).

8 Batchen (2014: 8).
9 Batchen (2014).
10 In an interview with Benjamin Buchloh about Polke, cited in Chapter 2, Buchloh was asked about the influence of American art on Polke's generation of German artists. The question is about influence, transmission, and the transformation into something genuinely distinct as an artistic and cultural form. But the real question, Buchloh states, is '[Does this] process generate into something authentically different? Does Polke enter into a dialogue with Lichtenstein that is worthy of anybody's attention, or is it just derivative provincialism?' Halbreich et al. (2014: 200). It is clear that for Buchloh Polke falls into the latter category.
11 Smith (2009: 151).
12 Gandolfo and Worth (2015: 244).
13 This question of what is deemed provincial is not an issue isolated to the peripheries. Used in any context, it amounts to an automatic dismissal. Anne Wagner notes that Jonathan Jones railed against the exhibition, *Barbara Hepworth: Sculpture for a Modern World* (Tate Britain, June–October 2015), 'a good six months' before it even opened. Jones, according to Wagner, was riled by the presumption that the exhibition would ignore Hepworth's last works in order to 'free her from any provincial status as an idiosyncratic British artist who chose to live far from urban modernity in seawashed St Ives'. His point? 'Modern art's true home was never St Ives, or Yorkshire. Pretending that it was, is complacent, insular and either intellectually dishonest or genuinely stupid.' To which Wagner replied: 'The show argues that where modern sculpture is concerned there was, and could be, no such place', that is no 'true' home; Wagner (2015: 33).
14 Gandolfo and Worth do not indicate that they are aware of any precedents to the positions they seek to outline. They do, however, note the fact that 'standpoint epistemology rose to prominence within feminist thought in the mid-1970s to early 1980s' (2015: 244).
15 Rafael Cardoso has referred to the tactic of *Antropofagia* as 'a sort of auto-exoticism', Cardoso (2017). See Gardner and Green (2013: 443). They do not define 'South' exclusively by geography, or geo-politically as 'a category of economic deprivation', but more broadly against 'histories of colonialism that coexist and are shared throughout the world'.
16 While Australia (along with New Zealand) would undoubtedly be included in the list of Western nations, even though geographically south, at the same time its cultural conceptions betray how it has felt constantly marginal to the geographical centres of modernism and contemporary art. It also underscores the fact that the Western

art system is not one coherent, uniform system based on a universal standard of judgement, as is often presumed, but is instead an artistic-cultural legacy with a diverse set of historical outcomes operating within a larger unequal set of competitive power relations.

17 Batchen (2014: 13).

18 See the comprehensive account of Burn's career by Stephen (2006).

19 First published in 1984, the essay is reprinted in Burn (1991: 69).

20 Smith (1974/1984), XIII (I), September; republished in Paul Taylor (1984: 48).

21 Ibid. In 1973 Burn had emphatically declared that the assumptions of the art world were hierarchical and that the rules of the game at that time were American rules. It prompted him to ask: 'Why is it that the political concerns of many South American artists have the effect of relegating them to minor artist status in New York?' See Burn (1973/1991: 131–2).

22 Smith (1974/1984: 54).

23 The classic texts of underdevelopment in political economy were written by Andre Gunder Frank, beginning in the late 1960s, as well as Immanuel Wallerstein, who focused on 'core' and 'periphery' in economic exchange.

24 In fact, fortifying this emphasis on power relations, the concluding paragraph of Terry Smith's 1974 essay on the provincialism problem could easily find a place in Gondolfo and Worth's 2015 essay on standpoint aesthetics. See for example 'Few can persist in pretending that instinctual devotion to an amorphous metaphysical entity "art" frees them from the responsibilities which clearly follow from recognizing art-making for what it is: a thoroughly context-dependent activity, in which most of the contexts are socially specific and resonant throughout the cultural settings in which they occur and to which they travel'. Smith (1974: 53).

25 McLean (2009: 627).

26 Batchen (2014: 12).

27 Burn (1991: 72–3).

28 Burn (1991: 68).

29 Burn refers to how Streeton uses a 'rich, transparent blue' as an organizing feature of his landscape painting depicting an industrial accident in *Fire's On! Lapstone Tunnel* (1891), but Nolan would also no doubt have in mind the more schematic landscapes of the interwar years, such as Streeton's *Land of the Golden Fleece* (1926), which did serve as a local orthodoxy in art. Then again, latter landscapes, such as *Mitchell's Lime Quarry* (1935), also highlight the impact of open-cut mining scarring the landscape, which set another precedent. See Burn (1984/1991: 69).

30 There could be a degree of autobiographical reflection in the analysis Burn offers of Nolan. Ann Stephen notes that the impact of a Mondrian retrospective Burn visited in The Hague in 1966, which placed Mondrian in 'a northern European tradition of landscape', which she argues made him reflect on how 'like Burn, Mondrian's origins were in a local landscape school which he found essential to expunge in order to make abstract art'. See Stephen (2006: 96).

31 Burn (1984/1991: 69).

32 Batchen (2014: 10).

33 The other avenue that Batchen mentions for rethinking art-historical inquiry is cultural inversions. Their critical potential arises from a capacity to think through provincial binds by inverting established norms and hierarchies. Inversion theories 'take an apparently fatal flaw' (Batchen 2014: 11) and turn the deficit into an asset. Batchen generously traces the outline of inversion theories to the 'Introduction' of the 2006 anthology of documents, *Modernism & Australia: Documents on Art, Design and Architecture 1917–1967*, edited by Ann Stephen, Andrew McNamara, and Philip Goad, Melbourne: The Miegunyah Press. The point was, however, to highlight the existence of artistic and cultural counter-models in the form of inversions, while maintaining our critical reservations about the aptness of such a strategy. Inversion strategies are too allied to what they invert; they simply reverse a dominant opposition without significantly altering the larger dynamic they seek to tackle. Inversion theories fail to present adequately permeable counter-models. Their reversals, while intriguing, never depart sufficiently from the initial opposition they seek to upend. The axioms of inverted relation are still too limited and one-dimensional to deliver an alternative account of complex and more diffuse interrelations. Thus, I believe it is wrong to associate our project with the failings that Batchen identifies with *Art Since 1900*: a 'hermetic approach', evolutionary, disconnected from life or modernity. As Batchen says, 'Art history … is about tracing what happened and why, good or bad', which explains why we could note a whole range of inversion theories, dubious or otherwise.

34 To date, the writings I refer to have not been gathered together in any collection. Burn wrote them, as mentioned, in the early 1990s up until his death in 1993. Batchen does not comment on these pieces at all, even while promoting Burn as an exemplar forging art history from the perspective of unorthodox cultural exchanges.

35 See Burn (1975), which also appears as chapter 14 of *Dialogue* (1991: 152–66). For Burn on 'deskilling', see 'The 1960s: Crisis and Aftermath', in *Dialogue*: 104–5. Ironically, the emphasis on deskilling is showcased in Foster, et al. (2004: 531).

36 One context for these remarks is his conversation with Imants Tillers, in which Burn distinguishes between different forms of appropriation. He rebuffs Juan Davila's work because he finds 'little that interests me on that visual level – his work is not visually intelligent, its intelligence functions only on a literary or academic level' (18). The conversation was conducted in April 1993 but not published until 2003. Refer Burn (1993a), in Stephen (2003: 18).

37 Burn (1994: 203).

38 This challenges some key assumptions about conceptual art. I offer two examples. First, as already mentioned, the philosopher Robert Pippin is largely indebted to Fried when arguing that great art still occurs today, but it is found in very particular quarters (the same as those identified by Fried): the 'creation of large photographs' serving 'as the inheritors of the conventions of easel paintings, and in some extraordinarily powerful video'. No great art can be found in the ranks of installation art or conceptual art, which Pippin finds quickly redundant and repetitive. This failing indicates, for Pippin, that such work 'was untrue to the non-conceptual, integral nature of aesthetic sensibility'. See Pippin's remarks in his interview with Hussain (2011b). This is complicated, but it is a fairly routine presumption Burn sought to counteract in these particular writings. The irony is that both Pippin and Burn focus on 'visual intelligibility'. Second, these writings present a challenge to Adrian Piper's contention that a Platonic influence pervades Burn, conceptual art and Art & Language, which manifests in the contention that 'the concept of a particular work – any work, be it sculpture, drawing, text, videotape, whatever you like – is a kind of perfect form to which the realization, the actual work itself, is just an imperfect approximation'. For Piper, the focus upon perfect form or a pure idea led to all manner of meta-art quests, which she identifies with Art & Language because they proposed the 'idea of transcending the art context, getting outside it completely'; Piper (1997). This is correct insofar as it relates to Burn's rhetoric of the time (particularly by the mid-1970s); it is particularly pertinent to his 1970 essay 'Conceptual Art as Art', as well as the whole strain of his thinking about an art history purely for artists. His recourse to a conceptual and/or cultural plenitude confuses the genuine challenge of modern and contemporary art that Burn would otherwise seek to endorse, which is coherently and more consistently asserted in these last writings. Their challenge to routine understanding of conceptual art is worthy of its own discussion. The focus here, however, is not the legacy of conceptual art, but the contribution of his discussion to the renewal of art-historical inquiry in a 'decentred' world.

39 Burn (1993a), cited in Stephen (2003: 18).

40 Ibid.

41 See Ian Burn, catalogue essay for the 1993 exhibition he curated: Burn (1993b).

42 Burn (1991: 177).

43 Burn recalls discussions with Mel Ramsden in mid-1960s London when they talked about 'how one perceives the edges of a window, how the contrasts set up certain illusions, what happens when you paint such an illusion into the painting'. See his letter to Ramsden, 14 December 1967; cited in Stephen (2006: 107).

44 Burn (1994: 203). Burn is discussing A. D. S. Donaldson's painting, *Banal Painting*, in an attempt to show how close attention to the particularities of the work challenged the generic postmodern framework of the curator Rex Butler's emphasis in *Banal Art*.

45 In May 1968 Hunter held his first solo exhibition at Tolarno Galleries in Melbourne; later that year he stayed in New York with Ian Burn and Mel Ramsden where he noted being impressed by the work of Sol LeWitt: 'Something that clicked very much with what I thought I was doing, but in a much better, much more specific way'. Cited in Duncan (1989: 7–8).

46 Hunter recreated the work(s) again in 2011 at Milani Gallery in Brisbane.

47 See Alan Dodge's reading of Hunter (2012: 92–3). See also Dodge's essay, 'Robert Hunter and Minimal Art' in Duncan (1989: 15–40).

48 Notoriously reticent to say much about his practice, Hunter did provide a statement for the catalogue accompanying the 1971 exhibition in which he described the works as alien: 'I want to make something alien – alien to myself. I want to produce something neutral – if it is neutral enough it just is.' Hunter cited in Duncan (1989: 9).

49 Nicholson (2014/15).

50 Burn (1991: 138).

51 Such an assertion may not be that surprising in light of subsequent admissions by Mel Ramsden that 'we were pushing at the edges of modernism to see what happened. That's what we thought it was all about.' Ramsden, cited in Stephen (2013). Again, the reference to the edges recalls Burn's comment about perceiving the edges of a window, and peripheral vision.

52 Burn (1992: 73).

53 Burn (1992: 69).

54 For a similar analysis of a conceptual artist who entertained similar propositions to Burn, but was accused of going back on conceptual art's 'advances', see Skrebowski (2009: 910–31). See especially

his assessment of the critic, James Meyer's 'combative' challenge
to Bochner's return to painting in an interview with the artist,
who claimed that he did not want to 'abandon the visual': 928–9.
This contrast of the successive as triumph against unfathomable
capitulation also marks the tenor of the purported divide between
modernism and contemporary art. See, as mentioned in the
Introduction, how the fascination of contemporary practices for
modernism and its legacy is often presented as an irresolvable puzzle,
an absolute quandary with no critical insight, only a symptom of a
nostalgic attitude, see Bishop (2013).
55 See Galvez (2002).
56 Bru (2009: 46).
57 Bois (2003).
58 Even this idea has roots in modernism. For instance, Alain Findelli
 traces a similar idea about design to Moholy-Nagy, who in 1938
 challenged the focus placed on the 'visual appearance of the
 material object'. Moholy-Nagy's alternative was 'to *see everything in
 relationship*'. (Emphasis in the original.) Moholy-Nagy (1938: 7–22).
 As Findelli notes, while an 'object has a visible presence, relationships
 are … invisible'. Therefore, Findelli argues for a 'visual intelligence' in
 terms of relationships. Findelli (2001).
59 Galvez (2002); Bois (2003).
60 Batchen (2014: 12).
61 The emphasis on nomadic or rhizomatic conditions is very popular
 among those supporting alternative models because it suggests other,
 free-floating possibilities. In other words, it offers the seduction of
 a complete departure from previous arrangements and the mire of
 their unequal power relationships. Note *ARTMargins*, which declares
 its mission, even while based in an American centre like MIT, is to
 'recognize a shift in the definition of what it means to speak to, or
 from, the margins: away from the binary center/margin model (East/
 West, North/South) that dominated modernism and postmodernism
 alike to one that conceives of the periphery as a nomadic zone
 of contact in which the possibilities for a different future may be
 explored'. See also the rather exuberant claim of Arjun Appadurai
 that the centrality–periphery nexus has more or less dissolved in
 the context of cultural globalization. Appadurai instead emphasizes
 deterritorialization. 'We seeing moving images meet deterritorialized
 viewers' (4). 'Culture becomes less what Pierre Bourdieu would
 have called a habitus (a tacit realm of reproducible practices and
 dispositions) and more an arena for conscious choice, justification,
 and representation, the latter often to multiple and spatially
 dislocated audiences.' Appadurai (1996: 44).

62 Hunter used a regular dimension, an 'archaic' four-by-eight-foot
 measure for his paintings. In addition, the paint was applied as if to
 negate his touch, as Nicholson notes (2014/15: 80). The intriguing
 factor of Hunter's deceptively straightforward, standard format
 as well as his sparse rendering is that his paintings defy adequate
 photographic reproduction. This reduction is elusive.
63 Batchen (2014: 13).

Conclusion

1 Burn (1973/1991: 138); Burn (1992: 69).
2 Benjamin (1918/1996: 104).

SELECT
BIBLIOGRAPHY

Adorno, T. W. (1961/1998), 'Those Twenties', in *Critical Models: Interventions and Catchwords*, trans. Henry W. Pickford, New York: Columbia University Press: 41–8.

Alberro, A. (2008/09), 'Periodizing Contemporary Art,' in Jaynie Anderson (ed.), *Crossing Cultures: Conflict, Migration and Convergence: The Proceedings of the 32nd International Congress of the History of Art*, Melbourne: Melbourne University Publishing, 2009: 935–9. Reprinted in *Australian and New Zealand Journal of Art*, 9, no. 1/2: 67–73.

Alexander, Jeffrey C. (2013), *The Dark Side of Modernity*, Cambridge: Polity Press.

Anderson, P. (2011, March–April), 'On the Concatenation in the Arab World: Editorial', *New Left Review*, 68: 5–15.

Ang, I. (2011), 'Navigating Complexity: From Cultural Critique to Cultural Intelligence,' *Continuum: Journal of Media & Cultural Studies*, 25, no. 6 (December): 779–94.

Appadurai, A. (1996), *Modernity at Large: Cultural Dimensions of Globalization*, Minneapolis: The University of Minnesota Press.

Ashford, D. (2017), *Autarchies: The Invention of Selfishness*, London: Bloomsbury.

Bardaouil, S. (2011), 'On Underwear Makers and Popes with a Healthy Libido', *Flashartonline*, November–December. https://www.flashartonline.com/article/on-underwear-makers-and-popes-with-a-healthy-libido/

Barikin, A. (2014), 'Zombie History: Contemporary Art in the Jungles of Cosmic Time,' in N. Croggon and H. Hughes (eds), *Three Reflections on Contemporary Art History*, Melbourne: Discipline magazine in conjunction with Emaj.

Batchen, G. (2014), 'Guest Editorial: Local Modernisms', *World Art*, 4, no. 1: 7–15.

Beaumont, P., P. Kingsley and A. Chrisafis (2013), 'The Rise of Violent Salafism', *The Guardian Weekly*, 15–21 February.

Belting, H., J. Birken, A. Buddensieg and P. Weibel, eds (2011), *Global Studies: Mapping Contemporary Art and Culture*, Cologne: Hatje Cantz.

Belting, H., A. Buddensieg and P. Weibel, eds (2013), The *Global Contemporary and the Rise of New Art Worlds*, Cambridge, MA: MIT Press.

Benfodil, M. (6 April 2011), 'Mustafa Benfodil: Because Art is Free to be Impolite: The Algerian Artist Explains His Installation, Censored at the Sharjah Biennial.' http://middleeast.about.com/od/algeria/qt/Mustafa-Benfodil-censorship.htm, https://www.facebook.com/notes/e-flux/mustapha-benfodil-because-art-is-free-to-be-impolite/10150150939540997/

Benfodil, M. (n.d), 'The Shuhada of the Past Fifty Years', *Manifesta Journal*, 16. www.manifestajournal.org/issues/regret-and-other-back-pages#page-issuesregretandotherbackpagesshuhadapastfiftyyears

Benjamin, W. (1931), 'The Destructive Character,' *One-Way Street and Other Writings*, trans. Edmund Jephcott and Kingsley Shorter, London: Verso, 1985: 157–8.

Benjamin, W. (1918/1996), 'The Coming Philosophy', in Marcus Bullock and Michael W. Jennings (eds), *Select Writings, Volume 1: 1913–1926*, Cambridge, MA and London: The Belknap Press of Harvard University Press.

Benjamin, W. (1996), *Select Writings, Volume 1: 1913–1926*, ed. M. Bullock and M. W. Jennings, Cambridge, MA and London: The Belknap Press of Harvard University Press.

Benjamin, W. (1931/1999), 'Mickey Mouse', in M. W. Jennings, H. Eiland, and G. Smith (eds), *Walter Benjamin: Selected Writings 1927–1934*, vol. 2, Cambridge, MA and London: The Belknap Press of Harvard University Press: 544–6.

Benjamin, W. (1933/1999), 'Experience and Poverty', in M. W. Jennings, H. Eiland and G. Smith (eds), *Walter Benjamin: Selected Writings 1927–1934*, vol. 2, Cambridge, MA and London: The Belknap Press of Harvard University Press: 731–6.

Benjamin, W. (2003), 'N: On the Theory of Knowledge, Theory of Progress', in *The Arcades Project*, trans. H. Eiland and K. McLaughlin, Cambridge, MA and London: The Belknap Press of Harvard University Press.

Bodick, N., and A. Anna Kats (2015), 'A Breakable History: Wael Shawky's *Cabaret Crusades* at MoMA PS1', *Blouin Artinfo*, 20 February. www.blouinartinfo.com/news/story/1102433/a-breakable-history-wael-shawkys-cabaret-crusades-at-moma-ps1#

Bois, Y.-E. (2003), 'Back to the Future: The New Malevich', *Bookforum*. www.bookforum.com/archive/win_03/bois.html

Boym, S. (2017), *The Off-Modern*, ed. D. Damrosch, New York, London, Oxford, New Delhi and Sydney: Bloomsbury.

Bru, S. (2009), *Democracy, Law and the Modernist Avant-Gardes: Writing in the State of Exception*, Edinburgh: Edinburgh University Press.

Brus, A. (2015), 'Der "Para" an der Düsseldorfer Akademie', unpublished paper.

Burn, I. (1975), 'The Art Market: Affluence and Degradation', *Artforum* 13, reprinted in Sandback, A. M., ed. (1984), *Looking Critically: 21 Years of Artforum Magazine*, Ann Arbor, MI: UMI Research Press: 173–6.

Burn, I. (1973/1991), 'Art is What We Do, Culture is What We Do to Other Artists', in Ian Burn *Dialogue: Writings in Art History*, North Sydney: Allen & Unwin: 131–39.

Burn, I. (1991), *Dialogue: Writings in Art History*, North Sydney: Allen & Unwin.

Burn, I. (1992), 'Uttered Objects/Reflected Words', *Art & Text*, 41 (January): 69–73.

Burn, I. (1993a), Stephen, A., ed. (2003), 'Ian Burn and Imants Tillers in Conversation (1993),' *Art Monthly Australia*, 159: 16–19.

Burn, I. (1993b), *Looking At Seeing & Reading* (exhibition catalogue), Sydney: Ivan Dougherty Gallery: n p.

Burn, I. (1994), 'Less is More, More or Less,' *Art and Australia*, 32, no. 2: 202–3.

Cardoso, R. (2017), 'Modernism and Periphery: A Transcultural View,' unpublished paper.

Chakrabarty, D. (2000), *Provincializing Europe: Postcolonial Thought and Historical Difference*, Princeton: Princeton University Press.

Clark, T. J. (1999), since *Farewell to an Idea: Episodes from a History of Modernism*, New Haven, CT: Yale University Press.

Clark, C. (2013), *The Sleepwalkers: How Europe Went to War in 1914*, London: Penguin.

Colhoun, D. (2010), 'Qatar Opens First Museum of Modern Arab Art, a Q&A with Chief Curator', *Huffington Post*, 29 December. www.huffingtonpost.com/damaris-colhoun/as-qatar-prepares-to-open_b_801055.html (accessed 21 January 2013).

Cotter, H. (2015), 'Review: *Cabaret Crusades* at MoMA PS1', *The New York Times*, 21 May, www.nytimes.com/2015/05/22/arts/design/review-wael-shawky-cabaret-crusades-at-moma-ps1.html?_r=0

Dagerman, S. (1947/2011), *German Autumn*, trans. R. F. Macpherson (Minneapolis: The University of Minnesota Press).

Davidson, C. M. (2011), 'The Making of a Police State', *Foreign Policy*, April 14.

Derrida, J. (2007), *Learning to Live Finally: The Last Interview*, Sydney: Allen & Unwin.

Dirlik, A. (1999), 'Is There History after Eurocentrism? Globalism, Postcolonialism, and the Disavowal of History', *Cultural Critique*, Spring, 42: 1–34.

Dodge, A. (2012), 'Robert Hunter: The Transcendental Minimalist?' in S. Cramer (ed.), *Less is More: Minimal + Post-Minimal Art in Australia*, Melbourne: Heide Museum of Modern Art: 92–3.

Duncan, J. (1989), curator and editor, *Robert Hunter Paintings 1966–1988*, exhibition catalogue, Clayton Victoria: Monash University Gallery.

During, S. (2002), introduction to *Modern Enchantments: The Cultural Power of Secular Magic*, Cambridge, MA and London: Harvard University Press.

Dussel, E. (1993), 'Eurocentrism and Modernity (Introduction to the Frankfurt Lectures),' *boundary 2*, 20, no. 3: 65–76.

Elkins, J. (2013), 'Introduction,' in J. Elkins and H. Montgomery (eds), *Beyond the Anti-Aesthetic and Aesthetic*, Pennsylvania: The Pennsylvania State University Press.

Elkins, J. (2017), 'The Limits of Globalization in Art History', The Keir Lectures on Art, Power Institute, University of Sydney, 24 October 2017. http://sydney.edu.au/sydney_ideas/lectures/2017/professor_james_elkins.shtml

Elkins, J., and H. Montgomery, eds (2013), *Beyond the Anti-Aesthetic and Aesthetic*, Pennsylvania: The Pennsylvania State University Press.

Engelhart, K. (2012), 'Slavoj Žižek: I Am Not the World's Hippest Philosopher', *Salon*, 30 December, www.salon.com/2012/12/29/slavoj_zizek_i_am_not_the_worlds_hippest_philosopher/ (accessed 11 July 2014).

Enzensberger, H. M. (1969), 'The Industrialization of the Mind,' *Partisan Review*, 36 (Winter): 100–11.

Enzensberger, H. M. (1976), 'Von der Unaufhaltsamkeit des Kleinbürgertums', *Kursbuch*, September 1976; translated by David J. Parent as 'On the Irresistibility of the Petty Bourgeoisie,' *Telos*, 30 (Winter): 161–6.

Eysteinsson, A. (1990), *The Concept of Modernism*, Ithaca and London: Cornell University Press.

Eysteinsson, A., and V. Liska (2007), 'Introduction: Approaching Modernism', in A. Eysteinsson and V. Liska (eds), *Modernism*, vol. 1, Amsterdam and Philadelphia: John Benjamins Publishing: 1–8.

Findelli, A. (2001), 'Rethinking Design Education for the 21st Century: Theoretical, Methodological, and Ethical Discussion', *Design Issues*, 17, no. 1: 10–11.

Florida, R. (2002), *The Rise of the Creative Class: And How It's Transforming Work, Leisure, Community and Everyday Life* (New York: Basic Books).

Forgács, É. (1997), *The Bauhaus Idea and Bauhaus Politics*, trans. J. Bátki, Budapest: Central European University Press.

Foster, H. (1983), *The Anti-Aesthetic*, Seattle: Bay Books.

Foster, H., R. Krauss, Y-A. Bois and B. Buchloh, eds (2004), *Art Since 1900: Modernism, Anti-modernism, Postmodernism*, London: Thames & Hudson.

Foucault, M. (1986), 'Of Other Spaces', *Diacritics*, spring: 22.

Francis, G. (2018), 'The Untreatable', *London Review of Books*, 40 (25 January 2018): 3–6.

Frisby, D. (1985), *Fragments of Modernity: Theories of Modernity in the Work of Simmel, Kracauer and Benjamin*, Cambridge, UK: Polity.

Fukuyama, F. (1992), *The End of History and the Last Man*, New York: Free Press.

Galvez, P. (2002), 'Avance rapide: le dernier Malevitch', *Cahiers du Musée National d'Art Moderne*, 79, Printemps: 83–98.

Gandolfo, D. I., and S. E. Worth (2015) 'Global Standpoint Aesthetics: Toward a Paradigm', in A. C. Ribeiro (ed.), *The Bloomsbury Companion to Aesthetics*, London and New York: Bloomsbury Publishing: 242–54.

Gao, S., S. Maharaj and T. Chang, eds (2008), *Farewell to Post-Colonialism: The Third Guangzhou Triennial*, Guangzhou: Guangdong Museum of Art.

Gardner, A. (2011), 'Whither the Postcolonial?' in H. Belting, J. Birken, A. Buddensieg and P. Weibel (eds), *Global Studies: Mapping Contemporary Art and Culture*, Ostfildern: Hatje Cantz Verlag.

Gardner, A., and C. Green (2013), 'Biennials of the South on the Edges of the Global,' *Third Text*, 27, no. 4: 442–55.

Gardner, A., and H. Hallam (2011), 'On the Contemporary – and Contemporary Art History (review of Terry Smith, *What Is Contemporary Art?*)', *Journal of Art Historiography*, 4: 1.

Gide, A. (1935), *Return from the U.S.S.R.*, New York: Alfred A. Knopf.

Grumley, J. (2013), 'Antipodean Enlightenment', *Critical Horizons*, 14, no. 2: 156–80.

GulfLabor, (7 January 2013), 'Jan 2013: GulfLabor Public Statement', *Who's Building the Guggenheim Abu Dhabi?* http://gulflabor.wordpress.com (accessed 10 February 2013).

Guston, P. (1978), 'Talk at "Art/Not Art?" Conference,' in C. Coolidge, ed. (2011), *Philip Guston: Collected Writings, Lectures, and Conversations*, Berkeley and Los Angeles: University of California Press.

Habermas, J. (1971), *Toward a Rational Society: Student Protest, Science and Politics*, Boston: Beacon Press.

Halbreich, K. (2014), 'Alibis: An Introduction', in K. Halbreich, M. Godfrey, L. Tattersall and M. Schaefer (eds), *Alibis: Sigmar Polke 1963–2010*, New York: The Museum of Modern Art.

Halbreich, K., M. Godfrey, L. Tattersall and M. Schaefer, eds (2014), *Alibis: Sigmar Polke 1963–2010*, New York: The Museum of Modern Art.

Harrison, C., and P. Wood, eds (2005), *Art in Theory 1900–2000: An Anthology of Changing Ideas*, Oxford, UK and Malden, MA: Blackwell Publishers and John Wiley & Sons.

Harutyunyan, A. (2011), 'When Matter Becomes Cultural Politics: Traps of Liberalism in the Tenth Sharjah Art Biennial', *Red Thread*, no. 3: 1–5. http://www.red-thread.org/en/article.asp?a=48

Hegel, G. W. F. (1975), 'The Beauty of Art or the Ideal', *Hegel's Aesthetics: Lectures on Fine Art*, trans. T. M. Knox, vol. 1, Oxford: Clarendon Press.

Heidegger, M. (1950), 'The Thing,' in *Poetry, Language, Thought*, trans. and intro. A. Hofstadter, New York: Harper and Row, 1971.

Herf, J. (1984), *Reactionary Modernism: Technology, Culture, and Politics in Weimar and the Third Reich*, Cambridge: Cambridge University Press.

Hobsbawm, E. (26 April 2012), 'After the Cold War: On Tony Judt', *London Review of Books*, 34, no. 8: 14.

Hobson, J. (2004), *The Eastern Origins of Western Civilisation*, Cambridge: Cambridge University Press.

Hussain, O. (2011a), 'After Hegel: An Interview with Robert Pippin', *Non-Site*, 18 June. http://nonsite.org/editorial/after-hegel-an-interview-with-robert-pippin (accessed 28 November 2012).

Hussain, O. (2011b), 'After Hegel: An Interview with Robert B. Pippin,' *Platypus Review*, 36 June. http://platypus1917.org/2011/06/01/after-hegel-an-interview-with-robert-pippin/

International Association of Art Critics (AICA) (2011), 'Protest against the Dismissal of Jack Persekian,' 15 April. http://aicainternational.org/en/protest-against-the-dismissal-of-jack-persekian-15-april-2011/

Jaggi, M. (2002), 'A Son of the Road', *The Guardian*, 16 November 2002. https://www.theguardian.com/music/2002/nov/16/classicalmusicandopera.fiction

Jolly, M. (2012), *Faces of the Living Dead: The Belief in Spirit Photography*, Silver Sands, Western Australia: TitleWave.

Judt, T. (2005), *Postwar: A History of Europe since 1945*, London: Penguin.

Koether, J. (2014), 'Bad Dad,' in K. Halbreich, M. Godfrey, L. Tattersall and M. Schaefer (eds), *Alibis: Sigmar Polke 1963–2010* (New York: The Museum of Modern Art).

Kolakowski, L. (1974), 'My Correct Views on Everything,' *The Socialist Register*, 11: 1–20.

Kolakowski, L. (1990), *Modernity on Endless Trial*, Chicago and London: University of Chicago Press.

Kolakowski, L. (2012), *Is God Happy? Selected Essays*, London: Penguin.

Krystof, D., and J. Morgan, eds (2006), *Martin Kippenberger*, London: Tate Publishing, 2006.

Lange-Berndt, P., and D. Rübel, eds (2011), *Sigmar Polke: We Petty Bourgeois! Comrades and Contemporaries, The 1970s*, New York: Distributed Art Publishers, Inc.

Marchant, O. (2014), 'The Globalization of Art and the "Biennials of Resistance": A History of the Biennials from the Periphery,' *CuMMA Papers*, no. 7, Aalto University, Helsinki: 1–12.

Márkus, G. (1994), 'A Society of Culture: The Constitution of Modernity', in G. Robinson and J. Rundell (eds), *Rethinking Imagination*, London & New York: Routledge: 15–29.

Márkus, G. (2011), *Culture, Science, Society: The Constitution of Cultural Modernity*, Leiden: Brill.

Martin, D. (2001), 'Rosemary Brown, a Friend of Dead Composers, Dies at 85', *The New York Times*, 2 December 2001. https://www.theguardian.com/news/2001/dec/11/guardianobituaries

Martin, B. (2013), *Hanging Man: The Arrest of Ai Weiwei*, London: Faber and Faber.

Masschelein, A. (2011), The *Unconcept: The Freudian Uncanny in Late-Twentieth-Century Theory*, Albany: State University of New York Press.

Maxwell, R., and T. Miller (2011), 'Old, New and Middle-Aged Media Convergence', *Cultural Studies*, 25, no. 4–5 (July–September 2011): 585.

McBride, Patrizia C. (2004), '"In Praise of the Present": Adolf Loos on Style and Fashion,' *Modernism/Modernity*, 11, no. 4: 745.

McCole, J. (1993), *Walter Benjamin and the Antinomies of Tradition*, Ithaca and London: Cornell University Press.

McLean, I. (2009), 'Provincialism Upturned', *Third Text*, 23, no. 5: 625–32.

McNeil, S. (12 November 2017), 'Ahmed Mansoor: NGOs Fear World has Forgotten the Arrest of UAE's Last Human Rights Defender,' *ABC News*.

Meecham, P., ed. (2018a) *A Companion to Modern Art*, Oxford, UK and Hoboken, NJ: Wiley Blackwell.

Meecham, P. (2018b), 'Introduction', in Pam Meecham (ed.), *A Companion to Modern Art*, Oxford, UK and Hoboken, NJ: Wiley Blackwell.

Meyer, R. (2013), *What was Contemporary Art?* Cambridge, MA and London: The MIT Press.

Mhenni, L. B. (2015), 'My Arab Spring: Tunisia's Revolution was a Dream', *Al Jazerra*, 17 December. http://www.aljazeera.com/news/2015/12/arab-spring-tunisia-revolution-dream-151209062258742.html

Milliard, C. (14 April 2011), 'Censored Algerian Artist Mustapha Benfodil on His Part in the Sharjah Biennial Controversy', *Blouin Artinfo*. www.blouinartinfo.com/news/story/37461/censored-algerian-artist-mustapha-benfodil-on-his-part-in-the-sharjah-biennial-controversy

Montgomery, H. (2013), 'Preface,' in J. Elkins and H. Montgomery (eds), *Beyond the Anti-Aesthetic and Aesthetic*, Pennsylvania: The Pennsylvania State University Press.

Morgan, J. (26 June 2011), 'What's the Future for the Blockbuster?' *Artworks*. Ultimo: ABC Radio National. http://www.abc.net.au/radionational/programs/artworks/whats-the-future-for-the-blockbuster/3658124

Najafi, S. (2007), 'Modern Enchantments: An Interview with Simon During', *Cabinet*, issue 26, summer. http://www.cabinetmagazine.org/issues/26/najafi.php

Nicholson, T. (2014/15), 'Robert Hunter 1947–2014,' *Art Monthly Australia*, 276: 80.

Oakley, K., and J. O'Connor, eds (2015), 'Introduction,' in *The Routledge Companion to the Cultural Industries*, London and New York: Routledge and Taylor and Francis: 1–32.

Orton, K. (2012), 'The Desert of the Unreal', *Dazed*, 9 November. http://www.dazeddigital.com/artsandculture/article/15040/1/the-desert-of-the-unreal

Osborne, P. (2013), *Anywhere or Not At All: Philosophy of Contemporary Art*, London and New York: Verso.

Papastergiadis, N. (2012), 'Can There Be a History of Contemporary Art?' *Discipline*, 2: 154.

Pasture, P. (2015), 'Formations of European Modernity: Cosmopolitanism, Eurocentrism and the Uses of History', *International Journal for History, Culture and Modernity*, 3, no. 1: 73–89.

Penny, N. (2017), 'Top Brands Today,' *London Review of Books*, 14 December.

Perloff, M. (1986), *The Futurist Moment: Avant-Garde, Avant Guerre, and the Language of Rupture*, Chicago and London: The University of Chicago Press.

Piotrowski, P. (2008/09), 'Towards a Horizontal History of Modern Art,' *Writing Central European Art History*, Austria: Erste Stiftung: 4.

Piper, A. (1997), 'Ian Burn's Conceptualism,' *Art in America*, 85, no. 12: 73–4.

Pippin, R. (1991), *Modernism as a Philosophical Problem: On the Dissatisfactions of European High Culture*, Oxford and Cambridge, MA: Basil Blackwell.

Pippin, R. (2004), 'Critical Inquiry and Critical Theory: A Short History of Nonbeing', *Critical Inquiry*, 30, no. 2: 427.

Pippin, R. (2005), *The Persistence of Subjectivity: On the Kantian Aftermath*, Cambridge: Cambridge University Press.

Pippin, R. (2007), 'Interview', *The Yale Philosophy Review*, Issue 3: 79–96.

Pippin, R. (2010a), 'Philosophical Film: Trapped by Oneself in Jacques Tourneur's *Out of the Past*', *New Literary History*, 41: 517–48.

Pippin, R. (2010b), 'Tea Party as Western Movie', *The Washington Post*, 29 June. http://voices.washingtonpost.com/political-bookworm/2010/06/tea_party_as_western_movie.html

Pippin, R. (2014), *After the Beautiful: Hegel and the Philosophy of Pictorial Modernism*, Chicago: The University of Chicago Press.

Poljarevic, E. (2015), 'Islamic Tradition and Meanings of Modernity,' *International Journal for History, Culture and Modernity*, 3, no. 1: 29–57.

Polke: Fenster-Windows, Grossmünster Zürich (2010), Zürich and New York: Parkett Publishers.

Rabbat, N. (2012), 'The Arab Revolution Takes Back the Public Space,' *Critical Inquiry*, 39 (Autumn): 198–208.

Ramadan, T. (2012), *The Arab Awakening: Islam and the New Middle East*, London: Allen Lane.

Rancière, J. (2004), *The Politics of Aesthetics*, trans. Gabriel Rockhill. New York: Continuum.

Richter, G. (17 November 2011), 'Grey Panic,' *London Review of Books*, 33, no. 22: 3–7.

Roberts, H. (2015), 'The Hijackers', *London Review of Books*, 16 July 2015: 5–10.

Robins, C. (2018), 'A Modern Art Education', in Pam Meecham (ed.), *A Companion to Modern Art*, Hoboken, NJ: Wiley Blackwell.

Rochlitz, R. (2000), 'Where Have We Got To', in *Photography and Painting in the Work of Gerhard Richter: Four Essays on Atlas*, Barcelona: Museu d'Art de Contemporani de Barcelona.

Ross, T. (2013), 'The Elusive "Beyond" of Aesthetic and Anti-Aesthetic,' in J. Elkins and H. Montgomery (eds), *Beyond the Anti-Aesthetic and Aesthetic*, Pennsylvania: The Pennsylvania State University Press.

Ross, S., and A. C. Lindgren, eds (2015), *The Modernist World*, Abingdon, Oxon and New York: Routledge.

Rottmann, K. (2011), 'Giornico: For a Red Switzerland', in P. Lange-Berndt and D. Rübel (eds), *Sigmar Polke: We Petty Bourgeois! Comrades and Contemporaries, The 1970s*, New York: Distributed Art Publishers, Inc.

Rübel, D., P. Lange-Berndt, D. Böhm, M. Liebelt, O. Pascheit and
P. Roettig, eds (2010), *Polke & Co. Wir Kleinbürger! Zeitgenossen und
Zeitgenossinnen: Dokumentation einer Ausstellung in der Hamburger
Kunsthalle (We petty Bourgeois! Comrades and Contemporaries:
Documentation of an exhibition at the Hamburger Kunsthalle)*, Köln:
Verlag der Buchhandlung Walther König.

Ryan, Y. (2012), 'Tunisia's Embattled Artists Speak Out', *Aljazeera*,
15 June. http://www.aljazeera.com/indepth/features/2012/06/2012615
111819112421.html

Safranski, R. (1994) *Ein Meister aus Deutschland: Heidegger und seine
Zeit*, Müchen, Wien: Carl Hanser Verlag.

Safranski, R. (1998), *Martin Heidegger: Between Good and Evil*, trans.
Ewald Osers, Cambridge, MA and London: Harvard University Press.

Schjeldahl, R. (2008), 'Many-Colored Glass: Gerhard Richter and Sigmar
Polke Do Windows', *The New Yorker*, 12 May. https://www.newyorker.
com/magazine/2008/05/12/many-colored-glass-peter-schjeldahl

Schürmann, E. (2013), 'What If We Really Have Never Been Modern?',
in J. Elkins and H. Montgomery (eds), *Beyond the Anti-Aesthetic and
Aesthetic*, Pennsylvania: The Pennsylvania State University Press: 143.

Shabout, N. (2015), 'Modernism and the Visual Arts in the Middle East
and North Africa', in S. Ross and A. C. Lindgren (eds), *The Modernist
World*, Abingdon, Oxon and New York: Routledge.

Shattuck, Roger (1968), *The Banquet Years: The Origins of the Avant-
Garde in France 1885 to World War One*, New York: Vintage Books
and Random House: 1.

Skrebowski, L. (2009), 'Productive Misunderstandings: Interpreting Mel
Bochner's Theory of Photography', *Art History*, 32, no. 5 (December):
910–932.

Slifkin, R. (2012), 'Is Contemporary Art History?' *Oxford Art Journal*, 35,
no. 1: 111.

Smith, S. B. (2016), *Modernity and Its Discontents: Making and
Unmaking the Bourgeois from Machiavelli to Bellow*, New Haven &
London: Yale University Press.

Smith, T. (1974/1984), 'The Provincialism Problem,' *Artforum*, 1974;
republished in Paul Taylor, ed. (1984), *Anything Goes: Art in Australia
1970–1980*, South Yarra: Art & Text.

Smith, T. (2006), 'Contemporary Art and Contemporaneity', *Critical
Inquiry*, 32, no. 4: 681–707.

Smith, T. (2008), 'Introduction: The Contemporaneity Question,' in
T. Smith, O. Enwezor and N. Condee (eds), *Antinomies of Art and
Culture: Modernity, Postmodernity, Contemporaneity*, Durham, NC:
Duke University Press.

Smith, T. (2009), *What Is Contemporary Art?* Chicago: The University of
Chicago Press.

Smith, T. (2011), *Contemporary Art: World Currents*, London: Laurence King Publishing.

Smith, T. (2014), 'A Philosophy of Contemporary Art? Some Comments on Osborne,' in N. Croggon and H. Hughes (eds), *Three Reflections on Contemporary Art History*, Melbourne: Discipline magazine in conjunction with Emaj.

Smith, T. (2015), 'Contemporary Art and Contemporaneity: Reflections on Method, Review of Reviews (Part 2)' *Discipline*, no. 4: 159–69.

Sorokina, E. (2006), 'Conversations with Elena Kovylina (interview),' *Conversations: New York Foundation for the Arts (NYFA)*. http://current.nyfa.org/post/73238399345/conversations-elena-kovylina (accessed 6 May 2015).

Stephen, A. (2006), *On Looking at Looking: The Art and Politics of Ian Burn*, Melbourne: The Miegunyah Press and Melbourne University Publishing.

Stephen, A., ed. (2010), *Mirror Mirror: Then and Now*, Brisbane: IMA Publishing.

Stephen, A. (2013), *1969: The Black Box of Conceptual Art*, Sydney: The University of Sydney: 79–80.

Steyerl, H. (2014) 'Too Much World: Is the Internet Dead?' in N. Aitkens (ed.), *Too Much World: The Films of Hito Steyerl*, Berlin: Sternberg Press.

Steyerl, H. (2015), 'Duty-Free Art,' *e-flux*, March edition. http://www.e-flux.com/journal/63/60894/duty-free-art/

Stoilas, H. (2011), 'Artists Boycott Guggenheim Abu Dhabi Project', *The Art Newspaper*, 17 March. www.theartnewspaper.com/articles/Artists-boycott-Guggenheim-Abu-Dhabi-project/23383

Stoilas, H. (2013), 'Artists Press for Better Working Conditions on Saadiyat Island', *The Art Newspaper*, 9 January. http://old.theartnewspaper.com/articles/Artists%20press%20for%20better%20working%20conditions%20on%20Saadiyat%20Island/28446

Storr, R. (2002), 'Gerhard Richter: The Day Is Long' (interview), *Art in America*, January: 67–74, 121.

Sunstein, C. (2003), *Why Societies Need Dissent*, Cambridge, MA and London: Harvard University Press.

Toepfer, K. (1997), *Empire of Ecstasy: Nudity and Movement in German Body Culture, 1910–1935*, Berkeley-Los Angeles-London: University of California Press.

Tolokonnikova, N. (8 August 2012), 'Closing Statements in Pussy Riot Trial'. http://eng-pussy-riot.livejournal.com/4602.html (accessed 20 August 2012).

Toukan, H. (2011), 'Boat Rocking in the Art Islands: Politics, Plots and Dismissals in Sharjah's Tenth Biennial,' *Jadaliyya*, 2 May. http://www.

jadaliyya.com/pages/index/1389/boat-rocking-in-the-art-islands_
politics-plots-and

Trotsky, L. (1938), 'Hue and Cry over Kronstadt', *The New International*,
4, no. 4 (April): 103–6. http://www.marxists.org/archive/
trotsky/1938/01/kronstadt.htm (accessed 29 December 2014).

Tunisia jails 16 Islamists over art riots (2013), *Arts Hub*, 25 January.
www.artshub.com.au/news-article/news/all-arts/tunisia-jails-16-
islamists-over-art-riots-193796

Vermeulen, T. (2013), 'As If,' in J. Elkins and H. Montgomery (eds),
Beyond the Anti-Aesthetic and Aesthetic, Pennsylvania: The
Pennsylvania State University Press.

Volkov, S. (2009), *The Magical Chorus: A History Of Russian Culture
From Tolstoy To Solzhenitsyn*, New York: Vintage Books.

Wagner, A. (2015), 'At Tate Britain', *London Review of Books*, 37, no. 16
(August): 33.

Whittaker, I. (15 January 2013), 'I Am the World, I Want to be Forgotten:
An Interview with Ai Weiwei' (interview conducted 18 December
2012), *Randian*. http://www.randian-online.com/np_feature/i-am-the-
world-i-want-to-be-forgotten-interview-with-ai-weiwei/ (accessed
25 January 2013)

Wiener, J. M. (1976), 'Marxism and the Lower Middle Class: A Response
to Arno Mayer', *The Journal of Modern History*, 48, no. 4 (December):
666–71.

Wildt, M. (2003), 'Plurality of Taste: Food and Consumption in West
Germany during the 1950s', in D. B. Clarke, M. A. Doel and K. M.
L. Housiaux (eds), *The Consumption Reader*, New York: Routledge:
107–12.

Wilson-Goldie, K. (22 March 2013), 'Spring Break: The Opening of the
11th Sharjah Biennial', *Artforum*. http://artforum.com/diary/id=39949

Wood, P. (2014), *Western Art and the Wider World*, London: Wiley-
Blackwell.

Zielinski, S. (1999), *Audiovisions: Cinema and Television as Entr'actes in
History*, trans. G. Custance, Amsterdam: Amsterdam University Press.

Žižek, S. (1998), 'A Leftist Plea for "Eurocentrism"', *Critical Inquiry*, 24,
no. 4 (Summer): 988–1009.

INDEX